CELEBRITY ACROSS THE CHANNEL, 1750–1850

PERFORMING CELEBRITY

Series Editor
 Laura Engel, Duquesne University

Editorial Advisory Board
 Steph Burt, Harvard University
 Elaine McGirr, Bristol University
 Judith Pascoe, Florida State University
 Joseph Roach, Yale University
 Emily Rutter, Ball State University
 David Francis Taylor, University of Warwick
 Mary Trull, St. Olaf College

Performing Celebrity publishes single-authored monographs and essay collections that explore the dynamics of fame, infamy, and technologies of image-making from the early modern period to the present day. This series of books seeks to add to exciting recent developments in the emerging field of celebrity studies by publishing outstanding works that explore mechanisms of self-fashioning, stardom, and notoriety operating across genres and media in a broad range of historical and national contexts. It focuses on interdisciplinary projects that employ current research and a wide variety of theoretical approaches to performance and celebrity in relation to literature, history, art history, media, fashion, theater, gender(s), sexuality, race, ethnicity, disability, and material culture.

CELEBRITY ACROSS THE CHANNEL, 1750–1850

*Edited by Anaïs Pédron
and Clare Siviter*

University of Delaware Press
Newark

Library of Congress Cataloging-in-Publication Data

Names: Pédron, Anaïs, editor. | Siviter, Clare, editor.
Title: Celebrity across the channel, 1750-1850 / edited by Anaïs Pédron
 and Clare Siviter.
Identifiers: LCCN 2020053159 (print) | LCCN 2020053160 (ebook) | ISBN
 9781644532126 (hardback) | ISBN 9781644532133 (paperback) | ISBN
 9781644532140 (ebook)
Subjects: LCSH: Fame--History--18th century. | Fame--History--19th century.
 | Celebrities--France--History--18th century. |
 Celebrities--France--History--19th century. | Celebrities--Great
 Britain--History--18th century. | Celebrities--Great
 Britain--History--18th century.
Classification: LCC CT1011 .C35 2021 (print) | LCC CT1011 (ebook) | DDC
 920.009/033--dc23
LC record available at https://lccn.loc.gov/2020053159
LC ebook record available at https://lccn.loc.gov/2020053160

A British Cataloging-in-Publication record for this book is available
from the British Library.

University of Delaware Press
© 2021 by Anaïs Pédron and Clare Siviter

References to internet websites (URLs) were accurate at the time of writing. Neither the author nor the University of Delaware Press is responsible for URLs that may have expired or changed since the manuscript was prepared.

The paper used in this publication meets the requirements of the American National Standard for Information Sciences—Permanence of Paper for Printed Library Materials, ANSI Z39.48-1992.

udpress.udel.edu

Distributed worldwide by Rutgers University Press

Manufactured in the United States of America

CONTENTS

FIGURES

PREFACE

ANTOINE LILTI

When I started to become interested in the history of celebrity over a decade ago, the subject did not seem to exist in scholarship. Not only was there no study dedicated to celebrity during the eighteenth century, but the subject often provoked shocked or condescending smiles, at least among historians. Certainly, there was the major study by Leo Braudy, and a handful of works on contemporary celebrity like those of Joshua Gamson and P. David Marshall, but the topic's bibliography was slim at best.[1] The state of affairs was such principally due to the disdain of historians for a subject they judged to be frivolous, as well the confusion of "celebrity" with close terms like "glory" and "reputation." This lack of interest contrasted sharply not only with the importance of stars in our own contemporary societies, but with the presence of a language of celebrity in the sources of the eighteenth century.

Over the last few years, the field has changed dramatically. There has been a flurry of publications, from historical overviews and multi-author volumes to monographs and sociological studies; even a specialist journal, *Celebrity Studies*, was launched. I am thinking particularly of the works of Fred Inglis, Tom Mole, Robert Van Krieken, P. David Marshall, Laura Engel, Edward Berenson, Eva Giloi, Heather McPherson and Sharon Marcus.[2] These scholars are cited and discussed in this volume, forming as they do a

rich resource of methodological and historical references. Celebrity Studies is poised to become a field that is particularly open and fertile, interdisciplinary and inventive, and that raises numerous discussions and lively debates. It is a great pleasure to see young scholars engaging energetically with it and proposing, through their own case studies and their own approaches, new and original perspectives. Anaïs Pédron and Clare Siviter have united an extremely stimulating selection of texts that speak to each other, offering the reader a rich insight into the possibilities that the history of celebrity affords.

The studies here confirm the historical importance of the period that stretches from the middle of the eighteenth to the middle of the nineteenth century. Colin Jones and Dror Wahrman have identified this period as that of the "cultural revolutions" and it marks a profound transformation in the mechanisms of recognition as a result of a genuine "media revolution."[3] This statement might seem excessive: did not mass media, with large-circulation press, radio, and cinema start at the beginning of the twentieth century? I argue that if we look at the qualitative changes in forms of communication, it becomes clear that the very rapid development in print (books, newspapers, and images) during the eighteenth century corresponded to a deep social and cultural change. While ancient societies were structured by face-to-face relationships and by orality, modern societies were transformed by media communication that allowed for the proliferation of long-distance interactions. Celebrities were known by a very large public, by a large number of anonymous individuals who had never met the famous person in question but who knew a lot about them, including about their private life. Such is the specificity of celebrity compared to other forms of recognition: it arouses the public's curiosity about the intimate, personal, and emotional life of famous people. It transforms some individuals into public figures, into characters who live a quasi-autonomous life in the newspapers and in conversations of people unknown to them; this life even extends into fiction sometimes. This transformation of individuals into genuine public figures often proves to be a difficult experience for those concerned, and much less straightforward than they would have imagined. This dialectic of prestige and burden, which makes celebrity simultaneously a desirable but

painful experience, is not the product of our media-dominated post-modernity—it was described very precisely by Jean-Jacques Rousseau, Lord Byron, Sarah Siddons, and Franz Liszt.[4]

The study of celebrity allows us to understand the interconnected development of the concepts of the public sphere and privacy. In the 1990s and 2000s, most scholars who tried to link the rise of privacy to the question of the public sphere were inspired by the work of Jürgen Habermas. They insisted on the importance of sociability, of the empowerment of civil society, and of public opinion as a force opposing the state. However, this approach has shown its limits, particularly through its inability to take into consideration the dynamics of working-class publics, the importance of the emotions, and the specifically commercial dynamics that organize the public sphere. The history of celebrity, however, allows us to study the ways in which the constraints imposed by a high public profile are set against the desire for personal authenticity. It reveals the importance of "curiosity," the role of scandals, and the fluctuating duration of celebrity. Celebrity is based less on admiration than on an ability to capture the attention of the public, to cause scandals, to make oneself be talked about, or even to arouse empathy.

As the essays in this volume show, eighteenth- and nineteenth-century contemporaries were very conscious of these issues, and they reflected intensely on the consequences. In their memoirs, essays, and fiction, they discussed the difference between glory and celebrity, the dangers of caricature and defamation, the public's insatiable curiosity, new forms of hierarchy, and the power that celebrity conveyed. One of the recurring questions was how to reconcile contemporary celebrity, a source of narcissistic satisfaction, with posthumous glory. From Abraham Hyacinthe Anquetil-Dupperon to Jeremy Bentham, scholars and authors adapted their publication strategies and their public representations to try and ensure glory, with Bentham going as far as to invent his own posthumous monumentalization.

Debates on celebrity were a way for contemporaries to interrogate the emergence of a public on the cultural and political scene. The public was a new actor in the political arena but its legitimacy was contested, and it was considered both a source of enthusiasm and a threat. The campaigns from the middle of the nineteenth

xii / ANTOINE LILTI

century to empower domains of cultural activity by assigning them their own norms and regulatory bodies were perhaps less directed against the state and the social elite, as cultural sociologists have often asserted, than against the public, its tastes, and its expectations.

Three important themes emerge from this remarkable collection of essays: political celebrity; the links between celebrity and talent; and the gendered nature of celebrity. These three elements open up paths for new research.

Several chapters insist on the impact of celebrity in the political sphere. For example, we read about antique models of revolutionary celebrities, the diplomatic disputes of the Chevalier d'Eon, the actions of the Princes of the Blood at the end of the Ancien Régime, and the role of the press in the construction of the public image of English politicians. At first, studies on celebrity focused primarily on authors (such as Rousseau, Voltaire, and Byron) or on figures from the theatrical world (including David Garrick, Siddons, and François-Joseph Talma). This is not surprising: these are two categories of people whose professions implied a relationship with the public, just like today's film actors, singers, and television stars. Scholars of political history have been prudent because for them the mechanics of celebrity appear sullied, indeed fundamentally illegitimate, in the sphere of power. According to most historians and political scientists, the advent of celebrity in the political sphere is a recent phenomenon that, they allege, appeared in the 1960s with John Kennedy, and which has developed worryingly, with Silvio Berlusconi and Donald Trump.

However, more recently, scholars have focused on the history of political celebrity. In *The Invention of Celebrity*, I made the case for the emergence of celebrity politics in the age of the Atlantic Revolutions. Brian Cowan has argued that celebrity culture already existed at the beginning of the eighteenth century, with figures such as Henri Sacheverell, and has even more remote origins in the charisma surrounding religious and political figures in the early modern period.[5] However, historians have mostly stressed the growth of political celebrity during the nineteenth century.[6] Simon Morgan has studied the appeal of public figures on popular politics in the wake of the French and American Revolutions, and has shown the

proximity between the worship of political heroism and the mechanisms of celebrity.[7] Political celebrity was stretched between two poles: traditional charisma, on one side, and artistic fame on the other. The specificity of political celebrity, in the Victorian era, was to be deeply connected with literary celebrity, as it was by the eloquent case of Benjamin Disraeli, who was famous both as a novelist and as a man of state, self-fashioning a public persona at the crossroads of authorship and politics.[8]

The texts in this volume rightly insist on the proximity between the political and theatrical stages, as Paul Friedland argued recently.[9] Modern politics, as it developed in Britain in the eighteenth century, was marked by the centrality of parliamentary debates but also by the development of the media, a point that has not been explored so thoroughly. The inherent theatricality of politics gained a new significance. Politics was no longer simply a matter of representing power, to put it on stage as per the classical model that utilized portraits of the kings and monarchical rituals. What mattered now was the place of the spectators, this public that was simultaneously a mix of both serious readers and gossip-seekers, but also a people who were citizens, who provided a source of political legitimacy. For the fresh players in politics, this new order allowed for new political strategies but also imposed its own heavy constraints.

It should be no surprise that figures from the world of politics became celebrities and that they were caricatured in the press next to actresses. The ability to efface the differences between spheres of activity is one of the great functions of celebrity. This function is often criticized today, but it does not date from the advent of television. The erosion of distinctions between celebrities from different domains results in the weakening of the link between celebrity and talent. If celebrity were only an extreme form of recognition, then it would only be accorded to the people with the most talent. In reality, celebrity depends much more on a large and curious public and on poorly informed intermediaries than on the opinions of peers or experts. Such is the extent of the role of the first two groups that the difference between celebrity and recognition of true talent is often an important one, nearly a cliché: celebrity is more often a disgrace and a burden than it is an honor.

One point has continuously been overlooked. The language of talent as a personal gift that needed to be cultivated was developed during the eighteenth century at exactly the same time as was the concept of celebrity. Deep down, both were new ways of legitimizing inequalities at a time when the traditional hierarchies that had structured the Ancien Régime became embroiled in crisis. The meritocratic ideal of talent would become the ideological foundation of democratic societies. In this schema, talent is certified by a series of assessments (such as exams, competitions, and judgments by peers) and is associated with the requirements of social utility, justifying social or economic inequalities. Celebrity, however, is based on media exposure and public curiosity, and is supported by the culture industry and by the "creativity machine" that is inherent to modern capitalism, leading from "performance stars" to "personality stars."[10] Celebrity fascinates those who dream of quick and spectacular success, but remains suspect in the eyes of moralists and meritocratic ethics.

From this stems the idea that talent is not necessary to become a celebrity. This criticism allows for the reproach that celebrity is simply a mill for stars without talent. The denunciation of celebrities as tautological, "well-known for their well-knowness" in Daniel J. Boorstin's words, has become commonplace.[11] But things might be changing, both because the language surrounding talent is evolving as a result of marketing and because the celebrity industry has insisted upon the idea that celebrity is the result of a constant effort and tireless work.[12] #NotBadForAGirlWithNoTalent was the ironic hashtag launched by Kim Kardashian. This reversal in stigma reveals the extent to which contemporary celebrity culture can play easily on sarcasm, at the risk of banalizing access to celebrity and making it lose its aura.

The case of Kim Kardashian reminds us that the mechanics of celebrity are heavily gendered. Several chapters in this volume tackle this question head on. Throughout her life, Mademoiselle Clairon had to defend her reputation and cultivate her future glory despite the dangers of her scandalous celebrity, which was fueled by a calumnious biography. Germaine de Staël appears in two chapters here, as the author of *Corinne, ou l'Italie* (1807), the great novel describing the torment of female celebrity, and as a celebrity figure herself. The inclusion of these two angles is surely no coincidence.

Staël lived through the turn of century and shrewdly observed the seismic cultural, social, and political transformations in Europe, never ceasing to reflect on the stakes of political celebrity and the menace this form of celebrity posed to democracy when it was monopolized by one man alone, such as Napoleon Bonaparte. But above all, Staël was attentive to the specific constraints that celebrity imposed on talented women, those who wished to distinguish themselves in the fields of art and literature. The quest for glory was blighted by the public exposure of women who were subjected to all forms of slander but incapable of defending themselves. We should reread the bitter pages that Staël dedicated as early as 1801 to "female writers" [femmes qui cultivent les lettres], like "the Pariahs of India" [Parias de l'Inde], who were alone and prey to curiosity and envy: "Let us suppose some female existing, who, seduced by the celebrity of talents, would ardently endeavor to obtain it, how easy would it be to dissuade her, if she had not already advanced too far, to recede?" [S'il existait une femme séduite par la célébrité de l'esprit, et qui voulût chercher à l'obtenir, combien il serait aisé de l'en détourner s'il en était temps encore].[13]

Celebrity is a major characteristic of contemporary societies. It seems to have invaded every sphere of activity, from the world of business to politics, as the career of the former President of the United States demonstrates. But celebrity is also changing rapidly. The Internet and social media have created new forms of micro-celebrities—people who broadcast their videos on YouTube receive millions of views and are idolized by a public that is often made up of adolescents, but who do not have access to traditional media and thus remain unknown by the wider public. Alongside this, the extreme visibility available today has destroyed a part of celebrity's prestige and forces more and more stars to seek obscurity and discretion. In a society where everybody is exposed and watched, "invisibility" might become a valuable resource. In the face of this double evolution, it is now necessary more than ever to study the complex history of celebrity.

Translated by Clare Siviter

Notes

1. Leo Braudy, *The Frenzy of Renown: Fame and its History* (Oxford: Oxford University Press, 1986); Joshua Gamson, *Claims to Frame: Celebrity in Contemporary America* (Berkley: University of California Press, 1994); P.

David Marshall, *Celebrity and Power: Fame in Contemporary Culture* (Ann Arbor: University of Michigan Press, 1997).

2. Fred Inglis, *A Short History of Celebrity* (Princeton, NJ: Princeton University Press, 2010); Tom Mole, *Byron's Romantic Celebrity: Industrial Culture and the Hermeneutic of Intimacy* (Basingstoke: Palgrave Macmillan, 2007); Tom Mole, ed., *Romanticism and Celebrity Culture, 1750–1850* (Cambridge: Cambridge University Press, 2009); Robert van Krieken, *Celebrity Society* (London; New York; Routledge, 2012); Laura Engel, *Fashioning Eighteenth-Century British Actresses and Strategies for Image Making* (Columbus: Ohio State University Press, 2016); Edward Berenson and Eva Giloi, eds., *Constructing Charisma: Celebrity, Fame, and Power in Nineteenth-Century Europe* (New York: Berghahn Books, 2010); P. David Marshall and Sean Redmond, eds., *A Companion to Celebrity* (Chichester, UK: Wiley Blackwell, 2016); Heather McPherson, *Art and Celebrity in the Age of Reynolds and Siddons* (University Park: Pennsylvania State University Press, 2017); Sharon Marcus, *The Drama of Celebrity* (Princeton, NJ: Princeton University Press, 2019); Robert van Krieken and Nicola Vinovrski, eds., "Celebrity's Histories: Case Studies and Critical Perspectives," special issue, *Historical Social Research Supplement* 32 (December 2019).

3. Colin Jones and Dror Wahrman, eds., *The Age of Cultural Revolutions: Britain and France 1750–1850* (Berkley: University of California Press, 2002).

4. Antoine Lilti, *The Invention of Celebrity, 1750–1850*, trans. Lynn Jeffress (Cambridge: Polity Press, 2017).

5. Brian Cowan, "Henri Sacheverell and the Politics of Celebrity in Post-Revolutionary Britain," in *Public Interiors: Intimacy and Celebrity in Eighteenth-Century England*, eds. Emrys D. Jones and Victoria Joule (Basingstoke: Palgrave Macmillan, 2018), 111–37; Brian Cowan, "Histories of Celebrity in Post-Revolutionary England," *Historical Social Research* 32 (2019): 83–98.

6. Berenson and Giloi, eds., *Constructing Charisma*.

7. Simon Morgan, "Heroes in the Age of Celebrity," *Historical Social Research* 32 (2019): 165–85.

8. Sandra Mayer, "The Prime Minister as Celebrity Novelist: Benjamin Disraeli's 'Double Consciousness,'" *Forum for Modern Language Studies* 54, no. 3 (July 2018): 354–68.

9. Paul Friedland, *Political Actors, Representative Bodies and Theatricality in the Age of the French Revolution* (Ithaca, NY: Cornell University Press, 2002).

10. Andreas Reckwitz argues that the modern celebrity system is a consequence of the rise of an "aesthetic economy" that promotes creativity and self-performance as central values of capitalist societies. Reckwitz, *The Invention of Creativity* (Cambridge: Polity Press, 2017).

11. Daniel J. Boortstin, *The Image: A Guide to Psuedo-Events in America, 50th Anniversary edition* (New York: Vintage Books, 2012), vii–viii.

12. Pierre-Michel Menger, ed., *Le Talent en débat* (Paris: Presses universitaires de France, 2018).

13. French from: Germaine de Staël, *De la littérature, considérées dans ses rapports avec les institutions sociales* (Paris: Classiques Garnier, 1998), 324–35. English from: Germaine de Staël, *A Treatise on Ancient and Modern Literature Illustrated by Striking References to the Principal Events and Characters that have Distinguished the French Revolution*, vol. 2 (London: George Cawthorn, 1803), 141, 159, 153.

CELEBRITY ACROSS THE CHANNEL, 1750–1850

INTRODUCTION

ANAÏS PÉDRON AND CLARE SIVITER

The concept of celebrity might be centuries old, but the marriage of Meghan Markle and Prince Harry has shown that its meaning, both with respect to the relationship between celebrity and royalty, and in the British context more generally, remains contested. Welcomed as a fairy tale romance, there was outcry as Markle's social media accounts were deleted, taking with them easy access to her life, and as it became clear that she would leave her acting career. The transition to the British monarchy had seemingly stripped Markle of the mechanics of her celebrity, but it persevered nevertheless; the couple has remained under intense media scrutiny, even after stepping back from being senior royals and arriving in North America. On the other side of the Channel, the monarchy may have gone but the presidency is occupied by "Jupiter," aka Emmanuel Macron, whose image is carefully crafted and then circulated through publications such as the gossip magazine *Paris Match*. Beyond the Channel neighbors, from Donald Trump in the United States to Volodymyr Zelensky in Ukraine, celebrities are becoming presidents: "celebrity politics" is the order of the day. These cases, like those of Markle, now the Duchess of Sussex, and Macron, may take the media by storm and appear inherently novel, but they can be better understood through studying the history of celebrity over the last three centuries from its rise during the Age of Enlightenment and the emergence of Western democracy. It is this

earlier history of celebrity that has shaped our contemporary world that is at the heart of this volume.

Responding to the need for further research on the roots of modern day transnational celebrity, this edited volume is the first to study and compare the concept of celebrity in France and Britain from 1750 to 1850, as the two countries transformed into the states we recognize today. It offers a transnational perspective by placing in dialogue the growing fields of Celebrity Studies in the two countries, especially by engaging with Antoine Lilti's seminal work, *The Invention of Celebrity*, translated into English in 2017. With contributions from a diverse range of scholarly fields, the present volume has a firmly interdisciplinary scope over the time period, an era marked by social, political, and cultural upheaval. The essays cover celebrity from royalty to adventurers and philosophers; from micro to macro levels; from the theater to the world of science. The careful ordering of chapters allows for new readings of the similarities and differences in the understanding of celebrity in Britain and in France. Consequently, the volume offers the first truly comparative analysis of celebrity across the Channel from 1750 to 1850 and initiates a productive dialogue across disciplines.

At the risk of homogenizing the diverse nature of the period, it is necessary to give a brief historical overview of the period as a background for this volume's contributions. The French and English kingdoms had been rivals since the medieval period and conflict still waged between France and Britain in the eighteenth century, notably with the Seven Years' War (1756–1763) and French participation in the American Revolutionary War (1778–1783), which fed into the rise of radicalism in Britain. This was the Age of Enlightenment: men of letters, such as Jean-Jacques Rousseau, Voltaire, David Hume, and Adam Smith developed new ideas and concepts, sparking great national and international debates; even if they disagreed with one another, their names became internationally known and they were revered for their work centered on reason. Anglomania gripped continental Europe and its financial, social, and intellectual elites often viewed England as the land of freedom and tolerance, one that provided refuge to avant-garde thinkers, such as Rousseau in 1766. Going in the other direction, young upper-class Britons were gripped by the prospect of going

on a "Grand Tour" of Europe to improve their language skills and discover European culture. Britain and France may often have been at war, but their people were not: they met during social events, exchanged letters, and visited one other, crossing borders intellectually and physically. Theaters of conversation and exchange, in combination with the growth of print culture including the rise of the novel and rapid increase in the number of newspapers, had a seminal role in the emergence of the public sphere. Contemporaries witnessed the advent of new cultural, political, and market forces as industrialization got underway, profoundly reshaping society.

Both countries were ruled by kings, but their appreciation of monarchy was different: whilst when he became king of the United Kingdom, George III generally gained the respect and love of his people with his piety and faithfulness toward his wife, Louis XV's poor government and infamous debauchery with Madame de Pompadour and Madame du Barry amongst others entailed increasing popular hostility toward the French king. The indecisiveness of Louis XVI, and the aversion toward his Austrian-born queen, Marie-Antoinette, led the French monarchy to be increasingly unstable. But by the 1780s, all was not rosy in Britain either: the monarchy became insecure in the 1780s due to the mental illness of the king, resulting in the Regency Crisis of 1788 where George's heir, the future George IV, briefly took the reins. The extravagant lifestyle of the latter proved a bone of contention for decades to come.

The instability of the French monarchy culminated with the onset of the French Revolution in 1789. Come 1792, even constitutional monarchy was no longer possible; now traitors, Louis XVI and Marie-Antoinette were executed in 1793, and many French aristocrats decided to emigrate to save their lives. The Revolution did not lead to a return to stability, but to multiple changes of government, including a constitutional monarchy, Republic, Directory, Consulate, and then finally an Empire in 1804. Laws and society also changed with the abolition of primogeniture, privileges, and feudalism; civil and political rights were accorded to French males, and in 1804, the first modern civil legal code to be adopted across swathes of Europe, the Civil Code, was brought into force. These changes impacted every layer of French society. On the other side of the Channel, George III's mental illness increased, but the British

monarchy remained comparatively steady, even if the country witnessed its own fair share of political upheaval including the Irish Rebellion of 1798. Whereas in Britain, leading politicians such as William Pitt the Younger and his arch-rival Charles James Fox had long received a great deal of attention from the press, in satirical pamphlets, and in prints, with the Revolution, the attention of the French public shifted from nobility to celebrity politicians and generals originating from lower classes, such as Maximilien Robespierre, Jean-Paul Marat, the Comte de Mirabeau, and Jean Bernadotte—later Charles XIV of Sweden.[1]

The French Revolution sent shockwaves across Europe. If it had initially given hope to many Europeans, it soon appeared as a threat; from 1792 on, many European armies were at war with France, wars that would continue when Napoleon Bonaparte came to power and conquered most of Europe, apart from Britain, before his epic fall at the Battle of Waterloo in 1815. Britain was not without its own crises during this period, notably the threat of invasion and the instauration of the Regency from 1811, but it did eventually emerge triumphant from the Revolutionary and Napoleonic wars.

Propped up initially by British support, the French monarchy returned for the Restoration period, where Louis XVIII was followed by his brother, Charles X. The Restoration coincided with the return of many French émigrés from European countries, especially England. However, the ground had fundamentally shifted and modes of renown were not as they had been prior to 1789, as Laure Philip discusses later in this volume. The Restoration went back on some of the Revolution's reforms and the government became increasingly conservative. Another revolution occurred in July 1830 that deposed Charles X and created a new liberal constitutional monarchy in France with Louis-Philippe I. Once again, compared to its tumultuous neighbor, Britain showed more steadiness with George III, George IV, and William IV. However, demands for parliamentary reform were mounting in Britain, occasioning events like the Peterloo Massacre of 1819. Tension lasted for years, and the Great Reform Act that overhauled the electoral system would not pass until 1832. Likewise, Catholic Emancipation had proved to be a sticky matter for decades, even toppling governments, until the Roman Catholic Relief Act was passed in 1829. Abolitionists finally won their cause

in Britain in 1833 (those in France would have to wait until 1848). In 1837, Victoria came to the throne, and she ruled England for the rest of the nineteenth century, overseeing major changes in society and communication networks, not to mention the expansion of the British Empire. The threat of revolution remained, however, and in 1848, turmoil spread across Europe. France witnessed yet another revolution that ended Louis-Philippe's reign and the French monarchy forever, whilst in the United Kingdom, the Young Irelander Rebellion only lasted a day with a death toll of two.

Europe underwent a series of metamorphoses from 1750 to 1850 that fundamentally changed the structure of society. It is the period we credit with the creation of modern Europe, so it is inherently linked to that of today. But with the power of hindsight, we can easily forget how radical the changes discussed here were for contemporaries and overlook the roots of our own societies.[2] Thrown into an increasingly anonymous world, people in the late eighteenth and early nineteenth centuries sought new reference points. The conditions were right for the rise of celebrity.

Applied historically, "celebrity" is often an anachronistic term. However, over the last decade it has consistently been well applied as a lens for historical analysis.[3] We must recognize that the term "celebrity" and the French "célébrité" did exist during the period 1750 to 1850, originating from the Latin "celebritas." This last term is translated today by the Oxford English Dictionary as the "state of being busy or crowded, festival, games or other celebration characterized by crowded conditions, reputation, renown, fame, frequency or commonness, in post-classical Latin also Christian festival (5th cent.), action of celebrating the Eucharist (6th cent.)."[4] Already, well before the eighteenth century, the masses and intersections with reputation, renown, and fame were key to the term. Scholars working on antiquity, such as Andres Jacobs, make strong cases for employing "celebritas" in their analyses of the ancient world.[5] The classical term would last well into the eighteenth century: Samuel Johnson defined celebrity as "celebration" and "fame," a definition that had not been updated as of 1847.[6] In France, though, the term underwent a transformation in the Académie française dictionary, from "This ceremony was carried out with great celebrity. It means also a great reputation. The celebrity

of his name" [Cette cérémonie se fit avec grande célébrité. Il signifie
aussi Grande réputation. La célébrité de son nom] in 1762 to "A
reputation that spreads far. To acquire celebrity. The celebrity of a
name, a person, a work, an event. The love of celebrity" [Réputa-
tion qui s'étend au loin. Acquérir de la célébrité. La célébrité d'un
nom, d'une personne, d'un ouvrage, d'un événement. L'amour de la
célébrité] in 1835.[7] Throughout these definitions, there is an inher-
ent crossover with fame, reputation, glory, and charisma that schol-
ars are still untangling.

The development of the French definition above reveals the evo-
lution in celebrity during this crucial period. This concurs with the
findings of seminal Celebrity Studies scholars such as Lilti, Joseph
Roach, and Chris Rojek, who have repeatedly underlined the impor-
tance of the eighteenth century in the development of celebrity, with
Rousseau often named as the first celebrity by Lilti, Leo Braudy,
and Robert van Krieken, amongst others.[8] Indeed, the importance
of the eighteenth century in the development of celebrity culture is
now commonly recognized in public history.[9] Certainly, as scholars
including Mary Luckhurst, Jane Moody, Rojek, and van Krieken
have recognized, we can see celebrity attributes—in their modern
sense—prior to the eighteenth century, but it is the century of the
Enlightenment, and the growth of the public sphere during it, that
was instrumental to creating a new type of celebrity.

In the 1990s, this development was attributed by French schol-
ars to the "Cult of Great Men" [le culte des grands hommes] under
the auspices of Jean-Claude Bonnet, but the concept did not cap-
ture the eighteenth-century public's curiosity and desire for inti-
mate details in the same way that "celebrity" does.[10] Lilti—whose
concept of celebrity has informed the thinking of all the essays in
this volume—argues that this emergence of celebrity in the eigh-
teenth century was made possible because it coincided with "the
appearance of public opinion" and "the new ideal self, based on
the demands of individual authenticity."[11] The burgeoning public
sphere was essential, but Lilti revisits Jürgen Habermas's notion of
the public sphere, arguing that it was not as critical as Habermas had
maintained but it was curious, and that curiosity was essential for
creating celebrity. What is more, the eighteenth century witnessed
a "media revolution" that democratized access to portraiture, and

cultivated a growing taste for biographies, autobiographies, and knowledge of private lives that fed the public's inquisitiveness over individuals' private existence, necessary for celebrity. There was now a new, affective, and intimate relationship conjoining celebrities and their public. It is this new relationship with celebrity and how contemporaries understood it that is central to this volume.

Much has been written on how celebrity functions and its commodification. In this vein, this collection of essays builds upon Luckhurst and Moody's analysis of "the interplay between individuals and institutions, markets and media," and the importance of private lives, intimacy, and staging in the construction of celebrity as detailed by Lilti and Roach amongst others.[12] In the wake of their studies, more scholars focused on the link between the private or intimate spheres and celebrity, including Julia Fawcett, Emrys D. Jones, Victoria Joule, and Sharon Marcus.[13] Performance and theatricality are central to them, and it is no surprise that theater is a key field for the development of Celebrity Studies: Sarah Siddons, for example, has been a central figure for such scholarship.[14] Recently, Francophone scholars have also turned to theater when considering celebrity during the period 1750 to 1850, as exemplified by the 2017 volume *Le Sacre de l'acteur*, but much more work needs to be undertaken in this regard, especially as the analysis of French actresses of the period has yet to integrate gender studies properly.[15]

The intense scrutiny to which actresses have been subjected in particular reveals the relationship between gender and celebrity. Although this is a recurring theme in current studies, there remains much work to be done. In the field of literary celebrity, which has readily engaged with male genius,[16] current works do not focus on early nineteenth-century females in the same way: Brenda Weber's investigation of female authors focuses on the Anglophone world after 1850; Lenard Berlanstein starts his investigation of French female celebrities in 1839; and Marcus focuses on Sarah Bernhardt in the second half of the nineteenth century.[17] One notable exception is Claire Brock, who examines "the feminization of fame" that allowed authors such as Mary Robinson, Frances Burney, and Germaine de Staël to "embrace celebrity" during the late eighteenth and early nineteenth centuries.[18] Whereas most of these works focus on a particular national context, in our volume the essays

on female literary celebrity purposefully contrast female celebrity in France and in Britain, as well as comparing women who crossed national borders through fame and emigration, such as Staël and Adèle de Boigne. In doing so, our contributors question the role that these women's status and their work played in their conception of celebrity, both then and since. It is through such approaches that this volume offers not only an interdisciplinary and transnational comparison of these individual artists but also of their treatment by scholars and thus uncovers the disciplinary and national differences within the historiography of celebrity.

The novelty of this volume lies in the comparative analysis of multiple case studies on both sides of the Channel. Starting with the geographical emphasis of the work, considerable attention has been paid to transnational or global celebrity within the twenty-first century context, and Sean Redmond in particular has investigated how this global celebrity is consumed at the national and local levels.[19] Likewise, the relationship between celebrity and travel has also had its fair share of attention, particularly from a postcolonial studies point of view under the editorial aegis of Robert Clarke and Jo Littler.[20] However, many of these scholars start their studies after 1850, with Anna Johnston's article on George Augustus Robinson in *Postcolonial Studies* and Cecilia Morgan's chapter in Clarke's volume on the Ojibwe Methodist minister Peter Jones (*Kahkewaquonaby*) in the 1830s being rare exceptions.[21] More recently, Páraic Finnerty and Rod Rosenquist have edited a special issue wherein two articles focus on British fame in nineteenth-century America before 1850,[22] and Ruth Scobie examines the construction of the myth of Oceania within the emergent celebrity culture of late eighteenth- and early nineteenth-century Britain, and how this impacted the metropolitan experience of empire.[23] Other works take a European approach, notably the volume edited by Edward Berenson and Eva Giloi for their study of late nineteenth-century charisma, which also engages partially with the concept of celebrity during this later period.[24]

This is where our chosen time period of the century from 1750 to 1850 becomes important in terms of the current field. It is not the first volume to concentrate on this period: excellent studies have already been undertaken by Lilti and Tom Mole on celebrity

culture from 1750 to 1850;[25] Brock's study starts in 1750 and ends in 1830;[26] and Scobie's work covers the period 1770 to 1823.[27] However, bar Lilti, whose case studies stretch from Britain and France to the German lands and the United States, these studies are British in their focus. Finding a middle way between these two approaches, this volume builds upon more recent scholarship and renewed approaches to celebrity to focus the current debates on transnational and global celebrity by concentrating on people in and between two geographical locations, offering a comparison of Britain and France. The chapters that follow offer an assessment of the impact of national contexts and transnational encounters, and an exploration of similarities and differences when it comes to celebrity within each country and across the Channel. This focus on two specific neighboring but vastly different countries helps us to study more closely the emergent notion of celebrity. Specifically, it allows us to investigate how contemporaries reconceived society in light of radical political and social changes, particularly as both went through the process of industrialization, and as one country went through a series of revolutions, while the other, which had experienced its own revolution in the seventeenth century, continued with its constitutional monarchy.

Each section of this volume has its own internal logic, but the essays as a whole are designed to be read as a collection through which the reader can compare and contrast the invention and evolution of celebrity across the Channel and build their own connections in light of their specialist knowledge. Our authors have deliberately opted to employ different definitions of celebrity, and to pursue different intellectual, political, and gender contexts across the disciplines that often segregate university departments today. The three sections that structure this volume, "Theorizing Celebrity," "Representing Celebrity," and "Inheriting Celebrity," offer a comparative transdisciplinary and transnational approach to celebrity. With this structure, we have avoided the simplistic division of the volume by chronology or between nations that might appear tempting given that academia is often divided along temporal and geographical lines. This volume's structure is much more appropriate for the cosmopolitan age at hand, where figures were rarely confined to the disciplinary boundaries that structure academic research today. Certainly,

some chapters do focus on national case studies, but they have been chosen because they can enter into a dialogue with other chapters in the volume, and each section combines British and French cases. Over a third of the chapters here address the specifically cross-Channel nature of celebrity during the period, which, through engaging in twenty-first-century transnational analysis, adds a contemporary weight to the collection. Consequently, the volume's essays allow for an overview of the impact of the distinctly different political, social, and aesthetic climates in each country, without forgetting the transnational connections celebrity forged between the two countries, so often separated by war during the period in question. In doing so, we demonstrate that the national approaches to celebrity that currently dominate scholarship of early Celebrity Studies cannot exist in isolation, reframing preexisting scholarly conceptions of celebrity, uncovering new connections, and proposing new modes in which we can understand the phenomenon.

In the first section, "Theorizing Celebrity," Chris Haffenden, Blake Smith, and Meagan Mason give a voice to individuals who attempted to understand the new phenomenon of celebrity and how they could potentially harness its powers for their own ends. This section combines figures whose lives have benefited from significant research—notably William Hazlitt, Jeremy Bentham, and Franz Liszt—with less well-known case studies, such as Pierre-Jean David d'Angers or Abraham Hyacinthe Anquetil-Duperron. Not only does the addition of the focus on celebrity reveal new findings about the lives of these men, but also one particularly interesting feature of this section is that all the characters involved used developing fields of scholarship to enhance their understanding of celebrity. This combination of contemporary scholarship, traditionally in the "high" realm of culture, with celebrity, often considered to be "lower," has not yet been properly addressed by current studies and needs to be investigated further.

In the chapters themselves, Haffenden turns to projects of monumentalization with works by British and French artists, and examines Bentham's original Auto-Icon project in conjunction with the writings of Hazlitt to investigate how monument and prose interacted to reconfigure celebrity in the Romantic age. Hazlitt's attempt to distinguish between proper fame and ephemeral celebrity

in 1818 is much cited, and it still weighs heavily on scholarship: poets' appeal to canonicity is considered as a defensive reaction to an emergent mass public, and works on Romantic celebrity focus on its popular format.[28] In contrast to these approaches, Haffenden argues for an "alternative reading of the interactions of monument and celebrity in the early nineteenth century."[29] This chapter interweaves ephemeral prints with longer-lasting memoirs and monuments to question the differences between celebrity, fame, and glory, alongside the role that media play in emphasizing these three strands. Whereas Haffenden grapples with a number of individuals, Smith's study focuses on the adventurer Anquetil, France's leading eighteenth-century Orientalist. Having looked at the relationships between prose and monumentality, Smith now invites us to consider how Anquetil crossed the sphere of Orientalist erudition to the sphere of publicity, in an attempt to gain celebrity. Unsuccessful as Anquetil's plan was, Smith argues that his efforts led the way for later "heroes of Empire," including T. E. Lawrence, who became global celebrities.

Coming back to the nineteenth century, but this time on the other side of the Channel, Mason takes the theorization of celebrity to new levels through emerging pseudosciences and medical fields by concentrating on international musicians in Paris, especially the Italian Niccolò Paganini and the Hungarian Franz Liszt. By the July Monarchy (1830–1848), musicians could no longer rely on royal and private patronage as they traditionally had, and their livelihood required large audiences at public concerts. One way of drumming up interest was through their physical appearance, the singularity of which was heightened through phrenology and physiognomy, two pseudosciences that held that head and body shape influence skill and morals. Mason shows how musicians employed these ideas for their own benefit to attract public attention, and to let the public "know" them in a manner that felt personal, thus nurturing the their celebrity. These essays all draw on contemporary theorizations of celebrity to offer new explorations of the role of intimacy (bodily and political) as the public sphere shifted with the rise of democracy and free speech in France and Britain. It is also striking that the case studies here are men who played on images of glory, heroism, and genius. The advantages gender accorded them

contrast with the gendered constraints encountered by female émi-
grée writers, as examined by Miranda Kiek and Philip, or the con-
straints on actresses, discussed later in the volume.

Having examined how intellectuals theorized celebrity and the
means of achieving it, the second section of this volume, "Repre-
senting Celebrity," turns to some of the active campaigns to gain,
and contemporary strategies for analyzing, celebrity in the domains
of the theater, literature, and politics. More specifically, this sec-
tion focuses on performance, be this theatrical, through writing
including novels and autobiography, or via the mouthpiece of the
press, to consider how such representations of celebrity impacted
on their subjects' reputations and legacy. The four chapters here
offer an investigation of campaigns for celebrity on both sides of the
Channel, as well as of cross-Channel exchange of celebrity and how
the larger international landscape—here in terms of figures from
the German lands, Switzerland, and Russia—could have a distinct
impact on celebrity within a specific national context. This incites
further questions about how celebrity and cosmopolitanism inter-
act, and also about the difference between the celebrity of those
who could achieve international prestige, often by birth, but also by
reputation, compared to that of those whose celebrity was framed
within a specifically national context, especially in an age when
nationalism was on the rise.

Starting with the theater, one of the most obvious arenas for
representing celebrity, Anna Senkiw and Anaïs Pédron's chapters
facilitate the comparison of eighteenth-century actresses within
very different national contexts. Actresses had been banned from
the stage in England until the 1660s, but their French counterparts
could perform publically. However, French actors were excommu-
nicated by the Catholic Church until the Revolution, so English
actresses were able to gain a status withheld from their French col-
leagues and could be buried in Westminster Abbey, as in the case
of Anne Oldfield. Theater was not just limited to the playhouse,
though: Senkiw reveals the interaction of political and theatrical
stages through female celebrity by taking up the satirical print
The Orators [sic] *Journey* (1785), which portrays the actress Sarah
Siddons sandwiched between politicians Charles James Fox and
Edmund Burke. Scholars often take such prints as a sign of celebrity,

but by situating this print within the contemporary press, Senkiw offers a nuanced approach, showing that not all contemporaries could read every reference in it, but that such prints could shape the future celebrity of their subjects. Pédron brings our attention to the fragility of actresses on the other side of the Channel with the case of Mademoiselle Clairon. Although Clairon became the talk of the European elite, she faced the publication of a calumnious fictionalized biography that portrayed her as a nymphomaniac courtesan and nearly destroyed her career. This chapter explores how Clairon rebuilt her career and examines her attempts to convert her celebrity into posthumous glory through her autobiography.

Having deliberated two national case studies, the second half of this section takes the representation of celebrities across borders. Whilst a heroine could be immensely successful in France, Miranda Kiek shows through the case of Staël's *Corinne* (1807) how a different national audience could reject her precisely because of her author's celebrity. Upon the translation of Staël's novel into English the year it was published, the eponymous celebrity heroine met with tepid approval at best, a remarkable difference from her French success. Kiek reveals how this challenging reception was anticipated within the novel itself, where Staël contrasts the half-Italian celebrity Corinne with the reserved Briton Lucile. Kiek uncovers the "existence of an unappreciated debt to *Corinne* in Jane Austen's *Mansfield Park*" and thus reveals the cross-Channel celebrity roots of a work by one of the English canon's best-known authors.[30] The different national contexts and the role of gender in how celebrity is experienced link Kiek's chapter with that of Clare Siviter, who considers how the Chevalier d'Eon, a cross-dressing French diplomat, army officer, and spy, achieved celebrity in both their native France and in Britain, where they sought refuge. D'Eon's celebrity was increased by a public trial in London, eagerly reported in France, to determine the Chevalier's biological sex, pushing celebrity's intrusion of the private sphere to new levels. Siviter explores how d'Eon, having passed the height of their celebrity, and in light of renewed Anglo-French hostilities, attempted to use their celebrity for patriotic purposes in the years until their death, and in so doing she examines the different conditions of celebrity depending on gender in different national and political contexts on either

side of the Channel. This chapter builds on the sources seen in this section so far, such as prints, autobiography, pamphlets, and newspaper accounts, to offer a comparison of how the representation of celebrity altered depending on the medium and national context. Together, this section's national and transnational case studies extend the findings of current, and often nationally focused, works on celebrity and gender.

After the first two sections on the theory of celebrity and how people represented themselves or were represented as celebrities (be they real or fictional), we then turn to the idea of "Inheriting Celebrity" in the last section of this volume. Reputation was key to success in this period, but little attention has been paid to how celebrity could be passed on through networks and models. This section brings together four chapters that investigate celebrity inheritance, either through a family legacy, be that in terms of a royal dynasty or a theatrical one, or through taking models of celebrity and reappropriating them from times long before "celebrity" is considered to have emerged, or from those encountered on the other side of the Channel. The inheritance of celebrity, how it is passed on, and how the receiver manipulates it for their own personal journey complicates our current understanding. Firstly, this is because celebrities, of this period especially, were often the first of their family to achieve such a status. Secondly, scholars have consistently divided celebrity from royalty for this period, a division that these chapters tackle head on.

Starting off with the inheritance of celebrity through one's family, Emrys D. Jones's chapter sets Charlotte Charke and the Cibber theatrical family alongside the Sheridans and the Kembles, two other prominent theatrical dynasties of the second half of the eighteenth century. Building on an analysis of Charke's contradictory relationship to her family name, this chapter explores the value of family connections in the construction of theatrical celebrity throughout the era. Jones asks whether the incorporation of the supposedly intimate domain of family into the manifestly public phenomenon of celebrity involved the subordination of one to the other. In doing so, he seeks to emphasize how competition and "discreditation" could be just as integral to a family's public value as cooperation and nepotism were. In Gabriel Wick's chapter, the dynasty at hand

is a royal one. Wick studies how the French princes attempted to intermingle royalty with celebrity, allowing them to create a new role for themselves and fueling public interest in political affairs. Indeed, in the political crisis termed the "Fronde des Princes" (1771–1773), Louis XV sought to silence his cousins, the Princes of the Blood, by sending them away from Versailles. However, that exile did not extend to Paris, and the city offered a variety of settings, such as the Opéra, the Vauxhall, and the boulevards, that allowed the disobedient princes to portray their private selves to the public sphere in an untraditional light, highlighting their physical and ideological remove from the royal court at Versailles.

Celebrity, however, does not just pass through blood in this section, and we are additionally interested in how celebrity can be inherited via models. Taking an alternative definition of "celebrity," Ariane Fichtl's essay examines the function and evolution of ancient "celebrity models" in the discourse of the French Revolution. Fichtl explores how politicians of the new French democracy promoted political principles or tried to discredit their rivals through references to "celebrity" individuals of the ancient republics. This essay contests the dominant opinion that Rousseau was the first celebrity, proposing a longer view of the history of celebrity and the use of past celebrities for political purposes. Finally, Philip's chapter looks across the Channel rather than back in time, concentrating on the *Récits d'une tante* (written c. 1835, published 1921–1923) by Boigne, a noble émigrée who fled to Britain during the French Revolution. Philip examines how Boigne reformulates the ethics of aristocracy of pre-Revolutionary France with her experience of British society and post-Revolutionary codes of behavior in an age where royalty was no longer sacrosanct and had to compete with celebrity. Through a comparison of the anecdotes surrounding fellow émigrés François-René de Chateaubriand and Staël, Philip's chapter leads on to a poignant discussion of how contemporaries had a gendered perception of romantic genius, leading the volume to come full circle back to an idea discussed by Haffenden in the first chapter. It is worth noting too that Philip's chapter here and that of Kiek in the previous section develop and significantly extend the recent spurt of scholarship on turn-of-the-century gender roles, female authors, and their engagement in the French context, a

field of knowledge currently led by Catriona Seth and Stéphanie Genand.[31] In this way, this work joins the foci of émigré studies, a rising field of international scholarship, with Celebrity Studies, a convergence that has yet to be properly considered. Philip and Kiek provide just one example of the new knowledge that reading this volume as a whole can uncover.

Throughout each section and across the contributions, this volume builds upon the questions that are currently at the heart of Celebrity Studies, such as the relationship between the public and the private or between royalty and celebrity, and tests some of the current assumptions in the field by taking a cross-Channel view. Bringing together the fields of history, politics, literature, theater studies, and musicology, to name just five, it also develops further methodologies to analyze the multifaceted nature of celebrity. At its heart, our cross-Channel comparison emphasizes how the phenomenon of celebrity did not evolve within an isolated national context and underlines how a thematic transnational approach to celebrity—often lacking for this period—helps us better understand the roots of this experience that dominates much of today's world.

Notes

1. Jessica Goodman, *Commemorating Mirabeau: "Mirabeau aux Champs-Elysées" and Other Texts* (Cambridge: Modern Humanities Research Association, 2017).

2. One such contemporary example is the shock felt by Chateaubriand, see François-René de Chateaubriand, *Mémoires d'outre-tombe*, ed. Maurice Levaillant, 2 vols. (Paris: Flammarion, 1982), especially the shock he felt upon returning to Paris, 2:17.

3. Simon Morgan, "Celebrity: Academic 'Pseudo-Event' or a Useful Concept for Historians?" *Cultural and Social History* 8, no. 1 (2011): 95–114.

4. *OED Online*, January 2020, Oxford University Press, accessed February 6, 2020, http://www.oed.com/view/Entry/29424.

5. Andres Jacobs, *Epiphanius of Cyprus: A Cultural Biography of Late Antiquity* (Berkeley: University of California Press, 2016).

6. Samuel Johnson, *Johnson's Dictionary of the English Language* (Dublin: James Duffy, 1847), 30.

7. "'Le Dictionnaire de l'Académie française,'" Dictionnaires d'autrefois ARTFL Project, accessed February 6, 2020, https://artflsrv03.uchicago.edu/philologic4/publicdicos/ .

8. Chris Rojek, *Celebrity* (London: Reaktion, 2001); Joseph Roach, "It," *Theatre Journal* 56, no. 4 (December 2004): 555–68; Joseph Roach, *It* (Ann Arbor: University of Michigan Press, 2007); Antoine Lilti, *Figures publiques,*

l'invention de la célébrité 1750–1850 (Paris: Fayard, 2014), translated as: Antoine Lilti, *The Invention of Celebrity*, trans. Lynn Jeffress (Cambridge: Polity, 2017) (regarding Rousseau, see 13 and 109–59); Robert van Krieken, *Celebrity Society* (London; New York; Routledge, 2012), 4–5.

9. Greg Jenner, *Dead Famous: An Unexpected History of Celebrity from Bronze Age to Silver Screen* (London: Weidenfeld & Nicolson, 2020).

10. Jean-Claude Bonnet, *Naissance du Panthéon: Essai sur le culte des grands hommes* (Paris: Fayard, 1998).

11. Lilti, *The Invention*, 12.

12. Mary Luckhurst and Jane Moody, "Introduction: The Singularity of Theatrical Celebrity," in *Theatre and Celebrity in Britain, 1660–2000*, eds. Mary Luckhurst and Jane Moody (Basingstoke, UK: Palgrave Macmillan, 2005), 1.

13. Julia Fawcett, *Spectacular Disappearances: Celebrity and Privacy, 1669–1801* (Ann Arbor: University of Michigan Press, 2016); Emrys D. Jones and Victoria Joule, "Introduction," in *Intimacy and Celebrity in Eighteenth-Century Literary Culture*, eds. Emrys D. Jones and Victoria Joule (Basingstoke, UK: Palgrave Macmillan, 2018), 1–10; Sharon Marcus, *The Drama of Celebrity* (Princeton, NJ: Princeton University Press, 2019).

14. Shearer West, "Siddons, Celebrity, and Regality: Portraiture and the Body of the Aging Actress," in *Theatre and Celebrity in Britain*, 191–213; Gillian Perry, Joseph Roach, and Shearer West, eds., *The First Actresses: Nell Gwyn to Sarah Siddons* (Ann Arbor: National Portrait Gallery and University of Michigan Press, 2011); Laura Engel, *Fashioning Eighteenth-Century British Actresses and Strategies for Image Making* (Columbus: Ohio State University Press, 2016).

15. Florence Filippi, Sara Harvey, and Sophie Marchand, eds., *Le Sacre de l'acteur, émergence du vedettariat théâtral de Molière à Sarah Bernhardt* (Paris: Armand Colin, 2017).

16. Peter Briggs, "Laurence Sterne and Literary Celebrity in 1760," *The Age of Johnson. A Scholarly Annual* 4 (1991): 251–80; Frank Donoghue, *The Fame Machine: Book Reviewing and Eighteenth-Century Literary Careers* (Stanford, CA: Stanford University Press, 1996); David Higgins, *Romantic Genius and the Literary Magazine. Biography, Celebrity, and Politics* (London: Routledge, 2005); Tom Mole, *Byron's Romantic Celebrity: Industrial Culture and the Hermeneutic of Intimacy* (Basingstoke, UK: Palgrave, 2007); Clara Tuite, *Lord Byron and Scandalous Celebrity* (Cambridge: Cambridge University Press, 2015).

17. Lenard R. Berlanstein, "Historicizing and Gendering Celebrity Culture: Famous Women in Nineteenth-Century France," *Journal of Women's History* 16, no. 4 (Winter 2004): 65–91; Brenda Weber, *Women and Literary Celebrity in the Nineteenth Century: The Transatlantic Production of Fame and Gender* (Farnham, UK: Ashgate, 2012); Marcus, *The Drama*.

18. Claire Brock, *The Feminization of Fame, 1750–1830* (Basingstoke, UK: Palgrave, 2006), 1.

19. Sean Redmond, "Global Celebrity: Introduction," in *A Companion to Celebrity*, eds. P. David Marshall and Sean Redmond (Chichester, UK: Wiley Blackwell, 2016): 213–18.

20. On celebrity and colonialism, see Robert Clarke, ed., "Travel and Celebrity Culture," special issue, *Postcolonial Studies* 12, no. 2 (May 2009), especially his introduction to this issue (145–52); Robert Clarke, ed., *Celebrity Colonialism: Fame, Power, and Representation in Colonial and Postcolonial Cultures* (Newcastle upon Tyne, UK: Cambridge Scholars Publishing, 2009); and more recently Lisa Ann Richey, ed., *Celebrity Humanitarianism and North-South Relations: Politics, Place, and Power* (Abingdon, UK: Routledge, 2016). On celebrity and the transnational, see Jo Littler, ed., "Celebrity and the Transnational," special issue, *Celebrity Studies* 2, no. 1 (2011), and Jo Littler, "Introduction: Celebrity and the Transnational," *Celebrity Studies* 2, no. 1 (2011): 1–5.

21. Anna Johnston, "George Augustus Robinson, the 'Great Conciliator': Colonial Celebrity and its Postcolonial Aftermath," in "Travel and Celebrity Culture," ed. Robert Clarke, special issue, *Postcolonial Studies* 12, no. 2 (May 2009): 153–72; Cecilia Morgan, "Missionaries and Celebrity within the Transatlantic World: The Ojibwa of Upper Canada, 1830–1860," in *Celebrity Colonialism*, 15–36.

22. Carolyn Eastman, "The Transatlantic Celebrity of Mr O.: Oratory and the Networks of Reputation in Early Nineteenth-Century Britain and America," in "Transatlantic Celebrity: European Fame in Nineteenth-Century America," eds. Páraic Finnerty and Rod Rosenquist, special issue, *Comparative American Studies: An International Journal* 14, no. 1 (September 2016): 7–20, and Páraic Finnerty, "The Poetics of Sisterly Celebrity: Sarah Hale, British Women Poets and the Gift of Transatlantic Fame," in "Transatlantic Celebrity," 21–33.

23. Ruth Scobie, *Celebrity Culture and the Myth of Oceania* (Woodbridge, UK: Boydell Press, 2019).

24. Edward Berenson and Eva Giloi, eds., *Constructing Charisma. Celebrity, Fame, and Power in Nineteenth-Century Europe* (New York: Berghahn Books, 2010).

25. Lilti, *The Invention*; Tom Mole, ed., *Romanticism and Celebrity Culture* (Cambridge: Cambridge University Press, 2009).

26. Brock, *The Feminization of Fame*.

27. Scobie, *Celebrity Culture and the Myth of Oceania in Britain*.

28. See Martin Postle, "'The Modern Appelles': Joshua Reynolds and the Creation of Celebrity," in *Joshua Reynolds and the Creation of Celebrity*, ed. Martin Postle (London: Tate Publishing, 2005), 17–33; Mole, "Introduction," in *Romanticism*, 1. See also Haffenden in this volume.

29. Haffenden in this volume, 21.

30. Kiek in this volume, 139.

31. Catriona Seth, "Qu'est-ce qu'une femme auteur?" in *Une "période sans nom." Les années 1780–1820 et la fabrique de l'histoire littéraire*, eds. Fabienne Bercegol, Stéphanie Genand, and Florence Lotterie (Paris: Classiques Garnier, 2016), 167–88; Stéphanie Genand, "La filiation et ses ombres. L'œuvre de G. de Staël au défi de l'histoire littéraire," in *Une "période sans nom*, 405–14.

THEORIZING CELEBRITY

"IMMORTALITY IN THIS WORLD"

Reconfiguring Celebrity and Monument in the Romantic Period

CHRIS HAFFENDEN

In a lecture given in 1818, the critic William Hazlitt sought to distinguish the lasting value of proper fame from the merely ephemeral renown of celebrity. While insisting that "[f]ame itself is immortal," he dismissed celebrity as "popularity, the shout of the multitude, the idle buzz of fashion, the venal puff, the soothing flattery of favour or friendship."[1] Considering the histories of fame and recognition subsequently written about the nineteenth century, it is striking the extent to which Hazlitt's oft-cited dichotomy has been naturalized as a starting point for conceiving of the relations between monument and celebrity in this period. Literary scholars such as Andrew Bennett and Lucy Newlyn thus turned to Hazlitt to show how poets deferred to the future appeal of a place in the canon as a defensive response to a nascent mass public, while recent histories of Romantic celebrity have made a concerted attempt to examine the other side of his contrast in exploring the making of popular celebrity.[2] Yet the effect of this separation of research emphases has been to bolster the force of Hazlitt's distinction. Treating monument and celebrity as distinct fields of inquiry has served to reinforce their incompatibility as regimes of value.

What happens if we move away from Hazlitt and view things from a different perspective? In this chapter, I make the case for an alternative reading of the interactions between monument and celebrity in the early nineteenth century. Rather than seeing a binary

division, I examine the potential for these modes of renown to meet and merge beyond simply antagonistic opposition. In doing so, I build upon the space recently opened by various literary studies to rethink these relations.[3] But in turning to sources beyond the literary field, I point toward the wider implications of problematizing this Hazlittian inheritance. Using the examples of French sculptor Pierre-Jean David d'Angers and British philosopher Jeremy Bentham, I explore the ways in which the logic, forms, and practices of lasting fame and popular acclaim could be mutually constitutive in the Romantic period. Sidestepping Hazlitt's distinction, I suggest we can glimpse in such interactions the appearance of a distinctly new phenomenon: namely, the public figure borrowing from the emerging sphere of celebrity culture to lay claim to monumental worth.[4]

Circulating Heads and the Problem of Priority

The standard use made of Hazlitt has been as a marker to date the emergence of modern concerns with canonicity, on the one hand, and of a distinctive celebrity culture, on the other. From the beginning of the nineteenth century, this account suggests, monumentality and celebrity were clearly demarcated and distinguishable: each with its own operative logic, each its own temporal order and set of practices.[5] Such an argument rests upon treating Hazlitt's distinction as an empirical judgment upon his times that celebrity and monument *were* separate concerns. Yet as a response to a specific set of circumstances concerning the problem of lasting value in an age of mass reproduction, his division was rather a normative plea, an attempt to claim that proper fame ought to be bracketed from popular renown. Instead of regarding the separation of these modes of renown as a *fait accompli* by the time Hazlitt was writing, I argue that it remained an open question. To grasp the implications of this for our understanding of celebrity-monument relations in this period, we must first consider the broader context in which Hazlitt proposed this dichotomy.

Watching from the vantage point of Hazlitt's rented cottage on Bentham's grounds in Westminster in 1814, the painter Benjamin Robert Haydon noted how: "Both Hazlitt and I often looked with

a longing eye from the windows of the room at the white-haired philosopher in his leafy shelter, his head the finest and most venerable ever placed on human shoulders."[6] That the attention, if not desire, of the younger men was drawn so powerfully toward Bentham's physical presence was certainly no coincidence. For this was a period when the bodies of the venerable were on display and in circulation to an unprecedented degree. From the statuary monuments of the emergent British Pantheon at St. Paul's Cathedral to the popular waxwork displays of Madame Tussaud's touring show, and from the literary figures commemorated in Poets' Corner at Westminster Abbey to the portrait engravings printed in the masses of biographical works published, the early nineteenth century witnessed an overwhelming volume of depicted bodies effectively competing for public attention.[7]

This overflow of public faces was a result of the shifting and competing systems for producing acclaim in the Romantic period. Indeed, the long span of Bentham's life was broadly coalescent with the emergence of a distinctly modern form of celebrity culture.[8] Enabled and driven by the industrial production of print media, along with broader infrastructural changes that created a mass reading audience and a publishing market in this period, the vastly increased output of public names, profiles, and bodies contributed to new ways of understanding the concepts of fame and celebrity—and the relations between them. The vast expansion of popular print journalism led to a considerable democratization of the potential to achieve celebrity as a publicly recognizable individual.[9] Yet then, as now, fame and celebrity would come to coexist in a complex web of interactions. Alongside the shift toward a more open notion of celebrity, this period also saw the emergence of a widespread fascination with the personal fame of the "great man" underwritten by the wider preoccupation with the Romantic genius, as broader publics came to be more actively involved in the making and celebrating of such figures.[10]

One way of grasping these changes has been to interpret the prominence of genius and celebrity in the nineteenth century as symptomatic of the individualism of a nascent democratic capitalism.[11] But these phenomena can also be placed in tension with one another, with the rise of the great man understood rather as a

response to the information overload risked by the democratization of renown offered by modern celebrity. With an ever-increasing flow of texts, images, and claims to fame and celebrity, it became an urgent question as to how to create order among these competing claims. More specifically, this was a matter of determining which bodies were worthy of a place in the public eye and on what basis.

A practical technology that emerged to address this problem was the expansion of canonization projects over the course of the nineteenth century. These undertakings spanned a range of cultural production and assumed various media forms: from attempts to anthologize national canons of literary texts to the founding of the National Portrait Gallery (1856), and from collective biographies of living artists to general attempts to classify the great and famous—such as Thomas Carlyle's *On Heroes and Hero-Worship* (1840) and Ralph Waldo Emerson's *Representative Men* (1850). Uniting these diverse enterprises beyond various nation-building aspirations was the ambition to assert a set of appraisive principles for sorting the wheat from the chaff. Faced with the unmanageable volume of claims to renown produced by print capitalism, canonical value—and the ordering device of the canon—offered the means of establishing priority and managing the threat of overload.

Lasting Fame For The Living?

It was in this specific context that Hazlitt came to propose his notion of fame as "the recompense not of the living, but of the dead."[12] In response to the large-scale media changes outlined above and the flooding of the market of renown this gave rise to, Hazlitt advocated his austere vision of canonization as "the spirit of a man surviving himself in the minds and thoughts of other men, undying and imperishable."[13]

Though he had occasionally shown an interest in the workings of public visibility in an emergent celebrity culture, a notable feature of Hazlitt's attempt to elevate fame as temporally distinct from—and morally superior to—present popularity was the insistence that the material trappings of contemporary renown had no relevance for the establishing of monumentality.[14] This was vividly demonstrated in his description of the workings of canonization as

a process of posthumous appraisal: "Death is the great assayer of the sterling ore of talent. At his touch the drossy particles fall off, the irritable, the personal, the gross, and mingle with the dust—the finer and the more ethereal part mounts with the winged spirits to watch over our latest memory . . ."[15] For Hazlitt, then, proper fame was necessarily posthumous, in marked contrast to what he regarded as the fickle judgment of contemporaries in the emerging celebrity system. Indeed, throughout his works he stressed that fame and celebrity were necessarily competing forms of renown with conflicting logics.[16] While "real greatness of mind . . . can wait patiently and calmly for the award of posterity," he claimed, the candidate for a "newspaper puff" in the present "who is always trying to lay violent hands on reputation, will not secure the best and most lasting."[17] What mattered in this model for producing monumentality was the *works* of the dead author, stripped entirely of celebrity paraphernalia from the world of present *things*. What this necessarily precluded was an individual striving to safeguard future renown, a maneuver he dismissed as the "forestalling" of one's "own immortality."[18]

Although Hazlitt's dichotomy has since become the established view, this was not the only way celebrity-monument relations were articulated in the early nineteenth century. While Hazlitt fervently denied the potential for these forms of renown to coexist, a range of his contemporaries were more sanguine. Lasting fame among the living was not necessarily dismissed as a contradiction in terms, and neither were active attempts to anticipate and claim immortality foreclosed, with an increasing array of nineteenth-century figures seeking to make their own monuments.[19]

A striking instance of this alternative view of celebrity and monument was offered by Haydon, Hazlitt's sometime friend and co-watcher of Bentham. As an artist convinced of his own greatness yet committed to self-promotion in his struggles in the increasingly commercial sphere of metropolitan art, Haydon had largely ignored the temporal division of the test of time doctrine. He regarded the present renown of celebrity and the future recognition of the canon as closely aligned, as suggested in the following allegory he had sketched: "On each side of the road of life, rise great lofty and craggy mountains on the top [of] each of which is placed a Fame

and when any one has had from the beaten road of life, the skill &
courage to reach the summit, Fame blows her immortal trumpet &
sounds his name to the crowd below, and the fame of every other
Mountain taking it up, the whole world is filled with a roar like
the thunder of cannon, the sound of which continues as long as
time lasts."[20] Here, present and future fame are taken as coincid-
ing. The "immortal trumpet" of Fame—conventionally presented
in female guise—was to be heard both by contemporaries in "the
crowd below" and in the future "as long as time lasts." This sug-
gests the degree to which Haydon was simultaneously concerned
with winning present acclaim *and* pursuing posthumous renown.
For Haydon, therefore, the Hazlittian either/or hardly seemed to
apply.

In denying this distinction between popularity and lasting fame,
Haydon was making a case for the possibility of pursuing what
he termed "[i]mmortality in this world."[21] Rather than patiently
submitting to the future judgment of posterity, as the test of time
dictated, this was a form of lasting value to be actively worked
toward and seized in the here and now. That Haydon had made
sustained efforts to assert himself as a *living* recipient of this monu-
mental status was evident from Hazlitt's pointed critique of such
practices: "I never heard him [Haydon] speak with enthusiasm of
any painter or work of merit, nor show any love of art, except as a
puffing-machine for him to get up into and blow a trumpet in his
own praise. Instead of falling down and worshipping such names
as Raphael and Michael Angelo, he is only considering how he may,
by storm or stratagem, place himself beside them, on the loftiest
seats of Parnassus . . . "[22] As these derisory comments suggested,
Haydon's long and contentious career as a public artist could be
characterized through the various "storms" and "stratagems" he
had pursued to realize the canonical value he was so certain he
deserved.[23] While desperately seeking to persuade the public of his
"Fame" in the present, Haydon was simultaneously writing his
own claims to posthumous celebrity in the diaries he insisted were
to be preserved and published for posterity.[24] Dictating the paper
traces of himself to be made available for future publics, Haydon's
approach was thus typical of a wider view that negated in very
practical terms Hazlitt's warning about forestalling immortality. It

is to a closer consideration of another such example of the interaction of celebrity and monument from across the Channel that we now turn.

David's Popular Pantheon of Living Greats

Haydon and Hazlitt were not alone in their admiration of Bentham's head. As Figure 1.1 attests, the physical appearance of the "white-haired philosopher" had been of interest to a range of his contemporaries, particularly outside of Britain.[25] What we see here is the bronze portrait medallion of Bentham made by the French sculptor Pierre-Jean David, or David d'Angers (ca. 1830). Depicting Bentham in profile with an inscription of his signature to the right, this was part of David's broader project of producing a *Galerie des Contemporains*, which he began in 1827, and resulted in the creation of over five hundred such medallions over the following decades.

Characterized by a recent commentator as "a collector of great men," David responded to the Romantic threat of personality overload with his expansive personal pantheon.[26] In his work as a public sculptor with Republican commitments, he had worked to continue the eighteenth-century project of forging a new form of civic memory based upon the commemoration of the *grand homme*. This earlier period had seen a deliberately meritocratic ideal employed, wherein talent and achievement rather than social status were taken to determine greatness.[27] David built upon this Enlightenment perspective in his sustained efforts to "record the features of whomsoever possesses some form of merit—virtue, genius, knowledge." Accordingly, in the making of each medallion he was "building a monument, within my means, to all that is a credit to humanity."[28]

Compiling this catalogue of the illustrious among his contemporaries, David saw himself as providing for "posterity the features of distinguished men of our times."[29] In this documentary project of archiving greatness, the notions of celebrity and monument were closely aligned, precisely as noted above with Haydon. Convinced that "genius" was "immortal" and yet—contra Hazlitt—certainly evident in the here and now, what was to be celebrated and

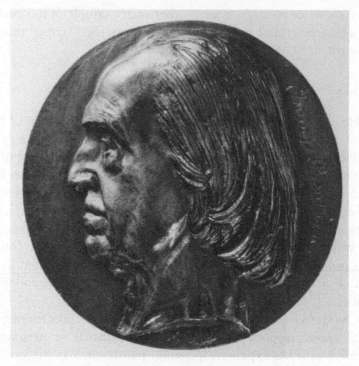

Figure 1.1. David d'Angers, *Jeremy Bentham*, medallion cast
by Jean-Georges Eck and Pierre Durand (1830). Metropolitan
Museum of Art, New York.

commemorated in David's medallions was, quite simply, the living
great.[30]

As a form of monumentalizing that coined lasting value in the
present, David's project was variously interwoven with the work-
ings of an emergent celebrity culture. As Hazlitt insisted that
celebrity was a particularly popular type of recognition closely con-
nected to the rise of a mass public, David emphasized the popular-
izing appeal of these medallions as material artifacts of veneration
offering close contact with greatness. Based on his conviction that
monuments performed an important public and political function,
he therefore conceived of his medallion project as a particularly
democratic enterprise. David had "dreamed above all of making

accessible to everyone the features of the illustrious men, of whom he had been so happy to form his collection of contemporaries," as his wife later recalled. To do so, he had allowed various founders to reproduce his medallions without claiming any legal rights to them, on the condition that the founders "sell them at a price low enough to fulfill his intentions."[31] This led to the mass production of these artifacts, which would circulate widely in many European cities amidst the growing demand for celebrity paraphernalia.

Such a desire to distribute and democratize the ownership of monumentality was further apparent in the commemorative vision David outlined to make the material of currency into a national canonizing project (something we now take entirely for granted). As he explained, "this would be to engrave the features of the illustrious men of France on our currency; thus, money would be ennobled and the biography of the great men would become popular."[32] In David's Republican numismatics the monarch or head of state was to be replaced by the illustrious members of his pantheon, marking a significant break with both the monarchical and the Revolutionary usage of coins as bearers of national worth. With this practical instance of making and circulating value, we can point to the connections David made between the commercial and the canonical, the "great" and the "popular," which were also notable features of his medallion enterprise.

David's interweaving of monument and celebrity was similarly evident in the physical appearance and material form of the medallion. As a commemorative object to be touched, collected, and displayed in domestic spaces, it was a mobile monument offering the effects of intimacy that are characteristic of the workings of modern celebrity.[33] While bringing famous heads into the home was nothing new in itself, what was distinctive about the medallions was the specific representational protocols employed for fashioning the heads of each unique individual.[34] In part this was a matter of the profile, so central to the visual economy of Romantic celebrity, as the circulating mass of frontispieces from this period attest. But more strikingly, the use of the reproduced signature was a means of capturing individual personality. Insofar as this inscription provided close and personalized traces of greatness, it was typical of a range of techniques in this period that responded to the alienating effects of an anonymous mass

public and an overflow of mass-produced texts and images. Where Romantic poets deployed a "hermeneutics of intimacy" in rendering themselves personally available to individual readers, these medallions used the profile and the signature to generate similar effects for the living great, who, in agreeing to sit for David's portraiture, had likewise offered themselves for public consumption and veneration.[35] Though mechanically reproduced, these objects thereby purported to provide their owners close contact with at least something of the aura of the original medallion.[36]

Unlike Hazlitt's parsing of present celebrity and future renown, the logic and form of David's portrait medallions brought these categories closer together. As a practical and accessible tool of monumentalizing, his project made these overlapping rather than conflicting concerns. Making portable monuments out of celebrities, these medallions were to be popularized, circulated, and engaged with by the people at large.

Bentham's Body and Public Renown

As the above example suggests, images of Bentham were enmeshed in the wider fabric of this period's contested public space, variously reproduced and circulated in competing early nineteenth-century systems for the making of renown. In this sense, Bentham can be understood as a product of these systems and their distinct configurations of the relationship between celebrity and monument. But he was also an active participant in negotiating that relationship, as the project he undertook to make his own monument demonstrates. By seeking to produce for future publics his own self-image—or "Auto-Icon," as he termed it—Bentham borrowed from the practices of celebrity culture and, like Haydon, challenged the Hazlittian position on forestalling one's own immortality.

Though Bentham fashioned himself at an ironic remove from the public sphere, he was far from disinterested about the workings of public recognition and the making of famous bodies. While both his Panopticon project and the coining of the term "publicity" pointed toward a general preoccupation with questions of public visibility, Bentham had also shown a more particular interest in

positioning himself in the space of an emergent celebrity culture.[37] This was suggested by the reportage of William Parry, an acquaintance of Byron engaged in producing celebrity gossip who had visited the philosopher's residence in Westminster and recounted that "Bentham is said also to have a great wish for celebrity."[38] Struggling to keep up with the "venerable philosopher" on his daily exercise through the streets of London, Parry recounted the moment when he realized the destination of Bentham's walk: "Fortunately the chase did not continue long. Mr. Bentham hove too abreast of Carlisle's shop [a bookshop], and stood for a little time to admire the books and portraits hanging in the window. At length one of them arrested his attention more particularly. 'Ah, ah,' said he, in a hurried indistinct tone, 'there it is, there it is,' pointing to a portrait which I afterwards found was the illustrious Jeremy himself."[39] It is not hard to see why someone with a complex relationship to the demands of celebrity such as Byron might derive "a great deal of pleasure" from this, as Parry claimed.[40] For what such a satirical account pointedly implied was that Bentham, the self-styled "hermit" with an austere and illustrious reputation, was himself far from immune to the imperative toward self-promotion operative in a celebrity culture. Indeed, insofar as Bentham's reputation as a great man was placed alongside this scene of a ridiculous old eccentric pointing to his own image on display in the commercial space of a shop window, Parry's anecdote demonstrated the interactions between celebrity and monument in this period at a very practical level.

If Bentham was closely concerned with monitoring his own celebrity in the present, he was also, like Haydon, entirely convinced of his claims upon lasting value in the future. This had been noted by Hazlitt, who had often overheard Bentham's conversations at close hand while he guided visitors around his garden. As Hazlitt recounted of his landlord: "He has been heard to say (without any appearance of pride or affectation) that 'he should like to live the remaining years of his life, a year at a time at the end of the next six or eight centuries, to see the effect which his writings would by that time have had upon the world.'"[41] Of course, this belied a particular Enlightenment sense of utopianism, and Hazlitt was unconvinced of the weight of the old philosopher's claim to such worth. Yet what

was especially striking beyond Bentham making such comments was the practical steps he had taken to ensure his body remained available as a site of commemoration for future publics to afford him tribute. He had left detailed commands attached to his will about how his body was to be preserved and transformed into the new form of self-monument that he coined an Auto-Icon.

By claiming lasting value in this way, Bentham was putting forward a radically individualized notion of self-consecration that both challenged the hold of established authorities on the production of monumentality and rejected the test of time doctrine endorsed by the Romantic cult of posterity.[42] Indeed, where this latter appeal responded to the problem of personality overload by insisting upon the exclusivity of future judgment, Bentham used his body as a means to forestall posterity and secure posthumous veneration via his own efforts alone. Particularly pertinent given my concerns in this chapter is that when he came to design his monument to this end, Bentham turned to the protocols of celebrity culture—a pointed instance of celebrity-monument entanglement we will now consider more closely.

Bentham's Auto-Icon and The Fashioning of Posthumous Identity

Dictating detailed plans for the making of his own monument, Bentham ignored Hazlitt's warnings about preempting future appraisals of immortality. Not only did his Auto-Icon bypass the temporal distinction between present popularity and lasting fame, but it also countered Hazlitt's insistence that the material practices of contemporary renown were irrelevant to the judgment of properly monumental status. For as we saw with David's medallions above, this was a project that sought to appropriate visual codes of representation from the sphere of popular entertainment and use them as means of materializing claims to lasting value.

This was especially apparent in the physical design and form of Bentham's corporeal monument. As we can see in Figure 1.2, he had prescribed the exact way in which his preserved body was to be presented to future publics. In the instructions left for his executor, Dr. Southwood Smith, Bentham specified that his body was "to

be put together in such a manner as that the whole figure may be seated in a chair usually occupied by me when living, in the attitude in which I am sitting when engaged in thought in the course of time employed in writing." The effigy was then "to be clad in one of the suits of black occasionally worn by me" and placed "together with the Chair and Staff in my later years bourne by me." Thus assembled, Southwood Smith was to produce for the "whole apparatus" "an appropriate box or case and will cause to be engraved in conspicuous characters on a plate to be affixed thereon . . . my name at length with the letters ob: followed by the day of my decease."[43]

In making the individual body a material for fashioning monuments, Bentham presented a sharp critique of established conventions for producing monumentality. This was entirely in line with the general principles of his philosophical system. On one hand, he had expressed a utilitarian distaste for the "expense" of existing protocols for making monuments, looking forward to a reformed future in which "[t]here would no longer be needed monuments of stone or marble."[44] On the other hand, he insisted that the representational efficacy of the preserved body was far superior to that of conventional materials for producing monuments. He had posed this question of "what painting, what statue of a human being can be so like him, as, in the character of an Auto-Icon, he or she will be to himself or herself. Is not identity preferable to similitude?"[45] Where David's medallions had attempted to broaden ownership of monuments, Bentham proposed a new medium that effectively brought monumentality within reach of all, since "[a] man's Auto-Icon is his own self."[46] Indeed, in a point that accentuates the force of this democratizing argument, he had even suggested that the "poor and rich" alike might be made into Auto-Icons "at the common expense."[47]

While Bentham sought to undermine the conventional system of production, it is striking the degree to which—like David's portrait profiles—his alternative vision for making monuments coincided with the visual and material codes of modern celebrity culture. Certainly, the very notion of leaving behind a perfectly preserved version of himself gestured powerfully toward the increasing significance of the *image*, and of the immediately recognizable profile, in the production of public renown in this period. The force of

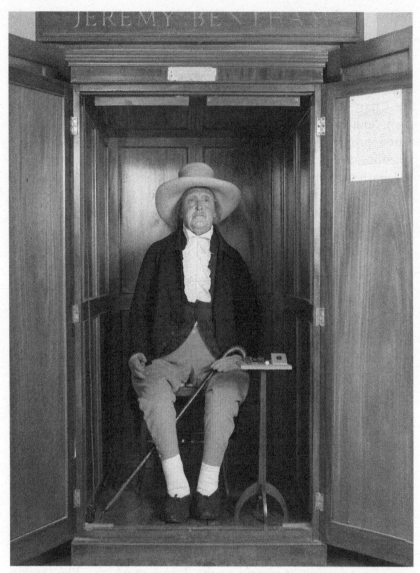

Figure 1.2. Jeremy Bentham's Auto-Icon on display in the South Cloisters of University College London. © UCL Media Services—University College London.

celebrity culture was evident in the distinctive material props to be deployed in the staging of posthumous identity that the Auto-Icon made possible.

Here Bentham borrowed—if not poached—from the protocols for representing significant public figures that were a notable presence in the broader exhibition space of early nineteenth-century London.[48] The wax effigy of Admiral Horatio Lord Nelson on display at Westminster Abbey from 1806, for instance, had been adorned with Nelson's original clothes, medals, and sword.[49] This emphasis upon authentic possessions witnessed the wider conviction that such material traces made possible intimate connection between publics and celebrity individuals, as we noted above with David's signatures, and as the carefully clothed bodies at Madame Tussaud's and the thousands of items of Napoleoniana displayed at The Napoleon Museum further attested.[50] By dictating the use of his own clothes and walking stick, of his own bodily posture, and of a display case for the Auto-Icon, Bentham appropriated practices of popular exhibition to fashion and preserve himself for commemorative attention. Putting them to work in the making of his own monument, he transformed these into practices of self-representation to buttress his claims to lasting value.

Where Hazlitt had dismissed "the personal" and the paraphernalia of contemporary renown in the making of canonicity, Bentham rather made these aspects of celebrity culture central to the formation of his own monument. For far from Hazlitt's austere textual vision of lasting value, the Auto-Icon was an embodied envisioning of posthumous fame that placed a priority on preserving physical appearance. In part this was connected to Bentham's specific concerns with the means of producing distinct and distinguishable individuals.[51] Yet, more strikingly, it was also a very clear instance of the celebrity-monument dynamics I am concerned with exploring here.

Embodied Canonization and the Material Forms of Popular Display

This entangling of these forms of renown was further evident in the future practices of commemoration Bentham envisioned for the

Auto-Icon. In the treatise he wrote to outline his system of monu-
mental reform, he had elaborated upon a wide range of uses for this
new type of monument ranging from the moral and political to the
commemorational and the genealogical.[52] Particularly interesting
in this context are the "Theatrical or Dramatic uses to which Auto-
Iconism may be applied," where he proposed the appropriate "stage
for the exhibition of an illustrious Auto-Icon."[53] Here he drew upon
the established genre of "Dialogues of the Dead" and imagined a
type of theatrical exhibition called "Scenes in the Elysian Fields,"
in which conversations between the preserved bodies of illustri-
ous figures in the history of knowledge would be staged to provide
public instruction.[54] With each performance to be ordered around
specific "subjects," a characteristic example would be for "Bacon,
Bentham, Dumont, Montesquien [sic]" to converse upon "Law as
it ought to be."[55]

One way of understanding such a scene is as a public perfor-
mance and display of canonicity. By placing his body and intellectual
achievements on stage alongside already canonized figures such as
Aristotle, Francis Bacon, and John Locke, Bentham was asserting
a sense of equivalent status for himself. This was partly a matter of
defining his idealized intellectual inheritance and seeking to control
the context in which his future reputation was to be judged. But it
was also a very literal enactment of his entrance into the canon of
lasting value. This was made especially clear by his description of
how these performances were to be structured: "Bentham, suppose
for example: One interlocutor in each group advances to him, takes
him by the hand, and welcomes him on his arrival, then presents
him to the others successively, beginning with the most ancient, the
introductor noticing, in regard to each, the principal improvements
made by him in that same branch of art or science."[56] Taken by the
hand and made part of the group, Bentham thus staged the perfor-
mance of his own future renown. In this sense, such imagined scenes
seem to align closely with the notion of *self-canonization* recently
put forward by Michael Gamer to characterize the phenomenon of
authors writing and publishing themselves into the prestigious space
of the emerging literary canon.[57]

Yet what was striking about Bentham's vision beyond the prac-
tices of such authors was the degree to which he drew upon wider

display practices in conceiving it. While the Romantic authors considered by Gamer pursued Hazlitt's textual model of canonization, Bentham's envisioning of self-canonization assumed a particularly embodied form that consciously borrowed from the workings of popular entertainment. Indeed, in imagining the visual spectacle of dead bodies interacting to perform canonical value, these borrowings were especially practical in character, ranging from the machinations "of strings or wires" to make the monumental figures move on stage, to the actors playing the historical figures who were to be "habited in the costume of the nations and the times."[58] While this concern with authentic costume pointed toward the spectral backdrop of this proposal—the emerging commercial institution of Madame Tussaud's traveling collection of waxwork icons—Bentham further discussed several other sources of inspiration for his theatrical conception from the shows of London. This included both the popular lectures of an earlier actor and playwright, George Alexander Stevens' *Lecture on Heads* (1764), which satirized interest in physiognomy by presenting a series of talking busts, and also Michael Faraday's public exhibitions of science in his lectures at the Royal Institution (from 1825).[59] Borrowing from these popular practices of performing bodies, Bentham imagined the enactment of his own canonicity in a particularly public setting.

A common theme in the longer reception history of Bentham's project has been to regard it as but the peculiar and idiosyncratic result of what one contemporary commentator dismissed as "the absurdities of his death bed dreams."[60] Yet what is significant with this example—regardless of the degree of whimsy involved—is that, in his preoccupation with imagining his posthumous renown, Bentham had no problem combining the practices of popular display and present renown with the pursuit of lasting fame. Indeed, in this "death bed" vision of the staging of his own canonicity, celebrity and monument were invariably intertwined.

Bentham's Auto-Icon was thus typical of a widespread overlapping and interaction between these forms of renown in the public space of the early nineteenth century, which belied Hazlitt's normative attempt to divide them. This broader tendency was perhaps nowhere clearer than at Madame Tussaud's, where celebratory and commemorative protocols proved so mutually constitutive in the

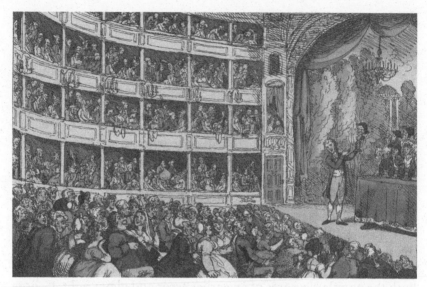

Figure 1.3. Frontispiece from *A Lecture on Heads* by George Alexander Stevens; etched by Thomas Rowlandson (1808). Metropolitan Museum of Art, New York.

display of exemplary bodies past and present. In a phrase revealing the porous and shifting boundaries between these realms of recognition in this period, and one coinciding with David's connection of the great and the popular mentioned above, the guidebook to Tussaud's traveling exhibition referred to the desire "to blend utility with amusement."[61] In this forum for exhibiting the great and the famous, entertainment and veneration were taken as two sides of the same coin.

Charting New Histories of Celebrity-Monument Interactions

Celebrity and monument in the early nineteenth century were not as incommensurable as Hazlitt had posited. My argument here has significant implications for the way in which we think about and approach the history of Romantic recognition. Once the opposition between lasting fame and popular renown is no longer simply assumed, we need to redirect our attention toward understanding how these forms of recognition could coexist and merge. The empirical examples discussed in this chapter make clear the degree

to which the boundaries between celebrity and monument proved messier and more complex than Hazlitt's neatly drawn borders, with Bentham's appropriation of the display protocols of popular exhibition to fashion his own monument an especially notable case of convergence. But in moving away from Hazlitt's constraining dichotomy we also need to interrogate other possible relations between these forms in the Romantic period and beyond. How did fame and celebrity come to interact, and to what effect?

As the instances of Haydon, David, and Bentham variously demonstrate, approaching this wider history of celebrity-monument interaction demands an alertness to the cultural manifestations of these forms of recognition beyond the confines of modern disciplinary boundaries. While the recent turn within literary scholarship to examine the engagement of Romantic poets with the workings of the celebrity system is undoubtedly one possible lead in pursuing this history, there are numerous other fields of cultural production where we might productively seek such interactions. Indeed, the many forms of public exhibition in this period provide a suggestive starting point for further reflection on these questions. Given that commercial and canonizing concerns were so closely interwoven in an exhibition like Madame Tussaud's, such displays offer a particularly apposite case to explore the interdependence of celebrity and monument—of commerce and canon—in this period. For once these are not regarded as diametrically opposed regimes of value, new lines of historical inquiry become possible. In conceiving of such an account and bringing into focus the shifting entanglements of celebrity and monument, we might finally be able to move beyond the long shadow cast by Hazlitt in our understanding of these matters.

Notes

1. William Hazlitt, "On the Living Poets," in *Lectures on the English Poets*, 2nd ed. (London: Taylor and Hessey, 1819), 283.

2. Andrew Bennett, *Romantic Poets and the Culture of Posterity* (Cambridge: Cambridge University Press, 1999); Lucy Newlyn, *Reading, Writing, and Romanticism: The Anxiety of Reception* (Oxford: Oxford University Press, 2000); Tom Mole, ed., *Romanticism and Celebrity Culture, 1750–1850* (Cambridge: Cambridge University Press, 2009); David Higgins, *Romantic Genius and the Literary Magazine: Biography, Celebrity, and Politics* (London: Routledge, 2005).

3. Eric Eisner, *Nineteenth-Century Poetry and Literary Celebrity* (Basingstoke, UK: Palgrave Macmillan, 2009), 2; Paul Westover, *Necromanticism: Traveling to Meet the Dead, 1750–1860* (Basingstoke, UK: Palgrave Macmillan, 2012), 83; Tom Mole, *Byron's Romantic Celebrity: Industrial Culture and the Hermeneutic of Intimacy* (Basingstoke, UK: Palgrave Macmillan, 2007), xiii, 157.

4. I explore this in greater depth in Chris Haffenden, *Every Man His Own Monument: Self-Monumentalizing in Romantic Britain* (Uppsala: Acta Universitatis Upsaliensis, 2018).

5. For canonicity, see Bennett, *Romantic Poets*, 4, 21–22, 200–2; for celebrity, compare the essays in Mole, ed., *Romanticism and Celebrity Culture*. Antoine Lilti's recent account frames this division in terms of a wider historical shift "from glory to celebrity," with Hazlitt as an example. Lilti, *The Invention of Celebrity: 1750–1850*, trans. Lynn Jeffress (Cambridge: Polity Press, 2017), 5–7, 89.

6. Benjamin Robert Haydon, *Life of Benjamin Robert Haydon, from his Autobiography and Journals*, ed. Tom Taylor, vol. 1 (New York: Harper & Brothers, 1853), 216–17.

7. Tom Mole, "Romantic Memorials in the Victorian City: The Inauguration of the 'Blue Plaque' Scheme, 1868," *BRANCH: Britain, Representation and Nineteenth-Century History* (2012), accessed February 6, 2020, http://www.branchcollective.org/?ps_articles=tom-mole-romantic-memorials-in-the-victorian-city-the-inauguration-of-the-blue-plaque-scheme-1868.

8. Mole, *Byron's Romantic Celebrity*, 1–18.

9. Elizabeth Barry, "From Epitaph to Obituary: Death and Celebrity in Eighteenth-Century British Culture," *International Journal of Cultural Studies* 11, no. 3 (September 2008): 260.

10. Higgins, *Romantic Genius and the Literary Magazine*, 3.

11. P. David Marshall, *Celebrity and Power: Fame in Contemporary Culture* (Minneapolis: University of Minneapolis Press, 1997), 6–8.

12. Hazlitt, "On the Living Poets," 283.

13. Ibid. Of course, there is a far longer history to the test-of-time doctrine that Hazlitt articulated here, but the appeal to posterity was reformulated in the Romantic period with a new urgency. See Bennett, *Romantic Poets*, 11–37.

14. This participation in the visual economy of celebrity culture can be seen in Hazlitt, *The Spirit of the Age: or Contemporary Portraits*, 2nd ed. (London: Henry Colburn, 1825), 6–7.

15. Hazlitt, "Lord Byron," in Ibid., 167.

16. Consider his contrasting of "the fame of a Pascal" with mere "popularity" and "being praised in all the reviews." *A Letter to William Gifford, Esq.* [1819] in William Hazlitt, *The Collected Works of William Hazlitt*, eds. R. Waller and Arnold Glover, vol. 1 (London: J.M Dent & Co, 1902), 410–11.

17. Hazlitt, "On the Living Poets," 285.

18. Ibid.

19. See Haffenden, *Every Man His Own Monument*.

20. Benjamin Robert Haydon, *The Diary of Benjamin Robert Haydon*, ed. W. B. Pope, vol. 2 (Cambridge, MA: Harvard University Press, 1960), 192–93 [March 10, 1818].

21. Benjamin Robert Haydon, *The Diary of Benjamin Robert Haydon*, ed. W. B. Pope, vol. 1 (Cambridge, MA: Harvard University Press, 1960), 167 [July 2, 1810].

22. Hazlitt, cited in Benjamin Robert Haydon, *The Diary of Benjamin Robert Haydon*, ed. W. B. Pope, vol. 3 (Cambridge, MA: Harvard University Press, 1963), 253.

23. For a discussion of Haydon's career in terms of "the dangers of publicity," see Higgins, *Romantic Genius and the Literary Magazine*, 127–48.

24. One of Haydon's final acts before committing suicide was to dictate the posthumous publishing arrangements for his memoirs and journals: see "Epilogue," Benjamin Robert Haydon, *The Diary of Benjamin Robert Haydon*, ed. W. B. Pope, vol. 5 (Cambridge, MA: Harvard University Press, 1960), 555–59.

25. Hazlitt had suggested that Bentham's "reputation lies at the circumference . . . His name is little known in England, better in Europe, best of all in the plains of Chili [sic] and the mines of Mexico." *Spirit*, 3.

26. Isabelle Leroy-Jay Lemaistre, "Preface" to J. G. Reinis, *The Portrait Medallions of David d'Angers* (New York: Polymath Press, 1999), xi. "Personality overload" is Tom Mole's apt term to characterize the effects of the rapid growth of claims to renown produced by industrial culture. Mole, *Byron's Romantic Celebrity*, 14.

27. Jean-Claude Bonnet, *Naissance du Panthéon: essai sur le culte des grands hommes* (Paris: Fayard, 1998); Mona Ozouf, "The Pantheon: The Ecole Normale of the Dead," in *Realms of Memory: Rethinking the French Past*, ed. Pierre Nora, trans. Arthur Goldhammer, vol. 3 (New York: Columbia University Press, 1998), 326–29; Thomas W. Gaehtgens and Gregor Wedekind, eds., *Le Culte des grands hommes en France et en Allemagne: 1750–1850* (Paris: Maison des Sciences de l'Homme, 2010).

28. David, cited in Reinis, *The Portrait Medallions*, xxiv.

29. Ibid.

30. Ibid.

31. Emilie David to Count de Las Cases [1863], cited in Jacques De Caso, *David d'Angers: Sculptural Communication in the Age of Romanticism*, trans. Dorothy Johnson (Princeton, NJ: Princeton University Press, 1992), 8, 244 n. 10.

32. David to Victor Hugo [1835], cited in ibid., 173, 259.

33. For discussion of the centrality of such "intimacy" to the emergence of a modern celebrity culture, see Joseph Roach, "Public Intimacy: The Prior History of 'It,'" in *Theatre and Celebrity in Britain, 1660–2000*, eds. Mary Luckhurst and Jane Moody (Basingstoke, UK: Palgrave Macmillan, 2005), 15–30, and Felicity Nussbaum, *Rival Queens: Actresses, Performance, and the Eighteenth-Century British Theatre* (Philadelphia: University of Pennsylvania Press, 2010).

34. Regarding the longer history of collecting famous heads, the houses of powerful Romans had been filled with commemorative busts; while more recently, the urge to create order in an age of industrial print and biographical overload gave rise to practices of Grangerizing from the later eighteenth century—with historical and contemporary portraits being cut and pasted into biographical dictionaries. See Marcia Pointon, *Hanging the Head: Portraiture and*

Social Formation in Eighteenth-Century England (New Haven, CT: The Paul Mellon Centre for Studies in British Art by Yale University Press, 1993), 62–67.

35. For this "hermeneutic of intimacy" developed by Romantic poets, see Mole, *Byron's Romantic Celebrity.*

36. See Walter Benjamin's classic essay on "The Work of Art in the Age of Mechanical Reproduction" [1935] in *Illuminations*, ed. Hannah Arendt, trans. Harry Zorn (London: Pimlico, 1999).

37. Dilip Parameshwar Gaonkar with Robert J. McCarthy, Jr., "Panopticism and Publicity: Bentham's Quest for Transparency," *Public Culture* 6, no. 3 (Spring 1994): 547–75.

38. William Parry, *The Last Days of Lord Byron* (London: Knight & Lacey, 1825), 195.

39. Ibid., 201–2.

40. "This little history gave Lord Byron a great deal of pleasure; he very often laughed as I told it." Ibid., 202.

41. Hazlitt, *Spirit*, 8.

42. Bennett, *Romantic Poets*. For a discussion of Romantic self-consecration that draws parallels with DIY celebrity in the present, see Haffenden, *Every Man His Own Monument*, 54–67, 219.

43. "Bentham's Last Will," May 30, 1832, in *Bentham's Auto-Icon and Related Writings*, ed. James E. Crimmins (Bristol, UK: Thoemmes Press, 2002), 8.

44. Bentham, "Auto-Icon, or Farther Uses of the Dead to the Living," [1832] in Ibid., 1, 3.

45. Ibid., 3.

46. Ibid., 10.

47. Ibid., 3.

48. For the notion of "poaching," see Henry Jenkins, *Textual Poachers: Television Fans and Participatory Culture* (New York: Routledge, 1992). The broader features of this culture of exhibition are still best captured in Richard D. Altick, *The Shows of London* (Cambridge, MA: Belknap Press, 1978).

49. Anthony Harvey and Richard Mortimer, eds., *The Funeral Effigies of Westminster Abbey* (Woodbridge, UK: Boydell, 1994), 182–91.

50. Stuart Semmel, *Napoleon and the British* (New Haven, CT: Yale University Press, 2004), 227.

51. For illumination of a striking element to accomplish this, namely Bentham's proposal for a universal tattooing system to brand each individual with a distinctive mark to render them visually and legally identifiable, see Sophie Coulombeau, "'Men whose glory it is to be known': Godwin, Bentham, and the London Corresponding Society," *Nineteenth-Century Prose* 41, no. 2 (Spring–Fall 2014): 281–83.

52. Bentham, "Auto-Icon," 3.

53. Ibid., 12.

54. For a sense of this theatrical genre, see Jessica Goodman, "Introduction" in Jessica Goodman, *Commemorating Mirabeau: "Mirabeau aux Champs-Elysées" and Other Texts* (Cambridge: Modern Humanities Research Association, 2017), 11–13.

55. Bentham, "Auto-Icon," 12–14.

56. Ibid., 13.

57. Michael Gamer, *Romanticism, Self-Canonization, and the Business of Poetry* (Cambridge: Cambridge University Press, 2017).

58. Bentham, "Auto-Icon," 13.

59. Ibid., 8, 13.

60. This particular phrase is antiquary William Barclay Turnbull's (1842), cited in C.F.A. Marmoy, "The 'Auto-Icon' of Jeremy Bentham at University College, London," *Medical History* 2, no. 2 (April 1958): 79.

61. Marie Tussaud, *Biographical and Descriptive Sketches of the Whole Length Composition Figures, and Other Works of Art, Forming the Unrivalled Exhibition of Madame Tussaud* (Bristol, UK: J. Bennett, 1823), 2.

THE SCHOLAR AS CELEBRITY

Anquetil-Duperron's Discours Préliminaire

BLAKE SMITH

Abraham Hyacinthe Anquetil-Duperron was *the* preeminent French Orientalist scholar of the eighteenth century. After a widely reported voyage to the Indian subcontinent, he became something of a household name in the 1760s, frequently mentioned by leading journalists. He published trailblazing translations of ancient texts (the 1771 *Zend-Avesta* and 1802 *Oupnek'hat*), a pioneering study of political norms in the Ottoman, Safavid, and Mughal empires (the 1778 *Législation Orientale*), and a score of articles examining diverse aspects of Asian history. His work and his connections to powerful patrons earned him a lofty place in the firmament of state-sponsored scholarship. In an era before there were French university chairs of such languages as Persian, Avestan, and Sanskrit, Anquetil was supported by a variety of prestigious state institutions associated with the preservation of texts and the study of history, including the Royal Library and the Academy of Inscriptions and Belles-Lettres. After a brief interruption during the Terror (Anquetil was interrogated by agents of the Committee of Public Safety in 1793), his career survived the French Revolution. In 1795, he was offered a position in the newly created Institute of France (which incorporated the state academies of the Old Regime), but he resigned in protest after Napoleon's seizure of power in 1799.[1]

In spite of a career spent as a member of France's most important scholarly bodies, Anquetil seems to have seen himself as

rather a failure, having been humiliated in pursuit of celebrity. In the last decades of his life, while he continued to publish significant scholarly works, he became a near hermit, renouncing the quest for fame and honor that had marked his earlier career. As Lucette Valensi observes, this renunciation had a theatrical quality, and from the 1780s on, Anquetil worked to disseminate an image of himself as a kind of sage who had fled the vanities of worldly life—even as he continued to collect his pensions from the prestigious institutions to which he was attached.[2] Valensi is rare among scholars in analyzing the self-construction and image-making that attended Anquetil's Orientalist scholarship; her approach, focusing on the second half of Anquetil's career, raises questions about the beginning of his scholarly life and the episode that seemed to define him as a failure.

Scholars have long characterized Anquetil's withdrawal from the public eye as the consequence of the mixed reception that greeted the publication of his first book, the 1771 *Zend-Avesta*.[3] This translation of Zoroastrian scripture did not address the sorts of questions about the ancient Asian religion founded by Zoroaster that many prominent French thinkers were then asking. While Anquetil lived up to the standards of official antiquarian study and helped extend the scope of state-sponsored erudition outside its traditional framework of classical Greco-Roman antiquity, he was not able to make his work seem relevant to other readers, some of whom attacked his studies as a waste of time. Historians have studied the reception of Anquetil's *Zend-Avesta* in the context of intellectual history as an episode that marks a conflict between the sphere of traditional erudition operating through official institutions and a new sphere in which "enlightened" thinkers appealed to public opinion, common sense, reasonableness, and utility through media channels and spaces of sociability not linked to the state.[4] Between these two spheres there was communication as well as conflict. Voltaire, Denis Diderot, and other *philosophes* used the work of antiquarian scholars even while denigrating the royal academies and other official bodies of erudition in which these scholars worked, creating an opposition between the *philosophes*' own publicly oriented writing and the supposedly musty, irrelevant world of state-sponsored learning.[5] Exaggerating the differences between

state erudition and their own projects of knowledge production helped *philosophes* cast themselves as novel and daring thinkers.

Criticism of the *Zend-Avesta*, however, was not only a consequence of *philosophes'* efforts to distinguish relevant, enlightened knowledge from pedantic antiquarianism. It also marked a moment in the definition of celebrity. Indeed, Anquetil's chief scholarly critic, the twenty-five year-old Anglo-Welsh Orientalist William Jones, savaged Anquetil's skills as a philologist (on grounds later found to be erroneous) and focused his attack on his French rival's search for celebrity.[6] Appealing to readers beyond the circuit of official erudition, Anquetil offered an image of himself as something other than a traditional scholar. He directed attention to his supposed courage and to what he claimed were his good looks; he presented himself as a hero and an adventurer whose life might be of interest to a wide public rather than an erudite *savant* whose work might be of interest to a handful of colleagues. This is in sharp contrast to the self-representation that Anquetil would develop in the second half of his life, as studied by Valensi. Before his dramatic retreat from the world, Anquetil first sought to capture its attention.

This representation was noticed by readers, some of whom responded by endorsing Anquetil's image and celebrating his heroism, while others, like Jones, responded by denouncing him as a false hero who was desperate for fame. Anquetil's failure to attain celebrity status, and the varied responses to his attempt to combine the figure of the scholar with that of the heroic adventurer, reveal the boundaries of and tensions within eighteenth-century constructions of celebrity. While *philosophes*, including some of Anquetil's admirers and critics, found ways to obtain celebrity without seeming to pursue it, Anquetil appeared a desperate bungler. Studying reactions to the *Zend-Avesta* in this light, rather than in its strictly intellectual context, offers a new perspective on the importance of celebrity in unsuspected corners of eighteenth-century history.

A Unique Individual

In his study of the emergence of celebrity in the eighteenth century, Antoine Lilti distinguishes his own mode of analysis

from previous historiographical approaches that either conflated celebrity with other kinds of fame (such as the glory possessed by figures of classical antiquity) or defined celebrity narrowly as a phenomenon of modern mass culture. In contrast, Lilti sees celebrity as having arisen as an ideological category (something people believed to exist) and as a set of practices and strategies (something people acted out) in the middle decades of the eighteenth century. He is concerned primarily with cases of individuals who achieved celebrity, even as they critiqued, decried, or appeared to flee it. He analyzes, for example, Voltaire's ambiguous response to his "coronation" at the Comédie-Française in 1778. This event, rehearsed privately by his entourage as Anaïs Pédron shows in this volume, raised the question of whether it was acceptable "to be celebrated in this way while still alive" [ainsi célébré de son vivant], at least if one had pretentions of being taken seriously by posterity.[7] Lilti's analysis highlights the tensions between the new phenomenon of celebrity—with its emphasis on being known, or appearing to be known, during one's own lifetime as an individual personality to a large number of people far outside one's social circle—and older sorts of renown that were oriented toward the judgment of a limited number of peers or of an imagined future.

The boundaries between eighteenth-century celebrity and other kinds of renown can be revealed by cases of failure as well as success in achieving such recognition. Indeed, failures reveal the implicit norms that surrounded celebrity and its pursuit; individuals who were criticized for their supposedly inappropriate desire for celebrity reveal what contemporaries understood as the proper way to become famous. Anquetil offers an ideal example for studying a failed bid for celebrity, and for delineating how celebrity differed from and clashed with other kinds of renown. While writers and *philosophes* like Voltaire, in spite of the hesitations explored by Lilti, could combine renown in literary circles with the pursuit of celebrity and the concomitant "intense public scrutiny" [intense curiosité publique] about their lives and personalities, Anquetil failed to make his scholarly renown compatible with celebrity.[8] His decision to introduce considerable biographical detail into his *Zend-Avesta*, in an apparent effort to create an image of himself as a fascinating heroic voyager whose compelling life and character

deserved public attention, earned criticism as a pathetic and self-aggrandizing display of intimate (even bodily) details.

Anquetil's botched attempt to integrate his heroic persona with his scholarly reputation in a bid for celebrity status recalls the analyses of eighteenth-century celebrity developed by Leo Braudy and Fred Inglis. Both scholars stress the tension in would-be celebrities' need to present themselves as having novel, unique personal qualities that made them not only admirable (for what they did) but also fascinating (for who they were). Inglis notes that the eighteenth-century celebrity needed to appear as a self-made individual, detached from networks of privilege, patronage, and official support, achieving success through the force of their charismatic and peculiarly personal "originality."[9] To attain celebrity under such conditions is, in Braudy's words, to "reach beyond the conventions of recognition and create a perceived self that is unprecedented without being unrecognizable."[10] But few celebrities are in fact independent of networks of support.

In this light, Anquetil can be understood as a figure who attempted to cross from the sphere of erudition, with its explicit and tight networks of patronage, into the spheres of publicity and potential celebrity through the articulation of a novel kind of self. Before Anquetil, European scholars writing about Asia were often armchair Orientalists who studied ancient languages without traveling. European travelers who wrote about their experiences in Asia were typically not scholars but rather wealthy merchants like François Bernier and Jean Chardin. Never before had readers in Europe seen someone claim scholarly expertise about Asian societies and history while recounting a life story filled with solitary acts of adventure. If it was not necessarily obvious to contemporaries that Voltaire's coronation at the Comédie-Française could align literary glory built on the quality of his writing with celebrity founded on public curiosity about his life and character, it was even more doubtful that Anquetil's narrative could align a scholarly reputation founded on a mastery of ancient Asian texts with a desire to solicit the public's attention through stories of derring-do. But while his attempt at celebrity was a failure, Anquetil did sketch the outlines of a new kind of celebrity, that of the "heroes of empire" who would become predominant figures of nineteenth-century celebrity culture across Europe.

The Scholar of Zoroastrianism

Anquetil was born in 1731 to a comfortable middle-class family in Paris. After receiving an education that included theology, classics, and Hebrew, he began work at the Royal Library, where he was shown copies of an ancient Zoroastrian text. This encounter began a journey that eventually established Anquetil as a rising star of French scholarship, widely recognized as a preeminent expert on Zoroastrianism. Anquetil, however, seems to have been dissatisfied with this scholarly form of renown, which he clumsily attempted to trade for another form of celebrity. In order to understand this attempt, it is necessary first to put into context Anquetil's status in the scholarly world.

At that time, Europeans knew little about Zoroastrianism, but they were eager to learn more. Zoroastrianism had been the dominant religion for much of classical antiquity in the region that became modern-day Iran, and ancient Greek historians had made tantalizing mentions of its beliefs and rituals. Zoroastrianism is a monotheistic religion, which holds that the conflict between good and evil will one day end with the arrival of a messiah. The parallels between Zoroastrianism and the beliefs of Old Testament prophets like Isaiah struck European thinkers. From the late seventeenth century on, religious scholars and radical *philosophes* hoped that discovering the origins of this religion would substantiate claims that could be used to defend or critique Christianity (for example, the uniqueness of Judaism and, by extension, Christianity as monotheisms).[11]

The first breakthrough in the study of Zoroastrianism occurred in the late seventeenth century. Thomas Hyde, the chair of Arabic at Oxford University, studied Arab histories and modern Persian-language texts by surviving Zoroastrian communities in South Asia known as Parsis.[12] Hyde's scholarship, however, did not satisfy the young Anquetil, who went to South Asia to study the original writings of Zoroaster, which Hyde had been unable to translate. These writings, compiled during the rule of the Sassanid Empire (224–651 AD) in Persia, were gathered in the *Avesta* and written in the ancient Iranian language Avestan, an ancestor of modern Persian. Anquetil spent six years on the subcontinent, working with

Parsi priests to study the *Avesta*. He returned to Paris in 1762 and disseminated his findings during the following decade in a series of articles and talks, culminating in the publication of his translation of the *Avesta* in 1771.

From its inception in the mid-1750s, Anquetil's scholarly project had been underwritten by a network of powerful supporters. While working at the Royal Library, he became the protégé of fixtures of state-sponsored antiquarian erudition, including the chair of Arabic at the Royal College, Michel Ange André le Roux Deshauterayes, as well as classicist Jean-Jacques Barthélemy of the Academy of Inscriptions and Belles-Lettres.[13] The Royal College (today the Collège de France) was a Renaissance-era institution designed to teach subjects such as ancient languages—including Hebrew, Arabic, and Syriac—that did not have a place in university curricula. The Academy of Inscriptions and Belles-Lettres, founded in 1663 to craft Latin mottos for the monarchy's statues and medals, soon became a hub of antiquarian research, focusing on the Greco-Roman classical world but gradually expanding to cover ancient Egypt, China, and South Asia. Deshauterayes and Barthélemy arranged for Anquetil to be given a stipend by the French government for his travel to South Asia, with the mission of adding to the collection of Asian manuscripts at the Royal Library.[14] While Anquetil would later try to convince readers of the *Zend-Avesta* that the success of his mission on the subcontinent had depended mostly on his own individual qualities, he was sent there as an agent of the French state's apparatus of erudition, not as an isolated individual.

Upon his return to France, Anquetil moved up the ranks of the scholarly establishment, becoming a member of the Academy of Inscriptions and Belles-Lettres. He published several articles in the academy's journal *Mémoires de l'Académie des Inscriptions et Belles-Lettres*, and several more in the *Journal des Savants*, a periodical in the academy's intellectual and institutional orbit.[15] The academy's members supported and promoted their protégé. Indeed, the world of official erudition had begun to anticipate the publication of Anquetil's findings even before he returned. Anne Claude de Caylus, a major figure of classical scholarship, wrote in 1761 that the present "voyage of Anquetil . . . should move us considerably further along in a path of which, at least, the door will have been

opened, and will likely change the ideas that we have today" [Le voyage d'Anquetil . . . doivent nous avancer considérablement dans une carrière dont la porte sera du moins ouverte, & qui changera vraisemblablement les idées que nous avons aujourd'hui].[16]

Anquetil's first publications whetted scholars' appetite for his translation of the *Avesta*, which appeared to be a work that would transform the state of the antiquarian field. Writers outside the circuit of official academies, libraries, and colleges, who pitched their writings at wide audiences of non-scholarly readers, also shared this sense of expectation about Anquetil's forthcoming translation. The amateur Egyptologist Pierre Adam d'Origny, in his 1765 *Chronologie des Rois du Grand Empire des Egyptiens*, celebrated Anquetil's courage and argued that his work would put the entire history of the ancient Middle East in a new perspective.[17] In his 1770 *Histoire générale de l'Asie, l'Afrique et l'Amérique*, journalist Pierre Joseph André Roubaud noted that his digest of existing information on Zoroastrianism and South Asia might soon be out of date; there would soon be "much light on this object and on the knowledge of the Indians in general from the research that M. Anquetil has carried out" [beaucoup des lumières sur cet objet et en général sur les sciences des Indiens, des recherches que M. Anquetil a fait].[18]

The *Correspondance littéraire, philosophique et critique*, one of the major periodicals of enlightened opinion, participated in the construction of a horizon of expectation around Anquetil. Founded by Guillaume Raynal, the *Correspondance littéraire* was edited by Friedrich Melchior Grimm, with contributions from Diderot, Louise d'Epinay, and other major figures of the French Enlightenment. Between 1762 and 1763, it published three articles on Anquetil, first announcing his return to France, and then encouraging readers to look forward to the publication of his translation. The last of the three articles, appearing in August 1763, was especially insistent on Anquetil's merits, praising him for his bravery as well as his "candor and modesty" [franchise et modestie], which, it claimed, lent credibility to his research.[19]

But even as the *Correspondance littéraire* presented Anquetil to readers as a reliable, objective scholar whose forthcoming translations might settle the long debates about Zoroastrianism, its contributors signaled that they expected the young scholar would use

his work to settle polemical debates among *philosophes* about the history of religion. They argued that Anquetil's scholarship should be of particular value to the extent that it could "throw light on the opinions of M. Boulanger" [jetterait sans doute beaucoup de lumière sur l'objet de recherches de M. Boulanger].[20] Nicolas Antoine Boulanger, a radical *philosophe*, had speculated in his recent, if posthumous—and widely read—*Recherches sur l'origine du despotisme oriental* (1761) that the origin of all religion and politics, had been the terror that natural disasters inspired in primitive humanity.[21] Anquetil, however, did not deign to comment on the theories of this amateur religious historian in his translation of the *Avesta*, a decision that may have contributed to the translation's mixed reception in 1771.

The *Correspondance littéraire* again signaled its expectations about how Anquetil ought to engage with other writers in a 1763 review of Voltaire's *Essai sur l'histoire générale* (1761–1763). The reviewer noted that Voltaire's references to Zoroastrianism needed to be revised in light of Anquetil's recent presentations at the academy and urged Anquetil to publish an article correcting Voltaire's mistakes.[22] Anquetil did not take up this invitation and, in his *Zend-Avesta*, avoided commenting on the discussions of Zoroaster among such non-scholarly *philosophe* writers as Voltaire and Boulanger. As the *Correspondance littéraire*'s remarks suggest, there was a non-scholarly readership interested in information about the history of Asian religions. What we might call the self-consciously "enlightened" press spent most of the 1760s and 1770s in rapture over the *Ezour-Vedam*, supposedly a manuscript of ancient Asian wisdom that had actually been written by a Jesuit priest in the 1750s. Voltaire and many other *philosophes* were fascinated by this text because it seemed to show that a belief in a single God, coupled with a "rational" ethical system, existed outside of a Judeo-Christian framework, and indeed preceded it.[23] Anquetil's scholarship was initially met with hopes that he too would provide new information that could be enlisted in debates about religion, but he either missed or deliberately declined the opportunity to do so.

As he prepared his translation of the *Avesta*, Anquetil may have suspected that he would disappoint the expectations readers of the *Correspondance littéraire* had of his work. He may also have been

aware that there was a strain of criticism against him emerging in the same circle of *philosophes* who wrote for the *Correspondance*. Diderot disparaged Anquetil's achievements in the *Encylopédie*'s article on Zoroastrianism ("Zend Avesta," written 1765). The text was in fact a satire, using Zoroastrianism as a whipping boy to attack religion in general, and suggesting that it was absurd to spend one's time studying the antiquated and futile religious practices of an obscure group of people like the Parsis. Although branding Anquetil's scholarship useless, Diderot did offer some praise: "While people cross oceans, sacrificing peace, parents, friends, and kin, putting their lives at risk to seek wealth, it is lovely to see one person letting go of the same advantages and running the same risks for the education of himself and his fellows. This person is M. Anquetil." [Tandis que les hommes traversent les mers, sacrifient leur repos, la société de leurs parens, de leurs amis & de leurs concitoyens, & exposent leur vie pour aller chercher la richesse au-delà des mers, il est beau d'en voir un oublier les mêmes avantages & courir les mêmes périls, pour l'instruction de ses semblables & la sienne. Cet homme est M. Anquetil].[24] Even this backhanded compliment, however, was undercut by another comment. In his *Salon de 1767* (published posthumously), Diderot wrote: "What would you say about a man who spent his life climbing from the attic to the basement, from the basement to the attic . . . This is the image of a traveller . . . a man without ethics . . . tormented by a kind of natural uneasiness . . . This is Anquetil." [Que diriez-vous (d'un homme) . . . qui emploierait toute sa vie à monter et à descendre des caves aux greniers, des greniers aux caves . . . C'est l'image du voyageur. Cet homme est sans morale, ou il est tourmenté par une espèce d'inquiétude naturelle qui le promène malgré lui . . . c'est Anquetil].[25] Diderot's comments on Anquetil in the 1760s testify to the latter's growing status as a traveler whose name would have been familiar to readers outside the world of antiquarian knowledge production. Anquetil was, in this sense, something of a household name.

These remarks also testify, however, to a certain undercurrent of criticism toward Anquetil amid the general stream of praise and optimistic anticipation: from the vantage of *philosophes* like Diderot, concerned with useful knowledge addressed to the needs of contemporary French society, Anquetil's travels and his scholarship

could seem equally irrelevant. It was perhaps such criticisms that inspired Anquetil, when he finally released his long-awaited translation of the *Avesta*, to cast aside the modest, unassuming character that commentators of the 1760s had noted, and to foreground his own personality as that of a heroic adventurer in order to make a play for celebrity status.

A New Image

While in the 1760s scholars and *philosophes* cast Anquetil as a promising young scholar whose work would speak to the concerns of a broad array of European thinkers, by 1771 he had taken the construction of his reputation into his own hands. Anquetil refused to enlist his scholarship in the polemical debates that were raging in the Republic of Letters over how the study of the history of religion should shape understandings of contemporary Christianity. Instead, he mobilized his autobiography, and particularly anecdotes that conveyed an impression of his physical courage and attractiveness, to bid for the attention of a public outside the bounds of erudition or philosophical debates. It is impossible to say why, precisely, Anquetil adopted this strategy—whether because he desired a form of renown that would not be based exclusively on his scholarly achievements, or because he felt that those achievements were not in themselves sufficient to attain the fame he sought. Whatever his motives, he aimed at celebrity by deploying an image of a unique and fascinating personality to capture the public eye.

The *Zend-Avesta*, a translation of Zoroastrian scriptures, may seem an unlikely means of attaining celebrity status. But the three-volume text begins with a several-hundred-page *Discours Préliminaire* in which Anquetil recounts his travels in South Asia to acquire the manuscripts and linguistic skills necessary for his research on the history of religion. He crafts here a specific, deliberate, and striking image of himself as a heroic figure, one worthy of public interest. Disguising certain aspects of his travels (such as his dependence on networks of patronage) and insisting on others (such as the dangers that he faced), Anquetil situates his own experience and his own body at the heart of his story.

To some extent, Anquetil's focus on his own physicality might have been a way to reinforce his claim to have experienced Asia firsthand, and thus to be in a legitimate position to attain and convey knowledge about it. There is an element of what Anthony Pagden calls the "autoptic imagination" in the *Discours*, as Anquetil attempted to ground abstract knowledge in corporeal experience.[26] But Anquetil's self-representation was far in excess of this modest goal. He repeatedly emphasized such qualities as his courage, good looks, and sexual appeal—qualities that had little to do with his Orientalist expertise. Rather than merely bolstering Anquetil's claims to expertise among his fellow scholars, the *Discours Preliminaire* represents a bid for the attention of a wider public.

Anquetil did not explicitly state that he sought celebrity, but his critics drew attention to how he referenced his physicality to generate publicity. Yet, as Lilti observes, it was rare for eighteenth-century public figures to admit that they desired and worked to become celebrities; many successful celebrities, in fact, represented themselves as having never sought public favor. In his analysis of Voltaire and Diderot, Lilti notes that while both men relished their celebrity, they disavowed its pursuit. Instead, they described themselves as being preoccupied with glory, a form of renown oriented toward the enduring admiration of posterity rather than the ephemeral fascination of one's contemporaries. In this schema, fame was a future reward for one's works—in this case, for Voltaire and Diderot's literary production. Yet even as they contrasted fleeting celebrity with enduring glory, Voltaire and Diderot courted the former through a variety of strategies. Voltaire in particular employed personal and epistolary networks, high-profile quarrels, interventions in *causes célèbres*, and staged appearances. The *philosophes* thus generated public curiosity about their personal lives and characters. Despite their protestations to the contrary, there could be no clear separation of their celebrity status from, on the one hand, the public's interest in them as personalities, and critical appreciation of their literary work on the other.[27]

Constructing celebrity, then, was a delicate business that demanded an ability to disguise one's pursuit of public attention. In the *Discours*, however, Anquetil made his hunger for celebrity obvious. The text clearly departed from the strategy of self-representation

that he had deployed in his previous publications. Until this point, he had eschewed any discussion of his own personality, and indeed had earned praise for his modest, self-effacing style. The only thing resembling a first-person narrative that he had published to that point was a short 1762 article in which he provided a sketch of his travels, and this was mostly an account of Zoroastrian ritual, belief, and language.[28] In his 1771 translation, however, Anquetil tried to present himself to readers in a new light.

Anquetil began the *Discours* by claiming that he had been so excited about the idea of going to South Asia, and so determined to go it alone, that he had enlisted as a common soldier for the French East India Company. After a few weeks' march from Paris, however, he discovered that his family and friends had obtained a royal stipend for him, forcing him to accept it.[29] Historians have found no evidence for Anquetil's story, which appears improbable. That Anquetil, twenty-four years old and with no military experience, would decide to pay for his passage to South Asia in this way when he was the protégé of the Bishop of Auxerre, Deshauterayes, and Barthélemy would certainly have been a surprising choice. True or not, Anquetil's attention to this episode is significant because it set a pattern for the rest of his narrative. Throughout the *Discours*, Anquetil systematically downplayed the importance of his personal network to his success. After his arrival in South Asia, for example, he had benefited greatly from the fact that his brother, Etienne Anquetil de Briancourt, was France's official representative at Surat, the port city that was home to the most important community of Parsis in the subcontinent. In the *Discours*, Anquetil minimized the support provided by his brother, and focused instead on situations in which he was alone, confronted with mortal dangers, with only his wits and pistol to protect him.

Just as Inglis and Braudy note that other eighteenth-century celebrities did, Anquetil sought to represent himself as a special individual whose achievements rested on his own personal qualities of heroism and intelligence, rather than as an agent in a powerful network of state and family patronage. One of the hallmarks of the emerging eighteenth-century understanding of celebrity was that it depended on its bearers seeming to be "original," in the sense of being both self-made and unique. By minimizing the importance

of his networks, Anquetil fulfilled the former criterion. He satis-
fied the latter by creating an unprecedented image of himself as
an Orientalist scholar immersed in a world of mortal danger. He
emphasized moments in his narrative when he was (he believed)
obliged to use force against his enemies, recounting dozens of such
hazardous situations.

To the present-day reader, many of these episodes in the *Dis-
cours* appear hardly to justify force on Anquetil's part. For example,
while taking a boat, Anquetil turned his pistol on the captain, accus-
ing him of making too many stops, and demanding that he and the
crew get back to work: "putting my hand on my pistol, I menaced
them" [Je les menaçai, mettant la main sur mon pistolet].[30] On two
different occasions, he used the pistol to frighten off police who
asked to see his papers: "I saw that it was necessary to demonstrate
firmness . . . I grabbed my pistol and walked straight up to the man
who seemed most obstinate" [Je me voyais contraint de démon-
trer de la fortitude . . . je mis la main à mon pistolet d'arçon].[31]
In another episode, he used it, somewhat more justifiably, to scare
away a tiger.[32] Firepower also came in handy during his scholarly
investigations into Zoroastrianism. In Surat, Anquetil had bor-
rowed a precious manuscript from Darab Kumana, a Parsi priest
(*dastur*), and kept it for several months. Fearing that Darab would
try to take the manuscript back before he had finished reading it,
Anquetil always "kept two loaded pistols on the table" [d'avoir sur
ma table deux pistolets chargés] during the priest's visits, ready to
shoot him down rather than return it.[33] In a similar episode, when
Anquetil was invited to participate in a Zoroastrian religious cer-
emony at a fire temple, he decided to go armed. Religious officials
sympathetic to Anquetil had allowed him entry into a sacred space
normally reserved for the faithful. As members of the congregation
began to pass bits of wood to the priest so that the bits could be
offered to the sacred fire, Anquetil's friends asked him to contribute
as well. He refused, loudly insisting that he was a Christian. With
all eyes on him, Anquetil grew nervous: "the situation was delicate;
I was alone, with no weapons except my sword and a pistol" [La
position était delicate; j'étais seul, sans autre arme que mon sabre et
un pistolet].[34] Luckily for Anquetil and the congregation, nothing
violent happened.

Anquetil reaches for his pistol on seven occasions throughout the *Discours*. Episodes that turn on gunplay highlight his courage in the face of danger and present him to the public in a new guise not only as a scholar but also as a hero familiar with danger. This strategy figures the narrator as the embodiment of masculine virtues. Anquetil even found ways to combine these qualities with physical attractiveness, noting that after months in the South Asian sun, his former "complexion of lilies and roses" [teint des lys et des roses] had faded, a claim that allowed him both to emphasize the hardships he had endured and how handsome he had been before undertaking his South Asian journey.[35]

In another, more troubling episode, Anquetil recounts that a South Asian nobleman, "Khoda Leti," who can perhaps be identified as Khuda-Yar Lutuf Khan, a general in the service of the governor of Bengal Siraj ud Daulah, had attempted to seduce him after stroking Anquetil's beard and admiring his features. Anquetil "seized [his] pistol immediately" [Je saisis aussitôt mon pistolet] and managed to escape from the general's clutches, although he had been "alone in the midst of a multitude of Moors, who, at the first sign from Khoda Leti, could have had their way with me, and even torn me to pieces" [seul au milieu d'une multitude des Maures qui, au premier signe de Khoda Leti, pouvoient disposer de moi, et même me mettre en pièces].[36] Such a scene has little precedent in the rather sedate travelogues of Bernier and Chardin. Here, Anquetil's physical attractiveness, boldness, and willingness to share intimate details are all foregrounded. His role as an erudite scholar is eclipsed by his unique personal qualities and the curious details of his life: the stuff of celebrity. But celebrity is not a solitary act of self-creation; it depends on the response of others.

Responses and Legacies

Readers understood the image of heroism that Anquetil developed in the *Discours*, and responded either with praise or mockery. The *Journal des Savants* applauded his "courage" [courage)] in the face of "dangers and misfortunes" [dangers et malheurs], and noted that he "had been able to triumph against every obstacle" [il sçut triompher de tous les obstacles].[37] A lengthy review of

the *Zend-Avesta* in the *Journal Œconomique* (which particularly noted the episode with "Khoda Leti") offered similar praise, saying that "it would be impossible to admire the courage of this literary hero (*héros littéraire*) too greatly; he risked his life many times to gather the sources that he presents to us" [on ne saurait trop admirer le courage de ce héros littéraire; il a plusieurs fois exposé sa vie pour rassembler les matériaux qu'il nous présente].[38] Yet there was a certain danger in this approach; both journals were rather less enthusiastic about Anquetil's scholarship than they were about his heroism. Anquetil the Orientalist risked being overshadowed by Anquetil the adventurer.

Anquetil's translation had not convinced readers outside the circuits of official scholarship that the *Avesta* was relevant to their intellectual concerns. The Zoroastrian scriptures were a collection of prayers and rituals. Many readers were struck by what seemed to be the outlandish practices of the Zoroastrians. These included aspersions using cow urine, a fact often repeated in reviews of Anquetil's translation. Critics, most notably the young British Orientalist Jones, argued that the *Zend-Avesta* must be a faulty translation or based on spurious manuscripts. If it were indeed accurate, then the *Avesta* had hardly been worth the trouble of translating.

Although Anquetil survived Jones's acerbic and widely circulated criticisms and became, as we have seen, a fixture of French erudition, those criticisms undermined Anquetil's intellectual reputation. Jones not only attacked Anquetil's philological skills and the importance of the *Avesta* as a historical document, but he also mocked Anquetil's hunger for celebrity. Jones criticized Anquetil in an anonymous French-language pamphlet published and widely distributed shortly after the appearance of the *Zend-Avesta*. He began by addressing Anquetil with mock encomium: "you have often risked your life, you have crossed stormy seas and mountains filled with tigers ... traveller, *savant*, antiquarian, hero" [vous avez souvent prodigué votre vie; vous avez franchi des mers orageuses, des montagnes remplies des tigres ... voyageur, savant, antiquaire, héros]. Compared to Anquetil, Christopher Columbus, "who had only discovered a new world" [ne découvrit qu'un nouveau monde], was of little account.[39]

Jones continued on in this rather labored comical vein for several pages, making many allusions to Anquetil's supposed good looks, which had been ruined by the South Asian sun. Jones suggested that Anquetil had heroically sacrificed "those charms you possessed before your difficult voyage" [les charmes que vous possédiez avant votre voyage difficile]. Toward the end of the pamphlet, having traded irony for direct attack, Jones claimed that Anquetil had left France "with a complexion perhaps of lily and rose, but, certainly, without a brain" [peut-être au teint des lys et des roses mais sûrement sans cervelle]. He concluded by saying that Anquetil was desperately vain, nothing better than an annoying insect, and should no longer "present to the public anything but the purest extracts from [his] writings" [ne présentez plus au public rien que les extraits les plus purs de [ses] écrits]. Anquetil's attempts to mobilize his own experiences (real or fictitious) in South Asia, in other words, had been a risible, contemptible failure that merely showed the public an arrogant fool eager to convince the world of his beauty and bravery.[40]

These criticisms stung Anquetil, who responded in subsequent works to some of the specific scholarly claims made by Jones about his translation, but not to Jones's savaging of his self-presentation. In later years, Anquetil continued to publish research on Asian religions for scholarly audiences, eventually switching to Latin rather than French to restrict his audience still further. He became just the opposite of what he had tried to become by publishing the *Discours*: a scholar whose renown was associated only with his writing, rather than with the intimate details of his personal life. As Valensi has shown, Anquetil responded to the falling away of public interest in his work with a dramatic rejection of society. But he had sketched new possibilities for more successful would-be celebrities to come.

The figure of the heroic scholar-adventurer that Anquetil created in the *Zend-Avesta* had little precedent in European culture. It can be understood as an early and unsuccessful draft of an archetype that would appear in nineteenth- and twentieth-century celebrity culture in the form of "heroes of empire" like Pierre Savorgnan de Brazza, David Livingstone, and T.E. Lawrence.[41] These men became global celebrities and national heroes for displaying a

combination of personal bravery and insights into non-European cultures, perfecting Anquetil's approach. Indeed, as they gained fame in the nineteenth century, so too did Anquetil. In the decades after his death, the Orientalist became part of France's emerging national canon of "great men." Sculptor Pierre-Jean David d'Angers struck his portrait (something that had not been done in Anquetil's lifetime) and included another image of Anquetil in an 1840 monument to Johannes Gutenberg (expressing the idea that Anquetil's writings were an example of the benefits of Gutenberg's invention, the printing press).[42] Historian Jules Michelet celebrated Anquetil's memory, describing him as "a poor pilgrim who confronted terrifying forests where the tiger and wild elephant dwelled, who snatched from the depths of the East an eternal treasure that transformed knowledge and religion" [affrontant, pauvre pèlerin, les effrayantes forêts qu'habitent le tigre et l'éléphant sauvage, ravit au fond de l'Orient le trésor éternel qui a changé la science et la religion].[43]

Anquetil's ambition of matching a scholarly reputation for Orientalist erudition with a public celebrity image as a fascinating and dashing hero had failed in his own lifetime. The image of the Orientalist-hero was, perhaps, too novel for eighteenth-century readers, or Anquetil's presentation of it too obvious and clumsy. Unlike writers such as Voltaire, Anquetil found that having renown among his colleagues based on his ability to write texts that adhered to the standards set by other members of his networks was incompatible with celebrity based on his ability to solicit public interest in details about his life and personality. Yet by the middle of the next century, Anquetil would be posthumously awarded the status he had sought, becoming famous as a unique, heroic individual whose scholarship and celebrity reinforced one another.

Notes

1. For Anquetil's biography, see Raymond Schwab, *Vie d'Anquetil-Duperron* (Paris: E. Leroux, 1934); Jean-Luc Kieffer, *Anquetil-Duperron: l'Inde en France au XVIIIe siècle* (Paris: Les Belles Lettres, 1983). For perspectives on Anquetil as a cosmopolitan liberal humanist, see Jonathan Israel, *Democratic Enlightenment: Philosophy, Revolution, and Human Rights, 1750–1790* (New York: Oxford University Press, 2011), 603; Jennifer Pitts, "Empire and Legal Universalisms in the Eighteenth Century," *American Historical Review* 117, no. 1 (February 2012): 92–121; Siep Stuurman, "Cosmopolitan Egalitarianism in the Enlightenment: Anquetil-Duperron on America and India," *Journal of*

the History of Ideas 68, no. 2 (April 2007): 255–78; Frederick Whelan, "Oriental Despotism: Anquetil Duperron's Response to Montesquieu," *History of Political Thought* 22, no. 4 (April 2001): 619–47. For more critical perspectives on Anquetil, see Blake Smith, "Counter-Revolution and Cosmopolitan Spirituality: Anquetil Duperron's Translation of the Upanishads," in *Freedom and Faith: The French Revolution and Religion in Global Perspective*, eds. Bryan Banks and Erica Johnson (Basingstoke, UK: Palgrave Macmillan, 2017), 25–48; Blake Smith, "Un cosmopolitisme sans islam: Dara Shikoh, Kant, et les limites de la philosophie comparative dans *l'Oupnekhat* d'Anquetil-Duperron," in *Cosmopolitismes en Asie du Sud: sources, itinéraires, langues (XVIe–XVIIIe siècle)*, eds. Corrine Lefevre and Ines Županov (Paris: Editions de l'Ecole des hautes études en sciences sociales, 2015), 121–40.

2. Lucette Valensi, "Eloge de l'Orient, Eloge de l'Orientalisme. Le jeu d'échecs d'Anquetil-Duperron," *Revue de l'histoire des religions* 212, no. 4 (October–December 1995): 419–52.

3. Claire Gallien, "Une querelle orientaliste: la réception controversée du 'Zend Avesta' d'Anquetil-Duperron en France et en Angleterre," *Litteratures Classiques* 81 (2013): 262. See also Antoine Lilti, "Querelles et controverses: les formes du désaccord intellectuel à l'époque moderne," *Mil Neuf Cent. Revue d'histoire intellectuelle* 25, no.1 (2007): 13–28, 28 n21.

4. See Lilti, "Querelles," 27 n6.

5. Jean-Louis Quantin, "Histoire et érudition au siècle des Lumières: le cas du fragment Diodore VIII, 12," *Histoire, Economie, Société* 9, no. 12 (1990): 213–42. See also Chantal Grell, *L'Histoire entre érudition et philosophie. Etude sur la connaissance historique à l'âge des Lumières* (Paris: Presses Universitaires de France, 1993), 20–23; Blandine Barret-Kriegel, *Les Académies de l'histoire* (Paris: Presses Universitaires de France, 1988).

6. Anonymous [William Jones], *Lettre à monsieur A*** du P***: Dans laquelle est compris l'examen de sa traduction des livres attribués à Zoroastre* (London: Elmsly, 1771).

7. Antoine Lilti, *Figures publiques, l'invention de la célébrité 1750–1850* (Paris: Fayard, 2014), 10, 27. Translation from Antoine Lilti, *The Invention of Celebrity*, trans. Lynn Jeffress (Cambridge: Polity, 2017), 15.

8. Lilti, *Figures publiques*, 27; Lilti, *The Invention of Celebrity*, 16.

9. Fred Inglis, *A Short History of Celebrity* (Princeton, NJ: Princeton University Press, 2010), 40.

10. Leo Braudy, *The Frenzy of Renown: Fame and its History* (Oxford: Oxford University Press, 1986), 392–93.

11. For the history of European views of Zoroastrianism before Anquetil, see Michael Stausberg, *Faszination Zarathushtra: Zoroaster und die Europäische Religionsgeschichte der Frühen Neuzeit* (Berlin: De Gruyter, 1998). See also Suzanne Marchand, "Dating Zarathustra: Oriental Texts and the Problem of Persian Prehistory, 1700–1900," *Erudition and the Republic of Letters* 1, no. 2 (March 2016): 203–45.

12. On the context and influence of Hyde's scholarship, see Dmitri Levitin, *Ancient Wisdom in the Age of the New Science* (Oxford: Oxford University Press, 2016), 101–11.

13. On the academy, see Thierry Sarmant, "De l'Académie des Médailles à l'Académie des Belles-lettres: entre mémoire et histoire, 1663–1716," in *Akadamie und/oder Autonomie: akademische Diskurse vom 16. bis 18. Jahrhundert*, eds. Barbara Mark and Christoph Olivier Mayer (Frankfurt: Peter Lang, 2009), 281–95; Fabrice Charton, "Censure(s) à l'Académie Royale des Inscriptions et Belles-lettres de la seconde moitié du XVIIe au milieu du XVIIIe siècle," *Papers on French Seventeenth-Century Literature* 36, no. 71 (2009): 377–94. On Deshauterayes's interest in Anquetil's career, see George Sarton, "Anquetil-Duperron (1731–1805)," *Osiris* 3 (1937): 195. On Barthélemy, see Irène Aghion, "Collecting Antiquities in Eighteenth-Century France: Louis XV and Jean-Jacques Barthélemy," *Journal of the History of Collecting* 14, no. 2 (November 2002): 193–203.

14. On the rise of Orientalist scholarship in these institutions, see Nicholas Dew, *Orientalism in Louis XIV's France* (Oxford: Oxford University Press, 2009).

15. Significantly, Anquetil did not publish in any other journals during the 1760s. On the influence of the Academy on the *Journal des Savants*, see Raymond Birn, "Le *Journal des Savants* sous l'Ancien Régime," *Journal des Savants* 1, no. 1 (1965): 28.

16. Anne Claude de Caylus, *Recueil d'antiquités égyptiennes, étrusques, grecque, romaines et gauloises*, vol. 4 (Paris: Tilliard, 1761), 70. These and all translations from the French are my own.

17. Pierre Adam d'Origny, *Chronologie des rois du grand empire des Egyptiens* (Paris: Vincent, 1765), 125–26.

18. Pierre Joseph André Roubaud, *Histoire générale de l'Asie, l'Afrique et l'Amérique* (Paris: de la Doué, 1771), 196.

19. *Correspondance littéraire, philosophique, et critique de Grimm et de Diderot*, vol. 3 (Paris: Furne, 1829), 314.

20. Ibid.

21. Paul Sadrin, *Nicolas-Antoine Boulanger (1722–1759), ou, Avant nous le déluge* (Oxford: Voltaire Foundation at the Taylor Institution, 1986).

22. *Correspondance littéraire*, 3:422.

23. Urs App, *The Birth of Orientalism* (Philadelphia: University of Pennsylvania Press, 2010), 372–407; Dorothy M. Figueira, *Aryans, Jews, Brahmins: Theorizing Authority Through Myths of Identity* (Albany: State University of New York Press, 2002), 12–15. See also Jyoti Mohan, "La Civilization la plus antique: Voltaire's Images of India," *Journal of World History* 16, no. 2 (June 2005): 173–85.

24. *Encyclopédie, Dictionnaire raisonné des sciences, des arts et des métiers, par une Société de Gens de lettres*, vol. 17 (Neufchâtel: Faulche, 1765), 700. Via ARTFL Encyclopédie Project, accessed February 6, 2020, https://artflsrv03.uchicago.edu/philologic4/encyclopedie1117/navigate/17/1/.

25. Denis Diderot, *Salon de 1767*, eds. J. Seznec et J. Adhemar (Oxford: Clarendon Press, 1963). On Diderot's *Salons*, see Stéphane Lojkine, *L'Œil révolté: les Salons de Diderot* (Paris: Editions Jacqueline Chambon, 2007).

26. Abraham Hyacinthe Anquetil Duperron, "Discours préliminaire," in *Zend-Avesta, ouvrage de Zoroastre, contenant les idées théologiques,*

physiques & morales de ce législateur, les cérémonies du culte religieux qu'il a établi, & plusieurs traits importans relatifs à l'ancienne histoire des Perses: traduit en françois sur l'original zend, avec des remarques; & accompagné de plusieurs traités propres à éclaircir les matières qui en sont l'objet, vol. 1 (Paris: Tilliard, 1771), lvi. See also the critical re-edition published as *Voyage en Inde: 1754–1762: relation de voyage en préliminaire de traduction du Zend-Avesta,* eds. Jean Deloche, Manonmani Filliozat, and Pierre-Sylvain Filliozat (Paris: Ecole Française d'Extrême-Orient, 1997).

27. Lilti, *Figures,* 28–29, 90, 128.

28. "Relation abrégée du voyage que M. Anquetil-Duperron a fait dans l'Inde pour la recherche et la traduction des ouvrages attribués à Zoroaster," *Journal des Savants* (1762): 413–25. A longer version of this article had been given by Anquetil as a lecture at a meeting of the Academy on May 4 of that year.

29. Anquetil, "Discours," viii.

30. Ibid., cxcii.

31. Ibid., lxiii, lxxix.

32. Ibid., lxx.

33. Ibid., cccxxix.

34. Ibid., ccclix.

35. Ibid., xciv.

36. Ibid., lvi.

37. *Journal des Sçavans [Savants]* (Paris: Lacombe, 1771), 711, 713.

38. *Journal Œconomique, Année 1772* (Paris: Boudet, 1772), 153.

39. *Lettre à monsieur A***,* 3–4.

40. Ibid., 45.

41. Edward Berenson, *Heroes of Empire: Five Charismatic Men and the Conquest of Africa* (Berkeley: University of California Press, 2010).

42. Copies of the portrait can be found in the Louvre, the Carnavalet Museum in Paris and David d'Angers gallery in Angers. J.G. Reinis, *The Portrait Medallions of David d'Angers: An Illustrated Catalogue* (New York: Polymath Press, 1999), 9–10. The monument is in the Place Gutenberg of Strasbourg.

43. Jules Michelet, *Histoire de France au seizième siècle* (Paris: Chamerot, 1855), 23.

THE PHYSIOGNOMIES OF VIRTUOSI IN PARIS, 1830–1848

MEAGAN MASON[1]

In Paris during the 1830s and '40s, two pseudosciences reached peak influence. Physiognomy and phrenology aligned traits of the body and skull with personality traits, teaching that particular physical features signal our predispositions to certain behaviors, desires, and talents. These ideas, conceived in the late eighteenth century in Switzerland and Germany, spread into France, Great Britain, and the United States, with societies and journals dedicated to them in each place.[2] The theories gained a significant following among many prominent thinkers, artists, and writers throughout Europe. They were especially successful in Paris, where people were open to such ideas and where phreno-physiognomy's[3] spread could coincide and meld with the rising celebrity culture in that city. Certain public figures' fame intensified to the point that they developed followings of people whom they never met, yet who nonetheless learned so much about them through the media as to have the illusion of knowing them intimately.[4] Phreno-physiognomy could provide insight into public figures' private lives by giving viewers a code or rubric for interpreting personalities just from an image. Theorists of this pseudoscience used celebrities as case studies, and in Paris, a particular interest for phrenologists were celebrated musicians. The publicity for virtuoso musicians reveals how phreno-physiognomists built up

celebrity culture by influencing public opinion about celebrities' qualifications and true identities.

The 1830s and '40s were a momentous time for musicians. They were achieving unprecedented renown and performing for larger audiences than they ever had before. Their business model had changed. Unless a musician managed to find a full-time position in a church or court system—rarely available since the 1789 Revolution—making a living required pleasing a public. Musicians reached outside what had previously been close-knit circles to now attract audiences of strangers. Publicity became crucial. Performers attempted to capture public interest however possible, as did anyone else who could profit from popularity, such as journalists, book authors, and portrait sellers. Paris, known for having audiences voracious for spectacle, attracted hundreds of musicians. Among the few dozen who actually achieved recognition there were the Italian violinist Niccolò Paganini and the Hungarian pianist Franz Liszt, who each solidified their international renown on the Paris stage. In their success, image was equally as important as skill. It was said that Liszt's face, by the time of his death, was the best known in Europe. Enthusiasm at his early career concerts was such that cartoons depicted audience members being carried away to the madhouse after hearing him.[5] Paganini, overwhelmed by the celebrity that preceded him on his first visit to Paris in 1831, found images of himself plastering the city walls.[6] Phreno-physiognomy became part of the conversation during the virtuoso craze. Its ideas, spreading through Paris society in pamphlets, newspaper articles, and correspondence, were used to discuss musicians' skills. They also brought audiences into the sense of being more intimately acquainted with celebrity musicians, who were often shrouded in gossip, myth, or sensationalism.

References to phreno-physiognomy are fairly frequent in literature, criticism, and portraiture from this time, but they escape our notice when we are unaware of how to spot and interpret them. Scholars have begun to discover ways that phreno-physiognomy was applied in literature, portraiture, exposés of singers' skills, and even the selection of students for music education.[7] After describing the context and teachings of phreno-physiognomy below, I demonstrate its influence in the public image formation of Liszt and Paganini, the two most celebrated virtuosos on the Paris stage.

A Trend for Social Understanding

The doubling of Paris's population—from 500,000 in 1801 to 1,000,000 by 1843[8]—roused a sense of alienation, anonymity, and uncertainty of who one's neighbors were. An obsession with trying to understand Parisian society pervaded print media.[9] One manifestation was that character descriptions abounded in novels.[10] In 1830, Honoré de Balzac began publishing pieces for his *Comédie humaine*, ninety-one interlinking novels, in which he intently studied human nature and attempted to sum up the entirety of Parisian society.[11] Physiognomy heavily influenced his character portrayals, as well as those of Sir Walter Scott, whose works were fashionable in Paris in the 1830s and valued for their rich character descriptions.[12]

A second manifestation was that publications that cataloged types of people reached a new vogue.[13] Like in nineteenth-century London, as described by Chris Haffenden in Chapter 1, representations of heads were acutely visible in Paris. The eight-volume *Les Français peints par eux-mêmes* (1840–42) contains sketches and descriptions of all sorts of people, aiming to record what was not usually recorded by historians: everyday life, "what sort of men we were, and how we employed our time."[14] The two-volume *Le Diable à Paris, Paris et les parisiens* (1845–46) chronicled "our physiognomy, our gesture, and our costumes."[15] Finally, a paperback series of "physiologies" (begun in the 1830s, with nearly 130 published between just 1840 and 1842[16]) satirized almost every imaginable type of Parisian: the bon vivant, the spoiled child, the godmother, the kept woman, the ventriloquist, the dock worker, etc. Music featured prominently in this series; various writers contributed the *Physiologies du violon* (1839), *du chant* (1840), *de la voix et du chant* (1841), *de la chanson* (1842), *du musicien* (1841 and 1844), *des bals de Paris* (1841 and 1845), *de l'Opéra* (1842), and *du cabaret* (1849). A *Physiologie des physiologies* said that these books plagued Paris like the gnats and frogs in ancient Egypt.[17] The captivation with creating taxonomies of people gave phreno-physiognomy an ideal environment in which to grow.

Phrenology and Physiognomy

In its most standard form, phrenology determined that the brain comprises approximately thirty-five smaller organs that each control an aptitude: concentration, hope, or perception of color or size, for example (see Figures 3.1 and 3.2).[18] With exercise, the organs of the brain could grow like muscles and change the shape of the skull. The theory had developed from cranioscopy, developed by Franz Joseph Gall, an Austrian doctor who moved to Paris in 1807.[19] His ideas had grown out of the much older theory of physiognomy, which aligned facial and bodily features with character traits.[20] The Swiss theologian Johann Kaspar Lavater was the most influential of recent theorists who had promoted these beliefs. His book *Physionogmische Fragmente* (1775) codified associations that still pervade our superstitions about human nature, such as that a hooked nose signals a domineering and overbearing personality, red hair warns of a quick temper, and a high forehead equates to intelligence (this is our source for the terms highbrow and lowbrow).[21]

Phrenology and physiognomy, though controversial, were also enormously popular (or infamous, depending on whom you asked). The *Encyclopædia Britannica* records a near hysteria following the publication of Lavater's book; the study of human character from the face became such an epidemic that "people went masked about the streets." Lavater was discussed in extremes: "the discoverer of the new science was everywhere flattered or pilloried" with "admiration, contempt, resentment, and fear."[22] Even before Gall published his work in France, the French philosopher Charles de Villers asked in 1802, "Who *hasn't* heard of Gall and his skulls?"[23] In the mid-nineteenth-century Larousse dictionary, the entries on *phrénologie* and *physiognomonie* are much longer than average entries.[24] The pseudosciences were taught in public courses, packaged into home study kits for adults and children, and satirized in plays.[25] Paris boasted a Société phrénologique of 150 members in its first year, two phrenology journals, and a museum of phrenology, all founded in the 1830s.[26] Participants were medical doctors, philosophers, artists, university faculty, lawyers, and justice officials, who all believed that improved ability to read human character could inform their work.

The implications disturbed some. They feared that weddings would be canceled or innocent men sent to the gallows if cranial bumps indicating coquetry or murder were discovered.[27] Jean-Pierre Dantan, creator of popular caricature-statues of Parisian celebrities, formed a sinister caricature bust of a phrenologist, giving substance to society's mistrust.[28] While skeptics remained unconvinced, others predicted phreno-physiognomy would be the science of the future: crimes would be solved or prevented and people would be spared ill-suited careers because phrenologists would prescribe professions for which those people had natural ability. Phrenology was used in music pedagogy in London in the 1830s to identify musicians at a young age and spare others the arduous path to failure.[29] In Paris, Alexandre-Etienne Choron apparently examined children's physiognomies before recruiting them to join his music school.[30]

Phrenology and Music

Phrenology was claimed to identify the mechanisms behind musical skill. Phrenologists found two primary cranial organs for musical skill: the organs of *tune* (giving the sense of melody and harmony) and *time* (giving the sense of rhythm; see Figures 3.1 and 3.2). These would be manifest by protrusions on the skull at their locations above the exterior part of the eye. Such protrusions were sometimes given special prominence in portraiture, such as in Henri Lehmann's *Portrait of the Young Franz Liszt* (1839) and David d'Angers's bronze bust of Paganini (1830–33). Both artists studied phrenology.

Other organs could combine with *tune* and *time* to create diverse kinds of musical giftedness. For instance, strong *combativeness* and *destruction* would incline a musician toward writing or performing accented or military music, while a large organ of *veneration* would dispose someone toward sacred music, and a large area of *mirth* would generate a propensity for comic music.[31] Developed organs of *weight* and *touch* would be advantageous for harpists, pianists, or cellists, who need finesse in applying pressure to the keys or strings of their instruments.[32]

Phrenologists tried to avoid being rash in their assessments. It was common, and even advised, that analyses be performed after

NOMENCLATURE DES ORGANES INDIQUÉS SUR
LES DESSINS.

—

Penchants.

1 Amativité.
2 Philogéniture.
3 Habitativité.
4 Affectionivité.
5 Combativité.

6 Destructivité.
7 Secrétivité.
8 Acquisivité.
9 Constructivité.

Sentiments.

10 Estime de soi.
11 Approbativité.
12 Circonspection.
13 Bienveillance.
14 Vénération.
15 Fermeté.

16 Conscienciosité.
17 Espérance.
18 Merveillosité.
19 Idéalité.
20 Gaieté, esprit de saillie.
21 Imitation.

Facultés perceptives.

22 Individualité.
23 Configuration.
24 Étendue.
25 Pesanteur.
26 Coloris.
27 Localité.

28 Calcul.
29 Ordre.
30 Éventualité.
31 Temps.
32 Tons.
33 Langage.

Facultés réflectives.

34 Comparaison.

35 Causalité.

NOTA. X placé au devant de l'oreille correspond à
l'*alimentivité* et à l'*amour de la vie*, organes douteux.

Figures 3.1 and 3.2. The organs of the brain. Source: Claude-Etienne
Bourdin, *Essai sur la phrénologie* (Paris: Mme Veuve Bouchard-
Huzard, 1847). Bibliothèque nationale de France, Paris.

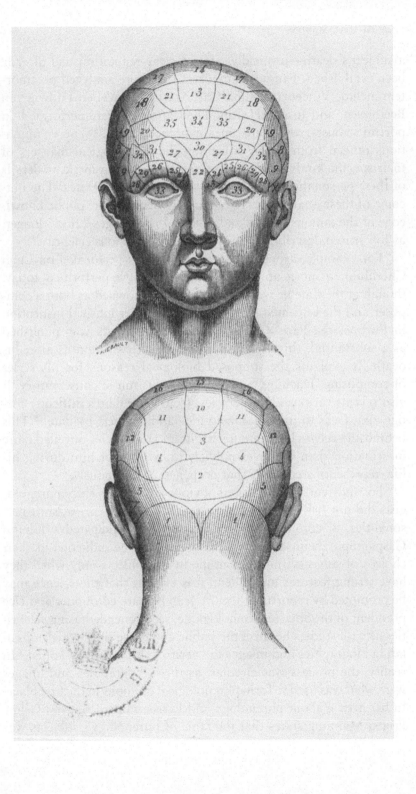

a subject's death—ironically, after a clear reputation had already been established. Famous composers that were analyzed postmortem include Vincenzo Bellini, Carl Maria von Weber, Ludwig van Beethoven, and Joseph Haydn. Their analyses were performed on portraits, busts, and sometimes exhumed skulls.[33] The examinations ranged from simply affirming the physiological markers of their specific kinds of musical talent, to providing intricate details of their personalities, strengths, weaknesses, and tastes. The outcome of these analyses was to add more detail to the public knowledge of the famous figures and to keep their images "alive" longer, as Joli Jensen describes in her work on posthumous celebrity.[34]

For example, a postmortem analysis was performed on Luigi Cherubini, a musician whose works are little-performed today, though at the time he was internationally renowned as both a composer and the esteemed director of the premier musical institution in Europe, the Paris Conservatoire. The analysis was published as a substantial, thirty-eight-page pamphlet two months after his death. It explains the supposed biological reasons for his styles of composing, teaching, and governing his music conservatory. It also reveals various idiosyncrasies, from Cherubini's difficulty recognizing faces to his organizing his handkerchiefs by date.[35] This behind-the-scenes look into his habits and tendencies unveiled more information than was ever publicly known about him during his life, representing celebrity that deepened posthumously.

Postmortem analysis posed obvious advantages since phrenologists did not risk that their subject would change career, shift personalities, or commit a crime that was not anticipated.[36] Johann Gaspar Spurzheim advised phrenologists to be judicious in their choices of subjects and to examine living subjects only when they have strong features and when "it is evident that the science may be promoted by reporting them."[37] Jean Fossati, cofounder and vice president of the Société phrénologique, recommended using celebrities as case studies because the public could use their widely circulating biographies and images to "verify" phrenology's claims.[38] In reality, the process was circular, as these biographies and images were what was used to form phrenological opinions in the first place. In her article about phrenology and Parisian opera singers, Céline Frigau Manning states that the fame of phrenology's subjects was

integral to its success.[39] As phrenologists reinforced what the public already knew—that famous musicians were talented—phrenology appeared reliable. The arrangement was beneficial on all sides: the musicians' publicity increased and audiences learned a fascinating new vocabulary through which to discuss them.[40]

Unsurprisingly, the instrumentalists to receive the most attention were the most celebrated: Liszt and Paganini. In their cases, however, phrenology more than simply told the public what it already knew; it was harnessed to actually construct public image. Alan Davison, a specialist in music and visual culture, has already examined phreno-physiognomy's influence in Liszt's portraiture.[41] I discuss here Liszt's intentional use of phreno-physiognomy to feed his audience's hunger for details about his private life and to form an image that would make him more accepted among high society. Paganini has not yet been examined in the phrenological context, though his sensational reputation is known to have been highly reliant on his physical appearance. His case shows that phreno-physiognomy held powerful sway over public opinion, even to the point of destroying a person's reputation.

Franz Liszt

Liszt might be called a virtuoso of self-promotion in addition to a virtuoso of the piano. He clearly engaged with his public's desire for knowledge of him. He expertly furnished "intimacy at a distance," mostly through widely published anecdotes.[42] In this vein, he actively pursued a phrenological analysis, which he had published in Paris. The report pays little attention to his ability as a pianist, focusing on Liszt himself, celebrating him apart from his skill.

Liszt's relationship with phreno-physiognomy is not straightforward. We know that he conscientiously employed it in several outlets: portraits and busts, two biographies, and a published analysis.[43] Yet, on at least two occasions, he wrote that he was ignorant about its theories. The paradox is both baffling and tantalizing, and makes his actions seem manipulative.

In autumn 1835, Liszt received a letter from the writer George Sand, which rapturously discussed the new potential of phrenology

and physiology. His reply was modest: "Although I know phrenology and physiognomy only very superficially and solely from hearsay, I am convinced that when these two systems are completed, the one through the other, magnificent results will be achieved."[44] Three years later, he wrote about his experience sitting for a bust by the sculptor Lorenzo Bartolini. He casually remarked on Bartolini's peculiar attention to his forehead: "He put trust in some bump or other that he discovered on my forehead and took a liking to the angle of my face."[45]

Liszt's pretending to have no understanding of the significance of this bump and to know phreno-physiognomy only superficially and secondhand can only be an attempt to seem naïve about something with which he had quite extensive experience. His relationship with phrenology was long-standing and already renowned among phrenologists. He had received three official phrenological examinations prior to writing his letter to Sand.[46] In the first of these, he had been presented as a fourteen-year-old to a founder of the London Phrenological Society. He already had a promising piano career, but was presented anonymously, as a "lazy boy, devoid of natural talents . . . whose family did not know what to do with him."[47] Laying hands on the boy's head, the phrenologist immediately asked him if he had ever tried music and said that he was firmly convinced that this was the path the boy was suited for.[48] This purportedly blind test of phrenology's ability to intuit Liszt's talent was considered proof of the discipline's reliability. The story appeared in Liszt's earliest biographies by Joseph d'Ortigue (1835) and later by Ludwig Rellstab (1843), which were both aimed to support Liszt's genius by all means available.[49] By the time of Liszt's second claim to ignorance, he had discussed having a fourth examination with another phrenologist and had attended a phrenology course with the writer (and his partner) Marie d'Agoult.[50] Liszt ultimately sat for at least five examinations and as many as ten head molds over his lifetime.[51]

Before his first denial, he had also participated in a highly publicized phrenological controversy involving a mentally insane woman who could accurately sing back any melody she heard, even though her location of melody was a depression in her head rather than a protrusion. Liszt visited her asylum cell and showered her

with so many notes that she vibrated as if electrocuted. The incident was written up in three Paris journals.[52] Finally, phrenology was a well-known influence in Saint-Simonianism, which Liszt was taken with; this utopian philosophy imagined a hierarchical society with theologians, poets, and artists at the top level as a "spiritual power" that would lead the people below them to a better quality of life for all.[53] Some of Saint-Simon's followers naturally gravitated to phrenology as a means of revealing the most enlightened and talented human beings.[54] All of these events and intersections present convincing evidence that Liszt must have been thoroughly aware of phrenology and its teachings. What did he gain in acting as if he was not? Perhaps he wanted to keep a safe distance from a controversial movement, while still using it as he needed.

Liszt went on to encourage the most extensive written phrenological analysis we have on a musician: the seventy-nine-page *Etude phrénologique sur le caractère originel et actuel de M. François Liszt* (1847).[55] The phrenologist who undertook the work was Michael Castle, a member of the College of Medicine in New York, purported to have written more than two thousand monographs of phrenological analyses of living subjects.[56] The writer Paul de Musset observed Castle at work in Milan and was astounded at his rapid unrolling of accurate examinations of people on whom he had no previous information.[57]

Liszt met Castle perhaps as early as 1841.[58] It is uncertain whether Liszt approached Castle about the study, or vice versa. However, Liszt's letter to Castle in March 1844 reveals his pleasure at the idea: "I will be very flattered and enchanted if You would like to occupy Yourself with a phrenological work on my more or less badly bumped noggin. . . . [A] phrenological study . . . would interest the Public, and would compensate for a lot of twaddle that it has swallowed on my account."[59] [Je serai assurément très flatté et très enchanté d'apprendre que Vous voulez bien Vous occuper d'un travail phrénologique sur ma caboche plus ou moins mal bossée . . . une étude phrénologique . . . intéresserait le Public, et le dédommagerait de beaucoup de fadaises qu'on lui fait avaler sur mon compte.] It is clear right away that Liszt desired the piece to be a form of publicity and to inform the public about what kind of person he was.

Once the study was finished, Liszt went to significant personal effort to publish it in Paris. He found an editor to patch up the French and a publisher to print it at a moderate cost.[60] He organized the publication himself since Castle, a foreigner, did not have the necessary connections. Nine preserved letters from Liszt pertain to the manuscript, a significant amount of documentation indicating the project's importance to him.[61] Liszt, throughout his life, carefully styled himself as an intellectual and cultured gentleman; this message jumps clearly from the pages of the phrenological analysis. Even by participating in Castle's study, Liszt presented himself as involved in a fashionable and avant-garde, supposedly scientific field. By this time, such an association was apparently acceptable and desirable for him.

Only one of the fourteen sections in Castle's study addresses Liszt's musical ability. Musset explained that with just one glance at Liszt's forehead, the public would know just as well as Castle did that Liszt had musical ability. He conjectured that Castle focused on personality in order to contribute something new to public understanding.[62] Castle particularly emphasized Liszt's intellect, his amiability and desire to please, his thirst for glory but conflicting self-criticism that made him sometimes loathe performing, his constant need for change and extreme emotions, and his passion for love. Passages in the study about the last characteristic are especially vivid. Considering the hysteria Liszt had already created among women—who are said to have vied for his handkerchiefs, gloves, and cigarette butts—the study's descriptions of his *"tyrannical* desires for *possession* of the loved object . . . *tenderness, generosity,* and *entire abandon* to *naive* and *instinctive joy* in the hours of intimacy"* [des désirs *tyranniques* pour la *possession* de l'objet aimé . . . en même temps qu'une *tendresse,* une *générosité* et un *entier abandon* à une *joie ingénue* et *instinctive* dans les heures d'intimité] could only have fanned the flames.[63] Castle's analysis reads as a cross between a gossip column and medical report; it contains details to interest casual readers in addition to those curious about phrenology. It was clearly written for those who appreciated Liszt's celebrity more than his musical ability. Readers receive insight into attitudes, passions, and behaviors that normally only close friends or lovers could access.

Liszt, in his letter to Castle above, states his intent to use the analysis to clarify aspects of his personality and reduce the "lot of twaddle" the public has "swallowed" about him. The twaddle likely involved rumors regarding his self-promoting ambition and his out-of-control sexual propensities—he lived openly with a married woman and was suspected of seeing other women while away on concert tours. Despite titillating public interest with descriptions of Liszt's amorous urges, Castle guarded against the spreading of harmful rumors by underscoring that "the title of moral man" fully belongs to him [le titre d'*homme* moral appartient *pleinement* à M. Liszt], as he is benevolent and affable, incapable of committing any ignoble action.[64]

Through publishing this study, Liszt conscientiously promoted the picture that he desired people to see, that he was appealing, intellectual, and well-mannered. This was a necessary message to communicate, as musicians strove to elevate themselves from being viewed as artisans and providers of a service for members of high society, to being considered well-bred and deserving members of it themselves. Liszt was well-aware of this necessity.[65] He was also aware of his need to feed public interest in order to remain celebrated. He used Castle's study to engage the public's interest in his inner life, desires, and personal struggles, as well as to ease his acceptance into society. The effort that he put into the study's publication demonstrates that he considered it an important investment for building his career. The context surrounding his publication of a phrenological analysis reinforces the idea that Liszt's reputation was no accident, but something he intentionally pursued and controlled. It would be appropriate if future scholars refer to Castle's analysis in their studies of Liszt's reputation and promotion.

Niccolò Paganini

Unlike Liszt, Paganini was more a victim of phrenology than an exploiter of it—but a somewhat lucky victim at that. Paganini's notoriety while living far exceeded Liszt's. He flaunted harrowing performance techniques: left-hand pizzicato, harmonics, double-stops, and playing on frayed strings that would successively break until he finished the piece on just one string. With

seemingly supernatural skill and a freakish physical appearance, he was renowned as the demon violinist, surrounded by an aura of evil and wrongdoing. It was rumored that he had seduced women, forced abortions, murdered, been imprisoned, and sold his soul to the devil.[66] Macabre associations only increased his fame. And such associations were reinforced or perhaps even generated by phreno-physiognomic assumptions. Paganini's critics used phreno-physiognomy to point out the malevolence written on his body; his supporters used phreno-physiognomy to defend him.

All sources agreed, at least, that Paganini's body bore signs of genius. Paganini's physician Francesco Bennati recorded a number of facial features that "to a certain degree testified to his undeniable genius."[67] The poet Heinrich Heine described Paganini's "pale, corpse-like face, on which trouble, genius, and hell had graved their indelible marks."[68] The critic Castil-Blaze mentioned eyes "bright with the fire of genius."[69] The critic-composer Hector Berlioz also cited Paganini's "piercing eyes" and "strange and ravaged face" as testaments to his genius.[70] Berlioz, relevantly, an ex-medical student, agreed with Gall's and Lavater's ideas, owned copies of their books, and even believed they had not taken their ideas far enough.[71]

Paganini had a bony frame, pale skin, and long, dark hair (see Figure 3.3). He was often compared with a cadaver or a ghost. The Parisian press cast him in an overwhelmingly morbid pall, frequently reporting his illnesses and periodic rumors of his death. His appearance is commonly acknowledged as a source for his reputation. As Mai Kawabata observes in her book on Paganini's reputation, "The focal point for the swirl of speculation and aura of mystery was Paganini's decrepit body. It was a source of endless fascination to his public: contorted, cadaverous, and disease-ravaged, it spoke of abnormality, alterity, excess."[72] Paganini, even at the time, recognized the role of his appearance. To his friend and lawyer Luigi Germi, he complained that his looks were receiving almost more attention than his playing was: "Now no one ever asks if one has heard Paganini, but if one has *seen* him . . . The papers talk too much about my outward appearance, which arouses incredible curiosity."[73]

Paganini was ambivalent about the malevolent persona growing around him. On one hand, he did not want this distinction: "To

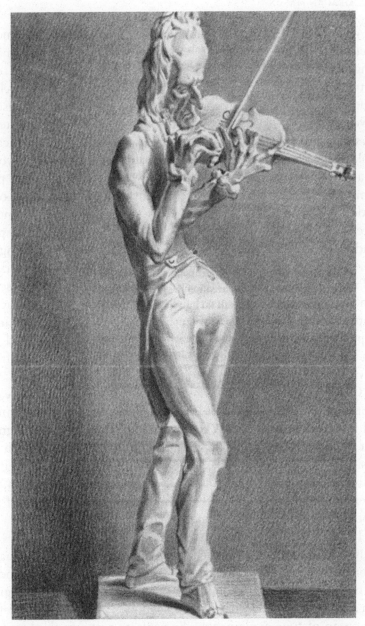

Figure 3.3. Dantan, Paganini, caricature sculpture reproduced in engraving, "Paganini." *Le Charivari* (1836). Bibliothèque nationale de France, Paris.

tell you the truth, I regret that there is a general opinion among all classes that I'm in collusion with the Devil."[74] Yet, he did many things that encouraged this perception of him: he behaved bizarrely onstage, performed repertoire such as *Le Streghe* ("The Witches' Dance"), bore a name that translated to "little pagans," visited graveyards to watch cholera victims being buried, and wrote to newspapers to allegedly deny harmful legends, which he graphically retold.[75] He was sullen, private, and hardly ever spoke with anyone. Because of his oddities, his renown grew to such extent that performing was no longer necessary to maintain his celebrity—he only needed to appear. He drew onlookers and customers to a music store in the Passage de l'Opéra as he sat daily in the shop's display window, wrapped in a cloak, reading scores, and acknowledging no one.[76] At the Casino Paganini (a short-lived enterprise capitalizing on Paganini's name; it offered concerts, music and painting lessons, game and reading rooms, gardens, and a café), he was contracted to appear three times a week.[77] Rather than perform, he sometimes simply walked through the garden so that the guests could see him.[78] His presence, eerie and otherworldly, without a note from his violin or a word from his mouth, drew crowds.

Contemporary consciousness of phreno-physiognomy clearly informed public perception of Paganini, tying his skill, appearance, and ill repute to one cause. Three pieces of publicity were significant in promoting this perception. One dealt exclusively with his musical ability; the two others implicated his character. Even if he really had wished to regain a positive and honorable reputation, the latter two illustrated that such a pursuit would be difficult, if not impossible, considering his appearance.

First, a brief review in the *Gazette musicale* summarizes an analysis delivered at the Société phrénologique.[79] The report remains aloof from gossip and assesses only Paganini's musical skill, focusing on his highly developed organs of *tune* and *touch*. *Touch* gives him ultra-precise agility in rapid and complex passages, but a defective organ of *time* explains why he neglects accurate rhythm. Second, Bennati's "Notice physiologique sur Paganini" in the *Revue de Paris* (1831) demonstrates a much larger intention. The ten-page article appeared as part of the press buildup preceding Paganini's much-anticipated tour in Paris. Bennati aimed to defend Paganini's

character and give a scientific and physical explanation for his great talent.[80] In the article, he describes Paganini's flexible ligaments, perfectly proportioned hands, large and well-defined ears, and (oddly) skin that sweats when he hears music—an indication of his musical sensitivity. Pertinently, Paganini's ears, as Bennati describes them, resemble the musician's ears described in the *Grand diction-naire* entry on *physiognomonie*, with well-defined grooves and ridges.[81] Bennati cites, of course, the strongly developed "lump of melody" in Paganini's forehead, described by Gall's and Lavater's theories. He asserts that physical fitness is the source of Paganini's skill:

> Paganini is in his entirety . . . an organism made expressly . . . for attaining the highest perfection as an executant musi-cian. . . . The superiority of the celebrated violinist is less a result of continued practice, as has been averred, but rather of special physical fitness . . . His head alone should have made Paganini a distinguished composer, a musician of the highest standing; but without his delicate sense of rhythm, the build of his body, his shoulders, arms and hands, he could never have been the incomparable virtuoso whom we all admire.[82]

In other words, Paganini's genius, skill, and acclaim are attribut-able to natural talent, inherent in the build of his body and head.

In the "Notice physiologique," Bennati describes Paganini's facial features but does not interpret their character implications. Readers at the time were likely familiar enough with physiognomy to read facial features themselves.[83] But it is also possible that Ben-nati refrains here because many of Paganini's features had negative physiognomic connotations. He notes Paganini's broad and massive forehead, which would indicate intelligence. However, a dispropor-tionately large head (which Bennati does not specify) would sig-nal brutality and animal instinct.[84] This interpretation would have rung true with the general perception of Paganini as brutish and cruel. Bennati mentions an aquiline nose, which was a sign of domi-nation and stubbornness.[85] He admits that the mouth is "full of . . . malice" [une bouche pleine . . . de malice]. However, he more posi-tively points to Paganini's "perfectly arched eyebrows" [des sourcils arqués d'une manière parfaite], which symbolized good nature and

simplicity, and protruding ears, which signaled ability, frankness, and openness—the opposite of what Paganini was often accused of possessing, with his secretive past and perplexing talent.[86] Bennati adds that Paganini is not melancholic and grieving, as people often think, but cheerful and witty, laughing with his friends and playing games with his little son Achille.

Despite pointing out Paganini's most complimentary features indicating good nature, intelligence, openness, and simplicity, Bennati hints at negative characteristics (malice, cruelty, domination), glossing over them without commentary. Other parts of his review make clear that he wanted to fuel an audience's appetite for gossipy detail. He described Paganini's being nearly buried alive during a bad case of measles at age four and his current suffering from hemorrhoids. The physical description Bennati offers without explanation is in part obligatory within a physiological notice, but it may also have been a way to tacitly guard the dark underbelly that had created Paganini's allure, while the article as a whole conspicuously defends him. Bennati recognized that scandal was part of Paganini's success. A few unsavory bits remain while Bennati focuses on humanizing Paganini and making him more socially acceptable.

The third piece of publicity demonstrates just how damaging phreno-physiognomy could be to a reputation. It provides, in addition, irrefutable evidence that phreno-physiognomy was used to understand and create celebrity. Théodore Poupin's two-volume collection of celebrity sketches, *Esquisses phrénologiques et physiognomoniques des contemporains les plus célèbres* (1836), contains one chapter for each phrenological organ, each epitomized by a different Parisian celebrity. Three musicians feature: the admired singer Luigi Lablache illustrates the organ of *time*; the superstar composer Gioachino Rossini represents *tune*; and Paganini represents *acquisition*, or what would more commonly be called *greed*.[87] The publication is less scientific than the others and was intended for a general audience. No physical analyses corroborate the figures' associations with their phrenological organs—readers must take the author at his word.

While Lablache's and Rossini's entries take pages to describe their training and professional accomplishments, Paganini's associates him with an unmusical quality, greed, and does not actually

mention him until the last two, abrupt paragraphs. There he is attacked as a "devious and wicked" miser [ce sournois et mauvais riche], who, for a few bow strokes, ungratefully "carried away twenty coffers of our gold without letting one parcel fall to our poor" [Paganini, l'ingrat artiste qui, pour quelques coups d'archet, a emporté vingt malles de notre or sans en laisser tomber une parcelle sur nos pauvres]. He is then taunted: "Look at this somber figure all cast in anxiety, in worry over small things and this sordid love [of money], which we have attempted to paint; look at him quickly, very quickly, because the time of recriminations is passed, and we cannot anymore, without cowardice, crush a fallen man. There he is, this Paganini, the exile of the press that chased him out of Paris forever."[88] [Regardez cette sombre figure toute empreinte d'inquiétude, de soucis des petites choses et de cet amour sordide que nous avons essayé de peindre, voyez-le vite, bien vite, car le temps des récriminations est passée, et nous ne pouvons plus, sans lâcheté, écraser l'homme tombé. C'est là ce Paganini, l'exilé de la presse, qui l'a chassé de Paris à tout jamais.] The association with greed stuck. The year after Poupin claimed that Paganini was "chased out" of Paris forever, Paganini returned to open the Casino Paganini, which soon folded and resulted in his losing more than 100,000 francs in lawsuit fees over accusations of mismanagement and avarice. Heine, that same year, wrote a story featuring "a corpse arisen from the grave, a vampire with a violin, who sucks, if not the blood out of our hearts, at the least the money out of our pockets."[89] Paganini indeed made immense amounts of money from performing (165,000 francs from his twelve concerts in spring 1831, for example).[90] However, he also donated liberally—20,000 francs to Berlioz, entire concerts' proceeds to charities, and large amounts to family, but these generosities went almost unnoticed.[91]

Regardless of any reality, Paganini's reputation hinged on one fact: to the nineteenth-century viewer, he did not *look* like someone who could be kind or generous. Bennati's notice presented a complex and three-dimensional person who had both good and bad qualities, toward whom readers could be sympathetic. But Poupin's message was more cogent, that Paganini was evil and his physiology proved it.

Paganini's notoriety as an untrustworthy person caused people to eye him all the more closely. People thronged to his performances, curious to see the mysterious and diabolical talent that such a mal-formed person could exude. As early as 1830, a biographer recognized that Paganini would have been less interesting to the public if he had been physically different. He wrote that Paganini's "peculiarities make of him an original, reminiscent of the spiritual and of all that is antithetical to the everyday . . . it would have been a real error if Nature had given him more flesh."[92] In Paganini's celebrity, skill and body were inseparably dependent on each other, much to the credit of phreno-physiognomy.

Conclusion

Publicity around Paganini and Liszt demonstrates that celebrated figures in the 1830s and '40s were critiqued through a perspective largely forgotten today. Musicians and their publicists saw phreno-physiognomy as an opportunity to influence public opinion; they used it to explain their talent and put forward a public image, whether positive or negative. And for phrenologists, well-known and often-seen celebrity figures brought attention to their ideas. Though phrenology and physiognomy were built on unreliable evidence, they succeeded for a time because they met a cultural need, responding to Parisians' mania for celebrity by explaining the talent and the inner lives of inaccessible public figures.

Study of this phenomenon demonstrates that the history of celebrity can intersect with other unexpected disciplines, such as the history of science. I hope that scholars will extend this work by looking for physical descriptions in writings from the late eighteenth and early nineteenth centuries and considering them in light of phrenology and physiognomy. Seeing through the cultural lens of the time can lead us to uncover more perceptions people had of each other and reveal other hidden factors at work in publicity campaigns.

Notes
1. An earlier version of this chapter appears in Meagan Mason, "Music Business and Promotion among Virtuosos in Paris, 1830–1848" (PhD diss., University of Southern California, 2018).

2. "La Phrenologie," *The Phrenological Journal and Magazine of Moral Science* 12 (1839): 176–77.

3. Phrenology and physiognomy during this time were often used in combination. Though the ideas were distinct, they were related and complementary. I use the term "phreno-physiognomy" to refer to them together.

4. Antoine Lilti, *The Invention of Celebrity* (Cambridge: Polity Press, 2017), 6–7.

5. Ibid., 236–37.

6. *Revue musicale* (April 23, 1831): 94.

7. See Graeme Tytler, "Character Description and Physiognomy in the European Novel (1800–1860)" (PhD diss., University of Illinois at Urbana-Champaign, 1970); Alan Davison, "High-Art Music and Low-brow Types: Physiognomy and Nineteenth-Century Music Iconography," *Context* 17 (Winter 1999): 5–19; Céline Frigau Manning, "Phrenologizing Opera Singers: The Scientific 'Proofs of Musical Genius,'" *19th-Century Music* 39, no. 2 (Fall 2015): 125–41; David Trippett, "Exercising Musical Minds: Phrenology and Music Pedagogy in London circa 1830," *19th-Century Music* 39, no. 2 (Fall 2015): 99–124.

8. Haejeong Hazel Hahn, "Street Picturesque: Advertising in Paris, 1830–1914" (PhD diss., University of California, Berkeley, 1997), 21.

9. Richard Sennett in Judith Wechsler, *A Human Comedy: Physiognomy and Caricature in Nineteenth-Century Paris* (Chicago: University of Chicago Press, 1982), 7. See also Martin S. Staum, *Labeling People: French Scholars on Society, Race, and Empire, 1815–1848* (Montreal: McGill-Queen's University Press, 2003).

10. Tytler, "Character Description and Physiognomy," 2.

11. Duncan McColl Chesney, "The History of the History of the Salon," *Nineteenth-Century French Studies* 36, no. 1/2 (Fall 2007–Winter 2008): 94.

12. See, for example, Christopher Rivers, *Face Value: Physiognomical Thought and the Legible Body in Marivaux, Lavater, Balzac, Gautier, and Zola* (Madison: University of Wisconsin Press, 1994), 104–39, and Tytler, "Character Description and Physiognomy," 2.

13. These types of publications had been a long Parisian tradition. An earlier example is the artist Edmé Bouchardon's series of prints, *Etudes prises dans le bas peuple, ou Les cris de Paris* (1737–1746).

14. Translated in Wechsler, *A Human Comedy*, 36.

15. Translated in ibid., 38.

16. Ibid.; Jillian Taylor Lerner, "Panoramic Literature: Marketing Illustrated Journalism in July Monarchy Paris" (PhD diss., Columbia University, 2006), 114.

17. *Physiologie des physiologies* (Paris: Desloges, 1841), 84; Wechsler, *A Human Comedy*, 16.

18. A helpful breakdown of phrenology's development can be found in John van Wyne, "The History of Phrenology on the Web," accessed February 6, 2020, http://www.historyofphrenology.org.uk/organs.html#gall.

19. Gall first presented his ideas in lectures that he gave starting in 1796, then published his four-volume treatise, *Anatomie et physiologie du système*

nerveux en général et du cerveau en particulier, avec des observations sur la possibilité de reconnaître plusieurs dispositions intellectuelles et morales de l'homme et des animaux par la configuration de leurs têtes, 4 vols. (Paris: Librarie grecque-latine-allemande, 1810–19).

20. The earliest record of this belief dates from ancient Mesopotamia (see "From Analogy to Causality: The History of Physiognomy before 1700" in Rivers, *Face Value*, 18–32). Lavater's book reached France in 1781 as *Essai sur la physiognomonie destiné à faire connaître l'homme et à le faire aimer*. A more popular version annotated and illustrated by Moreau de la Sarthe, *L'Art de connaître les hommes par la physionomie*, was published between 1806 and 1809. For a history of Lavater and physiognomy, see Graeme Tytler, *Physiognomy in the European Novel: Faces and Fortunes* (Princeton, NJ: Princeton University Press, 1982).

21. See Pierre Larousse, *Grand dictionnaire universel du XIXe siècle* (Paris: Administration du Grand dictionnaire universel, 1866), 914, for these and other examples of physiognomy's teachings.

22. *Encyclopædia Britannica* edition published between 1853 and 1860, in Tytler, "Character Description and Physiognomy," 58.

23. Trippett, "Exercising Musical Minds," 112.

24. Larousse, *Grand dictionnaire universel du XIXe siècle*, 896–98 and 913–15.

25. Johann Gaspar Spurzheim to George Combe, 20 May 1831, in Jan Goldstein, *The Post-Revolutionary Self* (Cambridge, MA: Harvard University Press, 2005), 291, 293; Staum, *Labeling People*, 50. Find a list of plays in Tytler, *Physiognomy in the European Novel*, 387.

26. Staum, *Labeling People*, 50.

27. Charles Fourier in Goldstein, *The Post-Revolutionary Self*, 299.

28. See also Laurent Baridon, "Jean-Pierre Dantan, le caricaturiste de la statuomanie," in "Sculptures et caricatures," special issue, *Ridiculosa* no. 13 (2006): 127–43. See an image at http://parismuseescollections.paris.fr/fr/musee-carnavalet/oeuvres/portrait-charge-de-holm-phrenologiste-allemand#infos-principales, accessed February 6, 2020.

29. Trippett, "Exercising Musical Minds."

30. Mme la comtesse de Bassanville, *Les Salons d'autrefois: souvenirs intimes, 1e série* (Paris: J. Victorion, n.d.), 62.

31. George Combe, *A System of Phrenology*, vol. 2 (Edinburgh: Maclachlan and Stewart, 1836), 532; Alfred Ellis, *Phrenology and Musical Talent* (Blackpool: "Human Nature" Office, 1896), 14, in Manning, "Phrenologizing Opera Singers," 133.

32. Combe, *A System of Phrenology*, 532.

33. Trippett briefly writes about Beethoven's, Haydn's, and Schubert's exhumed skulls: "Exercising Musical Minds," 104–5.

34. Joli Jenson, "On Fandom, Celebrity, and Mediation," in *Afterlife as Afterimage: Understanding Posthumous Fame*, eds. Steve Jones and Joli Jensen (New York: Peter Lang, 2005), xxi.

35. Charles Place, *De l'Art dramatique au point de vue de la phrénologie* (Batignolles: Hennuyer et Turpin, 1843); *Essai sur la composition musicale:*

*biographie et analyse phrénologique de Cherubini avec notes et plan cra-
nioscopique* (Paris: Les principaux librairies et éditeurs de musique, 1842),
23–28.

36. Phrenologists had a few embarrassing misdiagnoses. See, for example,
Cristina Belgiojoso, 14 February 1842, in Monica Chiyoung Yoon, "Princess
Cristina Trivulzio di Belgiojoso: Her Passion for Music and Politics" (DMA
diss., University of Washington, 2014), 6–7; Staum, *Labeling People*, 77; James
Q. Davies, *Romantic Anatomies* (Berkeley: University of California Press,
2014), 231; "Phrenological Quacks," *Edinburgh Phrenological Journal* 9 (Sep-
tember 1834–March 1836): 517; and *Phrenological Journal and Magazine of
Moral Science* 14 (1841): 84.

37. Spurzheim's advice, reported in "Phrenological Quacks," 517.

38. Jean Fossati, *Manuel pratique de phrénologie ou Physiologie du cerveau*
(Paris: G. Baillière, 1845), 101, cited in Manning, "Phrenologizing Opera Sing-
ers," 129, 131.

39. Manning, "Phrenologizing Opera Singers," 140.

40. Ibid.

41. Alan Davison has published groundbreaking studies of Liszt's interac-
tion with phreno-physiognomy, particularly in connection with Liszt's iconog-
raphy. See "Studies in the Iconography of Franz Liszt" (PhD diss., University of
Melbourne, 2001); "The Musician in Iconography from the 1830s and 1840s,"
Music in Art 28, no. 1/2 (Spring–Fall 2003): 147–62; "Liszt and the Physiog-
nomic Ideal in the Nineteenth Century," *Music in Art* 30, no. 1/2 (Spring–Fall
2005): 133–44.

42. Dana Gooley, "From the Top: Liszt's Aristocratic Airs," in *Constructing
Charisma: Celebrity, Fame, and Power in Nineteenth-Century Europe*, eds.
Edward Berenson and Eva Giloi (New York: Berghahn Books, 2010), 83.

43. See Davison's work, cited in note 41.

44. Letter dated autumn 1835 in Franz Liszt, *Selected Letters*, ed. and trans.
Adrian Williams (Oxford: Clarendon Press, 1998), 16.

45. Liszt, *L'Artiste* 2, no. 14 (1839): 156, quoted in Davison, "Liszt and the
Physiognomic Ideal," 142.

46. The dates of Liszt's analyses were: 1825 by James Deville; 1824–26 by
Gall; 1827–34 by Pierre-Marie Alexander Dumontier; 1836 by Fleury Imbert;
and 1844 by Castle; see Pauline Pocknell, "Le Liszt des phrènologues: ou Liszt,
Castle, la Comtesse et la Princesse," *Ostinato rigore: Revue internationale
d'études musicales* 18 (2002): 169–83.

47. Joseph d'Ortigue, reproduced in Trippett, "Exercising Musical Minds,"
104. Liszt had the previous year (1824) performed in London and been acclaimed
as a child prodigy.

48. Ludwig Rellstab, in Trippett, "Exercising Musical Minds," 104.

49. Benjamin Walton, "The First Biography: Joseph d'Ortigue on Franz Liszt
at Age Twenty-Three," in *Franz Liszt and His World*, eds. Christopher Gibbs
and Dana Gooley (Princeton, NJ: Princeton University Press, 2006), 304.

50. *Marie de Flavigny, comtesse d'Agoult: Correspondance générale, vol.
1, 1821–1836*, ed. Charles F. Dupêchez (Paris: Honoré Champion, 2003), 455.

51. Pocknell, "Le Liszt des phrènologues," 171.

52. Davies, *Romantic Anatomies*, 231; François Leurat, *Gazette médicale de Paris* (January 3, 1835), 1a; Leurat, *Vert-Vert: Journal politique du matin et du soir* (January 23, 1835): 1b and (January 24 1835): 1a; Leurat, *Le Pianiste* (February 5, 1835): 53b.

53. Staum, *Labeling People*, 18.

54. Ibid., 17ff.

55. Arthur Michael Castle, *Etude phrénologique sur le caractère originel et actuel de M. François Liszt* (Milan: n.p., 1847).

56. Castle was a rage in Milan (Paul de Musset, *Voyage pittoresque en Italie: Partie septentrionale* [Paris: Belin-Leprieur et Morizot, 1855], 217).

57. Ibid., 217–18.

58. Pocknell, "Le Liszt des phrènologues," 173–74.

59. Preface to Castle, *Etude phrénologique*.

60. Liszt to Marie d'Agoult, 14 April 1846, in Marie Broussais, "Liszt dans les collections anthropologique du Musée de l'Homme," *L'Education musicale* 309–10 (June–July 1984): 31.

61. The letters are reproduced in part in Pocknell, "Le Liszt des phrènologues."

62. Musset, *Voyage pittoresque en Italie*, 219.

63. Castle, *Etude phrénologique*, 31; see also 22. Emphasis original.

64. Ibid., 39.

65. Meagan Mason, "The Rising Status of the Musician in Salons," in "Music Business and Promotion among Virtuosos in Paris, 1830–1848," 164–86.

66. Regarding Paganini's morbid and diabolical personas, see Nina Athanassoglou-Kallmyer, "Blemished Physiologies: Delacroix, Paganini, and the Cholera Epidemic of 1832," *The Art Bulletin* 83, no. 4 (2001): 686–710, and Mai Kawabata, *Paganini: The "Demonic" Virtuoso* (Woodbridge, UK: Boydell Press, 2013).

67. Francesco Bennati, "Notice physiologique sur Paganini," *Revue de Paris* (May 1831): 61, translated in Jacques-Gabriel Prod'homme, *Paganini* (Paris: H. Laurens, 1927), 16.

68. Heinrich Heine in Jeffrey Pulver, *Paganini: The Romantic Virtuoso* (New York: Da Capo Press, 1970), 203–5.

69. Quoted in Prod'homme, *Paganini*, 15.

70. Alan Kendall, *Paganini: A Biography* (London: Chappell and Company, 1982), 98.

71. Trippett calls this Berlioz's private endorsement of phrenology (Trippett, "Exercising Musical Minds," 100).

72. Kawabata, *Paganini*, 36.

73. G.I.C. de Courcy, *Paganini, The Genoese*, vol. 2 (Norman: University of Oklahoma Press, 1957), 89. Emphasis added.

74. Ibid.

75. One defense against these rumors is found in the *Revue musicale* (May 14, 1831): 117–18.

76. Charles Hallé in Alan Walker, *Franz Liszt: The Virtuoso Years, 1811–1847* (New York: Cornell University Press, 1987), 169.

77. "Casino-Paganini" (advertisement), *Le Siécle* (November 18, 1837), last page.

THE PHYSIOGNOMIES OF VIRTUOSI IN PARIS / 89

78. William Weber, *Music and the Middle Class: The Social Structure of Concert Life in London, Paris and Vienna between 1830 and 1848* (Burlington, VT: Ashgate, 2004), 57.

79. "Nouvelles," *Revue et gazette musicale de Paris* (November 1, 1835): 359. The bust is likely one preserved at the Musée Carnavalet, accessed February 6, 2020, http://parismuseescollections.paris.fr/en/node/153823#infos-principales.

80. Bennati, "Notice physiologique sur Paganini," 52.

81. Larousse, "physiognomonie," *Grand dictionnaire*, 914.

82. Bennati, "Notice physiologique sur Paganini," translated in Prod'homme, *Paganini*, 16. Scholars now believe that Paganini's odd appearance can be attributed to a genetic abnormality called Marfan Syndrome (Myron Schoenfeld, "Nicolo Paganini: Musical Magician or Marfan Mutant?" *The Journal of the American Medical Association* 239, no. 1 [1978]: 40–42).

83. Davison, "Liszt and the Physiognomic Ideal," 134.

84. Larousse, "physiognomonie," *Grand dictionnaire*, 914.

85. Ibid.

86. Ibid. Complaints were given, for example, that in all his tours and traveling, no one ever heard him practice.

87. Incidentally, Cherubini would later be observed to have a small organ of *acquisition*, which protected him from a temptation to prostitute his music to commercialism. Place, *Essai sur la composition musicale*, 24.

88. Théodore Poupin, *Esquisses phrénologiques et physiognomoniques des contemporains les plus célèbres, selon les systèmes de Gall, Spurzheim, Lavater, etc.* (Paris: Librairie médicale de Trinquart, 1836), 190.

89. Heine, in Hannu Salmi, "Viral Virtuosity and the Itineraries of Celebrity Culture," in *Travelling Notions of Culture in Early Nineteenth-Century Europe*, eds. H. Salmi, A. Nivala, and J. Sarjala (New York: Routledge, 2016), 5, accessed February 6, 2020, https://www.researchgate.net/publication/296596933.

90. Paul Metzner, *Crescendo of the Virtuoso* (Berkeley: University of California Press, 1998), 134.

91. See Zdenek Výborný, "The Real Paganini," *Music & Letters* 42, no. 4 (October 1961): 348–63.

92. Julius Schottky, *Paganinis Leben und Treiben* (Prague: J. G. Calve, 1830), translated in Pulver, *Paganini*, 165.

REPRESENTING CELEBRITY

4

"TO PERDITION"

Politicians, Players, and the Press

ANNA SENKIW

In early February 1785, two stories were repeatedly mentioned in the London newspapers: William Pitt the Younger's complaints against Edmund Burke's "prolixity" (and Burke's rebuttals), and Sarah Siddons's poor delivery of an epilogue on January 31, followed by her celebrated London debut as Lady Macbeth a few days later. These stories might not appear particularly noteworthy, but the attention given to them in the press, which raged for several days, evinces the "cult of personalities" that emerged in the second half of the eighteenth century. Amidst the press furor, S. W. Fores published *The Orators [sic] Journey* (February 7, 1785), a timely graphic satire that brought together both scandals. It registers many of the contemporary preoccupations with oratorical performances, the similitude between theater and politics, and cultural anxieties about popular support. The surface message of *The Orators Journey* is not difficult to read: actress Siddons sits in between politicians Charles James Fox (left) and Edmund Burke (right) as they gallop away from Popularity and head toward Perdition. To read this print in more detail, however, I suggest that we must better understand the news culture in which it was produced. Using *The Orators Journey* as a touchstone, I will explore the relationship between newspapers, graphic satire, and celebrity, and the emergence of politicians and players as "media stars."

The evolution of celebrity culture in Britain is entwined with the rise of the newspaper, and in particular the increasing focus on "personalities" in the press over the eighteenth century. The print media context of celebrity in Britain differs from that of France, where newspapers remained subject to censorship and the first daily newspaper did not appear until 1777, seventy-five years after the first daily appeared in Britain.[1] Despite the newspapers' centrality to mediating "personalities" to the public, as Gabriel Wick discusses in the French case in this volume, they have often been understood, as in Chris Rojek's *Celebrity*, as simply a precursor to modern mass media.[2] More recently, however, scholars have begun to explore eighteenth-century news media and celebrity on their own terms.[3] This departs from a previous trend in eighteenth-century Celebrity Studies that attended more to excavating individual celebrity narratives and identifying their particular strategies for success.[4]

Though this earlier work informs mine, my central concern here is the role newspapers and graphic satires played in circulating stories, presenting public figures, and recovering the diurnal experience of celebrity—that is, attending to transitory forms that are only briefly current and have been saved more by accident than by design, rather than to more substantial forms like memoirs or portraits, which are intended to be preserved for posterity. Useful here is Antoine Lilti's critique of publicity and the public sphere in which he argues that "the public is defined not by rational arguments, but by sharing the same curiosity and the same beliefs, by being interested in the same things at the same time and by being aware of this simultaneity."[5] These shared sources of information, such as newspapers, have the power to create celebrities through a kind of public interest echo chamber: repeated motifs about particular individuals create their public persona. So too, Lilti points out "newspaper readers are rarely immunised against collective infatuation."[6] In terms of parliamentary reporting, then, facts become less important than the ideas that gain traction and are most circulated to a wider audience through newspapers. The constraint of such reporting lies not in what actually happened, but in what readers could believe did happen. This is not limited to political celebrity, but could apply to any public figure whose life is relayed in the press.

Depictions in prints and graphic satire are often highlighted as being an important sign of celebrity. Indeed, a print could enter an individual's private home, increasing the intimacy they could feel toward the featured celebrity. However, nuanced readings of prints in terms of celebrity and the news culture in which they participated are currently lacking. In what follows, I propose a detailed and multi-layered reading of *The Orators Journey*, extrapolating its different meanings and considering who could have read this print and how. It is only with such an approach that we can fully appreciate the role of prints and satire in the rise of celebrity. Before turning to assess *The Orators Journey*, what follows briefly sets out the overlap between theater and politics in newspapers and graphic satires.

Representing Political and Theatrical Stages

In 1793, Burke wrote, "it is very unlucky . . . that the reputation of a speaker in the House of Commons depends far less on what he says than on the account of it in the newspapers."[7] What appeared in print, of course, could never precisely replicate the original speech; truncated reports, misquotations, and misattributions—sometimes accidental and sometimes suspect—were commonplace.[8] Newspapers mediated parliamentary speeches in ways that vex simple classification as true or false. Moreover, as Christopher Reid explains, the tone and context of speeches were altered in that not only were they now "recorded" but also they were "reconstructed and textualized."[9] As we shall see, graphic satires worked in a similar way.

Despite his complaint, Burke played up to the newspaper exposure during his parliamentary career. Though he also published versions of his speeches, which speaks to his desire to "control" his message more substantially, he designed his parliamentary addresses knowing that they would be mediated in the press.[10] Burke's "print performances," a concept that could be readily applied to other written accounts of celebrity in this volume, were more important than the spoken delivery of speeches in the Commons, particularly because they were reproduced in the newspapers. For the reading public, at least, the newspapers were the stage on which his oratorical theatrics were really performed. Burke was not the only one

whose speeches were reported in the press. Consistent parliamentary reporting resulted in widespread shifts in the tone and purpose of parliamentary addresses, with politicians, including Fox and Richard Brinsley Sheridan playing both to their live audience and to indeterminable readers.[11] What was said in the Commons—and how—was no longer limited to a small group of spectators, although print could only mildly capture politicians' performances.

The evolution of parliamentary speeches and of their recording in the press did more than change the kinds of speech delivered, it also changed the way in which politicians were represented. Satirists were increasingly drawing together the theatrical and the political in order to critique and condemn both the spectacle of politics and the potentially powerful cultural authority wielded by theatrical stars.[12] The frequent deployment of politician-as-player in satires can be traced to newspapers that made media stars out of politicians. Graphic satires in particular rehearsed this topos frequently, invoking a range of theatrical spaces, themes, and references (often without specific depictions of actual players at all).[13] The satirical print tradition that mixed politics and theater continued long into the 1790s and 1800s. The repetition of the comparison between the two arenas does not lessen the comparison's power, but rather evinces the intensity of anxiety about authority, hierarchy, and public voice that pervaded public discourse. Strictly speaking, however, neither politics nor theater is the "theme" of *The Orators Journey*. Its currency is the well-knownness of Fox, Burke, and Siddons, playing on the politics-as-theater trope to make a joke at their expense. It also was a timely response to the news, and spoke to the ways in which the media staged public life and renegotiated the public's relationship to power at the end of the eighteenth century.

It is not unrelated, though it is largely overlooked in the history of political reporting, that pioneers of the field such as William Woodfall were also keen theatergoers. By the early 1770s, Woodfall introduced theatrical news and reviews as regular features of his paper, the *Morning Chronicle*. At the same time, rival newspaper editor Henry Bate, editor of the *Morning Post* and friend of actor David Garrick, introduced gossip to the newspapers, feeding readers' insatiable interest in the personal lives of public figures.[14] Together with the newfound interest in theatricals, a nascent "cult

of personalities" emerged that enabled both politicians and players to become stars—and the newspapers became their shared stage.

Parliamentary gossip and theatrical gossip were not confined to specific newspaper sections; rumors, references, and allusions to politicians and players appeared alongside each other in paragraphs throughout the papers. It was not simply satirical shorthand to collapse the worlds of politics and theater, but such elision mirrored the experience of reading the papers. The effect of this was to blur the social roles politicians and players played—as "public figures" their lives were similarly followed, consumed, and discussed. These parallels are important; the rise of the newspaper over the eighteenth century facilitated the emergence of a new celebrity culture in which all kinds of public figures could attract attention. It has not gone unnoticed that celebrity appeared as the power of kings and religions waned.[15] The celebrity, argues Joseph Roach, wields a kind of "secular magic," but attention to that wielding has derailed attention from the awestruck spectators—the people whose icons changed from kings to tragic queens. Their roles as readers, viewers, and consumers of celebrity requires further investigation. In order to do this investigation, we must first have a sense of who these people were.

Reading The Orators Journey

Who could read The Orators Journey, who was it for, and who understood both its general cultural idiom and its topical concerns? The satire directly addresses this issue of "Popularity," a low-regarded term at the time, and numerous contemporary works register concerns about the "People." An explicit attack is made on the people in another graphic satire, The Pit Door. La Porte du Parterre (1784), published the year before, in which a crowd throngs into the theater to see Siddons perform.[16] This image identifies the masses as a threat—with a popular actress as the cause. For politicians and players alike, the idea of popular support is charged with political overtones, but it is also foundational for celebrity status. The popular is at once suspect and celebrated as the "voice of the people."

Does The Orators Journey mock Fox, Burke, and Siddons for their recent bad press (and thus loss of popularity) or does

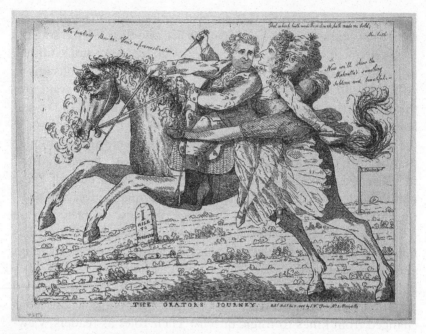

Figure 4.1. Anon., *The Orators Journey* (1785), engraving on paper. The
Library of Congress, Washington DC.

popularity necessarily lead to "Perdition"? This question is central
to recent critical debate in the study of graphic satires: were they,
as Heather McPherson argues, "a powerful *vox* and *imago populi*
that challenged aesthetic and social hierarchies and moulded popular
opinions?";[17] or, as Eirwen E. C Nicholson contends, were they a
"Westminster-oriented, licensed" form, and thus less radical than
McPherson suggests?[18] Perhaps both, as by the 1780s, Diana Donald
argues, there had been a shift from an "emblematic" iconography
used in the earlier satiric prints, for example those commissioned by
John Wilkes and his followers in the 1760s, that was accessible to
a wide audience to satires encoded with contemporary references,
which addressed a more exclusive audience familiar with the news.[19]

 The Orators Journey employs conventional imagery that would
have been recognizable to those familiar with the form: Fox's
thick eyebrows, and unshaven and dissolute appearance; Burke's
large round glasses, thin features, and turban-like headdress; and

Siddons's harsh appearance, long nose, and the accouterments of tragedy, the dagger and the bowl. Likewise, the reference to Burke's *A Philosophical Enquiry* (1757) is a recurrent textual feature in satires on Burke.[20] The use of these shorthands at once denotes the subjects' high profiles and clearly positions *The Orators Journey* in dialogue with other graphic satires. McPherson and Shearer West both contextualize *The Orators Journey* within a larger body of Siddonian representations, and their readings inform mine.[21] My interest here lies, however, in the satire's immediate potency and intervention in a particular news cycle, rather than in its participation in a wider artistic movement.

Many of the subtle textual references in *The Orators Journey* do not speak to the common man, but rather imply the expectation of a discerning viewer able to read its cues and recognize the rhetorical tricks employed.[22] Though some of these cues could be picked up on by those familiar with the graphic satire form alone, many more would have been legible only to those versed in the current news cycle. If newspaper culture was necessary to reading *The Orators Journey*, then this print may have been illegible to many people. Donald neatly sums up the change this represented: "if the satirical performers of the 1760s played to the gallery, those of the 1780s certainly had the stalls and the boxes in view."[23]

Though it is tempting to see graphic satire as a socially transgressive mouthpiece for the "public," a result of its lampooning of political leaders, this is frustrated by the difficulty in determining who the public(s) was. Nicholson persuasively debunks the widely held assumption that satire was a mass or popular form; she cites the prohibitive prices, low circulation figures, loaded iconography, and verbal cues that "presuppose up-to-date knowledge" as evidence for a far smaller market than generally suggested. So too, David Francis Taylor proposes that the "literariness" of many graphic satires suggests a readership familiar with both drama and prose texts.[24] Whilst it is beyond the scope of this essay to answer Nicholson's call for a "more secure identification" of the graphic print audience, I do contend that to understand fully *The Orators Journey*'s loaded visual and verbal cues, familiarity with newspaper culture was necessary.[25] I make no claims, of course, that any individual would have had access to all the newspaper

coverage available—but some awareness of that coverage would have been vital.

Nonetheless, the constitution of the newspaper-reading public remains a vexed question. Sales figures (where we have them) cannot account for all those who had access to newspapers,[26] and Jeremy Black has shown how one single newspaper could reach multiple readers and listeners if it was read aloud.[27] Though we therefore cannot hope to delineate exactly who had access to periodicals, the newspaper-reading populace was likely from a cross-section of society in terms of wealth, status, and class. The expansion of periodical culture at once created and reflected an enlarged extra-parliamentary reading public that was politically, socially, and culturally engaged, if not legally enfranchised.[28] We should be careful not to overstate—or mistake—the idea of a common readership, or to elide the "popular" or "common," with the notion of that extra-parliamentary audience. The newspaper, and its sister form, the graphic satire, certainly opened up the space for broader engagement with politics and culture than was hitherto possible.

The "cult of personalities" that emerged in the 1770s meant that the newspapers devoted more space to both parliamentary and theatrical "intelligence." It gave public figures greater exposure, but they had to manage the vicissitudes of public opinion and, whether theatrical or political stars, they developed similar strategies for holding sway with a socially invested public, as even the most celebrated figures could suddenly find themselves heading toward perdition. Public praise brought about public censure, but successful public figures recognized that the media had to be engaged with in order to secure popular approval. In terms of celebrity, facts become less important than the ideas that gain traction do, and are most circulated to a wider audience through the media. To be satirized either in graphic satires or in the press might have suggested a reduction in terms of the public's "liking" of a particular person, but that need not be detrimental to their celebrity; after all, public interest in details about the private lives of unsavory characters (such as criminals) could be just as intense as such interest in the life of an adored actress.

To be well-known enough to warrant caricature might even be considered a mark of success—and it could even lead to increased

public support. Bad press therefore was not necessarily the end of celebrity. It is worth noting that *The Orators Journey* depicts Fox, Burke, and Siddons headed on their shared steed toward "Perdition," not obscurity. As fellow travelers in this new world of media celebrity, the trio share a journey (if not a destination) through public life by navigating the same kinds of publicity. Presenting them on a horse in transit, rather than depicting them stationery, is surely done to suggest that politics and theater share a path propelled by public opinion. That they have not yet arrived at their destination perhaps offers a glimmer of hope: they might yet turn back.

A Picture Speaks A Thousand Words

Behind the visual features of *The Orators Journey* are several news stories that circulated in the weeks preceding its publication, which transform the image from a generic attack to a specific satire. The print invokes the defeat of Fox's India Bill in December 1783, the fall of the Fox-North coalition government, and the Whig Party's subsequent failure to win the General Election in 1784. Underscoring these political storms, during which time the leading Whig players were increasingly renowned for their public speaking, Siddons enjoyed unprecedented success following her celebrated reappearance in London in October 1782, which the press called "Siddonsmania"—a vexed term that does not quite celebrate her, but rather critiques the audience's hysterical responses, ultimately undermining her unprecedented success as the result of a kind of cultural madness. But to read *The Orators Journey* only as a vague response to larger political events and cultural anxieties crucially ignores its role in responding to and reflecting current affairs. Two major themes are suggested in the captions: "No prolixity Burke. Here's no procrastination" registers the long-standing joke (or complaint) about Burke's extensive oratory, whilst "Mahrattas" signals Burke's preoccupation with Warren Hastings, the former Governor-General of India. The Mahrattas (or Marathas) were the ruling Indian caste, who had fought the East India Company (headed by Hastings) during the first Anglo-Maratha war, which had concluded in 1782. *The Orators Journey* is strikingly prescient; Burke, Fox, and Sheridan's oratorical performances were to become

a cornerstone in the subsequent impeachment trial against Hastings from 1788 to 1795 and also in British responses to the French Revolution, both of which would become regular subjects for graphic satire.[29]

The Orators Journey engages with speech, which it cannot quite capture, nor does it attempt to; speech bubbles, for instance, are absent. David Bindman suggests that speech bubbles usually are associated with "demotic" figures, such as John Bull, used in popular imagery."[30] The choice not to include them has greater resonance here because the figures' spoken lines float near them— their words literally and figuratively get away from them (Burke's positioned behind his head).

But if it is not trying to show oratory, then what is it trying to do? Focusing on the work of James Sayers and James Gillray, Taylor argues that they "are reimagining the verbal as visual; they use a metaphoric of optics to think through an oratorical event."[31] I think, as Taylor suggests with optics, that *The Orators Journey* is an attempt to draw attention to representation and mediation, an exaggeration of the truncated speeches in the newspapers to show orators reduced to fragments of their speeches. They are not exactly "speaking" because they do not need to. The brevity of the text and the casual association between the figures and their texts suggests viewers already closely associated each character with these verbal cues. There is an obvious parallel here with the visual shorthands employed by artists to caricature public figures, but there is also a connection with parliamentary reporting and theatrical reviews, in which news writers used specific expressions to conjure particular figures. For example, Fox was known as the "Man of the People," which conveyed his propensity for popular politics, and Siddons's austere command of the stage was invoked through the epithet "The Siddons," or adjectives such as "inimitable," which was frequently deployed in the press coverage around her. To understand the verbal cues in *The Orators Journey*, we must now turn to the newspapers of February 1785.

In a Commons debate on February 2, Burke tried to interrupt the day's proceedings by requesting a reading of the parliamentary journals from May 3, 1782, which related to India, to which William Pitt demanded to know how long it would take and attacked

his rival's verbosity.[32] Burke disputed the charge of prolixity (at length) and somewhat dismissively claimed that he could not possibly know how long it would take. Burke was eventually allowed the reading, but not before the two traded insults. Burke sought public support for a proper investigation about potential mismanagement in India, and Pitt desired to present Burke as a time-waster, who stalled the more pressing concerns of Parliament. Pitt and Burke, both aware of the potential audience for their speeches, played to the (invisible) crowd. If public notice had been their aim, then they were rewarded. The newspapers bombastically reported Pitt's charge against Burke's tedious speech, and Burke's subsequent replies. As suggested above, there are discrepancies between the newspapers' reports as speech reportage was neither a precise art nor an unmediated form of publication.

On February 4, perhaps buoyed by the positive reaction to him (or at least the mirth at the joke against Burke) in the press, Pitt renewed his attack on Burke for time-wasting during a debate on the investigation (or, "scrutiny") into the 1784 Westminster election, in which Fox was absent.[33] Loren Reid neatly sums up the prolonged case: "The Westminster Election lasted forty days. But the scrutiny that followed lasted forty weeks."[34] The ongoing investigation undermined the House, so it was no surprise that prolixity became a topic of conversation, as both sides looked to blame each other. Burke spoke to defend Fox (who was injured) and blamed Pitt for the delay, intimating that Pitt disliked prolixity, except when it came to the scrutiny. The following week, "prolixity" was still in the news, with the *Morning Post* mocking Pitt's predilection for the word: "the more he thinks on the words *prolixity*, the more he raves: His doctor says, that it is impossible for even time to cure him, for the malady increases hourly—in his sleep, and at his meals, he raves out *prolixity, prolixity*, d——d, confounded, abominable *prolixity!*"[35]

So whilst McPherson and Robinson are not wrong to read "No prolixity" as a reference to Pitt's previous censure of Burke's oratory on July 30, 1784, it is remiss not to attend to the more recent exchanges, because it was those that filled the papers when *The Orators Journey* was published.[36] Robinson does alert us to Thomas Rowlandson's *The Fall of Achilles*, published January 7,

1785, in which Pitt (with bow and arrow) attacks Lord North, Fox, and Burke.[37] Burke's speech bubble reads, "Before thy Arrows Pitt, I fly / I D—n that word *prolexity* [sic]," which Robinson attributes to an exchange between Burke and Pitt in July 1784.[38] Though Robinson does not explicitly mention it, presumably we are meant to think that the reference to prolixity in *The Orators Journey* similarly invokes Pitt's earlier comment. But I remain skeptical that a debate from several months previous would have so much currency as McPherson and Robinson maintain. Rather, the renewed attention to "prolixity" in early January created a kind of snowballing effect in the media.

I do not assume a simple relationship whereby graphic satirists produced visual summaries of parliamentary news reports, but something far more interactive. For example, the renewed charge of prolixity in the House came days after political commentator "The Scrutineer," contributor to the *Morning Post*, attacked Fox and his supporters for delaying the scrutiny process, specifically using the word "prolixity." This may be coincidental, but as Reid points out, "debates were often initiated by items members had read in the morning's newspapers."[39] It is not inconceivable that Pitt or Burke read the "The Scrutineer" commentaries on January 27 and 31; so too we might speculate that "The Scrutineer" saw Rowlandson's print, which mentioned "prolixity" in the first place. Whilst we cannot plot every reference and trace the origins of every story, we can be more mindful about the traffic between media (both verbal and visual), and its role in both reflecting and creating news. By not attending to the proliferation of the word "prolixity"—in prints, in Parliament, and in the papers—McPherson and Robinson do not fully showcase the dynamic "media storm" in which *The Orators Journey* participated.

Next, let us consider the verbal cue next to Siddons, "That which hath made them drunk, hath made them bold," lines spoken by Lady Macbeth in the opening of the famous "dagger scene" (Act II Scene II) of *Macbeth*.[40] The quote emphasizes Lady Macbeth's active role in the plot to kill the king: at the close of Act I, she gave the king's chamberlains "wine and wassail"[41] in order for them to fall asleep to enable Macbeth to enter the king's bedchamber and kill him. Siddons's inclusion as the politically ambitious and

perdition-bound Lady Macbeth sharpens and heightens the anxieties surrounding politics during this period.

Macbeth was frequently used in graphic satires during the last decades of the eighteenth century.[42] After all, the monarchical system in *Macbeth* is not primogeniture, but rather tanistry, in which a "succession . . . was decided by election upon the 'eldest and worthiest' among the surviving kinsmen of the deceased lord."[43] It was not only used by satirists who saw the play's off-stage potential: Burke famously invoked *Macbeth* during a speech December 28, 1792 in the House of Commons on on the threat of French invasion, during which he brandished a dagger. In a context of regency, revolution, and reform, the play resurged as a touchstone for opponents of political radicalism and monarchical tyranny alike in the context of both domestic and foreign affairs.[44]

Lady Macbeth's character (ambition, political nous, and plotting) is clearly a useful shorthand in *The Orators Journey* for damning the politics of Burke and Fox. Siddons is not depicted here, however, simply to shape our understanding of Fox and Burke—by positioning her in the middle, she is center stage.[45] Figured here as a "tragic Queen," she represents the potential for a new social order, underpinned by popularity and oratorical strategy. Whether *The Orators Journey* celebrates or condemns such radical potential is less important than the fact that the very idea could be conceptualized.

For McPherson, Siddons's presence in *The Orators Journey* "slyly insinuates that Fox and Burke, at this juncture of their unpopular pursuit of Hastings, might profitably harness the popularity and acting skills of a Siddons to their cause."[46] This is a valid reading, but Siddons's political association is more complex as she was not avowedly for any particularly party. And though several scholars remark that she was well liked by the opposition Whigs, her unprecedented success meant that people from all corners applauded her. She was also a favorite of the royal family: George III, who greatly disliked Fox in particular, privately declared himself an "enthusiast" for her to Frances Burney; Siddons held an official role as the reader to the princesses; and in 1789, she delivered Robert Merry's "Ode on the Restoration of the King," dressed as Britannia, at a special gala held in the king's honor.[47] So whilst the

part of Lady Macbeth has important political ramifications in the context of the 1780s and 1790s, we ought to be careful not to read too much into the subversive potential of Siddons.

The inclusion of Siddons as Lady Macbeth in *The Orators Journey* is not simply a vague political metaphor, but there was a commercial benefit to her inclusion too. On February 2, 1785, Siddons appeared as Lady Macbeth for the first time in London, with Fox, Sheridan, and Joshua Reynolds reportedly in attendance.[48] Her performance was much praised; the *Gazetteer* (February 3) described it as one of her "noblest achievements" and the *London Chronicle* (February 3–5) called it her "*chef [d'œuvre]*." The *Chronicle*, as well as the *Public Advertiser* (February 3), also suggested that she achieved something in the role hitherto not achieved by previous actresses in the part. Such praise contributed to mythmaking about Siddons and Lady Macbeth (subsequently reinforced by her own remarks on the character) that would see the Siddonian style of Lady Macbeth dominate conceptions of the part well into the nineteenth century.[49] It became a stalwart of her repertoire and it was the part she played for her final performance before retiring in 1812. The "dagger scene" in particular became a repeated motif in depictions of Siddons. For instance, Thomas Beach chose it the following year for the first portrait of her as Lady Macbeth.[50] That *The Orators Journey* presented this depiction first speaks to the immediacy of the graphic satire genre, which, like newspapers and unlike formal portraits, could respond promptly to current events—perhaps this print even helped to secure Siddons's subsequent identification with this particular scene.

When *The Orators Journey* was published, of course, Lady Macbeth was just Siddons's most recent part, another triumph that reinforced her identification as leading tragedienne of the age. Her early success could be said to have obscured her celebrity behind a veneer that was her "Queen of Tragedy" persona. Her association with particular parts helped to create an unrivaled Siddonian brand that inspired "idolatrous" responses and created a myth that largely withstood her aging body, until it became impossible to ignore.[51] The myth has endured; received wisdom tells us that Siddons enjoyed unprecedented success over a thirty-year career, but the reality was that her popularity ebbed and flowed.

The *Macbeth* line distracts from another story about Siddons's performance, one much more closely aligned with oratory, that also played out in the press that week. On January 31, she spoke an epilogue, written by George Colman the Younger, to her brother John Philip Kemble's *The Maid of Honour* (1785). Epilogues were traditionally important for gauging audience reactions (hisses to condemn; claps for repeat performances). Since the Restoration, predominantly actresses had performed epilogues. Siddons's contemporaries Frances Abington and Elizabeth Farren were regular epilogue speakers due to their flirtatious rapport with audiences. Siddons only infrequently spoke them, perhaps only doing so on January 31 as it was for her brother's play. The epilogue was universally panned, and though some newspapers suggested it might have been Colman's fault, the majority felt it was due to Siddons's poor delivery. The *Public Advertiser* (February 1) noted that "to polish merriment and elegant familiarity, she cannot tune her voice, or adapt her motions"—both prerequisites for good epilogue delivery—whilst the *Morning Post* (February 2) went as far as to claim that "the Epilogue has blown up the *Siddonian junto*." The *Morning Post* (February 8) also used the epilogue to criticize aspects of her acting style more generally: "The manner in which an eminent Actress spoke the *vapid* Epilogue of Mr. Colman . . . proves that her declamation is *mechanical*, and that her boasted *feeling* is all the result of *practised art*."

Even Siddons's performance as Lady Macbeth was not left untouched by the reviewer in the *Morning Post* (February 3), who claimed that her banquet scene performance was "too much of the *familiar* manner, approaching to the *comic*; this may be called her *epilogue* style, in which she has already experienced an entire failure." Not only had the epilogue been poorly received, but also epilogues required a flirtatious rapport with the audience, which undermined Siddons's affecting tragic style and regal persona. There are parallels here to be drawn with the French monarchy's decline as Marie-Antoinette's fashionable status rose.[52] The great possibility engendered by celebrity (that anyone can be one) is also its great flaw—the sense that there is a person behind the Queen of Tragedy (or the Queen of France) has a remarkably leveling effect. The *Morning Post*'s attack also speaks to another crucial factor in

the relationship between celebrity behavior and its representation in the press: Siddons's actual performance was likely seen by fewer people than had access to the newspaper. Whether or not Siddons revealed herself in her performance through a "familiar manner" is less important than the fact that the *Morning Post* unmasked her.

The silence in *The Orators Journey* regarding this epilogue speaks volumes. For the next month, the newspapers frequently recalled it, whilst also praising Siddons's performance of Lady Macbeth, evincing the mercurial nature of popularity. Although McPherson does note Siddons's clash with the press a few months previous (in which Siddons's avarice was condemned), she does not acknowledge the more recent criticisms.[53] Given Siddons's failure to deliver the epilogue successfully, something newspaper readers would have been aware of, we might want to rethink or complicate McPherson's assertion that *The Orators Journey* expresses anxiety that the Whigs might "profitably harness" her.[54] McPherson perhaps misses part of the joke: Siddons, for all her success, was no orator. This is the heart of *The Orators Journey*'s satire. Hardly an "orator" comparable to Burke, Siddons and her unpopular voice point to the real concern here, not politicians harnessing her powers, but the fact that the politicians were potentially better actors than her. Indeed, Pitt's attempts to silence Burke, to distract and detract from his speech, were predicated on his wariness of Burke's oratorical skills.

It is surely significant that Burke and Fox are neither transfigured into a theatrical space nor reimagined as themselves (a typical device to send up politicians) in *The Orators Journey*. In fact, theatricality is signaled only by Siddons's presence, with Burke and Fox featured alongside her, as themselves, so as to draw attention to the similitude between politicians and players. In the print's subtlety lies its strength: rather than a bombastic caricature of political theatrics, it implies perhaps a more insidious theatricality at the heart of political strategy. Using Siddons indicates that this is not merely an attack on Whig politicians. There were, after all, highly visible Whig women, such as Georgiana Cavendish, Duchess of Devonshire, who were politically active (she openly canvassed for Fox during the 1784 Westminster election, for example) and would have been more useful if the satire had been intended primarily as

an attack on opposition Whigs, as Cavendish had been in the aftermath of the election. But though topical, and undeniably traceable to the news of the first week of February 1785, Siddons's inclusion also registers anxieties about the popular voice of the people, upon whom all kinds of success (including political and theatrical) relied. Siddons was emblematic of the kinds of success that could be achieved on merit and popularity—her presence in *The Orators Journey* therefore was not a satire on either the political or the theatrical, but rather on what newly underpinned success: popularity.

For parliamentary figures to be flanked by a (theater) queen reinforces the idea that power dynamics were in flux. By coupling Burke and Fox with Siddons as Lady Macbeth, the artist makes manifest specific concerns about political ambition that would have been unavailable if another well-known female figure (such as Cavendish) had been featured. Siddons's failure to inspire using her rhetoric skills in an epilogue is counterpointed by Lady Macbeth's powers of persuasion, which lead to her husband's downfall. *The Orators Journey* invokes all of these debates about Siddons; her presence as an orator akin to Burke and Fox as an obvious joke, and its allusion to Lady Macbeth, place it in the midst of contemporary culture. For the satirist, Siddons's successful portrayal of Lady Macbeth added further dimensions to the topical concerns of oratory and popularity: ambition, speeches, and pretense. Persuasion, people playing parts, and the fickleness of popularity are all juxtaposed in this nuanced satire—that at first appears to be a cheap gag with three public figures lumbering on a horse.

Political Hobbyhorses

The fourth character in *The Orators Journey*, the horse, merits attention too. Horses, or even individuals being ridden as if horses, are not an uncommon feature in graphic satires of the 1780s. However, their usage here differs from the reference to political "horse races." The horse might here represent the press, carrying along the three media stars, or even public opinion, which might at first offer "popularity" but swiftly shifts to "perdition." There is one absent figure who might be considered the horse: fellow Whig politician and Drury Lane manager Richard Brinsley Sheridan. His oratory

was as renowned as the Fox, Burke, and Siddons's, and his absence here is somewhat unexplained. It is he who materially connects the trio, and whom we might be tempted to view as the "horse" driving both the theatrics of the Rockingham Whigs and the politics of Drury Lane. Though, of course, a tongue-in-cheek reading, it remains that Sheridan's theatrical and political work nevertheless made him a key player in shaping popular opinion. After all, in celebrity terms, at least, success is often achieved on the backs of (anonymous) others.

Just over a week after *The Orators Journey* was published, the following appeared in the *Public Advertiser* (February 18, 1785): "It seems now to be agreed, that our great orators are to have leave in future to ride their several *hobby horses*. Mr. Fox is never to rise without lugging in the scrutiny, nor Mr. Burke without mentioning *Indian Affairs*." Perhaps the writer had *The Orators Journey* in mind when writing this, or the artist made a visual pun in light of a preexisting joke about Whig oratorical hobbyhorses. The previous year, on May 1, 1784, Thomas Rowlandson published *Every Man Has His Hobby-Horse*, which depicts Fox riding the Duchess of Devonshire.[55] In either case, this illustrates the interaction between visual and verbal forms, and how meaning is shaped intertextually. It also demonstrates the methodological problems with trying to map this interaction—a short reference to a horse, for instance, might easily be missed.

What, then, might be Siddons's "hobbyhorse"? Though free from the kinds of sexual scandal leveled at her contemporaries (and other notable women such as the Duchess of Devonshire and Marie-Antoinette), Siddons was attacked for her unrelenting work schedule and the resulting perception of her avarice. Her hobbyhorse could then be her apparently insatiable desire for money, for which she needed to achieve and maintain popularity, further evidence of the misogyny directed toward successful professional women like her. The suggestion that Siddons's unprecedented level of success, particularly seen in a saturation of puff in the papers, risked her popularity, was repeated in many press reports.[56]

Conclusion

I have made a case here for reading graphic satires not only alongside each other, but also as part of a wider news culture. The impetus behind this is the need to reorient Celebrity Studies away from retrospective accounts of famous people, such as the memoir. I use the ambiguous term "famous people" here to emphasize the idea that whilst newspapers and graphic satires are (supposedly) ephemeral forms that create the "celebrity," memoirs are often revisionist texts that seek to secure posthumous fame. A helpful guide is Lilti's sense that the celebrity is "of the moment," and therefore my interest lies in contemporaneous texts, images, and stories that circulated about people the public found fascinating.[57] It is this distinction that enables individuals to achieve different kinds of celebrity at different points in time.

Siddons's Lady Macbeth took on new resonances in the decade following her first performance of the role. The particular association between Siddons, Marie-Antoinette, and the performance of queens has been richly explored in scholarship, largely due to Burke's fascination with the theater of revolution, explored in his *Reflections on the Revolution in France* (1790). Christopher Reid makes the case that Siddons's acting served as a model for Burke's picture of female suffering, though work by David Worrall cautions, "many of Siddons' [sic] roles do not readily equate with Marie Antoinette's predicament."[58] In turn, Judith Pascoe and Sarah Burdett persuasively argue that Marie-Antoinette served as an apposite source for Siddons's post-Revolutionary portrayals of queens, particularly Hermione in *The Winter's Tale* and Lady Macbeth.[59]

Undeniably, Marie-Antoinette's influence on manners, fashion, and publicity was far-reaching and the circumstances of her imprisonment and death still more so. The enduring power of Siddons's Lady Macbeth, for example, speaks much to the role's display of the murderous tendencies of despotic power. Most salient for my purposes here is Pascoe and Burdett's discussion of Siddons's sartorial choices, particularly her use of a veil as a prop, which recalled Marie-Antoinette.[60] It is fashion, perhaps more so than the play's themes themselves, that act as a cue to conjure the dead queen. I suggest that this is a testament both to the centrality of fashion to

female celebrity and to the ways that celebrity might inflect political discourse.

Burke's appropriation of both Siddons and Marie-Antoinette in his *Reflections*, in order to illustrate his response to the theater of revolution, makes manifest the ways in which the identities of female public figures could be used to bolster real political power. In this way, we might say (as McPherson suggests) that Siddons is kind of "carried off," somewhat unwillingly, by Burke. If so, *The Orators Journey* anticipates Burke's use of her for his own political drama and of her affective powers for his (and Fox's) oratorical verve. Yet, that Siddons too inflected her performances with political dimensions (as her appearance as Britannia attests) complicates any simple reading that sees Siddons as a pawn in a wider Whig game.

Whilst I contend that politicians like Burke and Fox can be celebrities like Siddons, because they received similar kinds of notice in the press, I do not conflate different kinds of fame.[61] That Burke is still referenced in the House of Commons (not always accurately) during debates speaks to the longevity of his work as a politician. This is not, however, celebrity, but another kind of fame (one he was working toward perhaps through his publication of speeches). Yet, during the height of his political career, he was discussed in the press alongside gossip about others; for a newspaper reader, following the lives of a Burke or a Siddons was similar reading experience. I have shown that the newspapers were essential to the creation of "media stars" in the political and theatrical worlds, and played an important role not only in creating celebrities, but also in underpinning the celebrity structure itself that helped to transform the public's relationship to power and usher in a new democratic world.

Notes

1. Antoine Lilti, *The Invention of Celebrity*, trans. Lynn Jeffress (Cambridge: Polity, 2017), 68.

2. Chris Rojek, *Celebrity* (London: Reaktion Press, 2001), 13 and 103–6.

3. See Brian Cowan, "News, Biography, and Eighteenth-Century Celebrity," in *Oxford Handbooks Online* (Oxford University Press, 2016), 10.1093/oxfordhb/9780199935338.013.132; Lilti, *The Invention*; Stuart Sherman, "Garrick among Media: The 'Now Performer' Navigates the News," *PMLA* 126, no. 4 (October 2011), accessed February 6, 2020, http://ezproxy-prd.bodleian.ox.ac.uk:2084/stable/41414170; Gillian Russell and Daniel

O'Quinn, eds., "Georgian Theatre in an Information Age: Media, Performance, Sociability," special issue, *Eighteenth-Century Fiction* 27, no. 3–4 (Spring–Summer 2015).

4. Eighteenth-century players have been the subject of much discussion in particular, see Helen Brooks, *Actresses, Gender, and the Eighteenth-Century Stage: Playing Women* (Basingstoke, UK: Palgrave Macmillan, 2015); Laura Engel, *Fashioning Celebrity: Eighteenth-Century British Actresses and Strategies for Image Making* (Columbus: Ohio State University Press, 2011); Julia Fawcett, *Spectacular Disappearances: Celebrity and Privacy, 1696–1801* (Ann Arbor: University of Michigan Press, 2016); Felicity Nussbaum, *Rival Queens: Actresses, Performance, and the Eighteenth-Century British Theater* (Philadelphia: University of Pennsylvania Press, 2010); Joseph Roach, *It* (Ann Arbor: University of Michigan Press, 2007).

5. Lilti, *The Invention*, 9.

6. Ibid., 184.

7. Edmund Burke, *Epistolary Correspondence of Burke and Dr. French Laurence* (London: Printed for C. and J. Rivington, n.d.), 152, quoted in Arthur Aspinall, *Politics and the Press, c.1750–1850* (London: Home & Van Thal, [1949]), 243 n3; Edmund Burke, *The Correspondence of Edmund Burke*, eds. T. W Copeland, et al., vol. 9 (Cambridge and Chicago: Cambridge University Press and University of Chicago Press, 1970), 284, quoted in Christopher Reid, "Whose Parliament? Political Oratory and Print Culture in the Later 18th Century," *Language and Literature* 9, no. 2 (May 2000): 122, accessed February 13, 2020, DOI: 10.1177/096394700000900202.

8. Aspinall, *Politics and the Press, c.1750–1850*, 238–49; Reid, "Whose Parliament?"; David Francis Taylor, "Byron, Sheridan, and the Afterlife of Eloquence," *The Review of English Studies* 65, no. 270 (2014): 481. DOI: 10.1093/res/hgt091.

9. Reid, "Whose Parliament?," 126.

10. Ian Harris, "Publishing Parliamentary Oratory: The Case of Edmund Burke," *Parliamentary History* 26, no. 1 (February 2007), accessed February 12, 2020, DOI: 10.1111/j.1750-0206.2007.tb00632.x.

11. Reid, "Whose Parliament?"; David Francis Taylor, "Byron, Sheridan, and the Afterlife of Eloquence," *The Review of English Studies* 65, no. 270 (June 2014): 481, accessed February 12, 2020, DOI: 10.1093/res/hgt091.

12. Heather McPherson, *Art and Celebrity in the Age of Reynolds and Siddons* (University Park, PA: Penn State University Press, 2017), 131–33; Heather McPherson, "Painting, Politics and the Stage in the Age of Caricature," in *Notorious Muse: The Actress in British Art and Culture, 1776–1812*, ed. Robyn Asleson (New Haven, CT: The Paul Mellon Centre for Studies in British Art and the Yale Center for British Art by Yale University Press, 2003), 172. The crossover between theater and politics has been the subject of much study, see Daniel O'Quinn, *Staging Governance: Theatrical Imperialism in London, 1770–1800* (Baltimore: Johns Hopkins University Press, 2005); David Francis Taylor, *Theatres of Opposition: Empire, Revolution, and Richard Brinsley Sheridan* (Oxford: Oxford University Press, 2012); Gillian Russell, *Women, Sociability, and Theatre in Georgian London* (Cambridge: Cambridge University Press,

2007); *The Theatres of War: Performance, Politics, and Society, 1793–1815* (Oxford: Clarendon Press, 1995).

13. British Museum (BM) Satires 6636, *The Dancing Dogs, As Performed at Sadler's Wells with Universal Applause,* 1784; BM Satires 6994, *Employment During Recess,* 1786; BM Satires 7273, *The Raree Show executed for the benefit of Mr Somebody at the Expence of John Bull,* 1788; BM Satires 7627, *Peachum and Lockit,* 1790; BM Satires 8147, *The Dagger Scene, or The Plot Discover'd,* 1792; BM Satires 8647, *The Last Scene of the Managers Farce,* 1795; BM Satires 10549, *Pacific-Overtures,-or-A Flight from St Cloud's-"Over the Water to Charley."A New Dramatic Peace Now Rehearsing,* 1806. See Frederic George Stephens and Mary Dorothy George, *Catalogue of Political and Personal Satires Preserved in the Department of Prints and Drawings in the British Museum,* 12 vols. (London: British Museum, 1870–1954). Further "BM Satires" citations refer to this catalogue.

14. Lucyle Werkmeister, *The London Daily Press, 1772–1792* (Lincoln: University of Nebraska, 1963), 21; Robert Darnton, "The True History of Fake News," *The New York Review,* February 13, 2017.

15. Roach, *It,* 1–3; Rojek, *Celebrity,* 13.

16. *The Pit Door. La Porte du Parterre,* 1784, BM Satires 6769.

17. McPherson, "Painting, Politics," 172.

18. Eirwen Nicholson, "Consumers and Spectators: The Public of the Political Print in Eighteenth-Century England," *History* 81 (January 1996). For an overview of the critical debate on radical versus conservative politics and graphic satire, see David Francis Taylor, "The Practice of Caricature in 18th Century Britain," *Literature Compass* 14, no. 5 (May 2017): 3–5, accessed February 13, 2020, DOI: 10.1111/lic3.12383.

19. Diana Donald, *The Age of Caricature: Satirical Prints in the Reign of George III* (New Haven, CT: Yale University Press, 1996), 50–66.

20. McPherson, "Painting, Politics," 167.

21. Ibid., 175–77; McPherson, *Art and Celebrity,* 142; Shearer West, "The Public and Private Roles of Sarah Siddons," in *A Passion for Performance: Sarah Siddons and Her Portraitists,* ed. Robyn Asleson (Los Angeles: J. Paul Getty Museum, 1999), 27–28.

22. Nicholson, "Consumers," 9–15.

23. Donald, *The Age of Caricature,* 66.

24. Nicholson, 14. David Francis Taylor, *The Politics of Parody: A Literary History of Caricature, 1760–1830* (New Haven, CT: Yale University Press, 2018), 3–39.

25. Nicholson, "Consumers," 21.

26. Barker, *Newspapers,* 23. For sales, circulation and readership information see ibid., 22–24; Black, *The English Press,* 105–7; Michael Harris, *London Newspapers in the Age of Walpole: A Study of The Origins of the Modern English Press* (London: Associated University Presses, 1987), 189–90.

27. Black, *The English Press,* 106–7; Brian William Cowan, *The Social Life of Coffee: The Emergence of the British Coffeehouse* (New Haven, CT: Yale University Press, 2005), 174.

28. Marilyn Butler, *Romantics, Rebels, and Reactionaries: English Literature and Its Background, 1760–1830* (Oxford: Oxford University Press, 1982), 16.

29. For graphic satire and the Hastings trial, see O'Quinn, *Staging Governance*, especially Chapter 4, "The Raree Show of Impeachment."

30. David Bindman, "Texts as Design in Gillray's Caricature," in *Icons, Texts, Iconotexts: Essays on Ekphrasis and Intermediality*, ed. Peter Wagner (Berlin: De Gruyter, 1996), 317.

31. Ibid.

32. *Morning Post and Daily Advertiser*, February 3, 1785; *Morning Chronicle and London Advertiser*, February 3, 1785; *Public Advertiser*, February 3, 1785; *Morning Herald*, February 3, 1785; *General Evening Post*, February 1–3, 1785; *London Chronicle*, February 1–3, 1785; *Whitehall Evening Post*, February 1–3, 1785.

33. *Morning Chronicle and London Advertiser*, February 5, 1785; *Gazetteer and New Daily Advertiser*, February 5, 1785; *Morning Herald*, February 5, 1785; *Morning Post and Daily Advertiser*, February 5, 1785; *General Advertiser*, February 5, 1785; *General Evening Post*, February 3–5, 1785; *London Chronicle*, February 3–5, 1785.

34. Loren Reid, *Charles James Fox: A Man for the People* (London: Longmans, 1969), 205.

35. *Morning Post*, February 7, 1785.

36. McPherson, "Painting, Politics," 176; Nicholas K. Robinson, *Edmund Burke: A Life in Caricature* (New Haven, CT: Yale University Press, 1996), 79.

37. Robinson, *Burke*, 79; *The Fall of Achilles*, 1785, BM Satires 6770.

38. Robinson, *Burke*, 201n3. Robinson draws upon M. Dorothy George's catalogue description.

39. Reid, "Whose Parliament?," 130.

40. William Shakespeare, *Macbeth*, eds. Sandra Clark and Pamela Mason (London: Bloomsbury Arden Shakespeare, 2015), 2.2.1.

41. Ibid., 1.8.65.

42. On *Macbeth* in graphic satires, see Taylor, *Politics of Parody*, 101–39.

43. "Tanistry, n." *OED Online*. January 2018. Oxford University Press, accessed February 6, 2020, http://www.oed.com/view/Entry/197523?redirecte dFrom=tanistry.

44. See John Barrell, *Imagining the King's Death: Figurative Treason, Fantasies of Regicide, 1793–96* (Oxford: Oxford University Press, 2000), 87–100.

45. See Shearer West, *The Image of the Actor: Verbal and Visual Representation in the Age of Garrick and Kemble* (New York: St. Martin's Press, 1991); Robyn Asleson, et al., *A Passion for Performance: Sarah Siddons and Her Portraitists* (Los Angeles: J. Paul Getty Museum, 1999).

46. McPherson, "Painting, Politics," 177.

47. Frances Burney, *The Court Journals and Letters of Frances Burney*, vol. 1, Oxford Scholarly Editions Online (Oxford: Oxford University Press, 2014), 353, accessed February 12, 2020, DOI:10.1093/actrade/9780199658114.book.1.

48. *Morning Chronicle and London Advertiser*, February 5, 1785; *The Times*, February 3, 1785.

49. Sophie Duncan, *Shakespeare's Women and the Fin De Siècle* (Oxford: Oxford University Press, 2016), 61–62 and 89–90; Shearer West, "Roles and Role Models: Montagu, Siddons, Lady Macbeth," in *Bluestockings Displayed*

Portraiture, Performance, and Patronage, 1730–1830, ed. Elizabeth Eger (Cambridge: Cambridge University Press, 2013), 182.

50. West, "Roles and Role Models," 178.

51. Lilti, *The Invention*, 36–39. See also Lisa Freeman, "Mourning the "Dignity of the Siddonian Form," *Eighteenth-Century Fiction* 27, no. 3 (Spring-Summer 2015): 597–629. Both Lilti and Freeman discuss William Hazlitt's "To Mrs. Siddons" essay in which he famously writes that she "was Tragedy personified."

52. Lilti, *The Invention*, 164–77.

53. McPherson, "Painting, Politics," 177.

54. Ibid.

55. *Every Man Has His Hobby-Horse*, 1784, BM Satires 6566. On May 25, 1784, Edward Shirlock published *Ride for Ride or secret influence rewarded*, in which the Duchess of Devonshires rides Fox.

56. *Parker's General Advertiser*, October 22, 1782; *Morning Herald*, January 17, 1783; *London Courant*, February 4, 1783.

57. Lilti, *The Invention*, 7.

58. Christopher Reid, "Burke's Tragic Muse: Sarah Siddons and the 'Feminization' of the Reflections," in *Burke and the French Revolution: Bicentennial Essays*, ed. Steven Blakemore (Athens: University of Georgia Press, 1992), 1–27; David Worrall, *Celebrity, Performance, Reception: British Georgian Theatre as Social Assemblage* (Cambridge: Cambridge University Press, 2013), 191.

59. Judith Pascoe, *Romantic Theatricality: Gender, Poetry, and Spectatorship* (Ithaca, NY: Cornell University Press, 1997), 95–98; Sarah Burdett, "Martial Women in the British Theatre: 1789–1804" (PhD diss., University of York, 2016), 77–126.

60. Pascoe, *Romantic Theatricality*, 95–98; Burdett, "Martial Women," 96–102.

61. For an overview of the different concepts of fame, including "glory," "notoriety," and "renown," see Lilti, *The Invention*, 86–105.

CLAIRON'S STRATEGIES
TO ACHIEVE CELEBRITY
AND GLORY

ANAÏS PÉDRON

Leading actresses of France's premier theater for spoken drama, the Comédie-Française, were among the most celebrated women of eighteenth-century France.[1] A prominent figure among these women was Hyppolite Clairon. As women in the public eye, however, actresses were associated with prostitutes and courtesans,[2] and the immoral reputation of the acting trade in France did not help their cause—actors were excommunicated in France until 1789, while their English counterparts, such as Anne Oldfield, could be buried in Westminster Abbey. Some actresses and dancers even started as prostitutes or courtesans before finding a patron and becoming a performer,[3] and many actresses had to take wealthy lovers to better their living standards or to help their careers and obtain good roles.[4] While recent scholarship has done much to rethink the relationship between actresses and sex in eighteenth- and nineteenth-century France, we cannot deny that, at the time, French actresses were carefully scrutinized for loose morals and aroused comment and criticism from the public. That said, they could still become celebrities and push at the gender boundaries of the period.

Researching actresses and courtesans is challenging because of the ephemeral nature of performance and its inherent relationship with audience reception. Most eighteenth-century French actresses

did not leave many traces of themselves for history, except for gossip about their sexuality, usually in police records and comments in contemporary journals. Usually these records were produced both by and for men. Given the male dominance over these actresses' narratives, Clairon is an important case study, as she wrote her autobiography at the end of the century, and crucially was the only actress to do so at that time. *Mémoires d'Hyppolite Clairon, et réflexions sur l'art dramatique; publiés par elle-même* (1798) has two clearly stated objectives: to give information about Clairon's interesting private life and to leave her thoughts about acting to posterity. However, between the lines, there are two secret objectives: the rekindling of her dormant celebrity and the preparation of her posthumous glory.

If celebrity was not an invention of the eighteenth century, the intimate relationship linking famous people and their public was. Antoine Lilti has shown that the eighteenth-century "media revolution" allowed high-profile individuals to grow their celebrity through letters, newspapers, books, and through formats such as portraits and engravings. Needless to say, Clairon's celebrity was so established that she was a subject for letters and newspapers, the topic of a calumnious fictionalized biography *Histoire de Mademoiselle Cronel, dite Frétillon, actrice de la Comédie de Roüen* (1739) by Gaillard de la Bataille,[5] the subject of multiple artworks and prints, and the focus of her own autobiography. Crucially, it was through her autobiography that Clairon attempted to establish her glory. For this, she had to overcome the destruction of her reputation by the *Histoire de Mademoiselle Cronel*, which depicted her as a nymphomaniac courtesan. This fictionalized biography, reprinted throughout the century, impacted Clairon's life and the opinion of her contemporaries (notably policemen). Later, it would damage her legacy, as historians—for instance Edmond de Goncourt in his 1890 biography *Mademoiselle Clairon d'après ses correspondances et les rapports de police du temps*—used it as a truthful biographical document.[6] In response, Clairon used a genre that Jean-Jacques Rousseau had brought back into fashion: the autobiography. In her text, Clairon explained her public actions, revealed personal anecdotes, and refashioned her story, using her *Mémoires* to return some respectability to her name. She did not

deny that she had had lovers, but rather reduced their number and showed a personal code of conduct, arguing that if she had lovers, they were men she loved and cared about.

In order to understand the *Histoire de Mademoiselle Cronel* and *Mémoires d'Hyppolite Clairon* properly, we first need a quick overview of Clairon's life. Born in a provincial town on January 25, 1723, Clairon was the illegitimate daughter of Marie-Claire Scana-piecq, a seamstress, and François Joseph Léris, an army sergeant. In her *Mémoires*, she admitted that she was a weak and ill-educated child.[7] On January 8, 1736, at age thirteen, Clairon made her debut at the Comédie-Italienne in Paris, playing a maid in the *Ile des Esclaves*, a comedy by Pierre de Marivaux. She did not get along with the troupe, however, and quickly left to join that of Monsieur de Lanoue and Françoise Gautier in Rouen. Clairon spent a few years in the provinces, where she performed in Lille and Dunkirk. In 1743, she moved back to Paris and debuted at the Opéra; discontent with the institution, she requested to be transferred to the Comédie-Française by the end of the year. By 1750, she had become the queen of the French stage, taking over all the tragic roles of the Comédie-Française's repertoire until her retirement in 1766. She then spent her time between private acting and teaching eloquence.[8]

Clairon was considered deviant by her contemporaries, a view passed on to nineteenth-century biographers and scholars—especially Goncourt.[9] As mentioned above, Goncourt used sources (such as police reports and the biography *Histoire de Mademoiselle Cronel*) without critical analysis, reporting and reinforcing the negative image of Clairon created in the eighteenth century. Yet, Goncourt wrote the only non-fictional biographical work about Clairon, which makes its use a necessary evil. Even though Clairon's reputation had its roots in Gaillard's calumnious book, it was also supported by police reports regarding Clairon's misbehavior and numerous lovers. Clairon published her *Mémoires* over thirty years after she had retired from the stage. Her name was still famous, as she was a legendary former actress of the Comédie-Française, but she was not a fashionable player and now lived in the Parisian suburb of Issy. Even though she was no longer based in an urban center, Clairon was not completely isolated and enjoyed the visits of friends and acquaintances until her death on January 29, 1803.

This chapter aims to show how Clairon attempted to unite the concepts of reputation, celebrity, and glory through her career and, later, her autobiography. Whereas later in this volume Emrys D. Jones focuses on theatrical dynasties and the celebrity they could afford actresses, Clairon enjoyed no such privilege. First, this chapter tackles *Histoire de Mademoiselle Cronel*, its impact, and Clairon's late riposte in her autobiography. The second part then explores the different tools Clairon used to build her celebrity: her talent, new acting techniques on stage, and political activism. Finally, the last section of the chapter shows how she used her autobiography to renew her reputation, enforce her celebrity, and build her glory.

A Nymphomaniac Teenager? The Destruction of Clairon's Reputation

Little is known about Clairon's first years in Rouen, but we do know that because she was still young her mother accompanied her and worked for the theater.[10] This was unusual, as when girls became performers in the royal theaters—as Clairon was—their family usually lost all authority over them. In theory, this system allowed the actresses to make their own professional and personal choices, but it was commonly criticized, as many young actresses used their new autonomy to overcome familial power and lead the life they wanted.

When Clairon was sixteen, in 1739, the fictionalized biography *Histoire de Mademoiselle Cronel* was published by Gaillard. Written in the first person, it tells the life story of a young actress who was prostituted by her mother in Rouen. The allusion to Clairon was evident. Firstly, "Cronel" was simply an anagram of "Cleron," one of the eighteenth-century spellings of Clairon. Secondly, in the fictionalized biography, Gaillard's heroine starts her career in Paris at a young age before being hired by the theater of Rouen, where she starts to collect lovers. Her nickname Frétillon is due to her sexual appetite—in French, *frétiller* meant to wriggle, and, in this context, it hints that Clairon was relentless in flirting and collecting lovers. The book was announced as having been published not in France but in The Hague, which shows that it did not pass through the French censorship system, and it encountered lasting success

in the eighteenth century; it was republished and reprinted no less than ten times between 1739 and 1780.

Gaillard's publication was believed to be a biography of Clairon, and thus the author's assertions were generally accepted. In 1750, the policeman La Janière gave a biographical report on the actress to the General Lieutenant of Police, Nicolas René Berryer. Highly inspired by Gaillard's fictionalized biography, La Janière called Clairon "Chronel Clairon or Frétillon" [Mlle Chronel Clairon ou Frétillon] and stressed her loose morals.[11] He gave a long list of her presumed lovers and emphasized her engagement in the bedroom. These lovers allegedly helped Clairon to maintain her lifestyle and also to start her career at the Opéra and the Comédie-Française. The list given by La Janière is not only extensive but detailed, and shows that Clairon was well assimilated in the social, financial, and intellectual circles of her time. Considering the numerous inaccuracies in this police report (the policeman says she was born in Rouen, then explains that she started to act on stage around the age of sixteen, and that she entered the theater thanks to her first lover in Rouen), it should not be trusted. Police reports were written by men who were not only prejudiced against performers but also looking for gossip and juicy anecdotes to spice up their reports in order to entertain King Louis XV.[12] Thus, as subjective as it may be, La Janière's report offers us a privileged insight to understand the contemporary public perception of Clairon.

Clairon's nymphomaniac reputation was long-lasting: when Goncourt wrote her only biography in 1890, he first described *Histoire de Mademoiselle Cronel* as being "ill-informed, and mentioning scandals despite a lack of information" [Cette chronique romanesque, assez mal informée, et mentionnant des scandales peut-être un peu par approximation].[13] He then used it and took its information as a basis to show Clairon's misbehavior from the youngest age, stating that "I believe the young actress was already entertained by many lovers, and prepared to give herself to anyone who pleased or paid her." [Je suppose déjà la jeune comédienne entraînée par une foule de galants, et prête à se livrer à qui lui plaisait ou la payait].[14] Even if Goncourt was aware that the *Histoire* was calumnious and could not be taken seriously, he appeared seduced by the intimate and scandalous details described by Gaillard and

used the text to assert that Clairon had loose morals from a young age. To reinforce this idea, he used the police reports of the 1750s and 1760s. In the eighteenth and nineteenth centuries, Clairon's reputation was shaped by men, for men. As Catriona Seth has recently shown for female writers, such as Olympe de Gouges, their stories and reputations were dependent on male gazes and approbation. Male critics disparagingly judged female writers' works, not because of their lack of talent, but because of their gender.[15]

Sixty years later, in her autobiography, Clairon tried to reestablish her reputation by emphasizing her innocence and virtue. She denied every assertion made by Gaillard, stating that she was a pure girl, without any sexual education, who arrived in and left Rouen as a virgin: "I came out of this city . . . as pure as I came in" [Je suis sortie de cette ville . . . aussi pure que j'y était entrée].[16] Clairon not only asserted that she was virtuous, but also offered her own version of events. She explained that one of her colleagues became friends with her mother and came to live in their house. This actress had many friends who came to visit, gambled, and even brought lovers into the family home; when people started to gossip about this, Clairon's mother did not pay attention and did not change their lifestyle. Their home's bad reputation increased, tarnishing Clairon's own reputation in turn. In her *Mémoires*, Clairon gives her own account of the incident that inspired Gaillard's fictionalized biography. Gaillard was a poet who met Clairon in the salons of Rouen. Attracted to her, he praised her "charms and virtue" [son charme et sa virtue] and flirted with her, expecting to end up in her bed. Interestingly, she did not name Gaillard in the main body of the text, but referred to him with the pejorative expression "a poor devil" [un pauvre diable], clarifying in the footnotes that "his name was Gaillard" [Il se nommait Gaillard], allowing the reader to draw their own conclusions.[17] Clairon shows mercy by implying that his actions were forgiven—if not forgotten. The "poor devil" bribed an old maid and infiltrated the fifteen-year-old Clairon's house while her mother was out in order to seduce her. The actress recalled that when he entered her room and tried to take her in his arms, she escaped and cried for help. The maid and a neighbor came, grabbed brooms, and chased the assailant out of the house. According to her *Mémoires*, when her mother returned, she was

informed of the incident and complained to the local magistrate. Gaillard was rebuked and forbidden to return to the house.[18]

Clairon believed that her refusal of Gaillard's overtures and his reprimand by the magistrate transformed his love into hate. Soon after, he took his revenge with the publication of *Histoire de Mademoiselle Cronel*. Clairon was away at that time and recorded in her *Mémoires* the helplessness she experienced at that moment: "Away from my protectors, not knowing what to do, not daring, unwilling to rely on ignorance, stupidity, and carefreeness, I did not do anything against this offense" [Loin de mes protecteurs, ignorant ce que je devais faire, n'osant, ne devant pas me confier à l'ignorance, la bêtise et l'insouciance, je ne fis aucune demarche pour tirer raison de cet outrage].[19] With hindsight, she confessed that she should have made a complaint about the book, but she was just a sixteen-year-old girl, barely educated, with a mother who was even less so and a poor judge of character. A fatalist, Clairon was also aware that actresses were considered prostitutes in the public's mind, regardless of their actual behavior. An official condemnation of *Histoire de Mademoiselle Cronel* would not change public opinion. Gossip was—and still is—a good seller, and her reputation was already damaged by the publication. With this version presented in her *Mémoires*, Clairon introduced a different narrative of her youth, asserting that she was a pure and innocent girl who faced physical and moral assaults from Gaillard. She reversed the positions, putting the blame on Gaillard, and Gaillard alone.

In her autobiography, Clairon relates that she was afraid of the public's reaction and came back to Rouen prepared to find that she had lost her friends, especially the ones from noble and wealthy backgrounds. She was happily surprised to see that her wealthy influential friends did not believe the fictionalized biography and that their friendships remained regardless of the loss of her reputation.[20] This suggests that the good society of Rouen was aware that the fictionalized biography was defamatory, which is not surprising, considering that among Clairon's acquaintances was Madame de Bimorel, wife of the president of the Parlement of Rouen. The story of the invasion of Clairon's bedroom and the complaint made by her mother must have been well known among parliamentary circles. Madame de Bimorel would not have been friends with a

young debauchee, since that would have damaged her reputation. Clairon narrated this episode to undermine gossip about her misbehavior. By showing that the origin of her bad reputation was nothing but a jealous man's lies in her *Mémoires*, she suggested that every piece of gossip about her sexuality might not be true. Clairon's aim was to rebuild a reputation, strengthen her celebrity, and set the path for her glory.

Creating and Capitalizing on Celebrity

Despite Gaillard's best efforts, Clairon returned to Paris in 1743 and by the end of the year had managed to join the Opéra and then be transferred to the Comédie-Française. The most famous Parisian theaters in the eighteenth century were the Comédie-Française, the Comédie-Italienne, and the Opéra, and by the age of twenty Clairon had graced them all. All the performers of these theaters were placed under the supervision of the Gentlemen of the King's Bedchamber. Being a member of the Comédie-Française was very prestigious and served as a way for actors to secure a salary and a state pension when they retired. It was not an easy task to be admitted to these theaters: talent was the key to being accepted, but to be presented one needed a push. According to Goncourt—and we should take this with a grain of salt—Clairon seduced the powerful Farmer General Alexandre de la Popelinière, who found her a job at the Opéra.[21] Clairon requested to leave the Opéra after four months because the salary was lower than at the other royal theaters, which frequently led performers to take lovers to support them.[22] In fact, one-fifth of the courtesans under police surveillance were performers, especially those from the Opéra.[23]

Clairon then turned her hopes to the Comédie-Française, but the bad reputation she had since the publication of the *Histoire de Mademoiselle Cronel* at first aroused the opposition of some actors, including her former protector Lanoue. They believed her to be too depraved to join a royal company. Loose morals were accepted in theatrical troupes, but their publicity, especially in print, was not. There was a difference between having a liaison acknowledged by members of the Parisian elite and living a depraved life that was printed and reprinted in the public sphere. Goncourt argued that to

circumvent this publicity and to facilitate Clairon's transfer to the Comédie-Française, she used the help of two royal mistresses, who were also sisters, Marie Anne de Mailly-Nesle and Diane Adéla-ïde de Mailly-Nesle, whose interventions were decisive in Clairon's insertion into the Parisian elite.[24]

Clairon's connections overcame the actors' reservations, and she debuted at the Comédie-Française's in *Phèdre* by Jean Racine on September 19, 1743. As the *Mercure de France* reported: "She performed her role to great applause. This young woman is very intelligent and expresses the feelings that she seems able to delve into with a very beautiful voice" [Elle a joué le rôle avec un applaudissement général. C'est une jeune personne qui a beaucoup d'intelligence et qui exprime avec une très belle voix, les sentiments dont elle a l'art de se pénétrer].[25] At first, Clairon also appeared in comedies, such as *Tartuffe* (1669) by Molière, but she soon abandoned the genre in favor of tragedy, where she would monopolize the leading roles. Playwrights Voltaire, a close friend of Clairon, and Jean-François Marmontel, an occasional lover who was also an important intellectual, wrote prominent roles for her. As we have seen, Clairon's reputation was tainted: firstly, because of *Histoire de Mademoiselle Cronel* and its constant reprints, which ensured the actress's immoral reputation was not forgotten; and secondly, owing to her open liaisons with rich and wealthy men. While loose morals increased or broke some actresses' reputations, however, they did not impact Clairon in that way because, despite the comments about her private life, her increasing celebrity allowed her to escape reduction to a courtesan identity. Contrary to many actresses of her time, Clairon was passionate about her art and constantly improved her techniques, as we shall see below. Her increasing talent made critics and the public put aside most of her sexual indiscretions to focus on her very successful career.

In the 1750s, Clairon had an added opportunity to show the extent of her talent, when she became Voltaire's muse. The playwright called her "Melpomène," the Greek muse of tragedy, advised her on her acting, and occasionally listened to her suggestions on how to stage his plays.[26] Mostly, Voltaire praised her and her talent: "He is so docile that he congratulates himself that talents superior to his would not disdain all the observations that his admiration

for Mademoiselle Clairon ripped from him" [Il est si docile qu'il se flatte que des talents supérieurs aux siens ne dédaigneront pas à leur tous les observations que son admiration pour Melle Clairon lui a arrachés].[27] Even though she never toured outside France, Clairon became famous throughout Europe. Her international celebrity was driven by the increased circulation of French newspapers that covered her and by reports on her performances in personal correspondences.

She met the English actor David Garrick when he came to Paris in the early 1760s, and he was impressed by her acting style. He wrote to his friend, French writer Marie-Jeanne Riccoboni, in 1765 that, "My thoughts of Clairon cannot be exceeded. I am as constant to my Sentiment of her, as she is inimitable."[28] The year after, when the news of her retirement from the stage reached him, Garrick wrote to his friend, French actor Henri-Louis Lekain: "I have learnt with sorrow that my very dear Clairon does not act anymore—what a loss for Paris!" [J'ai appris avec peine que ma très chère Clairon ne joue plus—quelle perte pour Paris!].[29] From her admission to the Comédie-Française until her retirement, Clairon rarely left the French capital, but her reputation as a talented actress apread across the continent via communication networks that rendered her celebrity European. This shows the permeability of borders in Europe and the extent to which private correspondence and newspaper articles could help create an international celebrity.

In 1752, Clairon achieved another level of celebrity as her acting style developed. She shifted from an emphatic declamatory acting style, which was traditional in French tragedy, to a simpler and more natural one when she performed in Bordeaux as Agrippine in Racine's *Britannicus* (1669). Wanting to increase the authenticity of her acting, Clairon also simplified her costume and made it more appropriate to the subject of the play (it was common for eighteenth-century French actresses to display their expensive and beautiful gowns onstage, regardless of the character they were playing or the play's setting).[30] Clairon was famous for the hard work she put into her characters to achieve naturalness. Once her acting genius was recognized, her bad reputation no longer impacted her growing celebrity, and she became part of the popular culture of the mid-eighteenth century. In the late 1750s, the painter Charles-André van

Loo was commissioned to paint her; Louis XV saw the portrait, adorned the image with a gilded frame, and financed engravings of the portrait, requesting the profits from their distribution to be paid to Clairon herself. Alongside images of the most famous celebrities of the time, such as Voltaire, Rousseau, and the Chevalier d'Eon, Clairon's image entered the homes of the French population.[31]

She was a subject of conversations and of hundreds of articles. For instance, Lilti identifies the *Mémoires secrets* (1762–1787) as a key publication in the construction of celebrity, and only fifteen people were mentioned more than a hundred times in it. Amongst them was only one woman: Clairon. The newspaper described her successes on stage as much as her sentimental adventures.[32] It was the same case for the *Année littéraire* (1754–1790) by Elie Fréron. In 1765, only a few articles dared to go against general public opinion and criticize the actress; Voltaire upon hearing of them wrote to Marmontel: "I believe she is very happy this divine Clairon. Not only is she adored by the public, but additionally I heard that Fréron rages against her. She obtains all sorts of glory" [Je la trouve bien heureuse cette divine Clairon. Non seulement elle est adorée du public, mais encore Fréron se déchaîne, à ce qu'on dit, contre elle. Elle obtient toutes les sortes de gloire].[33] The bad press, however, also helped her celebrity.

Finally, Clairon's celebrity gained a new dimension in the 1760s, when she fought against the Church and the monarchy to secure actors the civil rights that had been denied to them. Clairon had, in fact, laid the groundwork for actors' rights before 1761. In 1757, the Comte de Valbelle, her lover, published a curious brochure on the matter entitled *Représentations aux puissances ecclésiastiques en faveur de cette classe d'hommes frappés des anathèmes de l'Eglise, qui instruisent les hommes en les amusant agréablement.* Thereafter, she protested against the systematic excommunication of French actors when she loosely collaborated in the publication of a pamphlet arguing in favor of actors' rights, *Libertés de la France, contre le pouvoir arbitraire de l'excommunication* (1761), by lawyer Francois-Charles Huerne de La Mothe.[34] Badly written and poorly argued, the pamphlet was a complete failure and was burned by an order of Parliament. Just after this, in 1762, Gaillard's *Histoire* was republished, which indicates that publishers were feeding on

Clairon's celebrity and prominence in the public sphere to ensure good sales for the book. The more famous she became, the longer the fictionalized biography interested the public.

Clairon's fight did not end there, though. In April 1765, the Gentlemen of the King's Bedchamber forced the Comédie-Française to reinstate the actor Louis Blouin, known as Dubois, whom the troupe had expelled for his bad behavior. In reaction to this, Clairon and the other actors refused to stage the popular play *Le Siège de Calais* (1765) by Pierre-Laurent Buirette de Belloy and staged a strike. The Gentlemen of the King's Chamber and the Lieutenant of Police threw Clairon and four of the troupe's leading performers in prison. By that time, Clairon was the most famous actress of the French stage. Believing that her talent, fame, and connections enabled her to challenge the authority of the French monarchy, she more than once declared herself the spokesperson of the Comédie-Française during her career. In doing so, she asserted her superior position in the troupe—not only as a celebrated actress, but also as the figure solving the actors' grievances—and positioned herself as the monarchy's main contact in the troupe. She attempted to use this power to pressure the monarchy to give actors civil and religious rights. As the most celebrated tragedian of the 1760s, Clairon believed that her threat to abandon the stage would be enough for the government to agree to her demands for actors' civil and religious rights. However, she overestimated her influence. While she refused to perform, all the other actors of the troupe returned to the stage, and even though she was the best tragedian of her decade, she was not the only one who was widely respected. Clairon learned the hard way that no one is irreplaceable, and that celebrity can never be guaranteed. Her failure led her to take a break in 1765, which became a definitive retirement in 1766.

Creating Glory through her Autobiography

To emphasize her own valor and personal glory, in her autobiography Clairon extensively commented on her talent as an actress, her engagement in the betterment of the actors' living conditions, and her goodness as a woman, especially regarding her sentimental and sexual life. Writing about her lovers in the later years of

the Revolution was a bold move for an actress. Before 1789, there was a general feeling that politics had fallen under the influence of women, and the moral rhetoric of the Revolution blamed the corruption of the Ancien Régime on them.[35] The Revolutionary ideology of government emphasized that the place of women was in the private sphere to please their husbands and raise their children. It was believed that this condition would achieve the restoration of the state's and its citizens' virtue.[36]

Even after Clairon's final retirement from the stage in 1766, she hardly fit the requirements of the virtuous woman developed in Revolutionary rhetoric. She was aware that her misbehavior was too well known for her to rewrite her story completely, so she was creative: in her *Mémoires*, she refashioned her story just enough to make it believable, especially with the way she dealt with her numerous lovers. Clairon created a version of herself that was not flawless, but rather driven by pure feelings of love toward men and ambition in her career. Though she obviously did not agree with the high number of lovers attributed to her in police reports, she did not deny she had taken numerous partners, and she changed her story to make her sexual encounters more acceptable. When her mother wanted Clairon to marry a man she disliked, Clairon decided to take a protector to save her from an unwanted marriage. For her, "this moment, which at first seems like libertinage, was perhaps the noblest, the most interesting, and the most striking of my life." [Ce moment qui ne présente au premier aspect que l'idée du libertinage, est peut-être le plus noble, le plus intéressant, le plus frappant de ma vie].[37] Clairon emphasized this need to be saved from an unwanted marriage and to gain her freedom from her mother's influence as the trigger for her first affair, even though she was not dependent on maternal authority.

Clairon never portrayed herself as a courtesan or a *libertine*, and she even denied having had patrons who helped her career and gave her money: "My talent, my staff, and the fact that I was easily approachable made me see so many men at my feet, that it was impossible that a naturally tender soul, forced to become impregnated by the most seductive passions, could be indifferent to love . . . Love is a need of nature: I satisfied it, but not in a way that would make me blush; I defy anyone to mention a shameful deal or

any man who paid me" [Mon talent, mon personnel, la facilité de m'approcher, m'ont fait voir tant d'hommes à mes pieds, qu'il était impossible qu'une âme naturellement tendre, obligée de se pénétrer sans cesse de ce que les passions ont de plus séducteur, pût se trouver inaccessible à l'amour . . . L'amour est un besoin de la nature: je l'ai satisfait, mais de manière à n'en point rougit; je défie qu'on me cite un marché honteux, un seul homme qui m'ait payée].[38] Clairon also argued that her reason for leaving the Opéra in 1743 was "the mediocrity of the salary that made the necessity to degrade oneself unconditional" [La médiocrité des appointements rendait la nécessité de s'avilir si absolue].[39] Indeed, as mentioned above, many performers from the Opéra were courtesans or prostitutes, and Clairon's transfer thus helped her avoid this fate. She preferred to work and earn her own money, rather than relying on a wealthy lover to pay the bills.[40]

When Clairon wrote about her lovers in her *Mémoires*, she emphasized her romantic connection to them. She developed a rhetorical pattern using the vocabulary of love and care to depict her relationships: her lover for twenty years, the Comte de Valbelle, was "the most seductive man of nature and the dearest one to my heart" [L'homme le plus séduisant de la nature, et le plus cher à mon coeur],[41] and the Margrave of Anspach-Bayreuth, her lover for twelve years, was "one of the most virtuous beings of nature" [Un des plus vertueux êtres de la nature)].[42] Clairon also defended the idea that she had her own code and claimed that, whatever she did, she never did anything that would make her ashamed. She highlighted her good intentions, in contrast to actresses who used their lovers to improve their wealth and status. She was, therefore, very proud of not having been married, even though she received many proposals including repeated ones from Valbelle. Clairon believed her refusals to be "the way of honor and duty" [la voie de l'honneur et du devoir], as she was aware that her status of performer would bring shame on a husband.[43]

Clairon was additionally proud of not being a mother. Considering that she never married, nor wanted to do so, having a child would mean having an illegitimate one, and she was aware of the indignity heaped upon such children and their mothers, as she was a bastard herself: "no child rebuked by morals and laws makes me

ashamed of its existence" [Aucun enfant réprouvé par les mœurs et les lois ne me fait rougir de son existence].[44] She was therefore particularly wary of becoming pregnant. Such a position is interesting considering the emphasis placed on motherhood during the last decades of the eighteenth century and the importance it was said to have in the regeneration of the French state during the Revolution. While the official position dictated that women stay in the private sphere as wives and mothers, Clairon offered her own proud model of a woman not only free from marriage and offspring, but also engaged with the public sphere.

Clairon hoped her *Mémoires* and her connections would ensure her glory. Even if often desired, glory is harder to achieve than celebrity: usually posthumous and universally recognized, glory is accorded by the public (and not only a single group of people) to a person with intellectual, physical, or moral virtues.[45] Clairon united the different concepts of reputation, celebrity, and glory. Her reputation had not only been commented on by Parisians, but also by all of Europe; yet by the end of the century she was no longer in the limelight, and so her *Mémoires* were an attempt at cultivating a posthumous glory that emphasized her talent as an actress and her bold status as a champion for actors' rights.[46] To achieve this, Clairon first emphasized her own valor and then linked herself to other people's glory. At the beginning of her *Mémoires*, Clairon states that they were written during her stay in Germany and were meant to be published ten years after her death, but the indiscretion of a friend who was supposed to take care of the manuscript led it to be published in German (showing her continued international celebrity currency). Clairon therefore decided to publish the *Mémoires* in French, arguing that this version was her sole biographical work. It is hard to believe that Clairon did not have ulterior motives in writing her autobiography, however. The genre itself shows her will to give to the public her own truth, and so we can comprehend Clairon's decision to write her *Mémoires* as a potential means to resume her celebrity and to ensure her glory would never die. Instinctively, Clairon grasped the difference between reputation, celebrity, and glory shown by Lilti, so in her attempt to ensure her glory, she undermined and twisted her reputation for immortality, stated her numerous successes on stage, and linked herself to many

high-ranking famous people. Yet, Clairon was too late: after thirty years away from the stage, she had been out of the public eye for too long, rendering her contribution to French theater and her fight for actors' rights a distant memory.

The word *gloire* can be found seven times in Clairon's autobiography, in relation to her friends, her lovers, and herself (she wonders "what could be the price of life if it must flow without glory?" [De quel prix peut être la vie, s'il faut qu'elle s'écoule sans gloire?]).[47] As an actress, she was close to many playwrights, including Voltaire and Marmontel. Voltaire's celebrity and glory were prevalent in the eighteenth-century French public sphere. In 1772, Clairon and Marmontel organized a private glorification of the playwright at her house. The event was reported in newspapers, and Clairon herself narrated it to her former student, the actor Larive, in a letter: "I held a small party at my house, M. de Marmontel wrote a poem for the installation of M. de Voltaire's statue; I declaimed this poem dressed as a priestess and crowning the bust of this great man" [J'ai eu une petite fête chez moi, M. de Marmontel a fait une ode pour l'érection de la statue de M. de Voltaire; habillée en prêtresse et couronnant le buste de ce grand home, j'ai récité cette ode].[48] The public glorification of Voltaire took place in 1778. During a trip to Paris, he was received at the Académie française and, while attending a play at the Comédie-Française, he received the ultimate glorification when the troupe's actors crowned his bust onstage in front of an adoring public.[49] The episode shows striking resemblances with the small event at Clairon's house, which was well known, as its attendees wrote of it in newspapers and private letters. Even if such a public and spontaneous glorification was ambivalent, it also shows that Voltaire was not only a celebrity but also something different. This moment represented the junction between his reputation as a writer, his international celebrity, and his growing glory.[50] By linking herself to such figures and helping them to achieve glory, Clairon attempted to increase her own, and to ensure her name and memory held a lasting space in the public's opinion.

To conclude, Clairon suffered the prejudices against her profession: fiction or not, *Histoire de Mademoiselle Cronel* permanently stained her reputation, not only in Rouen, but also across Europe.

Clairon was praised for her acting talent but was still the subject of extensive and unverifiable gossip about her private life, which almost destroyed her career, as some actors were afraid that she would tarnish the Comédie-Française. Her having lax morals within the context of the eighteenth century is a fact; even when we remove *Histoire de Mademoiselle Cronel* and the police reports that drew on it from the primary documents, the remaining police reports are consistent in their accounts of the quantity and diversity of her lovers, even though those reports were written by different policemen, such as La Janière, Saint-Marc, and Meunier. The importance of gender here should not be forgotten: actresses were highly scrutinized and the subject of much gossip. At the same time, actors were often believed to have similarly loose morals, but there are fewer documents that record their alleged immorality compared to those concerning actresses. Policemen were obviously partial, as they were looking for juicy details about public women to entertain the king (let us remember that the images of performer, courtesan, and prostitute were quite interchangeable at the time), and they did not provide many details about men. Instead, they wrote judgmental and prejudicial assertions about women of the time, including Clairon. The truth of their reports was taken for granted by later historians and biographers, which led to a significant misunderstanding about the period.

This is why Clairon's *Mémoires*, though unreliable, are an important and interesting document, as they reflect her vision of her own life. They show how she wanted to ensure her reputation, secure her celebrity, and build up to glory in her later years. She avoided possible criticisms of being a prostitute with grandiloquent assertions, such as "I defy anyone to mention a shameful deal, only one man that paid me," [je défie qu'on me cite un marché honteux, un seul homme qui m'ait payee] and that was for acting alone.[51] Moreover, Clairon asserted that she only had affairs with men she loved. She shared her personal code of conduct, demonstrating an awareness of her social status and claiming it would have been dishonorable for her to marry or have children. Her understanding and use of her celebrity was unusual for an actress, and she revealed her awareness of the impact she could have on the public sphere. Clairon's wish to cement her glory through touting her own actions, and those of her friends, also demonstrates her understanding

of social mechanisms and her desire to utilize them to secure her legacy. Clairon's life deserves a proper objective study, using all the relevant sources of her time. Reading between their lines offers an account closer to reality than that proposed by past and current studies.

Notes

1. Lenard R. Berlanstein, "Women and Power in Eighteenth-Century France: Actresses at the Comédie-Française," *Feminist Studies* 20, no. 3 (1994): 475.

2. Lenard R. Berlanstein, *Daughters of Eve: A Cultural History of French Theater Women from the Old Regime to the Fin de Siècle* (Cambridge, MA: Harvard University Press, 2001), 40.

3. Ibid., 24.

4. Ibid., 29.

5. Pierre Alexandre Gaillard, *Histoire de Mademoiselle Cronel, dite Frétillon, actrice de la Comédie de Roüen* (The Hague: n.p., 1739).

6. See Catriona Seth, "Qu'est ce qu'une femme auteur?" in *Une "période sans nom." Les années 1780–1820 et la fabrique de l'histoire littéraire*, eds. Fabienne Bercegol, Stéphanie Genand, and Florence Lotterie (Paris: Classiques Garnier, 2016), 167–88.

7. Hyppolite Clairon, *Mémoires d'Hyppolite Clairon, et réflexions sur l'art dramatique; publiés par elle-même* (Paris: F. Buisson, 1798), 167.

8. Antoine Lilti, *Le Monde des salons: Sociabilité et mondanité à Paris au XVIIIe siècle* (Paris: Fayard, 2005), 257. Private theaters were differentiated from public theaters: people could play on private stages without the risk of being excommunicated.

9. See Seth, "Qu'est ce qu'une femme auteur?"

10. Edmond de Goncourt, *Mademoiselle Clairon d'après ses correspondances et les rapports de police du temps* (Paris: Charpentier et Cie Editeurs, 1890).

11. François Ravaisson, ed., *Archives de la Bastille. Documents inédits*, vol. 12 (Paris: A. Durand and Pedone-Lauriel, G. Pedone-Lauriel, 1881), 348–51.

12. Pamela Cheek, "Prostitutes of Political Institution," *Eighteenth-Century Studies* 28, no. 2 (Winter 1994): 194.

13. Goncourt, *Mademoiselle Clairon*, 24–25.

14. Ibid., 25.

15. Seth, "Qu'est ce qu'une femme auteur?," 185–86.

16. Clairon, *Mémoires*, 278.

17. Ibid., 42. This expression refers in French either a poor man or an unworthy man.

18. Ibid., 179–80.

19. Ibid., 180.

20. Ibid., 183.

21. Goncourt, *Mademoiselle Clairon*, 37–38.

22. Clairon, *Mémoires*, 187.

23. Nina Kushner, *Erotic Exchanges: The World of Elite Prostitution in Eighteenth-Century Paris* (Ithaca, NY: Cornell University Press, 2013), 4–5.

24. Goncourt, *Mademoiselle Clairon*, 50–52.

25. *Mercure de France*, September 19, 1743.

26. Voltaire to Jean-François Marmontel, August 13, 1760, in Jean-François Marmontel, *Correspondance*, ed. John Renwick, vol. 1, *1744–1780* (Clermont-Ferrand: Presses universitaires Blaise Pascal, 1974), 66.

27. Voltaire to Hyppolite Clairon, c. January 15, 1750, in Voltaire, *Correspondence*, ed. Théodore Besterman, vol. 11 (Geneva: Institut et musée Voltaire, 1970), 227–28.

28. David Garrick to Marie-Jeanne Riccoboni, June 13, 1765, in Marie-Jeanne Riccoboni, *Mme Riccoboni's Letters to David Hume, David Garrick, and Sir Robert Liston, 1764–1783*, ed. James C. Nicholls (Oxford: The Voltaire Foundation and the Taylor Institution, 1976), 48.

29. David Garrick to Henri-Louis Lekain, January 29, 1766, in David Garrick, *The Letters of David Garrick*, eds. David Little and George Kahrl, vol. 2 (London: Oxford University Press, 1963), 491.

30. Barbara G. Mittman, "Women and the Theatre Arts," in *French Women and the Age of Enlightenment*, ed. Samia Spencer (Bloomington: Indiana University Press, 1984), 161.

31. Jeffrey S. Ravel, "Actress to Activist: Mlle Clairon in the Public Sphere of the 1760s," *Theatre Survey* 35, no. 1 (May 1994): 76–78.

32. Antoine Lilti, *Figures publiques: L'Invention de la célébrité (1750–1850)* (Paris: Fayard, 2014), 103.

33. Voltaire to Marmontel, March 17, 1765, in Marmontel, *Correspondance*, 1:109.

34. Hyppolite Clairon and François-Charles Huerne de la Mothe, *Libertés de La France, contre le pouvoir arbitraire de l'excommunication* (Amsterdam: n.p., 1761).

35. Dorinda Outram, *The Body and the French Revolution: Sex, Class, and Political Culture* (New Haven, CT: Yale University Press, 1989), 125.

36. Lynn Hunt, *The Family Romance of the French Revolution* (Berkeley: University of California Press, 1992), 98.

37. Clairon, *Mémoires*, 185.

38. Ibid., 204–5.

39. Ibid., 187.

40. Kushner, *Erotic Exchanges*, 31.

41. Clairon, *Mémoires*, 205.

42. Ibid., 217.

43. Ibid., 205.

44. Ibid., 205.

45. Lilti, *Figures*, 13–14.

46. Ibid., 12–14. The glory that Clairon attempted to create can be qualified as posthumous as her autobiography was supposed to be published after her death.

47. Clairon, *Mémoires*, 146.

48. Letter quoted in Christophe Paillard, "Amis ou ennemis? Voltaire et les gens de lettres d'après quelques autographes inédits ou peu connus," *La Gazette des Délices. La Revue électronique de l'Institut et Musée Voltaire* (Summer

2010), accessed February 6, 2020, http://docplayer.fr/76775157-La-gazette-des-delices-la-revue-electronique-de-l-institut-et-musee-voltaire-issn.html. The original is held at the Bibliothèque de Genève Institut et Musée Voltaire.

49. Lilti, *Figures*, 26–27.
50. Ibid., 27.
51. Clairon, *Mémoires*, 205.

6

CELEBRITY–THOU ART TRANSLATED!

Corinne *in England*

MIRANDA KIEK

On June 15, 1807, only a month after Germaine de Staël's *Corinne, ou l'Italie* first appeared in France, the English publishers Tipper and Richards announced that they would bring out an English edition in ten days' time.[1] They fell short of their promise, and their freewheeling anonymous translation, *Corinna, or Italy*, was not published until late July, when it was accompanied by an intensive advertising campaign in the newspapers.[2] A second, nominally more faithful translation (the work of a different publisher) followed in December.[3] With two different translations appearing in the space of a few months, lengthy reviews in major journals, and the author's celebrity, *Corinne* and its characters quickly permeated the collective consciousness of huge swaths of literate society.[4] No publication could blast through the thriving British fiction market in the manner in which *Corinne* did without leaving its traces on succeeding publications. Yet, while scholarship has accorded great attention to the influence of the "Corinne Myth" on the work of early Victorian writers such as Felicia Hemans, Elizabeth Barrett Browning, and Laetitia Elizabeth Landon, with few exceptions, it has not done likewise for the influence of the myth during the period immediately following *Corinne*'s publication.[5] This chapter argues that the Corinne character type did not reemerge Sleeping

Beauty-like with the early Victorians, but rather that her presence, if refracted, is traceable in the conservative domestic fiction of the preceding decades, wherein Corinne the celebrity was turned into a theatrical attention-seeker, of a sort ultimately rejected by the narrative in favor of a new form of intellectual observer heroine.

Corinne, "poet, writer, and improvisatrice" [poëte, écrivain, improvisatrice] and (importantly for the purposes of this chapter) actress, is the most "celebrated" woman in Italy.[6] This description, the very first mention of Corinne in Staël's narrative, is given by a Roman local in response to Lord Nelvil, a Scottish visitor to Rome, when he asks why church bells are ringing and canons firing. The occasion, he discovers, is the coronation as Roman poet laureate of a mysterious woman, known only as Corinne. Nelvil is caught between amazement and disapproval, for, as the narrative comments, "There is certainly nothing more contrary to the thinking of an Englishman than this great publicity given to the fortunes of a woman." [Il n'y a certainement rien de plus contraire aux habitudes et aux opinions d'un Anglais que cette grande publicité donnée à la destinée d'une femme].[7] Thus, even though Nelvil falls passionately in love with Corinne and she with him, he ends up abandoning her for her pale, proper, and irreproachably English half-sister, who lives unnoticed by the world, immured in rural obscurity. In consequence of this, Corinne falls into a sharp decline and dies. As the novel suggests, a talented woman is in an impossible position—to be publicly praised for her skills is to risk being blamed for the notice that such praise unavoidably entails.

Within the world of the novel, Corinne is both "celebrated" and a "celebrity." She is celebrated as a serious poet, actress, and artist, at the same time possessing that paradoxical mixture of "Mysteriousness . . . [and] publicity; this woman of whom all the world spoke, and whose real name no-one knew," which Joseph Roach, theorist of stardom, would much later define as the "It-factor," the "*sine qua non*" of celebrity.[8] Nelvil is unable to reconcile her greatness and unsullied celebrity with desirable female behavior. While the emerging field of Celebrity Studies has paid attention to "real" celebrities and, to a certain, lesser extent, to "fictional celebrities"—by which I mean those characters who have gained widespread recognition beyond the immediate frame of their containing

text (such as Alice of *Alice in Wonderland* and James Bond)—it has (almost without exception) yet to consider characters who are celebrities within the fictional world they inhabit.[9] Corinne is both a fictional celebrity and a celebrity in fiction, and a fictional narrative about celebrity is able to contain both a depiction of celebrity and responses to it within a single space. A narrative's die can be weighted in favor of female celebrity or against it, according to the views of the author. Staël's dice were weighted in favor (Corinne is not lessened by her celebrity); British conservative writers' dice were weighted against.

Corinne's success added fresh fuel to a rumbling contemporary debate on both sides of the Channel over how extensively female celebrity and admirability could coexist. Moreover, as the improvisatrice (the original Corinne's key artistic identification) was not a concept that translated easily to Britain,[10] many of the fictional daughters of Staël's Corinne, though still performers, performed in ways other than extempore poetic improvisation: they sang, they played music, and very often they acted.[11] This last occupation had specific ideological consequences, for it conferred on these English Corinnas the actress's historic associations with social mobility, unbounded sexuality, sentimentality, fakery, and above all ego. In this chapter, I use a parody of *Corinne*—*The Corinna of England, and a Heroine in the Shade* (1809), which was published anonymously about eighteen months after *Corinne*'s first translation—as a tool for charting the ways in which narratives of female celebrity were incorporated into the preexisting conventions of the British conservative novel and, in so doing, I show how theater became a feature of both plot and narrative structure. In the course of this analysis of fictional celebrity, I will suggest the existence of an unappreciated debt to *Corinne* in Jane Austen's *Mansfield Park* (1814).

The Corinna of England, and a Heroine in the Shade; a Modern Romance (1809)

The Corinna of England, and A Heroine in the Shade is the story of the quixotic heiress Clarissa Moreton, who convinces herself that she is the English embodiment of Staël's Corinne, a delusion that ultimately dooms her to an exemplary demise in the Covent

Garden Theater fire of September 1808. Meanwhile, her quiet and impeccably behaved cousin Mary Cuthbert emerges as the true heroine of the novel, triumphantly inheriting the dead Clarissa's money and property, and marrying the man with whom Clarissa had been in love, the insufferable clergyman-to-be Montgomery.

Between the early 1790s and the early 1800s, a group of novels—of which *The Corinna of England* is a late example—were published that countered views held up as dangerously radical, even Jacobin (a derogatory term used to describe viewpoints believed to be in sympathy with French Revolutionaries). A significant proportion of this group are deeply formulaic and, despite the heterodox conservatism of the period, display substantial ideological similarities, at least in terms of their identification of the Jacobin enemy.[12] These fictional Jacobins propounded a set of beliefs referred to at the time under the catchall term of "new" or "modern philosophy," the defining features of which were selfishness masquerading as utility, attacks on family and state religion, sexual voracity, grandiose but meaningless statements (cribbed from playhouses and spouting clubs), and—for women in particular—a love of attention and show. New philosophers in such novels can frequently be found advocating for atheism or free love, or knocking down some ancient edifice of England's mythical Burkean heritage. Clarissa, who is a dedicated apostle of new philosophy, almost manages to achieve a full house of these supposedly Jacobin traits, but, as a result of her Corinnean antecedents, her chief new philosophical fault is dissatisfaction with conventional domestic obscurity—or, to express it another way, her desire for celebrity.

What Staël's "celebrated" Corinne embodies for the author of this parody is not so much female genius but narcissistic female celebrity. To be as the Roman cynosure, believes Clarissa, is to have "numerous admirers" and a "*train* of lovers."[13] Moreover, it means being a celebrity, and this, she thinks, would complete her erotic enslavement of Montgomery: "how would [his] whole soul . . . dissolve in the full tide of rapture" when he found that " . . . the *Corinna* of England [i.e. Clarissa]—she, whose talents, and whose virtues had been born on the *blast of Fame* through the extended dominions of Great Britain; that *she* had elected *him*, to be the

partner of her fortune and her glory!"[14] After provoking an industrial protest, a delighted Clarissa does indeed achieve celebrity but fails to realize that, for a good anti-Jacobin woman, celebrity is synonymous with "notoriety."[15]

Along with a desire for celebrity, Clarissa also inherits from her literary forebear the habit of performance, here expressed as a type of theatricality. In fact, one of the first things that this parody helps to establish is the extent to which Regency England associated Corinne the character with theaters and actresses. Theater is everywhere in *The Corinna of England*, from the theatrical fire that consumes the doomed Clarissa, to the German play that Mary Cuthbert reads with disgust shortly after her arrival at the Attic Theater, to the unscrupulous redcoat Captain Walwyn's attempts to seduce Clarissa in the course of rehearsing several of the more torrid eighteenth-century dramas.[16] Even Clarissa's private living room, dubbed the Lyceum, shares its name with a London venue of public theatrical entertainment and is peopled by, among others, a group of ragbag foreign *artistes*. Staël's own celebrity salon had recently been compared to a theater in the conservative press, and this last theatrical folly of Clarissa's may have been as much, if not more, a reference to Staël's salon than to the fictional Corinne's own salon, which had a far more genteel membership.[17] It is through the theme of theater that the author makes manifest Clarissa's craving for celebrity. And this craving for celebrity is, in its turn, implicated in a whole panoply of other new philosophical vices.

Thus, for example, religious deviancy (which in anti-Jacobin terms encompassed atheism, paganism, and all Christian sects that did not fall within the narrow bounds of Anglicanism) is made in *The Corinna of England* an effect of the pursuit of celebrity. A common feature of the anti-Jacobin novel was the desertion of the Church of England by the anti-hero or anti-heroine, and once removed from the safeguards of the Church's behavioral boundaries, women in particular risked seduction and, consequently, ruin. Clarissa never attends church, and into the moral void left by Anglicanism she inserts the theater, filling her empty Sunday hours rehearsing scenes from plays and dreaming of theatrical greatness. Thus, as Mary Cuthbert piously attends the local church, Clarissa stays at home performing scenes from *The Fair Penitent* with Captain Walwyn, who has been eagerly

encouraging her theatrical pastimes for the "opportunities of prosecuting his suit with all the enthusiasm of passion:—that passion was there [in plays] depicted in words the most forcible, tender, and yet warmly coloured."[18] Through the means of this Sunday morning play rehearsal, the author is able, with an almost self-satirizing directness, to draw the conventional anti-Jacobin connection between neglect of religion and vulnerability to sexual predation.

That it was *The Fair Penitent* (1703)—Nicholas Rowe's famous tragedy about seduction—that Clarissa stayed home from church to rehearse was a clever authorial choice in ways other than the immediately obvious (its hilarious inappropriateness for a Sunday and the appeal of the dramatic central female role to the self-dramatizing Clarissa). *The Fair Penitent* was a favorite among aristocratic thespian amateurs,[19] who performed private theatricals in part because they believed along with Mr. Yates, a thespian hopeful in Austen's *Mansfield Park*, that it would bestow on them the "happiness" and "fame" of a "long paragraph [in the papers] . . . which would of course have immortalized the whole party for at least a twelve-month!"[20] And indeed a real-life performance of *The Fair Penitent* from August 1808 (a birthday celebration for the Prince of Wales) had recently had the "happiness" of being reported in at least two major London newspapers. This date fits in exactly with the chronology of historical events against which *Clarissa*'s author mapped the parody: after the publication of *Corinne* in summer 1807 and just before the Covent Garden Fire of September 1808.[21] The irony of this particular parodic attack on celebrity is its own allusive reliance on celebrity. It is because this real production of *The Fair Penitent* possessed some celebrity (insofar as it had received more than one "long paragraph" in the newspapers) that humorous half-references to it could be made in the first place. The same irony is true of the parody as a whole, which, so to speak, "doth mock the meat it feeds upon," as the celebrity of Staël's *Corinne*, which makes the parody possible, is also the target of the parody. In other words, narrative technique and ideological import run counter to each other.

One knock-on effect of Clarissa's Sunday rehearsal is a refusal to say grace before a meal because: "my spouting has nearly incapacitated me for any more exertion to-day [*sic*]; there is a great

deal of violent action in that last scene!"[22] Clarissa's most grievous dramatic sacrilege, however, is the conversion of the ancient chapel of her estate. She has the "old paintings, and the angels, and the ten commandments, torn down, from what used to be the Altar Piece, to make room for naked gods and goddesses," and she tests the chapel's acoustics by reading a play from the pulpit.[23] With thudding symbolism, the local carpenter she employs is lamed putting up a statue of Fame blowing her trumpet and, as a consequence, his family is almost ruined (Mary later provides a kind ear and practical aid). Clarissa even fetches a professional playhouse carpenter from London to complete the conversion, thereby robbing her community of the work they might reasonably expect from the estate owner. Clarissa's unfeminine desire to perform in order achieve fame—or in anti-Jacobin terms to abandon the cipherhood of being commonplace in favor of dangerous singularity—is shown to be at the root of the destruction of religious life in the very community to which she should be acting as role-model; and this destruction of religious life endangers not only spiritual health but also economic livelihoods and community cohesiveness.

The most iconic of the public performances given by Staël's Corinne is her triumphant coronation and extemporization on Capitol Hill. Clarissa, after practicing the art of oration in her repurposed chapel and receiving for her efforts the extravagant praises of a French émigré on the matrimonial make, determines that she should, like her heroine, extemporize in front of an adoring public and have her own Capitol moment of glory. Accordingly, Clarissa makes her oratorical debut in the less evocative environs of a crowded Coventry on the first day of the county fair. In spite of having a rival for the crowd's attention—a "naked" woman on a horse representing Lady Godiva—it is Clarissa who proves the more compelling spectacle. Her rousing address urging factory hands to abandon ribbon-making in favor of higher artistic pursuits provokes a riot during which workers surround the houses of the principle manufacturers of Coventry and threaten strike action unless their demands for higher wages are met. Clarissa causes every loom in the "whole city" to cease production and the wives and children of the workers to go supperless to bed.[24] "My niece," wails Mrs. Deborah Moreton to Mary Cuthbert the next morning,

144 / MIRANDA KIEK

"is become the public cry, and the public odium; -she is called an incendiary—an enemy to the country, the friend of the French and a secret emissary of Buonaparte"—a particularly inflammatory statement given the recent commencement of the Peninsula War.[25] Clarissa's crime of having attracted publicity is an equal transgression, in the eyes of Mrs. Deborah, to that of incitement to affray. The wealth of the nation, as much as public order, depends on every one of its members keeping their place (as assigned by the conservative middle and upper classes) within it. When a woman defies her supposedly proper position by seeking some sort of public selfhood, the effects ripple out into wider society.

The Corinna of England blames Clarissa's troublesome femininity on bad education. Anti-Jacobin fiction, especially when aimed principally at female readers, often blurs into educational treatise. Amelia Alderson Opie, Elizabeth Hamilton, and Jane West, who were all publishing novels around that time that were aimed at a similar market to that of The Corinna of England, never failed to exhaustively detail the minutiae of their heroines' educational background. Novelists were in agreement that bringing up little girls to believe themselves to be somehow exceptional or different (as is the case with Hamilton's Bridgetina or Opie's Mrs. Mowbray, for example) results in undesirable adult behaviors.[26] The debate between Edmund Burke and Thomas Paine over whether society is made up of a mass of individuals, everyone with their own inalienable rights (Paine), or of communities in which each sector or platoon has its function or duties that contribute to the working of the whole (Burke), was recapitulated in female pedagogical practice. "Setting aside this slang of modern philosophy," wrote one reviewer in response to Mary Hays's startlingly impassioned novel Memoirs of Emma Courtney, "The plain question is—Whether it is most for the advantage of society that women should be so brought up to make them dutiful daughters, affectionate wives, tender mothers, and good Christians, or by a corrupt and vicious system of education fit them for revolutionary agents, for heroines, for Staëls, for Talliens, for Stones, setting aside all the decencies, the softness, the gentleness, of the female character, and enjoying indiscriminately every envied privilege of man?"[27] The pluralization here both bears witness to Staël's celebrity and also changes her, and her revolutionary peers, from individuals to types.

The vicious female education that *The Anti-Jacobin* feared would turn women into such dangerous types—revolutionary agents, heroines, or Staëls—is identified as one in which little girls are encouraged to believe themselves exceptional. In the case of Clarissa, this encouragement takes the form of her father encouraging her to perform for his friends. This is what underlies her desire for celebrity, to which she gives adult expression in her various artistic and pseudo-intellectual performances. To seek to be "celebrated," as a woman, is made one and the same as the shallow pursuit of celebrity. The publication of *Corinne* had had two effects: it connected female intellectual achievement with artistic performance, and it caused the debate over what constituted proper feminine behavior to take a specifically theatrical turn. When all types of female performance are outlawed, female virtue is rendered more dependent than ever on invisibility, silence, and an existence in the shade. The unknown author of *The Corinna of England* lays down the boundaries of acceptable female behavior, narrowing the definition of a well-behaved heroine.

. . . And the Heroine in the Shade

Antoine Lilti contends that the modern novel paved the way for the emergence of the celebrity biography—both forms contain the story of an individual, a heroine or hero in terms of the narrative but not necessarily in terms of her or his deeds.[28] As a result, the two forms often resembled each other stylistically. This is seen, for instance, in the biographer Adèle de Boigne's novelistic account of the real-life princess Serge Galitzin, which, as Laure Phillip shows later in this volume, borrowed features from the sentimental novel.[29] In other words, there were clear associations between celebrities and the central characters of novels. These were imaginative associations insofar as the biography and novel cross-fertilized each other, and structural associations insofar as the novel's central character is the narrative subject and, like an actress or actor, the object of the reader's or audience's gaze. If, therefore, a heroine is somehow equivalent to a celebrity, and a celebrity is on a par with a revolutionary agent, then how can a conservative novelist write a female-led novel that meets the political demand for propriety? The work undertaken by the unknown author of *The Corinna*

of England is not only to rewrite the exceptional Corinne as the exceptionable Clarissa, but also to solve the political problem of the heroine. The way the unknown author does this is to rewrite or reassign the role of heroine. The reader of Staël's *Corinne* is left in no doubt that the eponymous character and the novel's heroine are one and the same, even though Corinne does not get the man. She is implicitly compared to Sappho, Isabella, and Juliet, all doomed like her and all unmistakable heroines.[30] No such correspondence between eponym and heroine can be drawn in *The Corinna of England*'s case; the author's greatest joke is to make her Lucile-equivalent, Mary Cuthbert, the true heroine of the Corinne tale.

This heroine switch is hinted at in the novel's full title: *The Corinna of England and a Heroine in the Shade*. The bipartite title sets up an opposition and makes a statement of national identity as it does so: in England, Corinne-types are *not* regarded as heroines. Real heroines are women who stay in the shade. What does it mean to be a heroine in the shade? Is it an oxymoronic proposition? We expect a heroine—in a female-focused novel at least—to be a central figure, a main character, a *celebrity* within the terms of the plot. Yet at the heart of the conservative model of womanhood, as laid down by *The Corinna of England*, is the rejection of a woman putting herself forward, being at the front of the stage. How then do you solve a problem like a conservative heroine? Is a conservative conduct-book heroine a self-defeating proposition? This is the epistemological dilemma that the author of *The Corinna of England* attempts to resolve. The author's answer here involves an original narrative strategy that shifts a novel's true heroine from stage to audience.

The reader is alerted to the quiet Mary's heroine status well before her final triumph due to several narrative sleights of hand that foreground her without seeming to do so. Thus, when she is made the focus of narrative attention, it is often only to describe her properly unattention-seeking behaviors, like wearing bonnets that shade her face, or walking through woods rather than driving on roads. Or it is to watch Mary watch Clarissa, as the narrator accords attention both to the actors of a scene (by which I mean the drivers of action or conversation), and to the reactions of their audience. Mary observes and reproves while her flamboyant cousin

pronounces and acts. Mary is made the center of moral judgment, if not the center of action. The theatricality that defines Clarissa's actions is used by the author as a way of structuring narrative relations between characters. Mary is a spectator-heroine. While Clarissa turns every space she occupies into a stage, literal or metaphorical, it is Mary's role to sit quietly, listen, watch, and direct the reader's reactions by giving access to her own. When Mary is shocked, the reader knows she should also be shocked; when Mary blushes (the only acceptable outward performance of interiority, because it is involuntary), the reader knows her countenance should also be "suffused by crimson."[31] Mary is our critic, as she watches and judges: "she saw, with the deepest concern. . . . "[32]

Sometimes the actress-audience relationship between Mary and her extravagant cousin is made explicit within the text. Such is Clarissa's desire to perform, to have her exploits charted, that "in the absence of all beside, Miss Moreton had recourse to her cousin and her ward," and she takes Mary, a usefully portable audience, to London with her in order to witness her effusions on the sublimity of Westminster Abbey (a parodic reference to *Corinne*, in which the heroine takes Lord Nelvil on a similarly intellectually challenging tour of the monuments of Rome).[33] We follow Mary around Clarissa's home, and as we do, we meet the eccentrics who reside there. We listen as her cousin delivers an absurd monologue, and then we are made to notice Mary again as she "look[s] . . . at her cousin with wonder, fear and pity."[34] Mary bookends scenes in which other characters are the focus of the events or discussion. She represents the audience and interiority, reacting and moralizing, and Corinna represents actresses, celebrities, and flashy surfaces, acting and displaying. The novel's hero, Montgomery, is a hero because he can see past Clarissa's showy looks and money, and detect Mary's moral worth and quiet blushing beauty; she is a heroine in spite of herself. In *The Corinna of England*, the observer-heroine is developed in order to solve the problem of the performer-heroine. The archetype of the watching heroine, the heroine who is not an actress, who is not seduced by the theater and its subversive celebrity values, must in some way be viewed as answering the need for an anti-Jacobin counterpoint to Corinne. Thus we learn from *The Corinna of England* that theater becomes a structural feature as well as a theme within the plot. In

other words, one effect of Staël's novel was to make play-acting the preferred metaphor in British conservative fiction for women's proper and improper relationships to the public realm.

From Corinne to Fanny Price

By using *The Corinna of England* as a focusing lens, we can trace the impact of *Corinne* on other literature of the time, even when there is no explicit allusion to *Corinne* or no central female genius to make this legacy easily apparent. To demonstrate this, I am using Austen's *Mansfield Park* as a case study, not to claim that Austen read *The Corinna of England*—though she may have done so—but rather to suggest that *The Corinna of England* clarifies how the political reaction against the performing heroine precipitated literary innovation.

Literary critics approach Fanny Price as a puzzle or a code in need of cracking. She is different from Austen's other heroines: where they act, Fanny observes and resists; where other heroines have tempers, make acerbic comments, or get into scrapes, Fanny dutifully kisses the rod that beats her. That Fanny is supposedly in some way unlikeable has led to study after study attempting to explain why Austen created quite such an "unyieldingly charmless heroine."[35] Even those who forgive Fanny for not being Elizabeth Bennett are driven to write exculpations.[36] All critics, however, agree that if Austen indeed created a heroine that nobody likes, she must have had a reason for doing so. Thus Fanny becomes the ultimate signifying heroine. She is Austen's Christian heroine, the author's defense of sentimentality, and criticism of conduct-book morality. Fanny is even a Gothic monster. In other words, scholars consider Fanny Price to be markedly different from any character written by Austen before Staël's *Corinne* took the debate over female celebrity and put it into a novel. The differences Fanny embodies—timidity, Englishness, quietness, depth—make her into an anti-Corinne.

Fanny begins the novel from the position of an audience member, and her driving motivation seems to be her all-conquering desire to remain there. She is defined by her unwillingness to perform. Given the problematic nature of finding Staël in Austen on a micro-level, I argue that Staël's impact, either direct or mediated, is evident in the architecture of *Mansfield Park* in the plot, scene

structure, and character contrasts, and not in the minutiae of plot points or language patterns. Like the unknown author of *The Corinna of England*, Austen responded to the challenge of how to write a novel in which the heroine is "in the shade." She too realized that theater can be used as both a structural device and theme and created a narrative that positions the heroine alongside the reader as spectator and interpreter.[37] It is my contention that this dynamic, which replicates that of *The Corinna of England*, is a response to the celebrity cult of *Corinne*.

Fanny Price, like *The Corinna of England*'s "heroine in the shade," is found at the edges of a scene. While Mary Crawford, Fanny's beautiful, witty rival, plays her harp sitting by a full-length window framed by summer foliage, like the proscenium arch of a theater, Fanny frequently slips out of view. "Where is Fanny? Is she gone to bed?" asks Edmund, looking around yet failing to perceive her lying on a sofa at the edge of the room.[38] Or she is forgotten for days on end, as Mary Crawford, with excruciating symbolism, expertly and energetically rides a mare Edmund bought for Fanny. When Edmund forgets his promise to go stargazing with his young cousin because Mary has started to sing a glee, Fanny is again found scenically at the edge of the room and narratively at the end (or edge) of the chapter, sighing "alone at the window."[39] The performer (Mary) may be Edmund's focus, but the performer's audience (Fanny) is the reader's focus. There is a scene in Maria Edgeworth's *Patronage*, which was published the same year as *Mansfield Park*, when the hero proves his moral mettle during a private theatrical by being less interested in the beauty acting on stage (who had engineered the performance for the purpose of attracting his attention) than in the novel's true heroine in the audience. But in Austen's novel, Fanny's self-appointed tutor Edmund fails this theatrical test, dazzled by the talents of the celebrity-like anti-heroine.

Critics refer most frequently to two incidents in which Fanny is positioned at the edge of the action; both occur in the first volume of the novel. In the first episode, an exhausted Fanny rests on a bench in the wilderness at Mr. Rushworth's seat of Sotherton, watching the rushed comings and goings and listening to the intimate conversations of the rest of her party. Henry Crawford flirts openly with Maria in front of Fanny's very eyes (in an exchange that, as Paula Byrne observes,

reads like a ready-made script),[40] Julia flies past her desperately trying to catch up with her older sister, and Edmund and Mary tease each other about the length of the path down which they have just walked. As with Mary Cuthbert observing the eccentricities of her cousin ("she saw, with the deepest concern. . . . "), Fanny is the audience member and moral arbiter, "sorry for almost all that she had seen and heard."[41]

The second of these episodes, which is even more discussed than the scene in the wilderness at Sotherton, is of Fanny's resistance to performing in *Lover's Vows*—a private theatrical that the young people of Mansfield Park attempt to stage during Sir Thomas's absence at sea. "I cannot act," says Fanny famously, and this refusal is widely seen as exemplary of her character and a representative function within the novel.[42] Fanny's refusal, however, needs to be understood in the context of Staël and her performing heroine having, if not created, at least cemented and underlined a set of connections linking foreignness and immorality to heroineship and female performance. We might note here that a dismayed Edmund is obliged to justify the readiness of Fanny's romantic rival, Mary Crawford, to take part in the theatrical very much in the terms of a second Corinne. "The charm of acting" he concedes, "might well carry fascination to the mind of genius" (the excessive use of the term "genius" in *Corinne* is poked fun at in its anonymous parody).[43] By including a private theatrical in *Mansfield Park*, Austen therefore makes explicit the great distance between her observer-heroine and acting anti-heroines such as Clarissa Moreton; so far is Fanny from a celebrity like Staël's Corinne that she is hardly even noticed within her own home. Fanny's position as rehearsal spectator does more than literalize her narrative position within the novel, it also allows her to bear public and active witness to a political conviction. Fanny's seat in the audience is a rejection of Mary's— and thus of Clarissa and Corinne's—showy celebrity. Thus, *Mansfield Park* is a manifesto for a new sort of heroineship founded not on glamour and celebrity, but on conservative political propriety.

Intellectualism and Celebrity

One of the consequences of the publication of Staël's *Corinne* and, indeed, of the increasing celebrity of the celebrated Staël

herself, was to strengthen the association between undomesticated womanhood and intellectual pursuits. After radical women such as Mary Wollstonecraft, Mary Hays, and Helen Maria Williams became prominent in the 1790s war of ideas and the ideology of female domesticity was made a component of "Britishness," conservative attitudes toward female intellectualism changed from cautious indulgence to, in some quarters, outright hostility. In anti-Jacobin writing, learnedness was a key characteristic of the dangerous (or risible) female new philosophers, as in Richard Polwhele's famous poetic satire *The Unsex'd Females* (1798). Ironically, however, France was an even less hospitable environment for female learnedness than Britain. Any tolerance for *les femmes savantes* had ended with the Revolution. Staël had apparently once asked Napoleon, "Whom he esteemed the best woman in the world, alive or dead?" only for him to reply, "Her, Madam, that has borne the most children."[44] *Corinne* attempts to reassert women's right to be both intellectual and admirable. Corinne cannot be a conventional timid Englishwoman, she explains to Lord Nelvil, for had she meekly put up with the insipid conversation of proper English ladies, her extraordinary talents would have moldered away for lack of stimulation. And do not women too, she asks, have a duty to cultivate the talents given to them by God? For Corinne, domesticity and intellect are antithetical if not mutually destructive. Thus in Corinne we have Staël's defense of the intellectual woman and the exceptional woman—the woman who seeks heroineship.

Corinne's mounting of the Capitol challenges Polwhele's condemnation of women like Wollstonecraft, "the Heroine" whose "mind by Genius fraught, by Science stor'd . . . mount[s] the dazzling dome" of Parnassus.[45] Staël's Corinne, however, is very unlike Wollstonecraft in that she combines her intellectualism with theatrical performance and celebrity. This, I want to suggest, gave some conservative writers an opportunity to create an acceptable form of feminine intellectualism. It has been argued so far that one of the literary effects of Corinne on writing of the period was to make the heroine an observer and the anti-heroine a performer. As the performing anti-heroine exists in binary with the observing heroine, so must the latter possess opposite associations to the former. This means that if the performer is all surface and theatrical

display, then the observer must be all interior and deep thought. The theatrical Clarissa, for instance, quickly forgets the plight of some impoverished tenants on her estate in spite of an initial extravagant display of pity, while quiet Mary, who truly feels compassion, proves a faithful friend. Here we return to Fanny Price, the ultimate thinking, feeling, and not acting, heroine. She eschews the showy arts of music and drawing (to her cousins' mystification). Instead, she spends her time reading and, more importantly, she does not just read but reads deeply, analyzing and discussing what she has read with Edmund. Fanny has true intelligence, not wit—Mary Crawford, we might remember, ends every performance on her harp with a witty comment—the ability to judge rightly rather than utter *bons mots*. Real intelligence is untheatrical, not drawing attention to itself. When Fanny refuses to act in the theatrical, she accepts the role of "judge and critic, and earnestly desired to exercise it and tell them all their faults."[46] As it is in the play episode, it is in the narrative as a whole. Fanny is the only one to "judge rightly" throughout the novel—the word "judge" and its cognates are repeated constantly, and all but Fanny are shown to judge wrongly. Her infallibility is a result of not performing but watching, of rejecting the stage for a place in the audience. Edmund is "blinded," but Fanny never is. The observer-heroine gains intellectual superiority over even the hero-tutor by the mere fact of her ability to watch and judge.

Rejecting the celebrity performer model of heroineship is made into an opportunity for advancing an acceptable model of female intellect. This response is to an extent anticipated in *The Edinburgh Review*'s assessment of Staël's *Corinne*, which refutes the claim that cleverness is the preserve of Englishmen alone. "The very circumstance of not being destined for active or public life," the critic opines, "renders the conversation more intellectual, more connected with general principles, and more allied to philosophic speculation. Their taste, also, is often more cultivated; and we have known instances, where the daughters of a family could relish the beauties of Racine and Mestasio, while the sons could not converse on any thing [*sic*] but hunting, horse-racing, or those methods of *training*, by which the talents of men and of horses are brought as near as possible to an equality."[47] As Fanny's story begins to

move along more conventional heroine lines in the second two volumes—Cinderella gets her ball and two men wishing to marry her—she struggles to cope with the attention, all the admiring looks she receives, and retreats to her room when possible. Whereas Mary Crawford always takes an energetic part in conversation, Fanny must be coerced from observation into speech. Like Mary Cuthbert, Fanny is a heroine who resists being a heroine. It is the female Quixote novel in reverse, as instead of the narrative reducing a heroine to a wife, it pushes Fanny from sidelined watcher into heroine—a heroine without an exceptional talent, or a tragic past, and no more in the way of good looks than soft eyes and a fine skin.

This chapter has sought to show that the reception of Staël's *Corinne* introduced the conversation about female celebrity to the conservative novel. There, the response to this celebrity in fiction (or its small-scale equivalent, the central figure of any group) was to create an anti-celebrity heroine who was an astute observer. This was the forerunner of a new type of novel narrative, in which the central figure was not the protagonist, but rather the watcher in the audience—from Fanny Price, to Evelyn Waugh's Charles Ryder, to the women of Barbara Pym.

Rejecting the role of performer, however, did not mean accepting a role of domestic nonentity. It meant becoming an observer, an audience member, a judge, and a critic. When conservative female authors such as Austen wrote about the relation of women to the public realm, or to performance, it was not to assert the superiority of domestic interiors but rather the superiority of intellectual interiority. Women were not *not* part of the public realm, but their role within it was to watch and not perform. This chapter has charted how Staël's *Corinne*, a novel written by a celebrity about a celebrity, led to the creation in England of a new type of observer-heroine who was imaginatively constituted in the context of the moral assassination of the performing woman—the celebrity woman.

Notes

1. "Multiple Classified Ads," *Morning Post*, June 15, 1807.

2. Germaine de Staël, *Corinna, or Italy*, 3 vols. (London: S. Tipper, 1807). The preface to Lawler's translation (see note 3 below) suggests that it was the work of more than one translator. Newspapers advertising *Corinna*

as being published "this day" appeared on several different dates in July and August. In the initial advertising campaign, *Corinna* received four adverts in the *Morning Chronicle*, six in the *Star*, and one in the *Edinburgh Evening Courant* (information for different newspapers has not been collected). This compares favorably with other such campaigns—Charlotte Dacre's *The Libertine* (1807) received two adverts in the *Morning Chronicle* and six in the *Star*; and Maria Edgeworth's *Leonora* (1806) received two in the *Morning Chronicle* and three in the *Edinburgh Evening Courant*. Information collated from "British Fiction 1800–1829: A Database of Production, Circulation & Reception," accessed February 6, 2020, http://www.british-fiction. cf.ac.uk.

3. Germaine de Staël, *Corinna, or Italy*, trans. D. Lawler (London: Colburn, 1807).

4. For example, the S. Tipper translation was reviewed in the *Monthly Review*, October 1807, 152–59, and the *Critical Review*, November 1807, 281–84. See "British Fiction 1800–1829"; *The Edinburgh Review Or Critical Journal* (A. and C. Black, 1808), 183–95 (originally Oct 1807). Staël was a famous name in England as in France, and she had been appearing in gossip columns of English newspapers since at least the late 1790s. Staël's celebrity was stressed in these reviews through the capitalization of her name in advertisements and the blurbs used for publicity, which were unusual for the time.

5. Exceptions include Angela Wright, "Corinne in Distress: Translation as Cultural Misappropriation in the 1800s," and Sylvia Bordoni, "Parodying Corinne: Foster's The Corinna of England," both in *Corvey CW3 Journal* 2 (Winter 2004), accessed February 6, 2020, https://www2.shu.ac.uk/corvey/ CW3journal/Issue%20two/bordoni.html; Erik Simpson, "'The Minstrels of Modern Italy': Improvisation comes to Britain," *European Romantic Review* 14, no. 3 (September 2003); and Ellen Peel and Nanora Sweet, "Corinne and the Woman as Poet in England: Hemans, Jewsbury, and Barrett Browning," in *The Novel's Seductions: Staël's "Corinne" in Critical Inquiry*, ed. Karyna Szmurlo (Lewisburg, PA: Bucknell University Press, 1999), 204–20.

6. Germaine de Staël, *Corinne, ou l'Italie*, 3rd ed., vol. 1 (Paris: Frères Mame, 1807), 48. Translations my own.

7. Ibid., 49.

8. Staël, *Corinna, or Italy* (Tipper, 1807), 1:55; Joseph Roach, "Public Intimacy: The Prior History of 'It,'" in *Theatre and Celebrity in Britain, 1660–2000*, eds. Mary Luckhurst and Jane Moody (London: Springer, 2005), 16.

9. As far as I have researched, Gatsby of F. Scott Fitzgerald's *The Great Gatsby* is the only celebrity in fiction who has been systematically analyzed as such. See for example: Allan Hepburn, "Imposture in 'The Great Gatsby,'" in *Modernist Star Maps: Celebrity, Modernity, Culture*, ed. Aaron Jaffe (London: Routledge, 2016), 55–70.

10. S. Tipper's edition translated the original French "improvisatrice" not as "improviser" but as "a composer of extempore rhymes," and added an explanatory note at the bottom of the page stating, "The *improvisitore*, or art of composing extemporary verses, is an accomplishment peculiar to the Italians." Staël, *Corinna* (Tipper, 1807), 1:51–52.

11. See for instance Jane West's Lady Pauline Monthermer, who was in the words of a reviewer in *The Lady's Monthly Museum*, "a copy of the celebrated Corinna" (Mrs. West, "THE LITERARY SPY," *The Lady's Monthly Museum*, July 1, 1810, 47.) Monthermer appears in West's novel *The Refusal* (1810). See also Rosamunda, the aggravating governess in "Vivian" from Maria Edgeworth's *Tales of Fashionable Life* (1812); and Charles Maturin's Zaira, from *Women: Pour ou Contre* (1818).

12. M.O. Grenby posits the existence of a recognized and coherent genre of anti-Jacobin novels, and identifies at least fifty novels published in the years 1791 to 1805 as belonging to it: *The Anti-Jacobin Novel: British Conservatism and the French Revolution* (Cambridge: Cambridge University Press, 2001).

13. Staël, *The Corinna of England, Or a Heroine in the Shade; A Modern Romance*, ed. Sylvia Bordoni, Chawton House Library Series (New York: Routledge, 2008), 78. All quotations refer to this edition.

14. Ibid., 78.

15. Ibid., 48, 118. Laure Philip notes the way in which, for celebrity women, Romantic conceptions of genius were not enough to counterbalance immorality. The case here is marginally different insofar as, for conservative authors, female celebrity was in and of itself problematic. See Philip in this volume, 257–68.

16. A German play translated by Elizabeth Inchbald from August von Kotzebue's *Das Kind der Liebe* (1791).

17. See, for example, the account of French celebrity actors at Staël's salon in the *Morning Post*, September 13, 1806.

18. Staël, *Corinna* (2008), 33.

19. Janine Marie Haugen, "The Mimic Stage: Private Theatricals in Georgian Britain" (PhD diss., University of Colorado, 2014), 239.

20. Jane Austen, *Mansfield Park: Authoritative Text, Contexts, Criticism*, ed. Claudia L. Johnson (New York: W.W. Norton, 1998), 86. All references are to this edition.

21. *Morning Chronicle*, August 17, 1808, and *Morning Post*, August 20, 1808.

22. Staël, *Corinna* (2008), 27.

23. Ibid., 42.

24. Ibid., 86.

25. Ibid., 85.

26. Bridgetina Botherim is the self-deluding anti-heroine of *Memoirs of Modern Philosophers* (1801), and Mrs. Mowbray is the mother of the title character in *Adeline Mowbray* (1804).

27. *The Anti-Jacobin Review and Magazine; or Monthly Literary Censor* 3 (1799), 54. Talliens, or Thérésa Cabarrus, Madame Tallien (1773–1835), was one of the most famous women of her age. She was a French-Spanish noblewoman, revolutionary politician, salon leader, double-divorcée, and performer of the Goddess of Reason. Stones was the radical activist and chronicler of the Revolution Helen Maria Williams, believed by some to have married the radical reformer John Hurford Stone after he scandalously abandoned and divorced his first wife.

28. Antoine Lilti, *Figures publiques, l'invention de la célébrité 1750–1850* (Paris: Fayard, 2014), 74.

29. Laure Philip, this volume, 253–54.

30. The sonnets of praise read during the coronation scene draw a female literary lineage connecting Sappho to Corinne, and Lord Nelvil wonders if Corinne is an "Armida or a Sappho" (Staël, *Corinna* (1807), 1:112); Corinne watches Sarah Siddons perform the tragic Isabella from Thomas Southerne's *The Fatal Marriage* (ibid., 3:196–203), and she herself acts Juliet in front of Lord Nelvil. (ibid., 1:374–91).

31. Staël, *Corinna* (2008), 57.

32. Ibid., 54.

33. Ibid., 90.

34. Ibid., 32.

35. Quote taken from Nina Auerbach, "Jane Austen's Dangerous Charm: Feeling as One Ought about Fanny Price," *Persuasions* 2 (1980): 9.

36. See for instance: Lionel Trilling, "Mansfield Park," in Trilling, *The Opposing Self: Nine Essays in Criticism* (New York: Viking Press, 1955), 208–30; Emily Auerbach, "All the Heroism of Principle: Mansfield Park," in Emily Auerbach, *Searching for Jane Austen* (Madison: University of Wisconsin Press, 2004), 166–200; Amy J. Pawl, "Fanny Price and the Sentimental Genealogy of Mansfield Park," *Eighteenth-Century Fiction* 16, no. 2 (January 2004): 287–315, accessed February 6, 2020, https://doi.org/10.1353/ecf.2004.0040; Margaret Kirkham, *Jane Austen: Feminism and Fiction* (New York: Harvester Press, 1983); Claudia L. Johnson, *Jane Austen: Women, Politics, and the Novel* (Chicago: University of Chicago Press, 1990).

37. There are other, more discrete plot parallels in that both a supposedly sacrosanct patriarchal space (a chapel and Sir Thomas's library) is made over to theater, and in both, fire is used as a means of cleansing the theatrical "infection" (Clarissa dies in the Covent Garden Theater fire, Sir Thomas burns copies of *Lover's Vows*).

38. Austen, *Mansfield Park*, 51.

39. Ibid., 81.

40. Paula Byrne, *Jane Austen and the Theatre* (London: Hambledon and London, 2002), 181.

41. Austen, *Mansfield Park*, 71.

42. Ibid., 102.

43. Ibid., 92.

44. Richard H. Horne, ed., *The History of Napoleon* (London: R. Tyas, 1841), 131.

45. Richard Polwhele and Thomas James Mathias, *The Unsex'd Females; a Poem, Addressed to the Author of The Pursuits of Literature* (New York: Reprinted by Wm. Cobbett, 1800), 19.

46. Austen, *Mansfield Park*, 118.

47. *The Edinburgh Review* 21 (October 1807).

CELEBRITY ACROSS BORDERS

The Chevalier d'Eon

CLARE SIVITER

Two centuries after their death, the Chevalier d'Eon's sex is still cause for confusion. The art dealer who sold Thomas Stewart's 1792 portrait of d'Eon to the National Portrait Gallery in London had tried cleaning the canvas, but the stubble on the lady's face remained.[1] After its acquisition in 2012, visitors transitioning between galleries met an aging woman in the portrait wearing a black hat with a tricolor ribbon of red, white, and blue, and a white feather. The red of her hat ribbon is picked up again by the decoration pinned to her breast: upon closer inspection, the military Cross of Saint Louis (see Figure 7.1). In the eighteenth century, the French army was theoretically off-limits to women, but the eighteenth-century viewer would have recognized the Chevalier d'Eon, who they believed to be a woman who had dressed as a man to fight for her country.

The Chevalier d'Eon was a celebrity of their day; their tumultuous life has given rise to over twenty biographies and continues to inspire artistic productions. D'Eon became a lively case study for research in the 1990s and early 2000s on eighteenth-century conceptions of gender on both sides of the Channel.[2] In reality, d'Eon was an anatomical male who made the conscious decision to live as a woman in the 1770s. The most complete account of their life to date is by Gary Kates, whose biography continues to be the reference work for recent scholarship on d'Eon.[3] Kates argues that

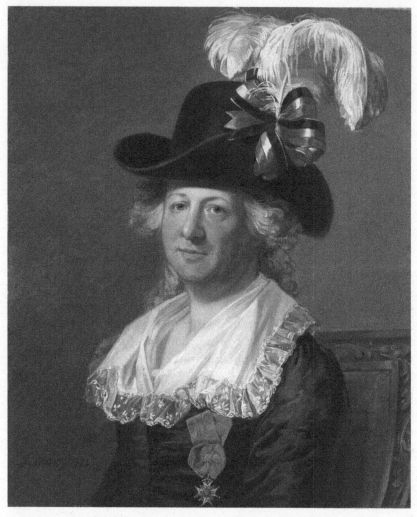

Figure 7.1. *The Chevalier d'Eon*, by Thomas Stewart, after Jean Laurent Mosnier (1792). National Portrait Gallery, London.

we should see d'Eon's cross-dressing as "gender dysphoria," not as proof that d'Eon was transsexual, and that "[d]'Eon came to a cognitive decision that it was best for him to live life as a woman," principally for political reasons, to avoid being condemned as a traitor.[4] During their lifetime, d'Eon and contemporary publications used both masculine and feminine pronouns when writing

about the Chevalier. Although scholars have often used masculine pronouns for d'Eon when writing in English, in light of the debate that the National Portrait Gallery's Instagram post created in June 2020 and the Gallery's subsequent change of pronouns for d'Eon, in this chapter I have followed the Gallery's use of the singular "they" when referring to d'Eon in English unless referring specifically to primary material being reproduced.[5]

Born in 1728 in Tonnerre, in North Central France, Charles-Geneviève-Louis-Auguste-André Timothée d'Eon de Beaumont received their legal training before joining the Secret du Roi in 1756, a top-secret spy network for Louis XV run by the Prince de Conti. D'Eon was sent to Russia that year in France's bid to dash the alliance between Russia and Great Britain. Toward the end of the Seven Years' War, d'Eon became a dragoon captain in the French army and saw military action. Then they were nominated as secretary to the Duc de Nivernais, making them one of the diplomats responsible for negotiating the treaty in London in 1762 that concluded the Seven Years' War when it was signed in 1763. Nivernais was replaced as ambassador by the Comte de Guerchy in 1763, and in the interim between the two men's tenures, d'Eon was nominated plenipotentiary minister to act temporarily in their place. It was also in this year that Louis XV awarded d'Eon the Cross of Saint Louis, a military order this time delivered for d'Eon's diplomatic efforts. Significantly, the award elevated d'Eon to the rank of "chevalier," a knight.

Until that point, d'Eon had led a successful diplomatic career, but in 1763, their life took a remarkable turn that would blur the border between public and private and ultimately grant them celebrity status. While the newly minted chevalier was in Paris to receive the Cross of Saint Louis, the Secret du Roi resumed contact with d'Eon, with plans to assess suitable sites for a French invasion of Britain and to influence the British Parliament. D'Eon received a note detailing the reconnaissance proposal signed by Louis XV himself. They worked diligently and, using their diplomatic status, led an extravagant campaign of wining and dining British political elites for France's benefit. However, French ministers, unaware of the king's secret ideas, were angered at such expense and informed d'Eon that they would be demoted to secretary to the ambassador.

Following their protestations, d'Eon was recalled to France, an order that they indignantly ignored, as returning to France would threaten the Secret's invasion plan. When French ministers remonstrated, Britain refused France's extradition request. After a vitriolic dispute with Guerchy during which they openly accused the ambassador of attempted assassination, d'Eon could portray themself as a victim of the French state.

The scandal increased in 1764 when d'Eon published *Lettres, mémoires et negotiations*, detailing their side of the Guerchy affair and making public diplomatic correspondence from France's most senior ministers. This act showed the French state that d'Eon was prepared to publish sensitive diplomatic information if their demands for financial and physical security were not met (they had not yet published Louis XV's compromising letter). The *Lettres* was welcomed by a "sensational reception," turning d'Eon into a celebrity overnight.[6] Kates explains the shock the *Lettres* caused: d'Eon had made secret diplomacy public and in so doing they were "submitting King Louis XV to the judgment of a higher authority: public opinion."[7] What made the exposed events even more believable is that a fellow Frenchman and spy, Pierre-Henri Treyssac de Vergy, formally testified that France had attempted to murder d'Eon. The public fallout from this affair led Louis to allow d'Eon to stay on as a spy in Britain to report on the island's politics, and accord them a lifelong annual pension of twelve thousand livres.[8]

The public quarrel in the press between d'Eon and Guerchy during 1763 and 1764 has been analyzed in relation to celebrity by Simon Burrows, who asserts that this media war taught d'Eon how "to fabricate evidence and to mold his public identity," laying "the groundwork for d'Eon's later celebrity and manipulations of his gender."[9] In short, this was d'Eon's training, starting a lifelong "need" for celebrity.[10] This chapter takes the baton from Burrows and both investigates how d'Eon implemented the lessons in celebrity that they had learned in Britain during their official political and diplomatic career and analyzes their efforts to remain in the public eye. It builds on new work in Celebrity Studies and questions the particular celebrity status d'Eon had compared to their contemporaries as a nonbinary individual living on both sides of the Channel. The first case study here is d'Eon's transition from

living as a man to a woman during the 1770s. This episode includes their return to France, which critics link to the end of their career and thus often ends their analysis. I show that d'Eon remained active in their efforts to sustain their celebrity, which was fueled by a European-wide curiosity. The Chevalier's days were far from over. The second case study is d'Eon's little-studied use of their celebrity in their attempt to return to France during the Revolution. Once again, this episode has received scant attention in d'Eon's biography but, using archival material, I expose d'Eon's continued attempts to use their celebrity to return home. This chapter brings the debate over d'Eon's gender to new ground and extends scholarly interest to their later years, as the political system that had borne the invention of celebrity crumbled.

Trials in Celebrity: The 1770s

D'Eon may very well have been a diplomatic celebrity in the 1760s, but their celebrity grew enormously with speculation about their sex in the 1770s. This is an excellent case study with which to evaluate the mechanics of the model of celebrity proposed by Antoine Lilti.[11] Lilti posits that curiosity for the private lives of famous individuals is essential in the creation of their celebrity, and that this confirms the uncritical nature of the public sphere. Using Lilti's theories along with contemporary documents, both archival and published, allows us to uncover new insights into questions concerning gender and national identity in the late eighteenth century. Scholars tend to agree that d'Eon's transformation was politically expedient and allowed them to reshape their image from traitor to heroine.[12] By analyzing the period when d'Eon refused to return to France closely, however, we can see how they played on the public sphere's uncritical nature with regard to their celebrity to ensure their own security.

Women dressing as men and vice versa were not as uncommon in the eighteenth century as hindsight might lead us to believe.[13] The Amazon was a key trope in the eighteenth-century understanding of women cross-dressing for combat, and Kates situates d'Eon alongside other contemporary women, such as Hannah Snell, who donned men's clothes to enter the military.[14] There were two

principal periods in the 1770s of scandal surrounding d'Eon's gender. The first was the initial "discovery" of their true sex over time from 1770 to 1772, when d'Eon was based in England, and the second was at the height of the court cases around this matter in 1776 and 1777, as d'Eon prepared to return to France. Although the source of the gossip that d'Eon was a woman remains unknown, Kates charts how these rumors started to spread in both France and Britain in 1770. By the end of that year, Louis XV was already informed, and by 1771, d'Eon's tale was firmly part of the Parisian gossip circuit. A few months later, the "news" had crossed back across the Channel, taking the English press by storm and being swiftly incorporated into satirical prints.[15] By March, someone had placed a bet of £800 on the Chevalier's real sex, and the sum reached £60,000 in May.[16]

It was also at this time that d'Eon expanded their network of contacts who were instrumental in fueling their celebrity, such as pamphleteer and hack writer Charles Théveneau de Morande, discussed by Gabriel Wick in this volume. Some critics then and now allege that the gossip about d'Eon was a hoax meant to profit them,[17] but even if the gender debate was not the result of a scam by d'Eon, we can see the Chevalier as complicit through their interactions with the press and agents such as Morande. However, d'Eon was soon uncomfortable with the situation, and the sheer sums bet by individuals on their sex are undeniable evidence of the public's interest in the most intimate details of a celebrity individual's life and body, and the extent that people were willing to go to learn those details. What is more, Lisa Forman Cody has convincingly shown through her analysis of the prints of d'Eon that the furor surrounding their gender transformation was heightened because they were a foreigner: "it was because he was French and thus had, a priori, a potentially plastic body and sexually polyvalent tendencies."[18] This is a noteworthy example of the uncritical public sphere that Lilti advances in his study to revise the traditional Habermasian concept.[19] D'Eon's celebrity could have had political consequences, demonstrating powers attributed to the public sphere like stirring anti-French sentiment or putting pressure on the British government, but the above analysis reveals how celebrity itself came through curiosity rather than critical reason.

Femininity did not come easily to d'Eon. In 1772, Louis XV received a report that a physical examination of d'Eon confirmed that the Chevalier was indeed female, and henceforth they were considered a woman in the eyes of the French state. However, the Chevalier—a title that *a priori* only existed in the masculine—was in London at this time, beyond the grasp of the French crown, and so continued to wear male military clothing until 1777. As Stephen Brogan records, d'Eon "made no effort to feminize himself emotionally or behaviourally, and so his contemporaries commented regularly upon his masculinity."[20] Brogan notes that d'Eon continued to respond to the masculine "Monsieur Chevalier" rather than the feminine "Madame Chevalière," and actively accentuated their physical masculine features, speaking in a low voice, sometimes letting their masculine facial hair be evident, and even showing off their shapely legs.[21] The juxtaposition between d'Eon's behavior and physical appearance, and then their reputed female anatomy, meant that their sex remained much commented on. Considering these comments stemmed from d'Eon's own actions, we can question whether the Chevalier acted consciously so as to fuel the curiosity necessary for the cultivation of their celebrity.

D'Eon's sex was also deliberated, and left for open interpretation, via prints such as *A French Capt. of Dragoons Brought to Bed of Twins* (1771) and *The Trial of M. D'Eon by a Jury of Matrons* (1771). In the first print, d'Eon lies in bed, swaddled in sheets, attended by the radical politician and known libertine John Wilkes. Cody has recorded how Wilkes was reputed to be the father of the twins d'Eon had supposedly borne,[22] and his hand pointed toward d'Eon's genital area emphasizes d'Eon's womanhood. However, the title of the print keeps d'Eon as a man—a "captain"—and "his" military armor hangs above the bed. In the second print, d'Eon is inspected by a jury of matrons who are supposed to decide upon their sex. D'Eon is naked, but for a hat and their Cross of Saint Louis, which conveniently hides most of their chest. A well-positioned drape and a piece of paper mask their genital area, a double coverage that suggests that d'Eon's sex is not just hidden by their clothing, but also by the printed word, echoing the debates in the contemporary press. These two prints are emblematic of the media

coverage that gave the public just enough salient details to debate the d'Eon polemic.

The furor surrounding d'Eon reached new financial and legal heights in 1776 and 1777. That the first issue of the Franco-British *Courier de l'Europe* dedicated two articles to the Chevalier on the front page of its first issue testifies to the extent to which d'Eon was an established celebrity on both sides of the Channel. These two pieces were symptomatic of the general commentary about d'Eon at that time. The first was more factual, explaining that such commentary was simply a way of filling newspaper columns; the second was pure gossip, maintaining that the Chevalier had been found in a French nunnery (they were still in England at this time). Playing on the erotic topos of the convent, in describing d'Eon's dress among the nuns the article exclaimed, "how that pricks your curiosity!" [quel aiguillon pour la curiosité!].[23] In theory, d'Eon was meant to have returned to France following the "Transaction" agreement in 1775 with the new King Louis XVI, facilitated by spy and playwright Pierre-Augustin Caron de Beaumarchais. However, d'Eon had not yet returned to France as ordered and had fallen out with Beaumarchais and their ally Morande. This time, the French government played d'Eon at their own game, making their secret correspondence with Louis XV public via the English press. The Chevalier could henceforth be portrayed as a foreign spy, leading them to fall out of favor with many Londoners.[24]

Regardless of the political stakes, debate around the Chevalier's sexual attributes increased in August that year when Morande claimed to have physical proof of d'Eon's true sex, and the subject was regularly discussed with opinionated commentary until March 1777 in newspapers such as *The Public Ledger, The Westminster Gazette, The London Packet, The Morning Post*, and the *Gazetteer*.[25] New prints also appeared, such as *Mademoiselle de Beaumont, or the Chevalier d'Eon. Female Minister Plenipo. Capt. of Dragoons* (1777). This striking full-length portrait of d'Eon is split down the middle: the left-hand side is d'Eon as a woman, complete with fan, powdered hair, and necklaces, while the right-hand side is d'Eon as a man, hat hiding behind their back, the Cross of Saint Louis pinned to their chest, and sword at their side. The betting war surrounding d'Eon reached such a point that a civil case on

the matter, Hayes v. Jacques, reached the court of the King's Bench and Lord Mansfield, Lord Chief Justice. *The Westminster Magazine* reported Morande's testimony that d'Eon was a woman.[26] Morande, as a pamphleteer, understood the importance of detail in mediating the public image of a celebrity figure and, as such, "added to [his testimony] some particulars, which excited the laugh of all the persons in the Court." The titillating details that sparked the public's curiosity included a scene in which d'Eon allegedly took Morande's hand and let him touch "her" genitals while "she" was in bed in 1774.[27] Morande was an important agent in the cultivation of d'Eon's celebrity, and therefore it is even more interesting to find that he was the sworn interpreter for the French doctor who attested d'Eon's physical sex for the court case (in reality, he had not actually examined d'Eon's genitals). Morande could potentially add a slant to the doctor's evidence or present it in such a way that he once again inflated the exciting details that made gossip about the Chevalier so rife.

D'Eon was deeply hurt by the trial, even if it was a success in terms of promoting their public image. Lilti has detailed how the bodies of famous people became commodities through prints during the media revolution that accompanied the invention of celebrity,[28] but d'Eon's experience went a step further in breaching the gap between public and private. Public interest in this noble body—that of a knight no less—had turned the most intimate details of d'Eon's private life into a public object that could be worth up to £200,000.[29] Such hype had driven other contemporary celebrities such as Jean-Jacques Rousseau to retreat from public life by 1770. Unlike with other celebrities like Rousseau or Voltaire, however, the invasion of d'Eon's private sphere was much more extensive and intrusive, notably by the courts investigating their genitalia. The public's interest in d'Eon's gender and national identity tied their celebrity to this invasion.

Shortly after the trial, d'Eon returned to France on August 14, 1777, and finally had to adopt women's clothes on Louis XVI's orders. Part of the "Transaction" agreement with the French king bettered d'Eon's finances, as their pension was set to become a lifetime annuity, and d'Eon's new wardrobe was to be made by the queen's dressmaker, Rose Bertin, at the Crown's expense. Regardless

of the extra cost, the decision to foot the bill for d'Eon's material transition revealed the Crown's desire, moreover its need, for the Chevalier to be confined to one gender in an attempt to eliminate the commotion around a woman openly wearing a military uniform. Indeed, this military uniform also posed legal problems that d'Eon played on later in life: their appointment as a dragoon was a lifetime commission, but d'Eon had now essentially been stripped of their rank. However, Louis XVI did allow d'Eon to retain the privilege of wearing the Cross of Saint Louis that adorned their chest, thereby distinguishing themself from all other women. The Cross was much remarked upon by contemporaries and, as we see in Stewart's portrait and prints of d'Eon, it became symbolic of the Chevalier: pinned onto female clothing, it made d'Eon instantly recognizable. As a woman, though, d'Eon was stripped of their position and employment, and their "public career was virtually finished."[30]

Contrary to this general belief, d'Eon's career was not over: their celebrity kept them in the public eye despite their de facto physical banishment to their hometown of Tonnerre. 1779 was a spectacular year for d'Eon and their celebrity in Continental Europe, and I contend that this would not have been possible without the scandal of 1776 to 1777 in Britain that then spread to France. In the intermittent year, the Chevalier published an epistle, the press continued to talk of them, and the prints of them still circulated. Kates lists how d'Eon dined with Voltaire and Benjamin Franklin, and the press had spoken of this "celebrity" [personnage célèbre].[31] D'Eon's letters opened the *Mémoires secrets* for the year 1779, a key publication that Lilti associates with celebrity in France during this period.[32] The letters laid bare d'Eon's conundrum: they may now have been "forced" to be subjugated to a woman's position and ergo subject to the restrictions of a woman's life, but they heartily desired to return to the army.[33] These letters were followed by Louis XVI's order from February 17, 1779, which banished d'Eon to Tonnerre and required them to remain in women's clothing.[34]

D'Eon's exile did not eliminate them from the public mind, however, as two polemical works relating to them appeared that year. The first was *Fastes militaires, ou annales des chevaliers des orders royaux & militaires de France*, by M. de la Fortelle (pseudonym),

and the second was *La Vie militaire, politique, et privée de Dem-oiselle Charles-Geneviève-Louise-Auguste-Andrée-Timothée Éon ou d'Éon de Beaumont*, also by de la Fortelle, but accepted to most likely have been written by d'Eon.[35] The *Affiches, annonces et avis divers* reviewed the two works together, claiming that the second was simply an extract of the first. Out of the history of French gene-alogy, the *Affiches* chose to focus principally on d'Eon, reiterating the extent to which their history captivated the French public.[36] The two publications, the latter of which was quickly translated into Italian, German, and Dutch,[37] revealed the commercial European interest in d'Eon. They also led d'Eon to engage themself in another legal dispute, according to the *Mémoires secrets*, this time with the Messrs Kercado (spelled also Carcado), who figured in d'Eon's genealogy. This new battle, which landed at the Châtelet court and was reported on in the *Mémoires secrets*, kept d'Eon in the public eye for years to come.[38]

The *Vie militaire* is also a significant work as much for its con-tent as its impact. Anne-Marie Mercier-Faivre has analyzed this document at length, classing it as a "vie privée," a private life, which Lilti has consistently associated with the rise of celebrity.[39] Mercier-Faivre shows how d'Eon (allegedly Fortelle) constructed an image of themself as victorious in the face of danger, reminiscent of Abraham Hyacinthe Anquetil-Duperron, analyzed by Blake Smith earlier in this volume: d'Eon "has seen everything, knows every-thing, is capable of everything."[40] Importantly, d'Eon also revealed their private life in London in the *Vie militaire*, but as Mercier-Faivre remarks, their image was now one of honor, not that of a political mastermind and spy who could blackmail France.[41]

In terms of d'Eon's cross-dressing celebrity, though, there is another section of the *Vie Militaire* that is especially relevant to the 1779 context. The author describes how, when at the Rus-sian court, d'Eon, seemingly a woman dressed as a man, could "make herself agreeable to Elizabeth and gain the goodwill of the Vice-Chancellor, the Empress's favourite minister" [se rendre agréable aux yeux d'Elizabeth, & de se concilier la bienveillance du Vice-Chancelier, Ministre favori de cette Impératrice], letting d'Eon advance the interests of their own court.[42] This was cross-dressing for their country, allowing d'Eon in 1779 to marry their

cross-dressing celebrity with patriotism (they were still banished to Tonnerre at the time). As Kates has established, the *Vie militaire* enabled d'Eon to rewrite the narrative of their own life, preparing a heroic image for their posthumous legend.[43] This reformulation of d'Eon's life narrative, however, could only happen following their rise to celebrity through the scandal surrounding their gender, and that scandal was essential to keeping d'Eon in the public's mind. As the Guerchy affair had been a lesson for d'Eon's celebrity in the 1770s, so the events of 1779—in which d'Eon's celebrity could be alimented far from Paris and spread across Europe—were a lesson for the Chevalier in using that celebrity to their advantage in an attempt to return to the army and the active world. They would later rely on these lessons while in England during the Revolution.

Revolution

In 1785, d'Eon crossed the Channel again, supposedly to rectify their precarious financial situation, but they never returned to France. The years 1789 to their death in 1810 were more difficult for d'Eon—it was then that they attempted to reap the fruits of a decades-long publicity campaign that had spread across the Western world. Analyzing that period sheds further light on not only the mechanics of celebrity, but also its fickle nature, and how celebrity could fail. That said, this part of d'Eon's life has attracted remarkably little attention; even Kates only accords seven pages to these tumultuous last decades in d'Eon's extensive biography. The time has come to rectify this.

Scholars generally agree that, by the 1780s, d'Eon's career was over, and in spring 1789, they set about attempting to publish their autobiography through Morande.[44] Already, we see d'Eon returning to the narrative of their life as they had in the 1770s as a way of earning sufficient money to live comfortably. The Chevalier was actively conscious of the pecuniary value of their celebrity, and having once so heartily condemned the European-wide interest in their sex, now that they were out of the limelight, d'Eon turned to it to make a living. However, the Revolution was to throw a wrench into these works.

D'Eon did not have an easy relationship with French politics. True, they had been in the French state's employ as a diplomat, soldier, and spy for their king. It was insults to the king and his household, moreover, which led d'Eon to break with some of their circle, including Morande for a while in the 1770s.[45] Yet, d'Eon was willing to blackmail their country, reveal state secrets, and be condemned as a traitor for this same crime. The traditional narrative of d'Eon's life during the Revolution recognizes their desire to return to France in 1792 but claims that the execution of Louis XVI put an end to this plan. Upon closer examination, though, the archives reveal that d'Eon actively engaged with the Revolutionary cause before refashioning themself for the British public.

D'Eon's first notable engagement with the Revolution was their celebration of the first anniversary of the storming of the Bastille on July 14, 1790. In France, this was marked by the Fête de la Fédération, an event curated to showcase national unity and a revolutionized France with a constitutional monarchy. D'Eon was a constitutional monarchist, and so it is no surprise to find them having participated with their nation's festival. The press eagerly reported d'Eon's gift of a stone from the actual Bastille as an emblem of France to Lord Stanhope for the anniversary celebrations of July 14, 1789, in London. This gift was quickly related by the French press and would be recounted across Europe.[46] What is more, in accounts by newspapers including *Le Moniteur*, *The Public Advertiser*, and *The Edinburgh Advertiser*, d'Eon was the only Frenchman who was not an active Revolutionary politician to be named at the London festivities, and *The Edinburgh Advertiser* avidly printed d'Eon's letter to Stanhope, offering him "the last stone of despotism."[47] Within this context and as a French person in Britain, d'Eon's nationality allowed them to increase their visibility in the public eye.

D'Eon claimed that with the Revolution, despotism was now over, and ergo they could return to their homeland. Newspapers became a platform for their attempt to return to France. For example, an acquaintance read of d'Eon's plans in a "papier nouvelle" and brought their cause to the attention of Comte de Mirabeau, then one of the leaders of Revolutionary France.[48] Likewise, d'Eon continued to orchestrate their media presence in 1791 via Morande.[49]

But it was in 1792 that the full power of the printed press came to bear in providing d'Eon aid, publishing their petition to the French National Assembly that requested they be allowed to return to France to fight for their "patrie." This was widely reported, and it is worth quoting a full extract of d'Eon's plea:

> although I have worn the clothes of a woman for over 15 years, I still dream, with regret, about my former life, and my bellicose humor rebels against my wimple and my skirts. My heart begs me for my helmet, my sword, my horse, to go and reoccupy my rank and grade in the army, a position that my services earned me. Never did I resign. The letter of September 24 [1789] states that the officers who were arbitrarily dismissed or suspended from their functions will be reinstated at the rank and grade that their length of service would have merited. Finding myself in this position, I beg the National Assembly to let me take back my uniform, as well as the rank that my services and injuries have merited, and to raise a voluntary legion, large and well disciplined, like that of the Romans; after all, the good Lord protects great battalions. I have been but a toy of nature, fortune, war, men, women, and husbands, etc. but today a greater career opens before me, and soon, with my weapons in my hand, I will go and fight for the nation, for law, and for the King.[50]

> [quoique depuis plus de 15 ans je porte l'habit de femme, je songe toujours avec regret à mon ancienne condition, et mon humeur guerriere [sic] se révolte contre ma cornette et mes jupes. Mon cœur me redemande à grands cris mon casque, mon sabre, mon cheval, pour aller reprendre à l'armée le rang et le grade que mes services m'ont valus. Jamais je n'ai donné ma démission. La lettre du 24 septembre dit: que les officiers qui ont été arbitrairement démis ou suspendus de leurs fonctions, seront remplacés au rang et au grade que l'ancienneté de leurs services aurait mérité. Me trouvant dans ce cas, je supplie l'Assemblée nationale de me permettre de reprendre mon habit uniforme, ainsi que le rang que mes services et mes blessures m'ont mérité, et de lever une légion volontaire, à la romaine, nombreuse et bien disciplinée; car le bon dieu protège les gros bataillons. Jouet de la nature, de la fortune, de la guerre, des

hommes, des femmes, des maris, &c. aujourd'hui une plus brillante carrière s'ouvre devant moi, et bientôt, les armes à la main, j'irai combattre pour la nation, la loi et le roi.]

D'Eon's petition actively played on their celebrity status and the notoriety that they had achieved during the 1770s. They painted themself as a poor victim of not only individuals, but also greater forces in life. Crucially, however, they were a victim of the Ancien Régime. They had given the French state their services and their blood, meaning they were betrayed both physically and emotionally. As d'Eon's gender transformation had allowed them to move from traitor to heroine, now their persecution because of this transition made them into a victim of despotic France, and a heroine for the Revolution. D'Eon could not have foreseen these events in the 1770s but, as then, in 1792 they used the same logic to turn their nonbinary celebrity to their political advantage.

The transcription and circulation of d'Eon's petition worked successfully to turn their image from troublesome noble to patriotic victim of despotism. *Le Patriote français* argued vehemently that d'Eon was a victim of "the harassment, jealousy, and ingratitude of the Ancien Régime" [les tracasseries, la jalousie et l'ingratitude de l'ancien régime], and firmly placed d'Eon on the side of liberty.[51] The *Journal de Paris* welcomed d'Eon's decision "to come back under the French flag" [revenir sous les drapeaux françois], adding that "there is not a single patriot who does not want to see him return and who does not applaud his petition" [Il n'est pas un Patriote qui n'aimât à l'y voir rentrer, & qui n'applaudisse à sa pétition].[52] Should d'Eon's political views have been in doubt, *Le Logographe* continued the extract from d'Eon where they recounted that, "I have successively passed from the state of a girl to a boy, from that of a man to that of a woman" [J'ai passé successivement de l'état de fille à celui de garçon, de celui d'homme à celui de femme].[53] D'Eon's ability to transform was sold as a positive value for Revolutionary France. Other celebrities in the past—Rousseau or Voltaire, for example—or those in the future such as Napoleon Bonaparte could not play on this, but d'Eon's precise form of nonbinary celebrity distinguished them from the crowd and allowed a specifically personal form of patriotism. The warm reception of d'Eon's transgressive gender state is even more interesting given that it clashed so openly with Revolutionary ideals of the

virtuous man. Their celebrity and the curiosity of individuals sur-
rounding it allowed the Chevalier to again occupy a unique position
in the face of the French government.

Despite the furor surrounding d'Eon in June 1792, their peti-
tion did not result in receiving enough money for their return to
France. A slip of counter-Revolutionary poetry collated by d'Eon in
1793 perhaps summarizes their feelings:

> Everywhere with great elation
> Of citizens' rights we talk
> But no longer do we mention,
> Alas, the rights of the nobles.[54]

> [Partout des droits du citoyen
> L'on parle avec ivresse
> Mais hélas on ne dit plus rien
> Des droits de la noblesse.]

D'Eon felt disenfranchised by yet another French government, and
worse, their state annuity had stopped. Their attempt to use their
celebrity to guarantee safe passage to France and a position in the
revolutionized nation had failed, although we should perhaps note
the misfortune that d'Eon had made their plea toward the end of one
Revolutionary government. In early June 1792, d'Eon could portray
themself as a constitutional monarch, but on June 20, demonstrators
stormed Paris, and by August the monarchy had been brought down.

Scholars have traditionally linked the fall of the monarchy with
the end of the Chevalier's attempts to return to France. Yet once
again the archives reveal a different story. Certainly, d'Eon could no
longer use their celebrity in France as they had desired—as a noble
living in an émigré hotspot like London, public opinion was now
dangerous—but they still wanted to return.[55] In their next attempt,
d'Eon avoided the press, and their request to be allowed back into
France was given weight by their diplomatic title as a "minister
p[lenipotentiary]" and sent directly to the Minister of War.[56] Their
passport was granted on April 2, 1793, and on December 1, 1793,
d'Eon was waiting at Dover to travel the twenty-one miles to their
homeland.[57] At this time, both Louis XVI and Marie-Antoinette
had been executed, and France was in the middle of the Terror, yet
d'Eon was still prepared to risk their life to go back to their *patrie*.

Perhaps their attempts reveal some of the security they believed celebrity and their status as victim of the Ancien Régime afforded them, because the threat of execution at the height of the Terror as a nonconformist noble was real. However, d'Eon's plans to return home failed, not because of their own actions, but because one of their family members fled before them to Ostende and then Brussels. This family betrayal is a point overlooked by scholars.[58]

Having come so close to going back to France, d'Eon was now stuck in Britain. Not only could they not return, but they could also still not get their French pension and therefore had to find another means to live by. From d'Eon's personal archives, we can see that they separated themself from the French cause over the course of 1794 and molded themself back to suit a British public. In contrast to the Chevalier's position in 1792, contemporaries in Britain spoke of d'Eon's "horror of the French Revolution" [horreur de la Révolution française]—a *de rigueur* political opinion at that time.[59] The luminaries with whom they had cultivated connections, notably William Seward, a member of the Royal Society, encouraged subscriptions for the publication of d'Eon's memoirs and letters.[60] Like Morande, Seward was a key agent in the network that maintained d'Eon's celebrity, but it should be noted that whereas Morande was a Grub Street hack, Seward was an intellectual of standing. Agents form a variety of social milieus helped spread d'Eon's notoriety in different circles. D'Eon's efforts were successful, and in the last decade of their life they contracted to publish their manuscript, which was to be translated into English, and received a sizeable advance.[61] It is through examining d'Eon's archives though that we see that they never gave up on their attempt to return to their homeland: in 1800, they corresponded with French Minister for Foreign Affairs Charles-Maurice de Talleyrand-Périgord in yet another attempt to go back to France, but the minister informed them that the papers for their much-desired pension had disappeared.[62] In 1802, d'Eon continued to correspond with the French government, this time with the Abbé Grégoire, asking for permission to come back to France, but the Chevalier was never to return.[63]

D'Eon died in poverty in 1810. To much shock, and as a final twist in their tale, the medical examiner discovered the Chevalier had

been anatomically male all along. As was fitting after four decades of the invasion of their privacy, a graphic anatomical print of their genitals signed by the doctors appeared and circulated.[64] Ultimately, it was the political situation in France that ruined d'Eon's plans, as the changing governments refused to accord them their pension. D'Eon's celebrity could allow them to influence the public sphere, defy governments, and cause a sensation across Europe, but at the end of the day it could not guarantee them their all-important income—celebrity had its limits. However, the precarious financial state in which d'Eon found themself did mean that they worked further on their autobiography. Their writing exemplifies the lessons they learned from celebrity, such as including titillating descriptions to rouse the reader's interest, which had been emblematic of the discourse surrounding the debate on their gender in the 1770s. Moreover, it is through the autobiography that d'Eon achieved the status of a legend, a lasting image of themself that continues to shape perceptions of them.[65]

The mechanics surrounding d'Eon's celebrity—the intermingling of private and public, the salacious accounts in the press and pamphlets, the circulation of prints, and the individual's response via the printed word—align with the findings of other current studies of celebrity. Yet they also reveal the need for further research into the networks and key agents, such as Morande or Seward, who facilitated celebrity, a comparative sociological study of which remains to be written.[66] Yet, d'Eon is a specific case because of their gender changes: their transition from living as a man to a woman (and arguably from one side of the Channel to the other, twice) meant that their celebrity was different from that which other individuals could achieve. As such, this chapter generates questions regarding the differences in celebrity that a man or a woman, a foreigner or a native, and individuals under different political regimes could be subjected to, both during the eighteenth century and today.

Notes

1. Mark Brown, "Portrait Mistaken for 18th-Century Lady is Early Painting of Transvestite," *Guardian* (London), June 6, 2012, accessed February 6, 2020, https://www.theguardian.com/artanddesign/2012/jun/06/portrait-18th-century-early-transvestite. The painting in question is Thomas Stewart, after Jean-Laurent Mosnier, "Chevalier d'Eon," 1792. Mosnier was an émigré artist who

had painted the likes of Marie-Antoinette. His portrait of d'Eon was exhibited at the Royal Academy in 1791, exhibition number 443, *The Exhibition of the Royal Academy, MDCCXCI. The Twenty Third* (London: T. Cadell, 1791), 14.

2. A selection includes Gary Kates, *Monsieur d'Eon Is a Woman: A Tale of Political Intrigue and Sexual Masquerade* (Baltimore: Johns Hopkins University Press, 2001); Gary Kates, "The Transgendered World of the Chevalier/Chevalière d'Eon," *The Journal of Modern History* 67, no. 3 (September 1995): 558–94; Anna Clark, "The Chevalier d'Eon and Wilkes: Masculinity and Politics in the Eighteenth Century," *Eighteenth-Century Studies* 32, no. 1 (Fall 1998): 19–48; Lisa Forman Cody, "Sex, Civility, and the Self: Du Courdray, d'Eon, and Eighteenth-Century Conceptions of Gendered, National, and Psychological Identity," *French Historical Studies* 24, no. 3 (Summer 2001): 397–407; *The Chevalier d'Eon and His Worlds: Gender, Espionage and Politics in the Eighteenth Century*, eds. Simon Burrows, Jonathan Colin, Russel Goulbourne, and Valerie Mainz (London: Continuum, 2010).

3. Kates, *Monsieur d'Eon.*

4. Ibid., xi.

5. National Portrait Gallery (@nationalportraitgallery), "Our #portraitoftheday is of celebrated soldier, diplomat and fencer, Chevalier d'Eon," June 10, 2020, https://www.instagram.com/p/CBQyEnigaB5/. On scholars' use of male pronouns, see Kates, *Monsieur d'Eon*, xii, and the translation of d'Eon's selected writings, Charles-Geneviève-Louis-Auguste-André Timothée d'Eon de Beaumont, *The Maiden of Tonnerre: The Vicissitudes of the Chevalier and the Chevalière d'Eon*, trans. and eds. Roland Champagne, Nina Ekstein, and Gary Kates (Baltimore: Johns Hopkins University Press, 2001). For recent studies of eighteenth-century gender, see the performance of *Eonnagata*, by Sylvie Guillem, Robert Lepage, and Russell Maliphant, Sadler's Wells, London, 2009, and Catherine Hermary-Vieille, *Moi, Chevlier d'Eon, Espionne du roi* (Paris: Albin Michel, 2018).

6. Kates, *Monsieur d'Eon*, 119; Simon Burrows, "The Chevalier d'Eon, Media Manipulation and the Making of an Eighteenth-Century Celebrity," in *The Chevalier d'Eon and His Worlds: Gender, Espionage and Politics in the Eighteenth Century*, eds. Simon Burrows, Jonathan Colin, Russel Goulbourne, and Valerie Mainz (London: Continuum, 2010), 15.

7. Kates, *Monsieur d'Eon*, 121.

8. Ibid., 130–36.

9. Burrows, "The Chevalier d'Eon," 13.

10. Ibid., 20.

11. Antoine Lilti, *Figures publiques, l'invention de la célébrité* (Paris: Fayard, 2014).

12. Kates, *Monsieur d'Eon*, xi; Clark, "The Chevalier d'Eon and Wilkes," 34.

13. See *The Annual Register, or A View of the History, Politics, and Literature for the Year 1781* (London: J. Dodsley, 1782). For a scholarly overview, see Sylvie Steinberg, *La Confusion des sexes. Le Travestissement de la Renaissance à la Révolution* (Paris: Fayard, 2001).

14. Kates, *Monsieur d'Eon*, 201–9.

15. Ibid., 182. Examples of prints held in the British Museum collection include *The Discovery of the Female Free-Mason*, June 25, 1771 (BM Satires 4865); *A*

Deputation from Jonathan's and the Free-Masons, 1771 (BM Satires 4871); *Chevalier d'E-n (d'Eon) returnd or the Stockbrokers Outwitted*, September 1, 1771 (BM 2010,7081.362); *A French Capt. of Dragoons Brought to Bed of Twins*, 1771; *The Trial of M. D'Eon by a Jury of Matrons*, 1771 (BM Satires 4862).

16. Kates, *Monsiuer d'Eon*, 182.

17. James Lander, "A Tale of Two Hoaxes in Britain and France in 1775," *The Historical Journal* 49, no. 4 (December 2006): 995–1024.

18. Cody, "Sex, Civility," 402.

19. See for example, Lilti, *Figures*, 102–3.

20. Stephen Brogan, "A 'Monster of Metamorphosis': Reassessing the Chevalier/Chevalière d'Eon's Change of Gender," in *The Chevalier d'Eon and His Worlds: Gender, Espionage and Politics in the Eighteenth Century*, eds. Simon Burrows, Jonathan Colin, Russel Goulbourne, and Valerie Mainz (London: Continuum, 2010), 85.

21. Ibid. See also Wendy Doniger, *The Woman who Pretended to Be Who She Was: Myths of Self-Imitation* (Oxford: Oxford University Press, 2005), 196, and Kates, *Monsieur d'Eon*, 256.

22. Cody, "Sex, Civility," 394.

23. *Courier de l'Europe*, June 28, 1776.

24. Kates, *Monsieur d'Eon*, 243–44.

25. For a good collection of these newspapers, see the Collection of Printed Paragraphs, cut out of English Newspapers, relating to the Chevalier d'Eon, 1776–1777, ADD MS 11340, British Library.

26. *The Westminster Magazine or the Pantheon of Taste*, July 1777.

27. Ibid. The pronouns used here are those in *The Westminster Magazine*.

28. Lilti, *Figures*, 84.

29. Obituary in Kates, *Monsieur d'Eon*, xix. On the legal impact of Hayes v. Jacques, see Warren Swane, "Da Costa v Jones, 1778," in *Landmark Cases in the Law of Contract*, ed. Charles Mitchell and Paul Mitchell (Oxford: Hart Publishing, 2008), 119–34.

30. Kates, *Monsieur d'Eon*, 264. This is also the opinion of the Archives Nationales, Odile Dresch-Krakovitch, "Fonds d'Eon, répertoire numérique détaillé," accessed February 6, 2020, https://www.siv.archives-nationales.culture.gouv.fr/siv/rechercheconsultation/consultation/ir/pdfIR.action?irId=FRAN_IR_000716.

31. Kates, *Monsieur d'Eon*, 32–37 (37). The quote comes from "Letter 1 Sur la Chevalière d'Eon," dated January 4, 1778, in *L'Espion anglois ou correspondance secrète entre Milord All'Eye et Milord All'Ear*, vol. 8 (London: John Adamson, 1784), 1.

32. See for example Lilti, *Figures*, 102.

33. Copy of a letter from d'Eon to Comte de Maurepas, February 8, 1778 [*sic*, actually 1779, see 13:349], Louis Petit de Bachaumont, *Mémoires secrets pour servir à l'histoire de la république des lettres*, vol. 14 (London: John Adamson, 1784), 3–6 (6).

34. Kates, *Monsieur d'Eon*, 7.

35. Anne-Marie Mercier-Faivre, "*La Vie militaire, politique et privée de Melle d'Eon* (1779): Biography and the Art of Manipulation," in *The Chevalier*

d'Eon and His Worlds: Gender, Espionage and Politics in the Eighteenth Century, eds. Simon Burrows, Jonathan Colin, Russel Goulbourne, and Valerie Mainz (London: Continuum, 2010), 133.

36. *Affiches, announces et avis divers*, March 3, 1779.

37. In addition to the abbreviated Italian (1779) and Russian (1787) translations noted by Kates, *Monsieur d'Eon*, 302, the British Library and Bibliothèque nationale de France catalogues also list *Das militarische, politische und Privat-Leben des Fräuleins d'Eon de Beaumont, ehemaligen Ritters von d'Eon* (Frankfurt: n.p., 1779) (recognised by Mercier-Faivre, "La vie," 145) and *Krygs-Staatkundig en Burgerlyk Leven van Mejufvrouw C. G. L. A. A. T. D. d'Eon de Beaumont. Benevens de Geschriften en echte Brieven, raakende de Verschillen met den Heer de Beaumarchais, aangaande haare Sexe* (Amsterdam: n.p., 1779). An English translation is notably absent.

38. The *Mémoires secrets* still speaks of it in 1780; Mathieu-François Pidansat de Mairobert, Barthélemy-François-Joseph Mouffle d'Angerville, and Louis Petit de Bachaumont, *Mémoires secrets pour servir à l'histoire de la République des lettres en France, depuis 1762 jusqu'à nos jours*, vol. 16 (London: John Adamson, 1784), 5–6.

39. Mercier-Faivre, "La Vie," 133. See for example, Lilti, *Figures*, 115–21.

40. Mercier-Faivre, "La Vie," 135.

41. Ibid., 138.

42. M. de la Fortelle, *La Vie militaire, politique, et privée de Demoiselle Charles-Geneviève-Louise-Auguste-Andrée-Timothée Éon ou d'Éon de Beaumont* (Paris: Lambert, 1779), 11.

43. Kates, *Monsieur d'Eon*, 72.

44. Letters from Morande to d'Eon dated between April 14 and May 31, 1789, 277AP/1, Archives Nationales (AN), Paris.

45. D'Eon to Morande, 4 May 1776, AN 277AP/1.

46. *Gazette nationale ou le Moniteur universel*, July 30, 1790. See also *Chronicon Viennense oder neueröffneter Österreichischer Bildersal vom Jahre 1790*, vol. 2 (Vienna: Alberti, 1791), 248.

47. We find the names of Marquis de Lafayette, Jean Sylvain Bailly, Riquetti the elder (Mirabeau), and Jean-Paul Rabaud Saint-Etienne in *The Public Advertiser*, July 16, 1790, *The Edinburgh Advertiser*, July 30, 1790, and *Gazette nationale ou le Moniteur universel*, July 30, 1790.

48. The letter is referring to events before Mirabeau's assassination.

49. Morande to d'Eon, 13 August 1791, AN 277AP/1.

50. *Courier Français*, June 13, 1792.

51. *Le Patriote français*, June 13, 1792.

52. *Journal de Paris*, June 13, 1792.

53. *Le Logographe, journal national*, June 14, 1792.

54. Papiers de la Chevalière d'Eon, classés par elle-même, MS 9033, Bibliothèque nationale de France (BnF).

55. D'Eon to Cleghorn, 27 March 1793, Carton de papiers intéressans à conserver pour le retour de Mlle d'Eon en la patrie, 1791–1803, MS 9362, BnF.

56. Ibid.

57. Papers included in MS 9362, BnF.

58. Note by d'Eon, December 1, 1793, MS 9362, BnF.

59. Excerpt from Professor Blumenbach to William Seward, January 1794, MS 9033, BnF.

60. Folder of letters and notes from Seward to d'Eon in 1794 about different subscription for the letters and memoirs of her life on which she was currently working, MS 9033, BnF.

61. Gary Kates, "Introduction," in d'Eon, *The Maiden of Tonnerre: The Vicissitudes of the Chevalier and the Chevalière d'Eon*, trans. and eds. Roland Champagne, Nina Ekstein, and Gary Kates (Baltimore: Johns Hopkins University Press, 2001), ix.

62. Excerpt from a letter from the Minister of Foreign Affairs of the French Republic to Citizen Otto, Commissioner for the Republic in London, 29 floréal year VIII (May 19, 1800); copy of a letter from Minister of Foreign Affairs, Talleyrand, 27 thermidor year VIII (July 14, 1800), MS 9362, BnF.

63. D'Eon to the Abbé Grégoire, c. October 1802, MS Chevalier d'Eon/40, Brotherton Collection, University of Leeds Library; Abbé Grégoire to d'Eon, 13 vendémiaire year XI (October 5, 1802), MS 9362, BnF.

64. "Print," c. 1810, BM number 1868,0808.7947.

65. Cody notes the scholarly disgruntlement at Kates's overreliance on d'Eon's autobiography, Cody, "Sex, Civility," 391.

66. Simon Burrows has written on Morande, but more in relation to his political engagement, in "A Literary Low-Life Reassessed: Charles Théveneau de Morande in London, 1769–1791," *Eighteenth-Century Life* 22, no. 1 (February 1998): 76–94, and *A King's Ransom: The Life of Charles Théveneau de Morande, Blackmailer, Scandalmonger, and Master Spy* (London: Continuum, 2010); and Robert Darnton has written extensively on "Grub Street hacks," see for example Darnton, *The Literary Underground of the Old Regime* (Cambridge, MA: Harvard University Press, 1982).

INHERITING CELEBRITY

"KNOWING MY FAMILY"

Dynastic Recognition in Eighteenth-Century Celebrity Culture

EMRYS D. JONES

Family, Performance, and Celebrity

The ties of family can look amusingly prosaic when they and their role within celebrity culture are subjected to close scrutiny. This was the underlying insinuation when the renowned actor, writer, and theater manager David Garrick derided a 1744 production of *Romeo and Juliet* (1595) by his rival Theophilus Cibber. Cibber's staging presented himself and his daughter Jenny as the eponymous lovers, and it was emblematic of Cibber's attempts to capitalize on the theatrical "brand" established in earlier decades by his own father.[1] Garrick recalled Cibber's prologue "letting us know, that his daughter was the grand-daughter of his father, who was a celebrated poet and player, and that she was the daughter of his first wife by him, who had formerly met with their approbation. I never heard so vile and scandalous a performance in my life; and, excepting the speaking of it, and the speaker, nothing could be more contemptible."[2] In the background of Garrick's response to the production is an awareness of Theophilus's scandalous reputation—his involvement in procuring a lover for his second wife and the shamelessness of his subsequent legal action against said lover, not to mention the scandal of his very attempt to capitalize on the reputations of his father and deceased first wife.[3] But for his part, Garrick here seeks to strip notoriety of its public interest, to

minimize scandal's popular appeal. He presents himself as unimpressed by the family connections on display. He anonymizes all the main players in his account to the point where, stated bluntly, the simple fact of one person being related to another need not be at all surprising or worthy of public excitement. Indeed, the statement that a man's "daughter was the grand-daughter of his father" is obviously circular in its logic. This gleefully short-circuits the pretensions of Cibber's boasts that Jenny had a "just, hereditary Claim" to theatrical success, considering the "Root" from which she had sprung.[4] Garrick's painstaking distinction between the words being spoken, the speaking of the words, and the speaker himself performs a parallel reduction, meticulously separating Cibber not only from the ancestral legacy he covets, but also from mastery of his own voice, and with it his own celebrity.

What Garrick hesitates to acknowledge, however, is that behind or within the banality of Cibber's dynastic maneuverings there was also potential for genuine public fascination, a value of family likenesses and inheritances that cannot be so easily dismissed, that can be difficult to quantify or to deploy calculatingly, but that is nonetheless recognizable as a critical component in celebrity culture from its eighteenth-century origins through to the present day.[5] In short, we are interested in how celebrities can be linked to each other as sisters, brothers, sons, and daughters. If celebrity is not in and of itself inheritable, it is at least conceived through a discourse of inheritance, where the drive to identify resemblances—between one celebrity and another, or between celebrities and our own commonplace selves—often becomes integral to the sustaining of public attention. New conversations and roles are woven from what has gone before, particularly in the world of stage (and later, screen) performance, where celebrities are professionally obligated to inhabit secondhand parts on a regular basis, and where they carry the memory of their own earlier roles with them.[6] As Richard Schoch has shown, the versions of theatrical historiography that were gradually coming into focus during the eighteenth century were themselves typified by their regard for both "pedigree" and "individuality"; they provided fertile ground for the cultivation of celebrity through their attention to genealogies either literal or symbolic.[7] The celebrity culture that we tend to imagine as being built

on exceptionalism and singularity is thus paradoxically and uncannily grounded in the familiar.[8]

Garrick himself, notwithstanding his indisputable fame and influence on the eighteenth-century British stage, was perhaps estranged to a certain degree from this dimension of celebrity. He did not spring from a notable literary or theatrical lineage, and he would bear no children to carry his name forward in the annals of the stage. Even in a symbolic sense, he was sometimes portrayed as being without genealogical interest. Reflecting on Garrick's inability to beget a true theatrical protégé, the actor Samuel Foote would quip that Garrick was "something like the famous running-horse Childers, the best racer in England *himself*, but *could never get a colt*."[9] Such singularity may go some way toward explaining Garrick's contempt for Cibber's dynastic game-playing in the account already quoted. But the significance of likeness retained an interest for him, even as he tried to ignore it. He ended up commenting in the same letter on the performances both of Jenny and of Theophilus's sister, Charlotte Charke, in ways that emphasize their very inseparability from the family tradition: "Mrs Charke played the Nurse to his daughter, Juliet; but she was so miserable throughout, and so abounded in airs, affectation, and *Cibberisms*, that I was quite shocked at her: the girl, I believe, may have genius; but unless she changes her preceptor, she must be entirely ruined."[10] Charke had given up the Cibber name in marriage, but its embarrassment still clung to her and fashioned her for public consumption. Garrick cannot resist reading her here as a Cibber, however much this cuts against his urge to minimize the attraction of familial recognition at the theater. The same is true of his verdict on Jenny, whatever the specific identity of the "preceptor" mentioned here.[11] Garrick's awareness of family's potential to contaminate was the flip side of his strategic use of intra-familial competition in theatrical scheduling. When audiences saw Susannah Cibber as Juliet in his 1748 production, they were of course supposed to remember the performance of her stepdaughter in the same role, albeit in order to judge the older actress her superior. Similarly, when Garrick responded to the success of Richard Brinsley Sheridan's *The Duenna* in 1775 with a revival of Frances Sheridan's *The Discovery*, he was clearly taking advantage of the

public curiosity surrounding resemblances between mother and son.[12]

Bound up in this business of resemblance and its potential audiences is a further question that Garrick, like many others, was unable or unwilling to resolve: the extent to which the connection between celebrities of the same family can be considered a natural connection, and the implications of its contested naturalness for theatrical practice. It is ironic that, in Garrick's description of Cibber's production, the most obvious bequests of the Cibber bloodline should be "airs" and "affectation," markers of artifice rather than essential, inherent qualities. To inherit affectation might be to conceal one's true inheritance, or it might be to conceal the fact that there is no underlying inheritance at all. The resemblance is of interest in either case; in fact, the ambiguity of its origin and authenticity only serves to make it more intriguing, complementing a theatergoing experience that itself encourages audiences to interrogate the legitimacy of the feelings and the virtues enacted on stage. Thus, when both the Cibber and the Garrick productions of *Romeo and Juliet* were recalled in 1750 by John Hill, he acclaimed Susannah Cibber for "all the spirit and feeling" that "appears natural" in her love for Romeo.[13] Hill was able to forget the actress behind the role. By contrast, the very remembrance of the familial bond between Theophilus Cibber's Romeo and his Juliet thwarted their attempts at emotional verisimilitude in the earlier production: "We remember a little *Juliet*, of very considerable merit [. . .] [S]he would have appear'd, even with the same share of genius and accomplishments, much more pleasing than she did, if there had been some gay young fellow for her lover, instead of a person whom we could not but remember, at every sentence she deliver'd concerning him, to be too old for her choice, too little handsome to be in love with, and, into the bargain, her father."[14] Poor Jenny Cibber may have been exactly the right age to play Juliet—a fact trumpeted in the published version of her father's prologue—but, even more perversely than in Garrick's judgement, a knowledge of her family was bound to undermine her prospects. The family name that perhaps bestowed on her a natural genius for the stage, and certainly furnished professional opportunity, also allowed something of the unnatural to infect her appearance before the public.

As already mentioned, there was potential for uncanniness in the relationship between a performer's celebrity and an awareness of his or her familial bonds. For Hill, this was manifested in an uncomfortable sense of the theatrical dynasty and its repertoire as incestuous. But the kinds of reaction inspired by such uncanniness—whether of unease or of fascination—did not always center on the sexualization of the stage family. When Dorothea Jordan and her brother, George Bland, performed as Viola and Sebastian in a 1790 production of *Twelfth Night* (1602), the *General Magazine* sang their praises, stating that, "[t]he effect of the scene was considerably improved by the very strong similitude of the brother and sister in respect to form and countenance."[15] There was presumably something uncanny in this extreme similarity, a danger of one actor making the other redundant, of the Bland family becoming visible at the expense of the fictional characters, or of William Shakespeare's playful twinning and gender-swapping being rendered too convincingly to be theatrically acceptable. But one can see this version of the uncanny contributing to the success of the production in ways that the Cibbers' father-daughter relationship patently did not. The sense of admiration built into the *General Magazine*'s response arises from an implicit understanding of the theater as a home for mirrored and mirroring forms.[16]

This chapter explores how the interest in familial identities came to inform and impinge upon theatrical celebrity in the latter half of the long eighteenth century, how this interest was articulated, and why it had such drastically different effects in relation to different theatrical dynasties. There has been a great deal of scholarship in recent decades on family's role in the evolving literary cultures of the eighteenth century and the Romantic period. Work by Michelle Levy and others has emphasized the ways that writing families entered and engaged with the public sphere, undermining strict narratives of domestication that interpreted the family as a purely private domain by the early nineteenth century.[17] In similar terms, Jane Spencer's *Literary Relations* demonstrates how even within a "predominantly masculine, and symbolically male" literary canon, women possessed, often by way of their familial positions, "a marginal, shifting, and sometimes unsettling place."[18] However, studies such as these tend not to give specific consideration to the ways in

which the intersection of family and theatrical life might have differed from that of family and authorship.

We are used to narratives of the private being made public or being constructed publicly in the eighteenth century, this being a defining feature of the era's social changes and new modes of literary production.[19] I have written elsewhere about the importance of these paradoxes for understanding how celebrity works and how the first celebrities came to be recognized as such.[20] And yet, part of the motivation of the present chapter is to outline some ways in which the idea of a publicized privacy is inadequate to describe the true situation of daughter or sister celebrities in this time period. For my two main case studies, Charlotte Charke and Sarah Siddons, familial intimacy and familial identity were not carefully cultivated in private before being rendered to a conscientious public; and, correspondingly, the pleasures derived by the public from the consumption of celebrity culture did not necessarily reside in a sense that knowledge of an actress's family would provide access to her inner self. Instead, with particular reference to written works that responded to and elaborated on the celebrity of these women, I will show how family could be conceived from the outset as a facet of public being, how a preoccupation with familial resemblance and its applications could owe less to notions of the domestic and more to a discourse of royal power that was at once central and antithetical to the concept of celebrity.[21] In this sense, though Ariane Fichtl and I adopt different definitions of celebrity and explore different national contexts, my examination of celebrity's inheritability is by necessity as attentive to "collective experience" and to models of rhetorical power as is her treatment of French Revolutionary discourse in the her chapter.[22]

Charlotte Charke

Characteristic of her general position within the Cibber dynasty, Charlotte Charke's first appearance in this chapter combined a sense of her marginality with the possibility of concealed influence. It is not impossible that Garrick in fact perceived *her* as the injurious "preceptor" who threatened to corrupt the genius of her niece Jenny. It is poignantly appropriate in any case that Charke should

appear to us in the character of Juliet's Nurse, given the latter's constant concern with her own valued but unsanctioned motherliness, her uncomfortable awareness of being both central and peripheral to the life of the Capulet family.

Charke was the youngest daughter of actor, playwright, and eventual poet laureate Colley Cibber. She unquestionably owed her celebrity to this family connection even as she diverged, at times drastically, from the model of more-or-less legitimate theatrical fame embodied by her father. Whereas he had sat within the establishment, managing Drury Lane and writing works closely aligned to the political interests of the Hanoverian regime, Charke—by accident or design—became a figure on the fringes. She pursued her own stage career through legislative loopholes and with recourse both to the lifestyle of a strolling player and to opportunities proffered by her father's various enemies.[23] On their own, her accomplishments as an actress were not widely publicized or celebrated enough for her to have achieved what we would think of as celebrity status. It is thanks to her 1755 autobiography, *A Narrative of the Life of Mrs Charlotte Charke*, that her name once more became familiar to the public in the last years of her life, and that she has proved such an attractive focal point for recent scholarship on eighteenth-century theater and gender. The *Narrative*'s publicizing of Cibber family feuds, its unsuccessful attempts to earn the forgiveness of Charke's father, and its allusions to Charke's identity as a cross-dresser (including her adoption of the persona Charles Brown) all make it an impressively rich, apparently counter-hegemonic historical source.

I write that the text is only "apparently" counter-hegemonic because, in spite of its abundant scandalous material and its peculiarly parodic relationship to Colley Cibber's own earlier memoir, much of the discussion surrounding the *Narrative* in the last few decades has hinged on whether it is as radically confrontational a work as it sometimes seems. Claims for Charke as a subversive, proto-feminist figure clash with the view that her cross-dressing was not inherently transgressive and that her imitations of her father, and her relationship to his social and cultural authority, could have worked to support patriarchal systems rather than overturning them.[24] The view of Charke that one takes depends to a

great extent on how one interprets her willful encouragement of ambiguity and enigma in her autobiographical text, as well as how sincere one regards her counterproductively public pleas for paternal mercy to have been.[25] For the purposes of my analysis here, it may not even matter whether we understand her as a rebel against her father's name or as a champion of his legacy, so long as we recognize as prerequisites for such ambiguity the inalienable stability, power, and publicness of the family name through which Charke's celebrity was constructed. In this sense, my reading of Charke parts ways with those studies that have emphasized hers as the most personally revelatory voice within the Cibber clan. Where Jean Marsden has described Charke as being eager to capitalize on the public exposure of her family's "histrionics," and where Robert Hume confirms her as someone who exploited the public performance of personal feeling, I would highlight the ways that family resemblance and family inheritance were never truly private qualities for Charke in the first place.[26] In adopting this approach, my interpretation finds common ground with recent work by Julia Fawcett that has explored "overexpression" as Charke's chief tool for concealing the private self while seeming to display it.[27]

The quotation used in the title of my chapter features twice in the early stages of Charke's *Narrative*, while she is tracing her early forays into performance and her almost instinctive use and abuse of the Cibber name as a child. First comes a supposedly quite successful adventure in concocting and dispensing medicines to disadvantaged neighbors. Charke describes visiting a local apothecary's widow, her shop suggestively sketched as "an Emblem of that described in *Romeo and Juliet*": "She, good Woman, knowing my Family, entrusted me with a Cargo of Combustibles, which were sufficient to have set up a Mountebank for a Twelvemonth . . . But, Oh! woeful Day! the Widow sent in her Bill to my Father, who was intirely ignorant of the curious Expence I had put him to; which he directly paid, with a strict Order never to let Doctor *Charlotte* have any farther Credit, on Pain of losing the Money so by me contracted."[28] "Farther" credit is also "father" credit. If "knowing" Charke's family does not necessarily entail a full acknowledgement of their celebrity here, it nonetheless intimates, in the context of the *Narrative*'s general strategies of self-representation, the inexhaustible

public credit that Charke understood as being attached to the Cibber name. Did she appreciate at this young age that her father was one of the most famous figures in the theatrical world? Perhaps only indistinctly, but she understood that her family's value was forged through recognition within a public space, even if that public space was for now just a local community of neighbors and shopkeepers. This understanding would lead in time to the publication of the *Narrative* itself and Charke's parenthetical self-description on its title page as "*Youngest Daughter of* COLLEY CIBBER, *Esq.*" There is little promise of intimacy in such deployments of family connections.

We also do not find that promise the next time the young Charlotte meets someone who "knows" her family, several pages after the encounter with the apothecary's widow: "The Owner of the Horse, knowing my Family, and seeing me often drive my Father's Horses, made no Doubt but that I was sent in Fact to make Tryal of his."[29] The man promptly gives his horse to Charlotte and there ensues a breathtaking, almost neck-breaking, dash over Uxbridge Common, culminating in a near-fatal collision with a three-year-old child. It is natural to look for the broader emotional significance of moments like this, the young girl's reckless manipulation of her father's credit perhaps being reminiscent of the tragic myth of Phaethon and its cautions against filial hubris.[30] But in a more obvious way, both anecdotes actually deny the reader access to family life as a source of personal truth. The neighborhood's knowledge of family is inevitably superficial. It is in fact a kind of ignorance, which suits Charke's purposes perfectly and suggests ways in which our knowledge as readers of her memoir might be similarly compromised.

In discussing how Charke situates herself in relation to the theatrical reputation of Cibber, Fawcett makes the provocative observation that the actress "rejects the royal spectacle for which her father was known."[31] This may ring true with reference to particular performances and lexical choices in the *Narrative*, but I would suggest that it in fact obscures from view the remarkable prevalence of royal imagery and ideas of royal familial association across the text. Fawcett highlights the interest of Charke's metaphor when, as she recollects her time as part of a group of traveling players,

she describes herself as the "Prime Minister" of their stage.[32] This perhaps parallels an earlier, much-analyzed moment in the *Narrative* when, as a girl, Charke donned "an enormous bushy Tie-wig" belonging to Colley Cibber, in an effort to be "the perfect Representative of [her] Sire."[33] The standard reading of the latter episode is that representation simply means imitation: that Charke was performing as her father, with all the psycho-sexual complications that such an act is bound to carry with it. This is certainly part of what Charke was doing and saying in this performance, but we perhaps ought also to consider representation in its political senses—the daughter as potential bridge between monarchical authority and the populace, or performing the role of monarch who is himself a "representative" of divine power in the world. With these meanings in mind, Charke's later self-identification as prime minister need not be understood as a straightforward rejection of the allure of royal authority, but instead as an acknowledgement of that authority and an expression of willingness to channel it in some way. For Charke, authority and celebrity do indeed stem from her father. However awkward her relationship to these concepts, and however faltering her attempts to embody them in turn, they are themselves set up as absolutes, rooted in the family name as public property, constant reminders that her family is theatrical royalty.

Such a construct—the celebrity dynasty as royal family—did not automatically imply harmony; it could easily encompass rebellion, disinheritance, and internecine conflict. Analysis of Charke's *Narrative* has regularly noted her implicit and explicit use of *King Lear* (1606) as a model for the relationship between her, her father, and her resented elder sister—a comparison thoroughly indebted to the idea that royal families may war within themselves but remain fundamentally, self-evidently royal as they do so.[34] The British royal family of Charke's own time also provided publicly visible precedents for heirs to the throne who stood in opposition to their parents. Frederick, Prince of Wales, who died four years before the publication of the *Narrative*, had resembled Charke insofar as he brazenly publicized his father's withdrawal of financial support and his impression that others had turned the king and queen against him.[35] Consequently, it is unsurprising that Charke's writing should so frequently frame her experiences in terms of royal

inheritance even when that inheritance was disputed or at risk of being undermined. Shortly after the wig incident, she describes how she rounded up "a numerous Retinue" of children while living close to Hampton Court, and with their assistance, "rode triumphantly into Town" on a donkey. Her father, hearing the noise from this hubbub, imagined that it might be "an Insurrection."[36] No, it was just his rebel daughter, using the very regality of their family position to foment disorder. Similarly, Charke's later defense of the family home against phantom attackers partakes of the ambience of royal privilege, albeit reaching past the constraints of enlightened leadership, arising from her determination to "secure my Seat of Empire; which, at that Time, I would not have exchanged for a Monarchy."[37] When seen in this context, even her scheme to provide medicine to locals, described previously, begins to look less like an adventure in trade than an homage to the supposed healing powers of bygone Stuart rulers. Her escapades are described as "Acts of Charity," expressly dependent on the faith and confidence of the ill-informed people she sought to help.[38]

Colley Cibber's role as poet laureate was surely a boon in facilitating the imaginative leap from the real royal family to a family of theatrical royalty. "Still Dunce the second reigns like Dunce the first," wrote Alexander Pope in a line that would eventually come to be applied to Cibber as king of the Dunces, and that deliberately erodes the lines between the king and his cultural representative, as between one generation and the next.[39] The point is not that royalty itself was beyond scandal—or beyond dullness for that matter—but rather that it inevitably preempted the public consumption of the scandalous, making the supposedly private bonds of family an essentially public medium for celebrity's formulation. There may well be an impression of intimacy in aspects of Charke's account, but this does not stem from the reader's entry into the hidden secrets of the Cibber dynasty itself. While we might justifiably be skeptical of whether kings and queens could themselves be considered celebrities, it seems undeniable that the language, imagery, and ideology of royalty could serve as central tools in the production of a celebrity status that was at once founded on familial recognition and impossibly remote from the everyday experiences of family by non-celebrities.[40]

Sarah Siddons

If the advancement of a specifically royal conception of celebrity was mostly implicit in Charke's life and autobiography, for the cult of Sarah Siddons later in the eighteenth century, it was extremely overt and deliberate. As pointed out in several recent studies, Siddons both received royal patronage and became increasingly famous as her career went on for playing queens on stage.[41] Her bearing and the quality of the adulation she received naturally led commentators to interpret her in royal terms, as a kind of "substitute queen," to use Antoine Lilti's phrase.[42] William Hazlitt, for instance, described her as receiving greater homage "than that which is paid to Queens," a statement that, as viewed by Lilti, indicates Hazlitt's attachment to fame's purity, his evocation of a theatrical glory untarnished by prurient interest in the actress as an individual.[43] In artistic artifacts and theatrical productions alike, Siddons was enshrined as an emblem of royalty, to some extent controlling her own visual representations.[44] As Shearer West has described, Siddons's regality was at least partly responsible for the durability of her celebrity, presenting an attractive, subtly ironic counterpoint to the "achieved," earned nature of her fame.[45] After all, Siddons's trajectory was in many respects quite the opposite of Charke's. She did not inherit celebrity. She began as the ignominious, strolling player that Charke ultimately became. Though her parents were actors, Siddons without question occupied the central position in the Kemble theatrical dynasty as it came to be understood, and this despite the fact that she had relinquished, through marriage, the Kemble name itself.

With so much already written about Siddons's celebrity and its multimedia manifestations, it should not be necessary to belabor the point of her regal status further. What I instead provide here is some discussion of the ways that this regality encompassed the ideas of family inheritance and family resemblance addressed earlier. Though Siddons had much more control over her celebrity and more respect from the other members of her dynasty than Charke ever obtained, one can see their readers' and audiences' knowledge of family being constructed similarly, as an obviously public facet of the performance of celebrity, often precluding or obstructing more intimate revelations.

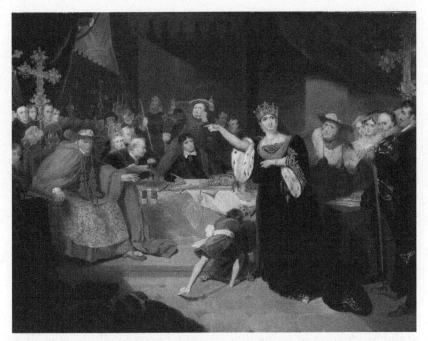

Figure 8.1. *The Trial of Queen Katherine, 'Henry VIII' Act 2 Scene 4, performed by the Kemble family,* by George Henry Harlow, c. 1817, supplied by RSC Theatre Collection.

Depicted as Catherine of Aragon in George Henry Harlow's painting of *Henry VIII*, Act II, Scene 4, Siddons points accusingly across the canvas toward her brothers: John Philip Kemble as Cardinal Wolsey; Charles Kemble as Thomas Cromwell; and Stephen Kemble, his face and raised hand positioned just above Siddons's finger, as Henry VIII himself. The actress's scandalized demeanor and the aggression of her gesture, presented in their theatrical and royal context, seem paradoxically to deny the possibility of petty family dramas being played out here. Enjoyment of the image rests not upon speculation about the real relationships between these performers, but on admiration of their corporate identity as Kembles, the possible likenesses between them, as well as glimpses of disparities (either in terms of appearance or theatrical talent). This is evident in a published response to a later print of the image, the reviewer disapproving of the poor quality of the reproduction but

praising the original painting: "it presents us with, at one and the same time, the pleasing recollections of nearly the whole of a great dramatic family,—a family which, individually and collectively, has done more, we suppose, to the honour of the stage than half the dramatic folk who have ever flourished in Great Britain."[46] It is telling that the reviewer is drawn throughout this sentence to several reflections on the relation of part to whole. That we can see the theatrical family "at one and the same time" and that their accomplishments are brought to mind both "individually and collectively" enhances the sense that this kind of familial celebrity operates not merely through piecemeal, curious observation, but also with a concurrent view to the authority of the dynasty in its entirety.

Further examples of this authority abound. On the occasion of Stephen Kemble's London debut in 1783—an appearance as Othello that one of Siddons's biographers attributed to Covent Garden's confusion of Stephen with his older brother—the *Morning Herald* described the attendance of Siddons and John Philip Kemble at the production in terms that stressed dynasty-making as itself a collaborative, calculatedly emotional performance: "*The* Siddons, and *the* Kemble were seated over the stage-box, on Wednesday evening, to see their brother Stephen's first appearance. Nature, whose effusions have in public secured to the former an universal admiration, operated very powerfully, and frequently on this occasion, the tears of sensibility stole down her cheeks and with a sister's sympathy, spoke all the brother felt!"[47] There is a danger of upstaging here, and along with it some awkwardness of identification. Entirely in keeping with the uncanny ambiguities of resemblance that I have explored already in this chapter, it is unclear what is natural and what is not, what belongs to the individual performer and what to the celebrity collective that he or she represents. That the most prominent members of the theatrical clan are presented to us as "*The* Siddons" and "*The* Kemble"—an admittedly standard naming convention for both—speaks at once to their individual authority and to the inextricability of their family names from their celebrity. In other words, they are enshrined as the indubitably superior and senior members of their dynasty, but they then cannot be anything other than this; their situation within the family,

however dominant, cannot be ignored. The upstaging takes place because it should surely be Stephen on the stage who speaks at the end of this passage. Instead, the passage leaves us with Siddons's tears as the true performer, articulating what her younger brother apparently feels but has either left uncommunicated or has sublimated in enacting the contrary feelings of his character. In essence, Stephen's actual performance gets drowned out by a performance of sisterly pride, which superficially offers insights into natural private feeling, but through the passage's very emphasis on nature's publicness—nature as a universally admired quality of Siddons's stage personae—in fact cements the role of family sympathy within the public sphere.

Although Siddons was indeed greatly admired, there were some who were prepared to question a mode of theatrical celebrity that seemed to restrict access to the private self even as it consolidated the family's place in public. One writer for the *Theatrical Inquisitor* complained in 1815, two years after Siddons's initial retirement from the stage, that "Kings and queens cannot always wear the cumbersome ornaments of state—they cannot always play an assumed part; there must be moments, many moments, when the mere mortal must peep out of this mimic greatness[.]"[48] Siddons disappointed precisely because of her immortality, and this immortality was closely bound up with conceptions of her place within the broader theatrical dynasty. The disdain felt in this commentary for "mimic greatness" seems somewhat curious at first. What else should one expect from the theater—or indeed from a theatrical family—but mimicry of one kind or another? Like many a connoisseur of celebrity then and since, the writer takes issue with performances so grand and so remote that they allow no pleasing impression of intimacy or common humanity.[49]

Still, there was obviously something remarkably moving and instructive about the forms of spectacle Siddons and her dynasty provided for their fans, even if these forms had little to do with an attempted rendering of private life in public. It is worth restating this point for emphasis: the display of family connection as a public condition could itself constitute a powerful basis for an audience's esteem. We witness as much in an early poetic publication by Siddons's friend, the future novelist Amelia Opie. The poem focuses on

busts that Siddons had made of herself and her brothers.[50] It accordingly positions Siddons, with great forthrightness, not simply as the most accomplished of her brood, but rather as their creator, and a self-fashioner to boot:

> Then in her hand the plastic earth she molds,
> And soon, o'erjoy'd, she mimic life beholds;
> Beneath her fingers sees, with eager eyes,
> Her beauteous face in soft proportions rise.
> Next, at the touch affection bids her give,
> See Grecian grace and Roman grandeur live!
> For into life behold her brothers start!
> The fair creations of their sister's art;
> While each resemblance glows with equal truth,
> Majestic manhood *here—there graceful youth*.[51]

Siddons's assurance as leader of her family is such that she seems to have gone past the language and imagery of royalty here. She acts instead like a pagan god, shaping her brothers out of the earth and, with mythopoeic circularity, looking upon her own beauty as it comes into being in her hands. It is the very strength and confidence of Siddons, her refusal to let family be compromised by individuality or subjectivity, that endears her to the poet. Resemblance is all. It leads to a "truth" infinitely removed from the true stories or secret histories that might more often be expected to accompany celebrity.

Coda: Another Juliet

I began this chapter with *Romeo and Juliet*, and I will end with the same play. The Cibbers and the Kembles were hardly "alike in dignity" as Shakespeare's Capulets and Montagues supposedly are.[52] But they shared an interest in this play about the public faces of family, with its many characters who are more similar, for better or for worse, than they choose to admit. The use of the play as an instrument of theatrical dynasty-making, particularly by each family's less illustrious personnel, therefore testifies to the true basis of their collective celebrity: not an invitation to enter into the lived experience of familial bonds so much as to court more superficial

curiosity, to savor the effects of family likeness itself, safe in the knowledge that the family's celebrity was already secure.[53]

Heather McPherson and others have already provided detailed accounts of how Fanny Kemble, the niece of Sarah Siddons, triumphed in her debut role as Juliet in 1829.[54] In contrast to Jenny Cibber close to ninety years earlier, she acquired enduring ownership of the part, being depicted in character in various artistic works and using the performance as the basis for a theatrical career that, while not rivaling her aunt's prestige, kept her family's dynasty thriving well into the nineteenth century. She could be thankful that her father did not play Romeo, as Theophilus had done for Jenny all those decades earlier. Charles Kemble instead took the part of Mercutio, with Fanny's mother in the uncannily appropriate role of Lady Capulet, at least for Fanny's very first performance.[55] Fanny was the star here, so much so that it seems almost impolite to focus on the ways that her Juliet exemplified for a new generation the intrinsically public value of familial recognition. This was not simply a matter of name-dropping or nepotism in the newspaper coverage of her success. These in and of themselves were not as noteworthy as the determination with which the family's very publicness was put on display, the strong impression that for this family there was no gap between the living of a relationship and the staged performance of it.

Regarding the aging Sarah Siddons's own response to her niece's achievement, the *Morning Post* commented at length: "It is said that the feelings of this great woman were moved in an extraordinary degree by several passages in the acting of her Niece, and that a scene of the highest interest succeeded the Tragedy, when the several members of Mrs SIDDONS's family assembled to interchange congratulations, in which a noble pride must have mingled with the more tender affections of the heart."[56] It remained Mrs. Siddons's family, of course; all the Kembles were in her shadow though grateful for her validating presence. Their familial celebrity prompted what seemed to be private speculation, inquisitiveness as to the great woman's "extraordinary" feelings. But as can be seen so often in the sources that have been discussed throughout this chapter, there was also an abiding sense that these emotions were themselves public property, honed through the theater and its

roles: the "scene of highest interest" was, from a certain perspective, merely a continuation of the dramatic action on stage. The presumed nobility of Siddons's pride elevates it and her other affections beyond the merely personal. It elevates her family, as well, in such a way that draws into question whether "celebrity" is even the right word for this relentlessly exposed, hyper-regal mode of dynastic life. Ultimately, as in Charke's spectacles of disobedience and disinheritance, the intimate allure of family is not as powerful as its performative authority.

Notes

1. The unlicensed production, which saw twelve performances at the Little Theatre, Haymarket—from September 11, 1744, prior to the intervention of the Lord Chamberlain—has been the subject of recent work by Elaine McGirr. McGirr describes Theophilus's ultimately unsuccessful efforts to wrest the "cachet of Cibberian celebrity" away from his estranged second wife, Susannah Cibber, who would receive more substantial acclaim in Garrick's own production of *Romeo and Juliet* later in the decade. See McGirr, "'What's in a Name?': 'Romeo and Juliet' and the Cibber Brand," *Shakespeare* 14, no. 4 (2018): 399–412; McGirr, "'Inimitable Sensibility': Susannah Cibber's Performance of Maternity," in *Stage Mothers: Women, Work, and the Theater, 1660–1830*, eds. Laura Engel and Elaine McGirr (Lewisburg, PA: Bucknell University Press, 2014), 67.

2. David Garrick to Somerset Draper, September 16, 1744, in David Garrick, *The Letters of David Garrick*, eds. David M. Little and George M. Kahrl, vol. 1 (London: Oxford University Press, 1963), 43–44.

3. For details of Cibber's lawsuits against William Sloper, see McGirr, "'Inimitable Sensibility,'" 69–70. On the precarious value of disgrace for formulations of eighteenth-century celebrity, see George Rousseau, "Notoriety's Public Interiors," in *Intimacy and Celebrity in Eighteenth-Century Literary Culture*, eds. Emrys D. Jones and Victoria Joule (Basingstoke, UK: Palgrave Macmillan, 2018), 259–92.

4. The prologue was eventually printed in Theophilus Cibber, *Romeo and Juliet, A Tragedy, Revis'd and Alter'd from Shakespear* (London: Printed for C. Corbett and G. Woodfall, [1748]), 73–74.

5. For a twenty-first-century example, see the Kardashian family's use of "sister-branding and sister-entrepreneurship" as "a relief from the social costs of entrepreneurial individualism." Alice Leppert, "Keeping Up with the Kardashians: Fame-Work and the Production of Entrepreneurial Sisterhood," in *Cupcakes, Pinterest, and Ladyporn: Feminized Popular Culture in the Early Twenty-First Century*, ed. Elana Levine (Urbana: University of Illinois Press, 2015), 215–31 (216).

6. See Marvin Carlson's description of theatrical space as "a site of the continuing reinforcement of memory by surrogation." Carlson, *The Haunted Stage: The Theatre as Memory Machine* (Ann Arbor: University of Michigan Press,

2001), 2. Also Joseph Roach, *Cities of the Dead: Circum-Atlantic Performance* (New York: Columbia University Press, 1996), 78. For the "always-already-signifying nature of star images," see Richard Dyer, *Stars* (London: British Film Institute, 1979), 129.

7. Richard Schoch, *Writing the History of the British Stage: 1660–1900* (Cambridge: Cambridge University Press, 2016), 163.

8. David Giles typifies the consensus when he states that the history of fame is "about the history of the *individual*." Giles, *Illusions of Immortality: A Psychology of Fame and Celebrity* (Basingstoke, UK: Macmillan, 2000), 12. Tom Mole similarly argues that "celebrity culture promotes an abstract notion of the individual as a self-determining agent and as a principle of cultural classification." Mole, "Introduction," in *Romanticism and Celebrity Culture, 1750–1850*, ed. Tom Mole (Cambridge: Cambridge University Press, 2009), 12. For one of the many acknowledgements that celebrities nonetheless do not represent "straightforward affirmations of individualism," see Richard Dyer, *Heavenly Bodies: Film Stars and Society* (London: Routledge, 2004), 7.

9. Samuel Foote, *Wit for the Ton! The Convivial Jester; or, Sam Foote's Last Budget Opened* (London: Printed for W. Adlard, [1778]), 26.

10. Garrick, *Letters of David Garrick*, 43–44.

11. See McGirr, "'What's in a Name?,'" 10–11, for discussion of whether Garrick considered Jenny's father or grandfather (the poet laureate Colley Cibber) to be her principal mentor.

12. Frances Sheridan had died almost a decade earlier. Her granddaughter, Alicia LeFanu, would later describe Garrick's strategy as a "setting-up of the mother against the son." I discuss this episode further in Emrys D. Jones, "Maternal Duties and Filial Malapropisms: Frances Sheridan and the Problems of Theatrical Inheritance," in Engel and McGirr, *Stage Mothers*, 159–78 (164).

13. John Hill, *The Actor: A Treatise on the Art of Playing* (London: Printed for R. Griffiths, 1750), 134.

14. Ibid., 134–35.

15. *The General Magazine and Impartial Review*, February 1790, 83.

16. Marvin Carlson posits that the eighteenth century witnessed the "first serious interest in actors as inhabitants of both a real and a fictive world," leading ultimately to the more overt experimentation of the twentieth and twenty-first centuries that has probed an "ambiguity between the real and the mimetic." At the same time, Carlson presents a concern with the mirroring of true and false forms as being inherent to all dramatic practice. See Carlson, *Shattering Hamlet's Mirror: Theatre and Reality* (Ann Arbor: University of Michigan Press, 2016), 6, 18.

17. See Michelle Levy, *Family Authorship and Romantic Print Culture* (Basingstoke, UK: Palgrave Macmillan, 2008), particularly 5–13; also Scott Krawczyk, *Romantic Literary Families* (Basingstoke, UK: Palgrave Macmillan, 2009). Levy responds to the narrative of "separate spheres" that had been promoted most famously, though perhaps inadvertently, in Leonore Davidoff and Catherine Hall, *Family Fortunes* (London: Hutchinson, 1987).

18. Jane Spencer, *Literary Relations: Kinship and the Literary Canon, 1660–1830* (Oxford: Oxford University Press, 2005), 17.

19. See, among many others, Jürgen Habermas, *The Structural Transformation of the Public Sphere*, trans. Thomas Burger (1962; Cambridge: Polity Press, 1989); Stella Tillyard, "Celebrity in Eighteenth-Century London," *History Today* 55, no. 6 (2005): 20–27; Marilyn Morris, *Sex, Money, and Personal Character in Eighteenth-Century British Politics* (New Haven, CT: Yale University Press, 2014). For the two main recent models of privacy publicized in a theatrical context, see Joseph Roach, "Public Intimacy: The Prior History of 'It,'" in *Theatre and Celebrity in Britain, 1660–2000*, eds. Mary Luckhurst and Jane Moody (Basingstoke, UK: Palgrave Macmillan, 2005), 15–30; and Felicity Nussbaum on the "interiority effect" in *Rival Queens: Actresses, Performance, and the Eighteenth-Century Theater* (Philadelphia: University of Pennsylvania Press, 2010), 45.

20. Emrys D. Jones and Victoria Joule, "Introduction," in Jones and Joule, *Intimacy and Celebrity*, 1–10 (4–5).

21. This argument in some ways parallels the longstanding recognition that exposure to the public sphere shaped private life as much as the private informed the public. In Habermas's words, "subjectivity . . . by communicating with itself, attained clarity about itself" (*Structural Transformation*, 51). However, this description still assumes that valid experiences (or at least intuitions) of subjectivity would naturally arise through public dialogue and debate. For the useful counterargument that it is misguided to search for distinctions between the "theatrical" and the "authentic" in celebrity culture, see Laura Engel, *Fashioning Celebrity: Eighteenth-Century British Actresses and Strategies for Image Making* (Columbus: Ohio State University Press, 2011), 2–3.

22. See especially Fichtl's chapter in the present volume, 225–47.

23. Among Charke's strategies for circumventing the strictures of 1737's Stage Licensing Act were her use of puppets and her scheme of charging for refreshments rather than for tickets to a given performance. See Fidelis Morgan, *The Well-Known Troublemaker: A Life of Charlotte Charke* (London: Faber, 1988), 63, 127. Philip E. Baruth describes how Charke alternated between such ventures and seemingly more desperate forays into the world of trade, experiments like her business as an oil seller and grocer, which can themselves be interpreted as a kind of immersive theater. See Baruth, "Who is Charlotte Charke?," in *Introducing Charlotte Charke: Actress, Author, Enigma*, ed. Philip E. Baruth (Urbana: University of Illinois Press, 1998), 9–62 (30–34). On Henry Fielding's use of Charke in attacks on her father, see Morgan, *Troublemaker*, 86–87; Baruth, "Charlotte Charke," 20–23.

24. Readings of Charke's text as a subversive critique of masculine authority include Kristina Straub, *Sexual Suspects: Eighteenth-Century Players and Sexual Ideology* (Princeton, NJ: Princeton University Press, 1992), 135–36, and Sidonie Smith, *A Poetics of Women's Autobiography: Marginality and the Fictions of Self-Representation* (Indianapolis: Indiana University Press, 1987), 102–22, though Straub and Smith disagree on whether Charke was successful in her critique. An opposing reading of Charke as attempting "entry into . . . the patriarchy" is offered in Erin Mackie, "The Narratives of the Life of Mrs. Charlotte Charke," *ELH* 58, no. 4 (Winter 1991): 841–65 (863). For a valuable synthesis of these viewpoints, see Cheryl Wanko's statement that "Charke both acknowledges and criticizes her father's authority," in Wanko, *Roles of*

Authority: Thespian Biography and Celebrity in Eighteenth-Century Britain (Lubbock: Texas Tech University Press, 2003), 83.

25. On Charke's ambiguity, particularly with reference to her sexuality, see Catherine Craft-Fairchild, "Sexual and Textual Indeterminacy: Eighteenth-Century English Representations of Sapphism," *Journal of the History of Sexuality* 15, no. 3 (September 2006): 408–31. As regards the practical functions of the *Narrative*, Sidonie Smith astutely describes how it at once purports to seek reconciliation with Colley Cibber and operates as a work of "filial blackmail" (Smith, *Poetics*, 117).

26. Jean Marsden, "Charlotte Charke and the Cibbers: Private Life as Public Spectacle," in Baruth, *Introducing Charlotte Charke*, 65–82 (74); Robert D. Hume, "The Aims and Genre of Colley Cibber's 'Apology' (1740)," *Studies in Philology* 114, no. 3 (2017): 676.

27. Julia Fawcett, *Spectacular Disappearances: Celebrity and Privacy, 1696–1801* (Ann Arbor: University of Michigan Press, 2016), 63.

28. Charlotte Charke, *A Narrative of the Life of Mrs Charlotte Charke* (London: Printed for W. Reeve, A. Dodd and E. Cook, 1755), 36–37.

29. Ibid., 48.

30. The story of Phaethon, as told in Book I of Ovid's *Metamorphoses* and elsewhere, sees the son of the sun god drive his father's chariot to fiery destruction. Charke performed as Phaeton's mother, Clymene, in Fielding's mocking *Tumble-Down Dick: or, Phaeton in the Suds* (London: Printed for J. Watts, 1736).

31. Fawcett, *Spectacular Disappearances*, 88.

32. Charke, *Narrative*, 207.

33. Ibid., 18.

34. See Sidonie Smith, "The Transgressive Daughter and the Masquerade of Self-Representation," in Baruth, *Introducing Charlotte Charke*, 95–96.

35. See Frances Vivian, *A Life of Frederick, Prince of Wales, 1707–1751*, ed. Roger White (Lewiston, ME: Edwin Mellen Press, 2006), 238–48.

36. Charke, *Narrative*, 21.

37. Ibid., 43.

38. Ibid., 35. For discussion of "touching for the King's Evil," a longstanding practice that persisted until the reign of Queen Anne, see Frank Barlow, "The King's Evil," *English Historical Review* 95, no. 374 (January 1980): 3–27.

39. The line is Book I, l.6 in both the original *Dunciad* (1728), which took Lewis Theobald as its hero, and the final four-book *Dunciad* (1743), where Cibber took his place. It derived yet more significance in the latter usage, with a facetious footnote commenting on the resemblance between Colley and his son Theophilus. See Alexander Pope, *The Dunciad, in Four Books* (London: Printed for M. Cooper, 1743).

40. I argue that monarchs cannot themselves be celebrities due to the non-contingency of their cultural authority, in Emrys D. Jones, "'A Man in Love': Intimacy and Political Celebrity in the Early Eighteenth Century," in Jones and Joule, *Intimacy and Celebrity*, 176.

41. See Shearer West, "Siddons, Celebrity, and Regality," in Luckhurst and Moody, *Theatre and Celebrity*, 201–5; also Heather McPherson, "Siddons

Rediviva: Death, Memory, and Theatrical Afterlife," in Mole, *Romanticism and Celebrity Culture*, 125–26.

42. Antoine Lilti, *The Invention of Celebrity: 1750–1850*, trans. Lynn Jeffress (Cambridge: Polity, 2017), 37.

43. Ibid, 37–38.

44. David Worrall describes Siddons's "control over her own visual imagery" as "an underlying aspect of her professional power." Worrall, *Celebrity, Performance, Reception: British Georgian Theatre as Social Assemblage* (Cambridge: Cambridge University Press, 2013), 111; see also Robyn Asleson, "'She was Tragedy Personified': Crafting the Siddons Legend in Art and Life," in *A Passion for Performance: Sarah Siddons and her Portraitists*, ed. Robyn Asleson (Los Angeles: Getty Museum, 1999), 46.

45. West, "Siddons, Celebrity and Regality," 208. West's use of the term "achieved celebrity" is derived from Chris Rojek's terminology in Rojek, *Celebrity* (London: Reaktion, 2001), 17–20.

46. *The Literary Chronicle and Weekly Review*, June 19, 1819.

47. *Morning Herald*, September 26, 1783. This passage is quoted in Thomas Campbell, *Life of Siddons*, vol. 1 (1734), reprinted in *Women's Theatrical Memoirs*, ed. Sharon Setzer, vol. 4 (London: Pickering & Chatto, 2007), 32.

48. *Theatrical Inquisitor, and Monthly Mirror*, July 1815.

49. The writer's criticism can also be understood as reflecting the shifting political discourse of the time. For context, see Michael Dobson's observation that the Kembles' status as "theatre royalty" was not always "to their advantage" in an era of growing republican sympathy: Dobson, "John Philip Kemble," in *Great Shakespeareans*, vol. 2, *Garrick, Kemble, Siddons, Kean*, ed. Peter Holland (2010; London: Bloomsbury, 2014), 92.

50. For discussion of Siddons's affinity with sculpture and her recourse to it as a distraction in periods of ill health, see Heather McPherson, "Sculpting Her Image: Sarah Siddons and the Art of Self-Fashioning," in *Women and Portraits in Early Modern Europe: Gender, Agency, Identity*, ed. Andrea Pearson (Aldershot, UK: Ashgate, 2008), 183–202.

51. Amelia Opie, "On Seeing Mrs Siddons' Busts of her Brothers and Herself," *The European Magazine, and London Review*, May 1800.

52. *Romeo and Juliet*, prologue.

53. The idea of celebrity being secure may be regarded as oxymoronic, given that some definitions of the phenomenon see it as rooted in contingency and ephemerality. See note 40.

54. McPherson, "Siddons Rediviva," 128–30.

55. Subsequent newspaper advertisements list Lady Capulet as performed by Miss Lacy.

56. *Morning Post*, October 23, 1829.

9
PRINCES
OF THE PUBLIC SPHERE

Visibility, Performance, and Princely
Political Activism, 1771–1774

GABRIEL WICK

The popular fixation with the private lives of *philosophes*, actors, and beauties in France in the late 1770s, which Antoine Lilti examines in *The Invention of Celebrity*, had a curious prefiguration in the early part of that decade in the journalistic coverage given to the men known reverentially as the *princes du sang*—the princes of the blood, the members of the junior branches of the Bourbon house.[1] Historically, the fame of the princes stemmed from a combination of the collective aura of glory that surrounded their dynasty, and a form of personal renown rooted in their supposed predisposition to individual greatness—a heroism in arms, sexual prowess, and profligate spending. In the years following the Seven Years' War, however, as the sacerdotal prestige of the Bourbons gradually dimmed, and as the kingdom's martial fortunes waned, the nature of the princes' fame drifted toward something that was closer to the modern phenomenon of celebrity, a fame for fame's sake. This shift can largely be attributed to the vast increase in stories about the princes circulated by the newly ascendant *nouvelles à la main*, illicitly circulated manuscript newsletters. This coverage focused more on the princes' everyday pastimes and foibles rather than on their heroic deeds. Such stories fed the reading public's curiosity about the princes' private lives and personal characters,

but also rendered the princes more relatable and likable. This led to a certain duality in the public's perception of the princes. In reality, they were privileged and physically remote figures, whose rare presence was invested with an aura of majesty. Yet the manuscript newsletters allowed the public to feel that they had a privileged knowledge of the princes' private lives—their eccentricities, their amorous adventures, and the *bons mots* they exchanged with their valets and mistresses.

When we examine the manuscript newsletter coverage of the princes, it seems readily apparent that they were not only aware of these journalistic incursions into their private lives, but they also adapted their behaviors and their living environments to encourage such incursions. Beginning in the early 1770s, newsletter coverage abounded with accounts of the princes' unusual behaviors, unexpected appearances, and unorthodox interactions with commoners. Setting aside etiquette and ceremony, the princes increasingly frequented public gathering and entertainment spaces, such as the horse races in the Bois de Boulogne, the boulevards, and most especially the so-called *vauxhalls*—the commercial pleasure gardens closely modeled on London's highly successful Vauxhall and Ranelagh gardens that had begun to sprout up in the late 1760s in the vicinity of the Parisian boulevards. In these untraditional settings, the princes staged their appearances in innovative ways that were sure to attract comment. In one instance, in June 1773, a newsletter journalist described the walks that one prince of the blood, Louis François de Bourbon, prince de Conti, was in the habit taking on the boulevards: "For the past few years, Monsieur le prince de Conti, a neighbor of the Boulevards, has been promenading there on foot, without a retinue, and chatting on familiar terms with many people. At first, this egalitarianism did not seem at all suspect at court because, in the year it started (1770), His Highness had had an operation upon a fistula, and was unable to go about in a carriage. However, ever since then, this practice of Monsieur le Prince has continued even without this pretext" [Depuis plusieurs années M le prince de Conti, voisin des Boulevards, s'y promenoit à pieds, sans suite, & causoit familièrement avec beaucoup de gens. D'abord cette popularité n'a point paru suspecte à la Cour, parce que cette année-là (en 1770) S. A. avoit été opérée de la fistule & ne

pouvoit aller en carosse: mais M. le Prince ayant continué depuis, sans ce prétexte].[2] Considering Conti's exalted position, for observers of the period such an ostensibly innocent habit could not be divorced from its political implications. The journalist went on to explain precisely why this anecdote was newsworthy:

> We are assured that, given the critical position in which he finds himself, an exile from court renowned for his patriotism, M. le Chancellor [Maupeou] and his supporters have insinuated to the king that this behavior is not at all acceptable and even dangerous, and that such a familiarity might tend to soften hearts in favor of His Highness, excite a dangerous fermentation, form a party, etc. They say that he has received warnings that he should be more circumspect in his behavior and not show himself in such an affable manner. Others suggest that it was [the prince's] own courtiers who had suggested that false interpretations might be accorded to such behaviors.

> [On assure que dans la position critique où il se trouve, exilé de la cour, & renommé pour son Patriotisme, M. le Chancelier & ses adhérens ont insinué au Roi que cette conduite étoit peu convenable & dangereuse, qu'une telle familiarité tendoit à réunir les cœurs en faveur de S. A. à exciter une fermentation dangereuse, à former un parti & c. On veut qu'il ait reçu une insinuation d'être plus circonspect & de ne pas se produire avec tant d'affabilité: d'autres prétendent que ce sont ses propres courtisans qui lui ont suggéré les fausses interprétations qu'on pourroit donner à ces promenades publiques & habituelles.][3]

The government was wary of the prince's casual appearances because, in setting aside considerations of personal security and the rules of polite comportment that obliged a prince to move with a retinue, Conti could communicate directly with members of the public. The writer sets up a stark contrast between Conti's simple and unaffectedly modern habits and the machinations of Chancellor Maupeou, the archetypal *éminence grise*, planting seeds of suspicion in the ear of the monarch.

Was Conti, however, truly such a victim of a paranoid and reactionary regime, or was he too playing a political game? In the early

1770s, Conti had reasons for cultivating the public's attention: for twenty-one months between March 1771 and late December 1772, he and all but one of his fellow princes were embroiled in a public schism with the crown. In an episode dubbed the *Fronde des princes*, Louis XV banished the princes from court for their public opposition to the judiciary reforms promulgated by Maupeou.[4] The dissident princes had risen to the defense of the magistrates of the parlements whom the chancellor had deprived of their offices. As the kingdom's highest courts, the parlements were charged with registering and verifying the legality of new laws and edicts. Yet, this is precisely what they had refused to do with a raft of fiscal measures through which the government hoped to meet the onerous debt obligations incurred during the Seven Years' War.[5] The forceful assertion of the crown's authority over the courts unleashed significant protests from the magistrates and a large portion of the elites who stood to lose the most with the imposition of new taxes. Louis XV showed remarkable restraint in dealing with the so-called *frondeurs* who often occupied prominent positions in his household, which many interpreted as evidence of his equivocal support for Maupeou. Reassured by the king's tempered response, many notables publicly aligned themselves with the self-styled *partie patriote*, a dissident faction that mounted an overt and coordinated campaign of resistance to Maupeou's reforms.[6] The rise of an opposition party was a sea change in a system of government that still considered political decisions to be a unique prerogative of the Crown. As the senior ranking supporters of the patriot cause, Conti and his would-be political acolyte Louis Philippe d'Orléans, duc de Chartres, were lauded as the veritable figureheads of the opposition.

This chapter examines how Conti, Chartres, and, to a lesser extent, Chartres's father, Louis Philippe duc d'Orléans, represented their private selves in the public sphere to draw attention to their physical and ideological distance from the court. I propose here that such representations allowed grandees to define and legitimize a new role for themselves in the political life of the kingdom, and to stoke public interest in political affairs. The symbiosis between journalist and prince brought about a somewhat contradictory condition that I term here "representative privacy," wherein descriptions of what were ostensibly private acts and settings were allowed

to circulate in the press. By exposing their private selves to public scrutiny, the princes were able to harness the public's curiosity in order to enhance their standing and visibility.

The Princes of the Blood and the Practice of Politics

The Bourbon kings' supposedly unilateral control over the political sphere had always been something of a myth. Politics was in reality more often a negotiation between the Crown and other corporate bodies and sectors of the polity that sought to leverage their influence to protect or advance their own interests.[7] As direct male descendants of Saint-Louis, the princes of the blood were eligible to ascend to the throne should the senior Bourbon line fail to produce a male heir, and thus they had something of a legitimate standing when it came to advising their cousin the king.[8] The princes' sense of their own status and position developed rapidly in the sixteenth and seventeenth centuries, to the point that they almost became their own order, at once distinct from the nuclear royal family, but also from the nobility.[9] The princes saw the monarchy, at its most extreme, as a collective institution—Conti allegedly asserted that the crown belonged to all the princes.[10] Historically, even the most pliant and faithful of the princes considered that their rank and ancestry gave them an obligation to protest, or even a "duty of revolt" [devoir de révolte], when they felt that their monarch was receiving poor or dishonest counsel from his ministers.[11] The princes tended to attempt asserting their autonomous power during periods of instability, transition, and change. The Orléans, Bourbon-Condé, and Bourbon-Conti families played a key role in the Fronde of 1648–1653, when they allied themselves with the parlements and even with foreign powers in violently contesting the rule of Cardinal Mazarin.

Having seen the dangers that restive princes posed to the monarchy, Louis XIV gave his close relations important, if ceremonial, positions in the court system and provided them with lavish apartments within their own wing of the château of Versailles, the *Aile des Princes*. Following the death of Louis XIV, Philippe, duc d'Orléans, assumed the Regency and showed himself to be a conscientious guardian of both the government and the interests of the

infant Louis XV.[12] With his death, another prince, the duc de Bourbon, became Principal Minister. During the first half of Louis XV's reign, the princes in general, and the prince de Conti in particular, played considerable roles in government, but their power was on the wane by mid-century. After 1747, Conti's relations with the king and his politically canny mistress, the marquise de Pompadour, were increasingly tempestuous. By the 1750s, the king could share the burden of power with not only Pompadour, but also his heir the Grand Dauphin and a clique of aristocratic ministers, most notably the duc de Choiseul.[13] Additionally, as the king's direct heirs—*fils de France*—became more numerous, the princes knew that the time would come when the king would redistribute the *apanages*, choice honors, and charges that they had long enjoyed. The princes also found themselves, quite literally, being pushed out of Versailles: it was evident that the princes would soon be obliged to cede their apartments to this new generation of *fils de France*.[14]

By the 1760s, some of the princes were showing signs of restiveness, and the king increasingly resorted to heavy-handed measures to keep them in line. As most significant aspects of the princes' lives—notably their marital projects, travel, real-estate ventures, even the staffing of senior positions within their households—were subject to the king's approval, he wielded a great deal of leverage over them. This lack of personal liberty weighed heavily on the princes: in 1782, the baronne d'Oberkirch wrote that the prince de Condé and his cousins "are often deeply unhappy in their slavery. Their chains are no less heavy for being made of gold" [Le fait est que les princes sont bien souvent malheureux de leur esclavage. Leurs chaînes pour être d'or ne sont que plus lourdes].[15]

The princes, however, could take some solace in the affection that a large portion of the public exhibited toward them. Because the princes spent a good part of each year in the capital, much of the populace held them in a far more favorable regard than they held the royal family.[16] The aged Louis XV's progressive retreat from public life and the widespread animosity toward his new mistress, the comtesse Du Barry, redoubled the princes' popularity in the late 1760s and early 1770s. One event in particular in this period cemented the public's fascination with the personal lives of the princes: Chartres's marriage in 1769 to a princess of the blood, the

fabulously wealthy Louise Marie Adélaïde de Bourbon-Penthièvre, was the first royal wedding in a generation, and it was celebrated throughout Paris with an immense splendor.[17] The birth on October 5, 1773, of the Chartres's first surviving child, the duc de Valois (future King Louis-Philippe), who was the first Bourbon of his generation, was a cause for even greater celebrations. For some twenty-two months, until the birth of a son to the comte d'Artois, Valois was the presumptive heir to the throne.[18]

Despite his wealth, Chartres felt deeply frustrated with the limited prospects for him to distinguish himself. Louis XV's apparent antipathy, and the scarcity of prestigious military charges befitting a man of Chartres's rank, sowed a deep resentment in him. In a revealing letter, he pleaded with his father-in-law, the duc de Penthièvre, to cede him his charge of Grand Amiral de France.[19] He wrote: "This position is the sole one that I could assume to acquire the public's esteem and consideration which are, for us, the only true fortune, and without which it is only our birth that places us above others" [Ce parti est donc le seul que je puisse prendre pour acquérir l'estime et la considération publique qui sont pour nous la seule fortune réelle et sans lesquelles notre naissance ne fait que nous mettre au-dessous des autres]. Later in this same letter, he described his current circumstances as "a personal obscurity" [obscurité personnelle], and conveyed his fervent wish to acquire "any reputation" [quelque réputation] that he could. Though Penthièvre showed no willingness to yield to the prince's pressure, Chartres nonetheless remained convinced that his most likely path to glory and distinction lay with the navy. In 1775, contravening the express orders of Louis XVI, Chartres even joined the navy incognito as a seaman without rank. His deeply unconventional gesture to elect to live the life of a simple sailor greatly added to his celebrity and popularity.[20] While traditional channels for Chartres's advancement and distinction were blocked, other avenues that lay outside of the monarch's authority presented themselves. In June 1771, he was elected as Grand Maître du Grand Orient, the titular head of French Freemasonry. This election offered ample evidence of how much Chartres had to gain from distancing himself from the king.

Returning to their political engagements in March 1771, all but one of the princes came together at the Palais Royal to draft a letter

of protest that they subsequently made public. In response, the king commanded them to stay away from court. Prior to the conflicts of the 1760s, such was the stigma associated with having displeased one's monarch that those sent away from court would retreat quietly into private life.[21] In this respect, however, the crisis of 1771–1772 proved transformative: the princes joined an increasingly long list of powerful figures and institutions that united in open opposition to the government's policies. The princes, the magistrates of the parlements, and even the once-powerful duc de Choiseul and his coterie all found themselves deprived of their traditional places in the parlements or at court. In light of what was increasingly perceived as the king's arbitrary and even despotic abuse of his powers, these exiles found a new sort of collective identity as martyrs who were obliged to bravely resist their king and defend the integrity of the kingdom's historically constituted order.

The crisis of 1771–1772 offered the princes considerable opportunities to enhance their positions at a time when their dynastic futures seemed relatively uncertain, but they also risked considerable perils should they overplay their hands and incur the anger of the king. The princes required strategies that would allow them to demonstrate their autonomy and their capacity for independent action while not overstepping the limits that tradition imposed upon their station. Letting the public glimpse into their private worlds at opportune moments allowed the princes to enhance their popularity in a manner that also ostensibly demonstrated a certain remove from public affairs. The representations of their private sphere in the public realm, particularly through the coverage of manuscript newsletters, thus allowed them to reconcile two seemingly opposing imperatives: they could enhance their political positions even as they were seen to obey the traditional constraints placed on the activities of exiles.

The Princes of the Blood and Political Representation

The behavior of individual princes while in exile varied as a function of their temperament, the nature of their relationship with the king, and their sense of loyalty to him. A prince who prided himself on his loyalty, the prince de Condé offers an example of a

cautious approach: he discretely retreated to Chantilly to take solace in hunting and the company of his mistress. He was hardly alone in only tentatively embracing an unfamiliar and perilous alignment with the king's enemies. One journalist acerbically recounted that the duc de Penthièvre, a prince renowned for his simple devotion but not his intelligence, had taken up fasting as an act of penitence on behalf of the king's ministers.[22] He also supposedly prayed that should the ministers be hung for their crimes against the constitution, at least they should enjoy a peaceful death. Orléans also erred on the side of caution, closing himself up in his Parisian residence, the Palais Royal, and barring all visitors.

The princes' most insignificant gestures offered guidance for political expression as many observers kept close track of their movements in order to gain insights into the nature and severity of the unfolding crisis. Writing in his private journal in mid-May 1771, the Parisian bookseller Siméon-Prosper Hardy noted that the princes' decision to ignore the king's orders to attend the wedding celebration of his grandson, the comte de Provence was a clear sign that the tensions surrounding Maupeou's reforms had not abated.[23] Another journalist observed that even though the princesses of the blood had obeyed the king's orders to attend, and while they had come suitably dressed for the wedding, they wore expressions befitting a funeral.[24] A few days later, Hardy noted that Orléans showed himself to the public in his park of Saint-Cloud even as the wedding festivities continued at court.[25] Hardy also observed that, while Orléans used the pretext of surveying ongoing repairs in order to show himself publicly, his real intention seemed to have been to underline his absence from court and thus his tacit disapproval of the king's policies. As Saint-Cloud was only a short trip by boat or carriage from Paris and was thus a much-appreciated resort for Parisians even of modest means, Orléans could retire there while still remaining in the public eye.[26]

The publicly accessible character of significant parts of the gardens and the princely residences in general, the Orléans's palaces in particular, leant themselves to such passive, but politically loaded public appearances. This was especially true of the Palais Royal complex, which contained not only one of the city's most fashionable promenades, but also the Opéra. When, in 1771, in retaliation

for the prince de Beauvau's continued public support of the exiled chief minister Choiseul, Louis XV deprived him of his governorship of Languedoc, Orléans spent the day with the embattled prince and welcomed him to his box at the Opéra.[27] Their joint appearance offered the public the opportunity to show their support with rapturous applause. In a further collective demonstration of animosity toward the government, as the prince left the Opéra, a vast crowd conveyed him to his hotel. When the public attended the Opéra, there was no question that the Orléans were their hosts: externally, the Opéra was indistinguishable from the rest of the Orléans' palace, and the only cue to its presence was the prince's cipher over its main entry.[28]

Even before their commercial redevelopment by Chartres after 1780, the gardens of the Palais Royal constituted an important resort where Paris's middling public could promenade and perhaps even lay eyes on the princes and their families. In this respect, the gardens of the Palais Royal had a distinct advantage over the capital's other principal promenades, royal properties such as the Tuileries and Luxembourg palaces, which had long since ceased to function as royal residences.[29] One of the privileges of the Bourbon princes was that their gardens, like their palaces, were off-limits to the police and forces of order. Thus, the gardens of the Palais Royal were also notorious as a place where dissident journalists, the *nouvellistes*, plied their trade with relatively little fear of the authorities. As the protection of the Orléans also extended to the rental properties nearby, the environs of the palace were popularly reputed to house both the secret scriptoria where manuscript newsletters were recopied as well as many of the clandestine presses that produced illegal pamphlets.[30]

The mutually beneficial relationship between the Orléans and the illicit press seems to have played an essential role in allowing Chartres to develop innovative approaches to publicity. One of the most influential *nouvellistes*, Mathieu Pidansat de Mairobert, who penned generally complimentary articles on Chartres, held the largely honorific sinecure of secretary of armaments in his household.[31] Pidansat de Mairobert had a profound influence on the evolution of manuscript newsletter journalism in the second half of the 1770s because he was the first to collect and print manuscript

newletter articles in regular retroactive serial editions such as the *Journal historique de la révolution opérée dans la constitution de la monarchie française par M. de Maupeou* (1774–1776), *L'Observateur anglais, ou correspondance secrète entre Milord All'Eye et Milord All'Ear* (1777–1778), and the *Mémoires secrets pour servir à l'histoire de la République des Lettres en France* (1777–1789). These illicitly circulated chronicles all played key roles in the rise of celebrity culture in France. Chartres's status as a prince of the blood, as well as the physical inviolability of the Palais Royal complex, played a fundamental role in allowing their production and circulation.

As we can see with the veritable public relations campaign that surrounded the birth of their first son, the duc and duchesse of Chartres profited greatly from Pidansat de Mairobert's skills as a propagandist. The manuscript newsletters trumpeted the fact that in an extremely untraditional move, Chartres gave an open invitation to the general public to come into his apartments to admire the infant.[32] The author noted that those who did not wish to come inside could see the child every afternoon with his nurse in the private garden of the palace, which was separated from the public promenade only by an iron fence.[33] The author even praised the couple's attitudes towards modern parenting: "He is in a basket, in [keeping with] the new fashion, and without swaddling and other shackles of the old education" [Il est à la nouvelle mode dans une corbeille, sans langes & autres entraves de la vieille éducation.].[34]

Unlike his uncles, and despite the risk of incurring the king's displeasure, Chartres evidently decided that the benefits of his political stunts far outweighed the dangers. In February 1772, Chartres was suspected of having orchestrated a daring send-up of the king at the annual Opéra Ball. An extensive manuscript newsletter article recounted that, at the end of the night, a troop of six figures appeared in masks in the form of extraordinarily long noses. From these were suspended blue ribbons (the insignia of the Ordre du Saint-Esprit—the kingdom's highest chivalric order). The ribbons bore the title "Chevalier of the king's orders" [Chevalier des Ordres du Roi].[35] The author decoded the none-too-subtle message: these were the *pied de nez* [a colloquial term for a snub] that the aspirants to this honor had received from the Crown. For months,

the king had dangled the honor before them, but at the last moment suddenly announced that nobody would be elevated to the order that year. The account finished by saying that everyone wanted to know who the author of this open mockery of the king was: "it is generally attributed to M. le duc de Chartres, and it could hardly have been conceived by anyone other than him, or someone of his rank" [On l'attribue aujourd'hui généralement à monsieur le duc de Chartres, & elle ne pouvoit guère s'attribuer qu'à lui ou à quelqu'un de son rang].[36]

In late December 1772, soon after the prince de Condé and his son had decided to return to court, Orléans decided that it would be wisest to make peace with the king. He obliged Chartres to do the same. For his part, Chartres made it clear to the king and everyone else that he was doing so under duress and fully intended to continue with his dissident stance. In this context, it is tempting to see Chartres behind a similarly pointed political performance mocking Orléans himself that took place at the Opéra Ball of 1773.[37] This time, one of the masked guests came disguised as a wicker artist's dummy with a windmill on his head, upon which was placed a small lantern. By means of string, the masker was able to make the windmill turn in one direction and then the other, while at the same time extinguishing and relighting his lantern periodically. The masker positioned himself directly under the loge where Orléans was sitting. For Orléans and the assembled company, the insinuation was clear: the prince's convictions blew with the wind. When the duc descended to confront his guest and attempt to discover his identity, the mysterious figure upbraided him loudly for his faithlessness and his attempts to encourage Conti to also break ranks and make peace with his sovereign, then gave him the slip.

For Chartres and Conti, the advent of an important new sort of venue in Paris, the *vauxhalls*—commercially operated pleasure gardens at the periphery of the city that offered fireworks, music, and theatrical entertainments—could not have come at a more opportune moment. The first *vauxhalls* grew out of the competition between Italian fireworks impressarios and emulated similar enterprises that had been operating in London for the better part of a century.[38] These cosmopolitan origins contributed to the sense that the gardens were permissive spaces that allowed for new usages, the

flouting of hierarchical distinctions, and interactions between those of different social orders. In 1767, planning began on an establishment that was to eclipse all the other *vauxhalls*: the Colisée on the Champs Élysée.[39] It was a vast and grandiose venue that was intended to serve as a setting for the celebration of the dauphin and his siblings.[40] Chartres's ally and would-be political mentor Choiseul had a significant, albeit covert, financial stake in the project.[41]

The Chartreses attended the Colisée for the first time on May 17, 1771, one month after its opening and two months into their enforced absence from court. Contemporary accounts of their appearance described it in a highly political light: the *Mémoires secrets* noted that the "The public viewed the happy couple with great veneration and bore witness to its satisfaction in the most marked fashion" [Le public a vue avec la plus grande vénération cet heureux couple, & en a témoigné sa satisfaction de la façon la plus marquée].[42] The subsequent arrival of Conti's son, the comte de La Marche, the sole prince of the blood who sided with the king, "did not cause the same sensation" [M. le Comte de la Marche est venu aussi à ce spectacle, il n'a pas fait la même sensation]. The author records that the public eagerly observed how the two princes would greet one another. Hopes for a public confrontation, however, were misplaced—La Marche quickly withdrew without acknowledging his cousin.

Chartres evidently made himself quite at home in this public setting: describing the Colisée in her memoirs, artist Elisabeth Vigée-Lebrun recounted that, on her first visit, she found the prince standing at the top of the steps leading to the Colisée's front entrance, where he ruthlessly critiqued the appearance of all the women who passed by.[43] Such appearances put Chartres's legendary libido and infamous nastiness on full display, and yet at the Colisée—as opposed to the Palais Royal—he was not performing the role of host, but was rather a member of the public and something of a star attraction. When Conti appeared there, he was happy to give the public the sort of spectacle they desired. Journalist Charles Théveneau de Morande recounted that when the prince encountered the duc de Richelieu, Maupeou's outspoken supporter, at the Colisée, he provocatively asked the duc "how much longer would he be Maupeou's valet?" [Jusqu'à quand il serait le valet de

Maup . . . ?]⁴⁴ This provoked Richelieu to ask for how much longer
Conti "intended to disobey his king?" [Jusqu'à quand serez-vous
désobéissant au roi?] The situation deteriorated quickly and ended
with Conti threatening and then chasing the septuagenarian duc,
with his cane raised above his head, to his carriage. Théveneau de
Morande prefaced his account by announcing that it was "the duc
de Richelieu who won the recent race at the Colisée" [Le Mar . . .
de Rich . . . a gagné le prix de la course au Colysée].

Chartres and Conti's politically loaded appearances at the Coli-
sée continued into the reign of Louis XVI: one day in July 1774,
when the new king summarily exiled Orléans and Chartres for
their continued refusal to recognize the legitimacy of the reconsti-
tuted parlements, Chartres (who was supposed to go hunting with
the king that afternoon) went to the Colisée where he recounted the
incident to his friends there.⁴⁵ At the end of the following month,
when Louis XVI finally submitted to popular opinion and exiled
Maupeou, Chartres and Conti reportedly hastened to the Colisée
to announce the fact.⁴⁶

The Colisée's bloom faded quickly. Among many other defi-
ciencies, the reflecting pool at the complex's heart was infamous for
its fetid stagnant waters, earning it the sobriquet of *crapaudière*—a
toady swamp.⁴⁷ Having been built to accommodate national fêtes
of forty thousand people, the average night's attendance was more
around three thousand, which left the place feeling lifeless and bar-
ren.⁴⁸ For Chartres, however, the *vauxhall* had an evident value as
a setting for new forms of public representation that were autono-
mous from the court. Its failings, however, made the princes' asso-
ciation with the Colisée something of a social liability. By 1773,
Chartres was actively engaged in developing a private retreat that
would nonetheless allow for the same degree of public exposure as
did the Colisée.

Chartres's Monceau: A *Vauxhall* in the Guise of Princely Residence?

Chartres began discretely to acquire leases on properties sur-
rounding his *maison de plaisance* at Monceau in June 1771, a
month after his election as Grand Maître. The original house, which

was notorious as the princes' *Petite maison*—a setting for erotic adventures with courtesans and women from the Opéra—had been shielded from public view by walls and dense plantings. In its new guise, the expanded property was to be far more open to its surroundings. This was because it was partially enclosed by a series of ha-has, linear dry moats popularized by English landowners who wished to keep intruders and cattle out of their landscape gardens while also allowing for views out over the surrounding countryside. Because of Monceau's relatively urban setting, just at the outer edge of the city (the garden was only nine hundred meters from the Colisée and a short carriage ride or stroll from the center of Paris), the ha-ha rendered it largely visible to the general public, who could partake in the spectacle simply by promenading in the surrounding fields. This was how the duc de Croÿ chose to visit the garden in June 1775. He wrote: "I was able to see with the greatest ease, from the outside, walking along the fields, the singular garden of the duc de Chartres" [Je fus très aisé de voir, de dehors, le long des blés, le singulier jardin du duc de Chartres].[49] Luc-Vincent Thiéry's popular *Guide des Voyagers* (1787) informed readers that the printer La Fosse had engraved seventeen perspectives of the various views the visitor could have during "a promenade around the open perimeter of the garden" [en se promenant autour de son enceinte qui est à découvert].[50] Monceau, like many aristocratic gardens, was also open to the visits of *honnêtes gens* [respectable people] when its owner was not in residence.[51] Thus, it was a new form of princely residence that invited a diverse swath of the public to peer into its ostensibly private realm and partake, visually at least, in Chartres's pleasures. In this sense, Monceau was tailored to Chartres's need for representative privacy, and in this we can see a transition from royal glory to a more accessible royal celebrity that had been influenced by the fields of journalism and theater.

Monceau's roots in the *vauxhall* are evident in the 1773 account given in the *Mémoires secrets*, which describe it as having been modeled on the Tivoli, the garden of Simon-Charles Boutin, Treasurer General of the Navy and the Colonies.[52] The *Mémoires secrets* noted in July 1771 that Boutin had spent a million livres on his garden and was assembling there "all the products and spectacles that savage and cultivated nature can furnish in all possible genres" [Tout

ce que la nature agreste & cultivée peut fournir de productions et de spectacles en quelque genre que ce soit].[53] The author noted that while all of Paris wished to see this new garden, one could only enter by means of a ticket. Like a *vauxhall* or the Colisée, both Tivoli and Monceau offered spectacles—*tableaux vivants* of exotic scenes that featured rare animals and exotically costumed extras. At Monceau, the principal garden facade of the prince's pavilion was obscured by Turkish tents and overlooked an elaborate Chinese-style manually powered merry-go-round [*jeu de bague*].

Many of the features employed at Monceau served to underline Chartres's status as the kingdom's leading Freemason.[54] Coverage given to the garden in the *Mémoires secrets* also emphasized its use of new building materials and technologies, such as engineer Antoine-Joseph Loriot's mastic or the steam engine that pumped the waters of its artificial river.[55] One of the most prominent features of Monceau was the Naumachie, a lake surrounded by what appeared to be the ruins of a classical colonnade. The Naumachie had powerful associations with antiquity and the Roman emperors, evoking similar installations that were used as settings for staged maritime battles at the late Imperial palaces, such as Hadrian's Villa at Tivoli.[56] But it also bore more than a passing resemblance to the Colisée's *cirque*. Given that the Naumachie stood on a corner site where it could be viewed from multiple angles from the other side of the ha-ha, it was clearly a feature intended to be seen and admired by the public. Given Chartres's naval career and his aspirations to succeed his father-in-law in the charge of Grand Amiral, the Naumachie's evocation of maritime glory was intended to communicate to the public something of the prince's love of the navy and the sea.

Chartres was, by no means, the first grandee to have transformed the landscape garden into a setting for performance. Since the late 1760s, princes had been using their rural and suburban gardens for professionally produced amusements. These were immensely important and well-attended public events: one highly critical account in the *Mémoires secrets* of an amusement staged by the prince de Soubise in August 1773 claimed that some twenty thousand Parisians had traveled out to Saint-Ouen to witness the show.[57] The same article described a pastoral entertainment thrown for the comtesse de Provence in July of that same year by Condé's daughter, Mademoiselle

de Condé, at her retreat at Vanve.[58] This nascent tradition notwith-standing, Chartres was the first to create a suburban garden on such a scale with such permanent, costly, and theatrical decors, and his was the first garden to attract such extensive coverage (presumably with his acquiescence). Thus, Chartres's Monceau can be seen as something of a new type of hybrid that combined the traditional publicity of princely domestic spaces with the playfulness, informal-ity, and visual accessibility of the *vauxhall*. In transplanting a rural and English-inflected model—the aristocratic landscape garden—to the edge of the city, Chartres disposed of a venue that framed him as a voluntary exile, a contented defector from the court, indifferent to the ire of the king, who reveled in his modernity and the pleasures and entertainments he shared with the public.

The End of the Affair: Duc de Chartres's Fall from Public Grace

By the second half of the 1770s, the public reputation of the princes of the blood had begun to erode. The death in 1776 of Conti, the most competent of their number, deprived the *patriote* faction of its most revered figurehead. Conti's refusal of the sacra-ments on his deathbed allowed the government to dispense with the potentially embarrassing and costly rites of mourning that were nor-mally accorded to royalty. It was Conti, however, who would define his own exit in bold new terms. In one last politically canny gesture, the prince insisted that his remains be interred not within the seignio-rial chapel of his château L'Isle-Adam, but rather within the nearby parish church, which sat beside a much traveled road. Thus, visitors could pay their respects easily.[59] His epitaph pointedly recorded that "It is the man, the citizen, and the prince that all mourn . . . " [C'est l'homme, le citoyen et le prince que tous pleurent].

Chartres had little hope of stepping into Conti's shoes; he pos-sessed none of his uncle's education or intellect. But another factor hin-dered the prince's political prominence in the later 1770s: the advent under Louis XVI of boldly reformist ministers—notably Anne Robert Jacques Turgot and Jacques Necker—deprived the princes of their importance as heads of the opposition. Under Louis XVI, political discourse increasingly came to be dominated by ministers who were

empowered by their own public support and fame, and who did not hesitate to adopt positions that went against the personal opinions of the king.[60] Chartres's naval career also brought him discredit in the public's estimation: although his role in the French naval victory at the battle of Ushant in July 1778 was initially lauded, it was soon revealed that his ineptitude at reading signals had cheated the French out of a decisive defeat of the English. Chartres was also much criticized for not mounting a more gallant defense of his own sister, the duchesse de Bourbon, when she was publicly insulted by the comte d'Artois at the Opéra Ball that year.[61] In what was termed "l'affaire des princes," public opinion turned strongly against the perceived churlishness of the king's brother and the royal family more generally, and the public rallied to the side of the princes of the blood. However, Chartres, a constant companion of Artois, was loathe to criticize him and, thus, as the *Mémoires secrets* record: "The public . . . has judged the Duc de Chartres and blames him openly; this means that it will require some time for the prince to regain its affection" [Le Public . . . à jugé le Duc de Chartres & le blâme ouvertement. Ensort qu'il faudra quelque tems pour que ce prince regagne son affection].[62] In light of the public's animosity, when Voltaire made his triumphal entry at the Comédie-Française in March 1778, Chartres did not dare to present himself to the *philosophe*, but rather discretely observed the crowd's frenzied reaction from the back of the theater.[63]

Chartres' political fortunes were temporarily buoyed with the collapse of the monarchy and the coming of the Revolution. He alone among the princes managed to adapt and even very briefly flourish in the years surrounding the collapse of the monarchy. Succeeding his father as duc d'Orléans in 1785, he was widely suspected of having used his fortune to foment discord and unrest. At the opening of the Estates General, Orléans chose to take his seat with the nobles of the second estate rather than upon the dais reserved for the royal family. He also advocated uniting the three orders of the assembly and having them vote as a single body. Following the abolition of feudal titles in August 1789, it was as a simple citizen that Louis-Philippe-Joseph d'Orléans took his place as an elected representative of Paris in the National Convention. In September 1792, after the end of the monarchy, the Revolutionary authorities

obliged him to shed his family name of Orléans, which they alleged was by its very nature a vestige of feudalism. In its place, he was given the surname Égalité.[64] Allied with the Girondin faction in January 1793, he cast a deciding vote in favor of the execution of the former king, an act of perceived betrayal that would damn him and his descendants in the eyes of legitimists. This last and most radical reinvention was perhaps the ultimate proof of the former prince's pragmatism and adaptability in the face of shifting public expectations. Nonetheless, these concessions to modernity were all in vain. The Revolutionary government had little interest in either former princes or recently minted republicans, and Égalité followed his royal cousin to the scaffold in November of that same year.

His apparent determination to imagine a place for himself and his heirs within what appeared to be a dawning century of Republicanism was vindicated nearly forty years later in 1830, when his eldest son was enthroned as France's first truly constitutional monarch. Louis-Philippe, King of the French, whom we last encountered being so proudly displayed to the public in the arms of his nursemaid in the gardens of the Palais Royal, had been groomed to be a thoroughly modern prince by the father whose memory he revered. This education stood him in good stead in the Revolution of 1830, when he presented himself to the Parisian public as an ideal middle ground between monarchy and republic. A deft communicator who could reconcile the Revolutionary past embodied by his father with the hereditary legitimacy of his Bourbon ancestors, Louis-Philippe proved for nearly two decades to be an able "citizen king," fully cognizant of the popular rather than the divine origins of his authority.

Notes
1. See Antoine Lilti, *The Invention of Celebrity*, trans. Lynn Jeffress (Cambridge: Polity, 2017).
2. Mathieu-François Pidansat de Mairobert, *Journal historique de la révolution opérée dans la constitution de la monarchie française*, vol. 4 (London: n.p., 1774), 214.
3. Ibid.
4. On the exile of the princes, see Julian Swann, *Exile, Imprisonment, or Death: The Politics of Disgrace in Bourbon France, 1610–1789* (Oxford: Oxford University Press, 2017), 219–32.
5. For an overview of this conflict, see Colin Jones, *The Great Nation: France from Louis XV to Napoleon, 1715–99* (New York: Columbia University Press, 2002), 236–92.

6. On the *partie patriote*, see Durand Echeverria, *The Maupeou Revolution: A Study in the History of Libertarianism in France, 1770–1774* (Baton Rouge: Louisiana State University Press, 1985).

7. See Swann, *Exile*, 31–36.

8. See "Princes du Sang" in *Dictionnaire de l'Ancien Regime; Royaume de France XVIe–XVIIIe siècle*, ed. Lucien Bély (Paris: Presses Universitaires de France, 1996), 1018–19.

9. On the historical evolution of the role of the princes of the blood, see Richard A. Jackson, "Peers of France and Princes of the Blood," *French Historical Studies* 7, no. 1 (1971).

10. Cited in Jones, *The Great Nation*, 239–40.

11. See Arlette Jouanna, *Le Devoir de révolte: la noblesse française et la gestion de l'état moderne, 1559–1661* (Paris: Fayard, 1989).

12. Jones, *The Great Nation*, 28–52.

13. See ibid., 228–30, 252.

14. William Ritchey Newton, *L'Espace du roi: la cour de France au château de Versailles, 1682–1789* (Paris: Fayard, 2000), 37–38.

15. Henriette-Louise de Waldner de Freundstein Oberkirch, *Mémoires de la baronne d'Oberkirch sur la cour de Louis XVI et la société française avant 1789*, ed. Suzanne Burkard (Paris: Mercure de France, 2000), 281.

16. Mathieu-François Pidansat de Mairobert, Barthélemy-François-Joseph Mouffle d'Angerville, and Louis Petit de Bachaumont, *Mémoires secrets pour servir à l'histoire de la République des lettres en France, depuis 1762 jusqu'à nos jours*, vol. 7 (London: John Adamson, 1777), 87.

17. Évelyne. *Philippe Égalité* ([Paris]: le Grand livre du mois, 1996), 81.

18. Louis Antoine d'Artois, duc d'Angoulême (1775–1844), first child of the comte and comtesse d'Artois, was the only heir in the principal branch of the Bourbons until the birth of the Dauphin, in October 1781.

19. Cited in Amédée Britsch, *La Maison d'Orléans à la fin de l'Ancien Régime: la jeunesse de Philippe-Egalité (1747–1785), d'après des documents inédits* (Vannes: Imprimerie Lafolye frères et Cie, 1926), 143.

20. See ibid., 170.

21. Julian Swann, "Disgrace without Dishonour: The Internal Exile of French Magistrates in the Eighteenth-Century," *Past and Present* 195, no. 1 (May 2007): 87–126.

22. Charles Théveneau de Morande, *Le Gazetier cuirassé, ou Anecdotes scandaleuses de la cour de France* ([London]: Imprimé à cent lieues de la Bastille, à l'enseigne de la liberté, 1771), 91.

23. Siméon-Posper Hardy, *Mes Loisirs ou Journal d'événemens tels qu'ils parviennent à ma connoissance, 1753–1789*, eds. Pascal Bastien, Simon Dagenais, and Sabine Juratic, vol. 2 (Paris: Hermann, 2014), 284.

24. Théveneau de Morande, *Le Gazetier cuirassé*, 70.

25. Hardy, *Loisirs*, 2:291.

26. For an ironic description of Saint-Cloud as a destination of the middle classes, see Louis-Balthazar Néel, *Voyage de Paris à Saint-Cloud, par mer et retour à Paris par terre* ([Paris]: Duchesne, 1748).

27. Gaston Maugras, *La Disgrâce du duc et de la duchesse de Choiseul* (Paris: Plon-Nourrit et Cie, 1903), 87.

28. Édouard Fornier, "Le Palais Royal et ses environs," in *Paris à travers les ages*, ed. Fedor Hoffbauer, vol. 2 (Paris: Firmin-Didot, 1875), 189.

29. On the comparative characters of the Paris promenades, see Laurent Turcot, *Le Promeneur à Paris au dixhuitieme siècle* (Paris: Editions Gallimard, 2007).

30. On the role of princely enclaves in the production of newsletters, see François Moureau, *Répertoire des nouvelles à la main: dictionnaire de la presse manuscrite clandestine XVIe–XVIIIe siècle* (Oxford: Voltaire Foundation, 1999), 20.

31. Robert Tate Jr. and Tawfik Mekki-Berrada, "Mathieu Pidansat de Mairobert (1727–1779)," in *Edition électronique revue, corrigée et augmentée du Dictionnaire des journalistes (1600–1789)*, eds. Anne-Marie Mercier-Faivre and Denis Reynaud (Lyon: Littérature, idéologies, représentations, XVIIIe-XIXe siècles (LIRE UMR 5611), n.d.).

32. Pidansat de Mairobert, *Mémoires*, 7:87.

33. Ibid.

34. Ibid.

35. Mathieu-François Pidansat de Mairobert, Barthélemy-François-Joseph Mouffle d'Angerville, and Louis Petit de Bachaumont, *Mémoires secrets pour servir à l'histoire de la République des lettres en France, depuis 1762 jusqu'à nos jours*, vol. 6 (London: John Adamson, 1777), 93.

36. Ibid.

37. Pidansat de Mairobert, *Journal historique*, 4:97–98.

38. On the *vauxhall*, see Alain-Charles Grubert, "Les 'Vauxhalls' Parisiens au XVIIIe siècle," *Bulletin de la société de l'histoire de l'art français* (1972), 128.

39. Jonathan Conlin, "Vauxhall on the Boulevard: Pleasure Gardens in London and Paris, 1764–1784," *Urban History* 35, no. 1 (May 2008), 24–47.

40. Mathieu-François Pidansat de Mairobert, Barthélemy-François-Joseph Mouffle d'Angerville, and Louis Petit de Bachaumont, *Mémoires secrets pour servir à l'histoire de la République des lettres en France, depuis 1762 jusqu'à nos jours*, vol. 4 (London: John Adamson, 1777), 243–44. See also Alain-Charles Grubert, *Les Grandes Fêtes et leurs décors à l'époque de Louis XVI* (Geneva: Librarie Droz, 1972), 52–74.

41. Pidansat de Mairobert, *Mémoires*, 4:254; See "Le Camus" in Michel Gallet, *Les Architectes parisiens du XVIIIème siècle: dictionnaire biographique et critique* (Paris: Mengès, 1995), 290.

42. Mathieu-François Pidansat de Mairobert, *Journal historique, de la révolution opérée dans la constitution de la monarchie française*, vol. 1 (London: n.p., 1774), 341–42.

43. Louise-Élisabeth Vigée Le Brun, *Souvenirs 1755–1842* (Paris: Honoré Champion, 2015), 146–47.

44. Théveneau de Morande, *Le Gazetier cuirassé*, 121, note 1.

45. Mathieu-François Pidansat de Mairobert, *Journal historique de la révolution opérée dans la constitution de la monarchie française*, vol. 6 (London: n.p., 1776), 114–15.

46. *Mélanges publiés par la Société des Bibliophiles français* (Paris: Firmin Didot, 1826), 81.

47. Mathieu-François Pidansat de Mairobert, Barthélemy-François-Joseph Mouffle d'Angerville, and Louis Petit de Bachaumont, *Mémoires secrets pour servir à l'histoire de la République des lettres en France, depuis 1762 jusqu'à nos jours*, vol. 5 (London: John Adamson, 1777), 288.

48. Mathieu-François Pidansat de Mairobert, Barthélemy-François-Joseph Mouffle d'Angerville, and Louis Petit de Bachaumont, *Mémoires secrets pour servir à l'histoire de la République des lettres en France, depuis 1762 jusqu'à nos jours*, vol. 3 (London: John Adamson, 1777), 81–82.

49. Emmanuel de Croÿ-Solre, *Journal inédit du duc de Croÿ publié, d'après le ms. autographe conservé à la Bibliothèque de l'Institut*, vol. 3 (Paris: E. Flammarion, 1906), 211.

50. Luc-Vincent Thiéry, *Guide des amateurs et des étrangers voyageurs aux environs de Paris* (Paris: Hardouin et Gattey, 1787), 246.

51. Gauthier de Simpré, *Voyage en France de M. le comte de Falckenstein*, vol. 1 (Paris: Cailleau, 1778), 55.

52. Pidansat de Mairobert, *Mémoires*, 7:20.

53. Ibid., 5:281.

54. David Hays, "Carmontelle's Design for the Jardin de Monceau: A Freemasonic Garden in Late-Eighteenth-Century France," *Eighteenth-Century Studies* 32, no. 4 (Summer 1999).

55. Pidansat de Mairobert, *Mémoires*, 7:48.

56. See Abbé Jaucourt, "Naumachie," in *Encyclopédie, Dictionnaire raisonné des sciences, des arts et des métiers, par une Société de Gens de lettres*, vol. 11 (Neufchâtel: Faulche, 1765), 60.

57. Pidansat de Mairobert, *Mémoires*, 7:43.

58. On the private entertainments of the princes, see Grubert, *Les Grandes Fêtes*.

59. See Caroline Béziès, "Le Mausolée du prince de Bourbon Conti par Mérard," in *Les Trésors des princes de Bourbon Conti*, ed. Frédéric Chappey (Paris: Somogy, 2000), 139–45.

60. Julian Swann, "From Servant of The King to 'Idol of the Nation': The Breakdown of the Personal Monarchy in Louis XVI's France," in *The Crisis of the Absolute Monarchy: France from Old Regime to Revolution*, eds. Julian Swann and Joël Félix (Oxford: Oxford University Press, 2013), 63–89.

61. Mathieu-François Pidansat de Mairobert, Barthélemy-François-Joseph Mouffle d'Angerville, and Louis Petit de Bachaumont, *Mémoires secrets pour servir à l'histoire de la République des lettres en France, depuis 1762 jusqu'à nos jours*, vol. 11 (London: John Adamson, 1779), 158, 163–65.

62. Ibid., 11:164.

63. Ibid., 11:177.

64. On the circumstances surrounding Orléans's renaming, see Evelyne Lever, *Philippe Égalité* (Paris: Fayard, 1996), 446–47.

ANCIENT PARALLELS TO EIGHTEENTH-CENTURY CONCEPTS OF CELEBRITY

ARIANE VIKTORIA FICHTL

References to public figures from classical antiquity abound in the social and political discourse of Revolutionary France, especially during the early years of the French Republic from 1792 to 1794, as it came into existence. To erudite French contemporaries, antiquity offered an extensive compilation of historical lessons on the nature of man as a political being, that is to say as a member of a civic community whose rules were founded on the principle of civic equality, which resulted from multiple experiences of active participation in the public life of the Greek city states in the fifth and fourth centuries B.C.

Confronted with the imminent necessities of war, however, most French politicians preferred to discard abstract reflections on political philosophy in order to consider more practical concepts by looking for parallels between historical examples from antiquity and their own era. Their attention was especially caught by successful revolutions, like the one orchestrated by the founders of the Roman Republic at the end of the sixth century B.C. Back then, those who overthrew the monarchy gained a reputation of personal fame as well as public celebrity by going so far as to sacrifice their lives in order to assure that the republic survived foreign attacks and subsisted for more than five centuries.[1]

In his most recent work on the *Invention of Celebrity*, Antoine Lilti writes that the first celebrities appeared in the eighteenth

century, which is the assumption that most of the chapters in this volume make.[2] Looking at the social and political discourse that the Revolutionaries were involved in, however, it becomes evident that the eighteenth-century erudite French public regarded public figures of the ancient republics as celebrities too.[3]

Lilti carefully distinguishes between "glory," which attributes positive distinction to outstanding individuals posthumously, and "celebrity," a feature of the opinion of contemporaries, that is to say a form of contemporary "publicity" that focuses on positive as well as negative aspects of an individual's life.[4] He considers "celebrity" gained by public scrutiny, however, as in anticipation of achieving posthumous "glory."[5] Lilti also observes that one's becoming a celebrity implicates that the public is curious about the details of that individual's private life, as such lives are presented in eighteenth-century epistolary novels and autobiographic writings such as Samuel Richardson's *Pamela* (1740) or Jean-Jacques Rousseau's *Confessions* (completed in 1769, published in 1782).[6] The eighteenth-century reader certainly did not find an equal amount of information about the private lives of ancient public figures in texts like Plutarch's *Parallel Lives*. But as Philip A. Stadter has shown, Plutarch did not avoid mentioning certain private aspects of ancient public figures' lives, which helped the ancient biographer to "humanize" his subjects by developing their full moral portraits, making it easier for his own contemporaries to identify with them.[7] It is thus necessary to emphasize that while many scholars follow the modern conception of "celebrity" by understanding celebrities in the eighteenth century as people who were associated with rumors and scandals (which is of course true to a certain point), like Laure Philip in the next chapter, I have developed a specific understanding of celebrity. In this chapter, eighteenth-century celebrity involves the capacity to step back from individual pursuits and to emulate and represent, as authentically as possible, certain qualities that were connected to the achievement of the well-being of the public, in order to be celebrated. Using this definition, this chapter demonstrates both the evolution of celebrity models that were inspired by the historiography of ancient republican antiquity within the French Revolutionary process, and how that process rejected individual fame especially when it was gained through populism.

In their speeches and public writings, many eminent politicians of late eighteenth-century France evoked models of ancient republican antiquity. These models were renowned for their effectiveness in resolving domestic crises and fending off foreign threats. For instance, the Revolutionary journalist Camille Desmoulins did not hesitate to paint his comrade Georges-Jacques Danton as a man of "Roman character,"[8] that is to say as manly, eloquent, and courageous, like a people's tribune back in the times of the Roman Republic. For the most part, French Revolutionaries restricted their references to the Republican past in their speeches and writings, addressing their peers or an erudite public. One of the central questions in this study is, therefore, how the nature of those references to antiquity changed from an approved rhetorical and artistic device, which corresponded to the taste of the era of Neoclassicism, to an instrument of political action during the French Revolution.

There was indeed an indissoluble connection between a collectively used rhetorical style and its application by individual French political representatives, known as "deputies." French Revolutionaries occupied a double role as political thinkers and actors who were eager to convince their audiences that the direction of politics they propagated was beneficial to the Republic. In order to achieve that goal, they found themselves in need of having their proposals backed up by examples of political experience that they could not themselves provide, but that were taken from ancient historiography (a subject they knew well thanks to their humanist education, which was heavily influenced by classical texts). Those deputies who presented themselves as the most capable imitators of qualities connected to famous public figures from the ancient republican past could equally claim some sort of public, "revolutionary" celebrity among their contemporaries, and the knowledge of how to operate a "happy revolution" as a path toward a progressive future. It is this "revolutionary celebrity," which simultaneously invokes antiquity and eighteenth-century France, that is of interest here.

As much as history and historical figures have been continuously used for the purpose of emulation, this was a practice already well established in antiquity, when noblemen could gain status by having their qualities and deeds compared to those of famous figures from the past. One could think of the heroes in Homer's *Iliad*

or the patriotic ancestors in Titus Livy's *Roman History*, who were praised foremost for their courage in battle and for their personal sacrifice to a common cause. The continuous popularity of these qualities can be observed even in the modern age. In his work on *Fame and its History*, Leo Braudy outlines his conception of the evolution of fame in ancient times with the figure of Alexander the Great, whose heroic pursuits in the Persian Empire were an inspiration in the Late Roman Republic. Braudy analyzes the most important examples of famous figures in the first century B.C., such as the Roman generals Pompey and Julius Caesar, as well as the ambitious self-made man in the Roman Senate, Cicero. Braudy's outlook on classical antiquity is based on fame as an individual rather than a collective achievement (an essential feature that he only mentions in order to develop the portraits of his protagonists).[9] The analysis in this chapter, however, will focus on the concept of celebrity as a collective experience and its relation to the individual, which became a major ambiguous issue in late eighteenth-century France. More precisely, while Braudy's analysis moves forward chronologically (from Caesar's dictatorship toward modern concepts of fame), mine turns back through time, using the late eighteenth century as a starting point to look at the world of the ancient republics. This is essential in order to understand the rejection of individual fame, and therefore of personal glory, that accompanied the French Revolutionary process.

Popular Fame and the Model of Cicero

First of all, before we can understand how French Revolutionaries used the technique of "parallelizing," that is drawing connections between present and past figures, we need to understand its use in the ancient world. Many ancient poets used this device to emphasize the greatness of the subjects of their eulogies. An important figure who employed this technique was Plutarch of Chaeronea, author of the so-called *Moralia*, a collection of seventy-eight essays and speeches reflecting on topics of contemporary civic education, ethics, and religion, and of the *Parallel Lives*, forty-six biographies that compared the lives of famous Roman and Greek statesmen. Stadter points out the contemporary function of the *Parallel Lives*

by writing that Plutarch highlighted the moral choices of his pro-
tagonists by using a comparative method, setting one life beside
another, and therefore displaying "nuances of moral action which
might not otherwise be noticed," inviting the reader to "enter into
the comparison as well."[10] Stadter concludes that Plutarch's aim
was to recommend the examples set by Greek and Roman ancestors
to his contemporaries. Offering more than a set of moral political
portraits, the *Parallel Lives* encouraged a large readership to iden-
tify with them, showing how the technique of parallelizing invited
a constant comparison between present public figures and models
from the past.

Roman senator Marcus Tullius Cicero was a key staple of eigh-
teenth-century collegiate studies and a figure whom Plutarch included
in his biographies.[11] Cicero had already drawn parallels between him-
self and famous public figures, such as Cato the Elder or Demosthenes,
associating himself with their qualities and deeds to compensate for
his lack of noble ancestry.[12] Cicero's style of rhetoric had a profound
impact on France's Revolutionary generation, notably when its mem-
bers sought to advance in public careers as magistrates, orators, and
barristers by exhibiting qualities of civic virtue.[13] Following Cicero's
model, young newcomers in the French parlements, such as the notori-
ously rebellious lawyer Simon Linguet and the future Revolutionary
Jacques-Pierre Brissot, presented themselves as advocates for those in
need, and as prosecutors of partiality and corruption.[14]

Most of all, Cicero was characterized as savior of the Roman
Republic's liberty for having spoken out against the conspiring
senator Catiline in 63 BC. In that speech, the consul referenced the
Roman Senate's emergency decree, *Senatus Consultum Ultimum*,[15]
to declare the accused and his co-conspirators condemned and out-
lawed as public enemies. In doing so, Cicero evoked an alternative
source of jurisdiction to the common Roman civil law: the principle
of the welfare of the people [Salus populi suprema lex esto].[16] This
maxim, which in eighteenth-century France was almost exclusively
associated with Cicero, had been referred to several times at the
Constituent Assembly in order to limit civil liberties,[17] such as the
privacy of correspondence.[18]

Salus populi suprema lex esto was also propagated by the Revo-
lutionary press as a guiding principle of daily life.[19] At the National

Convention, it became a major argument during the trial of the king, and it informed the creation of the Revolutionary tribunal, underlining the fact that it was a principle that invoked the legal sphere of the natural law. As early as spring 1793, members of the Committee of Public Safety, modeling themselves on Cicero, reused the principle of the people's welfare—and therefore the autocratic style of politics associated with Roman consulship—to defend the newly founded French Republic against both attacks from its European neighbors and civic uprisings, such as the one in the Vendée.[20] They could therefore claim the same celebrity as defenders of the French Republic that Cicero had claimed in defending the Roman Republic.

In terms of credibility and authenticity, Cicero was, however, not the most popular model for the French Revolutionaries due to his political flexibility toward Caesar's rise, which foreshadowed the fall of the Roman Republic. Yet, Cicero's claim that it was useful for civil society to include multiple accusers in order to keep audacity subjected to fear served to legitimate the civil right to freely accuse public functionaries who violated their powers.[21] In the popular assemblies of the Parisian sections, for example, the role of public accuser was positively perceived due to the opinion that active vigilance was a civic virtue associated with patriotism, as indicated in the contemporary pamphlet *Mille et unième dénonciation* (1790), as well as in the characterization of the public accuser by Desmoulins in the periodical *Révolutions de France et de Brabant* (1789–1791).[22] Both publications stress the necessity of denunciations that are not shameful as long as they are made publicly. According to Cicero, who had saved the Roman Republic from a political coup by publicly accusing Catiline, public denunciations were even honorable insofar as they made a celebrity of the accuser (as Cicero had become by publishing his Catiline orations).

Cicero's conception of the public accuser's role also struck the main Jacobin spokesman and member of the Committee of Public Safety, Maximilien Robespierre, who strongly identified with Cicero's position on the practice of public denunciation. By spring 1792, Robespierre already supported the Parisian sections' claim to censuring their public functionaries on the basis of debating whether

or not France should wage war against its neighbors.[23] In his speech on December 18, 1791, he additionally referred to the Ciceronian metaphor of the Capitoline geese in order to propagate the principle of public vigilance among his fellow Jacobins and successors in the Legislative Assembly. He evoked the episode of the sack of Rome by the Gauls in 390 BC from Livy's *Roman History*.[24] In Livy's account, the handful of Roman soldiers that survived the sack of Rome reassembled at the Capitoline Hill under the command of Marcus Manlius, who, succeeding the events, had gained the consulship as well as the nickname of Capitolinus, "savior of the Capitol." When the Gauls prepared to attack at night, their arrival was announced by the clamor of the watchful geese that inhabited the area. Manlius reacted promptly by ordering his soldiers to counterattack, and the small garrison succeeded in defending the Capitol until Camillus, appointed lawful dictator by the senate, arrived with the Roman army to deliver the city from the invaders. The reference to the geese, as it was employed by Robespierre, therefore served to underline the utility of preemptive public denunciations in order to safeguard public liberty, even if the stigmatized turns out to be innocently accused. Figuring as a key principle of Jacobin ideology, Cicero's propagation of the function of public denunciations was soon incorporated into Revolutionary rhetoric and imparted a form of ancient celebrity on the Revolutionary accuser.

One particular danger to public liberty was seen in public figures that could claim a certain degree of popular fame. Cicero himself had attributed this threat to the political group the Populares, who, especially as tribunes, rallied on the cause of the plebeian Romans by proposing agrarian laws, whereby the government regulated the division of public land (*ager publicus*) among Roman citizens.[25] Ironically, the very term "tribune," which Desmoulins had once ascribed to Danton in favorable terms, was used as a denunciation by the French royalist press against those deputies of the Constituent Assembly who were members of the Jacobin Society and considered themselves to be advocates of the people's cause. For the French contemporaries, the best-known figures of popular tribunes were the famous Gracchi brothers, whose lives were depicted by Plutarch. The royalist press attributed the term "tribune" to those deputies who, in their speeches, apostrophized

the French people directly, and were looked upon as agitating demagogues or anarchists. These included the Jacobin Society's most important spokespersons: the Comte de Mirabeau; the so-called "triumvirs" Antoine Barnave, Adrien Duport, and Alexandre de Lameth; and Robespierre himself. Although this reference gradually fell out of active usage after the declaration of the Republic in September 1792—especially due to the Gracchi brothers's positive image, propagated in Marie-Joseph Chénier's play *Caius Gracchus* (1792)—the very notion of popular fame continued to be a source of anxiety due to its potential to elevate powerful individuals above the masses.[26]

Also, radical popular measures such as the agrarian laws that could disrupt civil peace and lead to civil unrest and anarchy continued to be seen as a vital concern to the liberty and inner safety of the state. History had shown that measures like these destroyed public liberty and created autocratic regimes.[27] Those employing populist techniques were denounced as counterrevolutionaries who imitated the example of Roman tribune Livius Drusus, who supported the senate by proposing extreme popular measures, which even surpassed those of Gaius Gracchus. According to Plutarch, Gracchus lost the support of the Roman people and was chased from Rome, whereas the measures proposed by Livius were deliberately dropped.[28] In other words, the charge against the imitators of Livius in Revolutionary France (those propagating federalism) was one of demagogy, an excess of republican principles. This demagogy could destroy the very basis of the newly created French Republic—national sovereignty—by creating an environment in which the republic could not prosper, but would instead be dissolved as a result of division, generally leading to anarchy and enabling the return of monarchy or absolutism. That argument influenced the first years of the constitutional monarchy (1789–1792), when republicanism was considered a crime and the title of tribune was associated with seditionists in the Parisian sections. That situation was not unique to France alone: a similar depiction of the "bad" tribune Livius can be found in the Irish radical playwright James Sheridan Knowles's play also named *Caius Gracchus* (1815). Knowles's work was very well received by his countrymen of republican sentiment and shows the impact of French Revolutionary ideology on Irish sympathizers.[29]

Cicero's speeches against Catiline inspired the members of the Revolutionary government of 1793–1794 to use a similar form of emergency decree. The government employed Cicero's consular example in times of inner political crisis, especially in order to fight members of political factions within the National Convention itself.[30] Once again, Cicero's rhetoric offered practical guidance to eighteenth-century contemporaries who were eager to advance their careers in public life. The argument of populism, connected to the accusation of tribunate, was first adopted against the so-called Brissotins, the Girondin leaders at the National Convention, due to their motions, which appealed to the people. The Revolutionary government again used it in autumn 1793 against the *agrairiens* of the so-called Enragés, a group of radical *sans-culottes* who followed the priest Jacques Roux. In spring 1794, at the height of what historian Marisa Linton has called the "Politicians' Terror" of the second year of the French Republic, the populist accusation was further extended to the Hébertist and Dantonist factions.[31] The Revolutionary government turned itself against populist movements in the sections, as the constitutional monarchy had done before them. Following Cicero, who had ironically been an orator who used populist rhetoric in imitation of those he condemned, eighteenth-century contemporaries believed popular fame and celebrity should not be confused.

Revolutionary Celebrity and the Model of Aristides the Just

Other, notably Greek, examples were wisely used during the Revolution in order to define what celebrity meant. One example of particular interest is the Athenian general and statesman of the early fifth-century BC, Aristides the Just, who became one of the most cited models of political morality to French Revolutionaries, especially in terms of social justice. Robespierre referred to Aristides on several occasions in his speeches at the Constituent Assembly and at the National Convention. He particularly evoked Aristides's civic virtues of disinterestedness and love of equality, as depicted by Plutarch, which were directed against decrees that tied rights of political participation to a census. Using the reference to Aristides, Robespierre propagated a theory of property

that openly favored what he called "honorable poverty." By doing so, Robespierre indirectly opposed the agrarian laws that had rallied poor citizens on the side of populist factions, such as the Enragés.[32]

Robespierre's use of Aristides was similar to the French philosopher Gabriel Bonnot de Mably's use of Phocion, a fourth-century BC Athenian general and statesman, in his *Entretiens de Phocion: sur le rapport de la morale avec la politique* (1763),[33] and to Jean-Jacques Rousseau's use of the Roman consul and censor of the third century BC, Fabricius, in his *Discours sur les sciences et les arts* (1750).[34] Aristides became the French Revolution's personification of revolutionary celebrity, which was defined by the principle that public merit should not be reserved for those in possession of the greatest wealth and thereby of the greatest individual fame, but rather for those who deserve it through their qualities of civic virtue and their selfless devotion to public affairs, even in their private lives.[35] The very principle that came to be called honorable poverty would assure civil equality and peace much more effectively than the idea of agrarian laws would. The celebrity model of Aristides was claimed by some famous public officials, such as the Girondin minister Jean-Marie Roland, who portrayed himself as a man of simple manners and appearance favoring civic equality.[36] Roland was, however, ridiculed by Desmoulins for his habit of wearing his shabbiest clothes in public in order to show off his disregard for luxury goods.[37]

The rupture between Girondins and Montagnards in 1793 provoked a change in the way references to Aristides functioned. Although Aristides did not cease to be a popular model for public officials, the emphasis was now laid on the story of his ostracism as described by Plutarch.[38] In this account, an individual could be ostracized for up to ten years even if his rights of citizenship remained untouched. The ostracism of the virtuous Aristides became associated with rejecting the idolatry of public figures in general, in reference to Plutarch's report on Aristides's encounter with an Attic peasant. This episode was evoked at the National Convention by future members of the Revolutionary government, such as Bertrand Barère and Jacques-Nicolas Billaud-Varenne, who associated idolatry with the reestablishment of royal power.[39] The

Revolutionary government openly promoted the rejection of idolatry as a safeguard against the return of autocratic rule in Republican France, and assigned this responsibility to the deputies themselves, urging them to denounce anyone among them susceptible to rise above the others, even by reputation of civic virtue, that is to say by revolutionary celebrity. This responsibility was among a number of reasons used to justify the expulsion of twenty-nine leading Girondin deputies from the National Convention at the end of May 1793.[40]

The right to accuse, legitimized by Cicero, was to be put into practice for the reproduction of Athenian ostracism. Robespierre had argued for this in his analysis of the Girondin deputies' strategy prior to the king's trial in December 1792, when they were calling for the banishment of the nephew of Louis XVI, Philippe-Egalité, and his family.[41] Yet, for a deputy to become an object of idolatry, he needed to be an object of celebrity first. French Revolutionary deputies gained their reputation foremost by their display of what Desmoulins had called "a Roman character," or more precisely, by manners that were inspired by "manly" qualities (from Latin *virtus*).[42] These characteristics were diametrically opposed to the customs of the courtiers of the Ancien Régime and included frankness, modesty, incorruptibility, love of one's country, faithfulness to the laws, and especially the willingness to sacrifice oneself and everything dear to them for the Revolutionary cause. Those who succeeded in making the public believe that they personified these qualities were elevated to the highest positions in the young French Republic. Whereas experience was certainly valued, most of the former public functionaries that were connected to the Ancien Régime were replaced with younger men of lesser experience but more patriotic fervor, such as the twenty-six-year-old member of the Committee of Public Safety, Louis Antoine de Saint-Just.

Following in the Footsteps of Brutus: A Genuinely Revolutionary Model

Scholars have not yet sufficiently studied how the French Revolutionaries' modeling on the celebrity of ancient public figures contributed to the development called the "Politicians' Terror," which

devoured most Jacobins who became famous during the Revolution. Some, such as Jean-Paul Marat and Louis-Michel Lepeletier, became "apotheosized" as martyrs in the Panthéon; others were subjected to some sort of *damnatio* by facing death on the guillotine, which figured as the Tarpeian Rock of Republican France.[43]

One striking example of the use of ancient figures during this period can be seen in the motion to exile Philippe-Egalité, put forward by the Girondin deputies François Buzot and Jean-Baptiste Louvet before the king's trial in December 1792. In their proposal, they referred to the enormously popular revolutionary figure of mythical Roman first consul of the sixth century BC, Lucius Junius Brutus.[44] According to Livy, Brutus had gained celebrity defending the newly founded Roman Republic by suppressing a royalist plot, executing his own sons, and forcing his co-consul Collatinus into exile, even though Collatinus was nephew to the Tarquinian king (as was Brutus himself).[45] This was a highly politicized and morally effective republican celebrity model due to Brutus's public display of patriotism before love of his family. In eighteenth-century France, the figure of Brutus was interpreted to support multiple notions of social discipline and political virtue, including paternal authority and the primacy of the public good before private interests. He was the protagonist of Voltaire's play *Brutus* (1730), which became enormously popular after 1789, was staged mandatorily several times a week in 1793, and inspired the famous painting by Jacques-Louis David, *The Lictors bring to Brutus the bodies of his sons* (1789).[46] It was, however, not until after the proclamation of the French Republic in 1792 that Brutus was declared a legitimate model to public functionaries, due to his recorded hostility to monarchical rule. Together with the Revolutionary martyrs Marat and Lepeletier, Brutus represented a figure of identification and emulation for French citizens who embraced civic cults, due to his devotion to the laws of the Roman Republic.[47]

By spring 1793, the Girondin deputies' recurring demands to expel other, more popular members of the opposition in the National Convention, such as Marat and Robespierre, had backfired. Accused of abusing the figure of Brutus by arbitrarily reproducing not the system of Athenian ostracism, but rather that of harsher Syracusian petalism—which had once enabled the ancient

Syracusians to banish their fellow citizens without imposing any rules[48]—twenty-nine deputies suffered some sort of involuntary exile, and most ended up dead. In the aftermath of their downfall, the Girondins chose to no longer evoke the figure of Brutus and portray France as a new Roman Republic, as was henceforth claimed by the Committee of Public Safety, but rather to refer to Paris as the seat of a degenerated Roman Empire that oppressed its provinces.[49] The deputies never formally adopted the proposition to institute a ban on celebrity figures in the National Convention in order to eliminate the danger of idolatry. Yet such a ban became an unspoken rule that was put into practice, especially after the removal of the Girondin leaders.

A policy that was adopted, however, was that of the ancient Roman law at the basis of the Ciceronian emergency decree, called the *lex Valeria de sacrando*. The law was created following the failed royalist plot against the young Roman Republic at the beginning of the sixth century BC, as described by Plutarch and Livy, and in which Brutus's sons were implicated. Attributed to Brutus's co-consul Valerius Publicola, it declared anyone who aspired to reestablish royalty in Republican Rome "sacer," that is to say doomed by the gods and therefore outlawed. The law also permitted Roman citizens to persecute and kill those who had been declared outlaws by the consuls. It can be described as a precursor to the Roman Senate's emergency decree employed by Cicero against Catiline.[50] The first to refer to the law of Publicola was Danton at the Jacobin Society in summer 1792, by proposing the adoption of martial law against the constitutional monarchy.[51] The reference to the Roman law reappeared at the National Convention in the form of a motion, once again proposed by Danton the day after the declaration of the Republic on September 22, 1792, as well as in late March 1793, when French politicians tried to use the policy to condemn to death any potential aspirants to autocratic rule, ergo anyone who could be considered of counter-Revolutionary sentiment.[52] During the early stages of the Roman Republic, the same law ordered the death penalty against those who aspired to royalty, including those who acted as treasonous co-conspirators. One intriguing example is that of the savior of the Capitol, Marcus Manlius, who, a few years after his successful defense of the Capitoline Hill from the Gallic

siege, dared to search for popular fame by supporting the Roman plebeians. He was accused of aspiring to kingly power and died by being thrown from the Tarpeian Rock. Hence the saying frequently employed by the French Revolutionaries: "il n'y a pas loin du Capitole à la roche Tarpéienne," translated into English as "pride comes before a fall."[53] In the minds of contemporaries, revolutionary celebrity should never lead to aspirations to political power.

The Revolutionary government's politics of public safety provoked resistance at the very heart of the National Convention, especially from the indulgent Dantonist party, which began to reject the Ciceronian-inspired political agenda of the Revolutionary committees. Danton's popularity and his opposition to the ultra-Revolutionary agenda doubtlessly posed a danger to the Revolutionary government's policy. To send Danton and his comrades from the Capitoline Hill (the National Convention) to the Tarpeian Rock (the guillotine), Robespierre addressed the National Convention the day after their arrest, calling Danton a supposed idol, a man without authenticity, who ridiculed the concept of civic virtue and was unworthy of being called a true Roman—that is to say a true Republican.[54] In Robespierre's eyes, Danton certainly resembled ancient figures like Manlius Capitolinus.

Searching for popular favor was regarded as one of the most effective ways to rise to power, especially in a democratic republic. As principal spokesman of the Jacobins, especially after the fall of his opponents Brissot and Danton, Robespierre became the main subject of this accusation, as he made it his trademark to imitate Cicero's pledge to sacrifice his life rather than to sacrifice his liberty to the popular faction of Caesar and Marc Antony.[55] By doing so, "the Incorruptible," as Robespierre was dubbed, made himself vulnerable to comparison with populist autocrats such as the Athenian tyrant Peisistratos,[56] who had stylized himself as the people's advocate, claiming his right to special protection by a personal guard. Following the principle of rejecting idolatry, Robespierre's attitude of presenting himself as a man of irreproachable and uncompromising civic virtue, that is to say as a man of authenticity and true revolutionary celebrity, directly contributed to his condemnation as populist conspirator, a modern Catiline.[57]

Cicero Delegitimized: Celebrity as a Double-Edged Sword

Celebrity models from antiquity fulfilled multiple functions in Revolutionary France. Those endorsed by members of the government in the years 1792–1794, including Brutus, Aristides, and Cicero, embodied the qualities of civic virtue, notably of social (and by extension military) discipline. These models were inspired by accounts of the extraordinary patriotic and self-denying deeds of early republican Roman and Greek magistrates and soldiers, as presented by Plutarch and Livy. Other ancient figures, such as Catiline and Peisistratos, were referred to as synonymous with public enemies who lacked or, worse, feigned civic virtue in order to gain and abuse celebrity, which was regarded as a crime to be punished, especially in times of civil unrest.

However, during the Revolution and within the National Convention, gaining a celebrity reputation that matched models of civic virtue did not protect from being associated with figures of conspirators. Mirabeau raised this point in May 1790,[58] and Robespierre referred to this in his speech on 8 Thermidor an II (July 26, 1794) in which he directly addressed the conception of celebrity as a double-edged sword: "Some slandered, others prepared the pretexts for slandering. The same system continues openly today . . . Today . . . their language is more affectionate than ever. Three days ago, they were ready to denounce me like a Catiline; today they ascribe to me Cato's virtues" [Les uns calomniaient, les autres préparaient les prétextes de la calomnie. Le même système est aujourd'hui continué ouvertement . . . Aujourd'hui . . . leur langage est plus affectueux que jamais; il y a trois jours, ils étaient prêts à me dénoncer comme un Catilina; aujourd'hui, ils me prêtent les vertus de Caton].[59] Here, Robespierre was referring to Cato the Younger, who was approved as the model *par excellence* of civic virtue in eighteenth-century England. Cato the Younger was the protagonist of Joseph Addison's play of the same name (1712), which had been enormously popular with the American revolutionaries.[60] In his speech, Robespierre was actually reclaiming a public figure that the Dantonist Desmoulins had placed in opposition to Cicero in his journal *Le Vieux Corde-lier* (1793–1794) to combat the Revolutionary government's pretense to punish those with dissenting opinions. In the last issue of

the *Vieux Cordelier*, published posthumously, Desmoulins copied a passage from Thomas Gordon's commentaries on the writings of the Roman republican author Sallust that referred to the trial against a powerful Roman senator charged with corruption, Lucius Licinius Murena.[61] In his defense for Murena, which he wrote in 63 BC, Cicero criticized Cato's uncompromising stance against the slightest move of civic misconduct, which he ascribed to Cato's embrace of the Stoic philosophy.[62]

In reproducing the passage, Desmoulins aimed to delegitimize the model of Cicero by employing the method of the Socratic dialogue in order to illustrate the hypocritical pragmatism of Cicero's proceedings as *arbitrer moderate* in the fight between the Caesarian faction and the Senate, which would ultimately lead to the downfall of the Roman Republic. Desmoulins's position thus corresponds to a vein of anti-Ciceronianism that developed during the Renaissance.[63] This movement followed Plutarch's preference of the cautious Demosthenes over the "fame-desiring" Cicero in the comparison between the two orators, who could both equally claim a certain degree of celebrity in their lifetimes as accusers of aspirants to autocratic power.[64] In the case of Cicero, it was his speeches against Catiline that promoted this image;[65] in the case of Demosthenes, it was his speeches directed against Macedonian King Philip II and his description of the monarchical strategy of "dividing and conquering" that made him particularly interesting to the French Revolutionary generation. Through Demosthenes, they learned about the danger of the corruption of French deputies by the royal courts of Europe.[66]

The day of the fall of Robespierre, 9 Thermidor an II (July 27, 1794), his young colleague on the Committee of Public Safety, Saint-Just, defended him against the charges of conspiracy and of tyranny made by their colleagues Jean-Marie Collot d'Herbois and Billaud-Varennes, by choosing to evoke not the model of Cicero, but rather that of Demosthenes:

> Those who knew how to move opinion, they all have been enemies to the oppressors. Was Demosthenes a tyrant? If he was, his tyranny shielded Greece's liberty for a long time. Jealous mediocrity wants to lead the genius to the scaffold . . . Well! Since the rhetorical talent that you profess here is a

talent of tyranny, soon they will accuse you [addressing Collot d'Herbois and Billaud-Varenne] to be despots of opinion. The right to interest public opinion is a natural right; it is timeless, inalienable, and I don't see any usurpers than among those who try to suppress that right.

[Ceux qui ont su toucher l'opinion ont tous été les ennemis des oppresseurs. Démosthène étoit-il un tyran? Sous ce rapport, sa tyrannie sauva pendant long-temps la liberté de toute la Grèce. (. . .) Comme le talent de l'orateur que vous exercez ici est un talent de tyrannie, on vous (s'adressant à Billaud-Varenne et Collot d'Herbois) accusera bientôt comme des despotes de l'opinion. Le droit d'intéresser l'opinion publique est un droit naturel, imprescriptible, inaliénable; et je ne vois d'usurpateurs que parmi ceux qui tendroient à opprimer ce droit.][67]

In this speech, which Saint-Just was unable to deliver, he promoted, as Desmoulins had done before him, the civil right to freedom of opinion that had been related to Demosthenes by the French philosopher Mably in his *Observations sur l'histoire de la Grèce* (1766). In his *Observations*, Mably outlined Demosthenes's role as vigilant guardian of Greek political freedom, criticizing his fellow Athenians' lack of alertness to Philip II's pretensions to universal rule over Greece.[68] Saint-Just, for his part, compared Demosthenes to Robespierre, who, according to him, was not a tyrant of opinion, but rather made rightful use of his freedom of opinion to act as a watchdog over the political freedom of the young French Republic.

As in the case of the Dantonists, the Robespierrists did not stand a chance; the National Convention had adopted a principle of unity and would no longer accept a dissenting group. It was only shortly after the Robespierrists' fall that doubts arose surrounding the usefulness of inflexibly adapting the Roman maxim of the sacrifice of personal relations to the public good, which was incarnated not by Cicero, but rather by his celebrity predecessor, first consul Lucius Junius Brutus. The journalist Jean Joseph Dussault, who was known for his moderate views, therefore rightly noted with reference to the death of Robespierre: "We don't know yet how to handle the power of Brutus" [Nous ne savons pas encore manier le pouvoir de Brutus].[69]

Celebrity figures from the ancient world certainly offered some remarkable models for eighteenth-century concepts of celebrity, which gradually adopted the characteristics of the new phenomenon of publicity by replacing the old practice of exemplarity. At first, Cicero had been the most important model for young parliamentarians in terms of rhetorical style, as well as for the deputies of the National Assemblies, and especially for the members of the Revolutionary committees of 1793–1794, in terms of his politics. However, Cicero's ambiguity, characterized by his political tiptoeing—as well as the inaccessibility of his writings to some of the newly elected deputies of the National Convention, who had not profited from an education based on the study of Latin—did not qualify him to leave a lasting footprint on the young Republican generation. Neither did the figure of Aristides, whose popularity began to shrink with the expulsion of the Girondin deputies from the National Convention in spring 1793 and the upcoming federalist revolt in the departments, provide a guiding legacy.

As for Lucius Junius Brutus, although Plutarch described him as "driven by hatred against monarchy," he was an even greater public figure for the Romans than their founding father Romulus, since the sacrifice Brutus made by ordering the death of his sons in order to secure the newly established Roman Republic was of the highest order.[70] The sacrifice of family was one that felt too familiar for the Revolutionary generation. The type of celebrity associated with Brutus was, without doubt, regarded as one that highlighted an individual's dedication to the state as a collective entity rather than a state's dedication to a single great man; it was therefore related neither to the military glory of Alexander the Great and Caesar, nor to Cicero's rhetorical self-fashioning as liberator of the Roman Republic. Identification with the uncontested popularity of the Revolutionary model of Brutus began to decrease continually until it was cast out by Napoleon's coup in November 1799.[71]

Roman celebrity figures of social and military discipline dominated the political scene of the years 1792–1794, which were marked by the exceptional circumstances of war. By the summer of 1794, the would-be state religion, the Cult of the Supreme Being, promoted the veneration of republican martyrs, among whom figured some famous Romans, especially Cato the Younger and

Marcus Junius Brutus, who was often referred to together with republican founding father Brutus. As the most prominent Roman from antiquity during the first two years of the French Republic, it was Brutus's consular attributes, the fasces with the hatchets on top of them, that symbolized the only form of idolatry acceptable: the idolatry of republican law (especially of the *lex Valeria de sacrando*), which was the very basis of French Revolutionary celebrity.

Notes

1. By the time of the Late Roman Republic, their portraits had been collectively erected at the public Forum. See Beth Severy, *Augustus and the Family at the Birth of the Roman Empire* (New York: Routledge, 2003), 167–69.

2. Antoine Lilti, *The Invention of Celebrity, 1750–1850*, trans. Lynn Jeffress (Cambridge: Polity Press, 2017), 7.

3. See Beffroy de Reigny, *Dictionnaire néologique*, vol. 2 (Paris, 1800), 477: "Under the monarchy, the younger generations were only given republican works without thinking about the French constitution, morals, or character. A pupil in the fourth class took himself as Aristides; every boy boasted that he had the courage of Brutus" [Au sein d'une monarchie on ne mettait entre les mains de la jeunesse que des ouvrages républicains, sans égard pour la constitution, les mœurs et le caractère des Français. Un écolier de quatrième se croyait un Aristide; chacun vantait le courage de Brutus]. All translations are the author's own unless otherwise stated.

4. Lilti, *Invention of Celebrity*, 5–6.

5. Ibid., 16.

6. Ibid., 12.

7. Philip A. Stadter, *Plutarch and his Roman Readers* (Oxford: Oxford University Press, 2015), 230.

8. *Les Révolutions de France et de Brabant par Camille Desmoulins*, no. 74 (1791): 402.

9. Leo Braudy, *The Frenzy of Renown: Fame and its History* (Oxford: Oxford University Press, 1986), 58.

10. Stadter, *Plutarch*, 230.

11. Chantal Grell, *Le Dix-huitième Siècle et l'antiquité en France, 1680–1789*, vol. 1 (Oxford: Voltaire Foundation, 1995), 101–2.

12. Henriette Van der Blom, *Cicero's Role Models: The Political Strategy of a Newcomer* (Oxford: Oxford University Press, 2010), chapter 7.

13. David Bell, *Lawyers and Citizens: The Making of a Political Elite in Old Regime France* (Oxford: Oxford University Press, 1994), 198.

14. J.P. Brissot de Warville, *Le Sang innocent vengé, ou discours sur les réparations dues aux Accusés innocens* (Berlin [Neufchâtel]: Defauges, 1781), 20.

15. Dean Hammer, *Roman Political Thought From Cicero to Augustine* (Cambridge: Cambridge University Press, 2014), 67–69.

16. As a basis of Roman law, the maxim has been retaken on several occasions by political theorists, such as Machiavelli, Thomas Hobbes, and John

244 / ARIANE VIKTORIA FICHTL

Locke, who present it as the essential principle to the (executive) government of the early modern state. It was also adopted as a watchword by the seventeenth-century Leveller movement, preceding the Jacobins in a form of display of national sovereignty. Cicero himself refers to it in describing the competences of the two Roman consuls and the basis of dictatorial power. See Cicero, *De Legibus* III, 3, 8.

17. Among the French Revolutionaries, the Latin maxim was to be identified with an autocratic style of politics that was directed by political necessity. See Robespierre's speech on the principles of the Revolutionary government, Maximilien Robespierre, *Œuvres de Maximilien Robespierre*, vol. 10 (Paris: Phénis, 2000), 273.

18. Ibid., 6:47.

19. *Les Révolutions de France et de Brabant*, no. 66 (1791): 47.

20. Winfried Nippel, "Images of Antiquity in the Age of the French Revolution," in *De Oudheid in de Achttiende Eeuw: Classical Antiquity in the Eighteenth Century*, eds. Alexander Raat, Wyger Velema, and Claudette Baar-de Weerd (Utrecht: Werkgroep 18e Eeuw, 2012), 35.

21. Cicero, *Pro Sextio Roscio Amerino*, 56: "It is a useful thing for there to be many accusers in the city, in order that audacity may be kept in check by fear; but it is only useful with this limitation, that we are not to be manifestly mocked by accusers. A man is innocent. But although he is free from guilt he is not free from suspicion." Translation from *The Orations of Marcus Tullius Cicero*, trans. C.D. Yonge (London: George Bell & Sons, 1903), accessed February 6, 2020, https://www.perseus.tufts.edu/hopper/text?doc=Perseus:abo:phi,0474,002:56.

22. François-Alphonse Aulard, *La Société des Jacobins: recueil des documents pour l'histoire du Club des Jacobins de Paris*, vol. 2 (Paris: Maison Quantin, 1891), 58. See also *Les Révolutions de France et de Brabant*, no. 5 (1789): 238.

23. Hervé Leuwers, "Servir le peuple avec vertu," in *Vertu et politique. Les Pratiques des législateurs (1789–2014)*, eds. Michel Biard, Philippe Bourdin, Hervé Leuwers, and Alain Tourret (Rennes: Presses universitaires de Rennes, 2015), 405.

24. Cicero, *Pro Sextio*, 56. See also Maximilien Robespierre, *Œuvres de Maximilien Robespierre*, vol. 8 (Paris: Phénix, 2000), 58–59

25. Cicero, *De Officiis*, trans. Walter Miller (Cambridge, MA: Harvard University Press, 1913), II, 22, 78.

26. *Archives parlementaires de 1787 à 1860. Recueil complet des débats législatifs et politiques des chambres françaises*, ed. Jérôme Mavidal et al., vol. 65 (Paris: Dupont, 1904), 395.

27. See Titus-Livy, *Ab urbe condita*, II, 41. See also Montesquieu, *De l'Esprit des Lois* (Geneva: Barillot et fils, [1748]), L. XI, Chap. 18.

28. Plutarch, *Life of Gaius Gracchus*, XXIX–XXX.

29. Edith Hall and Rosie Wyles, "The Censoring of Plutarch's Gracchi on the Revolutionary French, Irish, and English Stages, 1792–1823," in *The Afterlife of Plutarch*, eds. John North and Peter Mack (London: Institute of Classical Studies, 2018), 141–47.

30. Robespierre evoked Cicero to justify the measures of the Politicians' Terror in his speech on the principles of political morality given on February 5, 1794: Œuvres de Robespierre, 10:358–59.

31. Marisa Linton, *Choosing Terror: Virtue, Friendship, and Authenticity in the French Revolution* (Oxford: Oxford University Press, 2013), 188–91.

32. *Archives parlementaires de 1787 à 1860. Recueil complet des débats législatifs et politiques des chambres françaises*, ed. Jérôme Mavidal et al., vol. 11 (Paris: Dupont, 1880), 323–24, and *Archives parlementaires de 1787 à 1860. Recueil complet des débats législatifs et politiques des chambres françaises*, eds. Jérôme Mavidal, et al., vol. 63 (Paris: Dupont, 1903), 197. See also Jean-Pierre Gross, *Fair Shares for All: Jacobin Egalitarianism in Practice* (Cambridge: Cambridge University Press, 1997), 35–40, 145–47.

33. Jonathan Kent Wright, "Phocion in France: Adventures of a Neo-Classical Hero," in *Héroïsme et Lumières*, eds. Sylvain Menant and Robert Morrissey (Paris: Honoré Champion, 2010), 166.

34. In his essay, Rousseau uses the Roman consul renowned for his simplicity and incorruptibility as mouthpiece to his social criticism of contemporary commercial society.

35. Eric Nelson, *The Greek Tradition in Republican Thought* (Cambridge: Cambridge University Press, 2004), 72.

36. Alexandre Guermazi, "Les Législateurs face aux demandes de vertu des citoyens parisiens," in *Vertu et politique. Les Pratiques des législateurs (1789–2014)*, eds. Michel Biard, Philippe Bourdin, Hervé Leuwers, and Alain Tourret (Rennes: Presses universitaires de Rennes, 2015), 193.

37. Camille Desmoulins, *Fragment de l'Histoire secrète de la Révolution* (Paris: Imprimerie Patriotique et Républicaine, 1793), 45.

38. Plutarch, *Life of Aristides*, VII.

39. *Archives parlementaires de 1787 à 1860. Recueil complet des débats législatifs et politiques des chambres françaises*, eds. Jérôme Mavidal, et al., vol. 52 (Paris: Dupont, 1897), 228. See also *Archives parlementaires de 1787 à 1860. Recueil complet des débats législatifs et politiques des chambres françaises*, eds. Jérôme Mavidal, et al., vol. 79 (Paris: Dupont, 1911), 452.

40. A week after the exclusion, the deputy Jean-Baptiste Boyer-Fonfrède referred to his colleagues in detention by comparing them to Aristides and Cicero. See *Archives parlementaires de 1787 à 1860. Recueil complet des débats législatifs et politiques des chambres françaises*, eds. Jérôme Mavidal, et al., vol. 66 (Paris: Dupont, 1904), 280.

41. Maximilien Robespierre, *Œuvres de Maximilien Robespierre*, vol. 5 (Paris: Phénix, 2000), 166.

42. *Les Révolutions de France et de Brabant*, no. 74: 402.

43. Jacques René Hébert, *La Grande Colère du Père Duchesne*, no. 317 (Paris, 1793). The Tarpeian Rock is a cliff at the southern summit of the Capitoline Hill of Rome where, in times of the ancient Republic until the early empire, the death penalty was executed. See Titus-Livy, *Ab urbe condita* I, 11.

44. Louvet cited Titus-Livy (*Ab urbe condita*, II, 2, 3–7) at the session of the National Convention of December 16, 1792, cf. *Archives parlementaires de*

1787 à 1860. Recueil complet des débats législatifs et politiques des chambres françaises, eds. Jérôme Mavidal, et al., vol. 55 (Paris: Dupont, 1899), 80.

45. Titus-Livy, *Ab urbe condita*, II, 5, 5–8.

46. For more information on the reception of the piece during the Revolution, see Catrin Francis, "The Politics of Appropriation in French Revolutionary Theatre" (PhD diss., University of Exeter, 2012), 86–120.

47. Edith Flamarion, "Brutus ou l'adoption d'un mythe romain par la Révolution Française," in *La Révolution Française et l'Antiquité*, ed. Raymond Chevallier (Tours: Centre de Recherches A. Piganiol, 1991), 91–112.

48. Robespierre, *Œuvres de Robespierre*, 5:169.

49. Brissot, *Le Patriote françois*, no. 1365 (Paris, 1793), 521.

50. Plutarch, *Life of Publicola*, XIV.

51. François-Alphonse Aulard, *La Société des Jacobins: recueil des documents pour l'histoire du Club des Jacobins de Paris*, vol. 3 (Paris: Maison Quantin, 1892), 702.

52. *Archives parlementaires de 1787 à 1860. Recueil complet des débats législatifs et politiques des chambres françaises*, eds. Jérôme Mavidal, et al., vol. 52 (Paris: Dupont, 1897), 131; *Archives parlementaires de 1787 à 1860. Recueil complet des débats législatifs et politiques des chambres françaises*, eds. Jérôme Mavidal, et al., vol. 60 (Paris: Dupont, 1901), 603–4.

53. Paul M. Martin, "Noms 'antiques' de Communes sous la Révolution Française," in *La Révolution Française et l'Antiquité*, ed. Raymond Chevallier (Tours: Centre de Recherches A. Piganiol, 1991), 208–9.

54. Robespierre, *Œuvres de Robespierre*, 10:413–14.

55. Cicero, *Second Philippic*, 46. See also Robespierre's speech of 8 Thermidor an II, Robespierre, *Œuvres de Robespierre*, 10:567.

56. See the account of the session of the National Convention on December 19, 1792, in *Le Courrier des 83 départemens*, which describes Robespierre's refusal to leave the tribune, Maximilien Robespierre, *Œuvres de Maximilien Robespierre*, vol. 9 (Paris: Phénix, 2000), 176: "There is the monkey of Peisistratus, they cried" [Voilà le singe de Pisistrate, s'écrie-t-on].

57. Marisa Linton, "Robespierre et l'authenticité révolutionnaire," *Annales historiques de la Révolution Française* no. 371 (2013): 172. See also the judgment of Jacques René Hébert that can be seen as prevalent among his contemporaries: "I do not know of anything as imperfect as a man without fault. He who is too virtuous is a real rascal" [Je ne connois rien de si imparfait qu'un homme sans défaut. Celui qui est trop vertueux est un véritable coquin]. See *Père Duchesne*, no. 317.

58. *Archives parlementaires de 1787 à 1860. Recueil complet des débats législatifs et politiques des chambres françaises*, eds. Jérôme Mavidal, et al., vol. 15 (Paris: Dupont, 1883), 655.

59. Robespierre, *Œuvres de Robespierre*, 10:564–65.

60. Keith Michael Baker, *Inventing the French Revolution: Essays on French Political Thought in the Eighteenth Century* (Cambridge: Cambridge University Press, 1990), 133–34.

61. *Discours historiques et politiques sur Salluste, par M. Gordon traduits de l'anglois par Pierre Daudé*, vol. 1 (Amsterdam: Cramer, 1759), 392.

62. *Le Vieux Cordelier* n° 7 (1794): 117–18. See also Barbara Besslich, "Cato als Repräsentant stoisch formierten Republikanertums von der Antike bis zur Französischen Revolution," in *Stoizismus in der europäischen Philosophie, Literatur, Kunst und Politik. Eine Kulturgeschichte von der Antike bis zur Moderne*, eds. Barbara Neymeyr, Jochen Schmidt, and Bernhard Zimmermann, vol. 1 (Berlin: De Gruyter, 2008), 368–69.

63. Eric Nelson, "Utopia through Italian Eyes: Thomas More and the Critics of Civic Humanism," *Renaissance Quarterly* 59, no. 4 (Winter 2006): 1042.

64. Plutarch, *Comparison of Demosthenes and Cicero*, II.

65. Braudy, *The Frenzy of Renown*, 76.

66. François-Alphonse Aulard, *La Société des Jacobins: recueil des documents pour l'histoire du Club des Jacobins de Paris*, vol. 6 (Paris: Maison Quantin, 1897), 6. See Robespierre's observation here that "No faction can exist without the support of tyranny" [Il n'est pas de faction qui puisse exister sans l'appui de la tyrannie].

67. Saint-Just cited in François-Alphonse Aulard, *L'Eloquence parlementaire pendant la Révolution française*, vol. 2 (Paris: Hachette, 1886), 471.

68. *Collection complète des Œuvres de l'Abbé de Mably*, vol. 4 (Paris: Desbrières, 1794), 149–50.

69. Flamarion, "Brutus," 94.

70. Plutarch, *Life of Marcus Brutus* I, 2, and *Life of Publicola* VI, 4.

71. Francis, "Reappropriation," 117.

THE CELEBRITY, REPUTATION, AND GLORY OF THE EMPIRE AND RESTORATION FRANCE THROUGH THE LENS OF ADÈLE DE BOIGNE'S MEMOIRS

LAURE PHILIP

Born in Versailles, Adèle d'Osmond was the daughter of the marquis d'Osmond and was just eight years old when she left France with her parents. During her time in London, she married the wealthy General de Boigne, ending her family's financial precariousness and becoming the Comtesse de Boigne. Her emigration experience is narrated in her *Récits d'une tante* (1921–1923), a five-volume memoir covering the period from the Revolution to the July Monarchy. She also refers to her trauma of exile in her two novels, *La Maréchale d'Aubemer* (1866) and *Une Passion dans le grand monde* (1867).[1] Although these works were published posthumously, they are likely to have been written around 1835.[2] Through her memoirs, this chapter examines how Boigne employed stylistic techniques from the sentimental novel to portray eminent émigrés and post-Revolutionary figures, reformulating the ethics of aristocracy in the age of celebrity.

Boigne's status as an émigrée—émigré in the feminine—is meaningful in the context of post-Revolutionary Europe. The term "émigré" was officially created by a 1793 law, and eventually entered the

dictionary of the Académie française in 1798. It defined a hetero-geneous group of French citizens who sought refuge in neighboring countries after the fall of the French monarchy. The historiography on the emigration and its associated myths have long been biased and stereotypical. This is partly due to the political recuperation of the image of the émigré that occurred during the nineteenth cen-tury and well into the twentieth century.[3] The first international conference on émigrés held in twenty years in June 2017 and a sub-sequent edited volume mark the recent development in emigration scholarship.[4] This new scholarship continues the efforts of Kirsty Carpenter, Philip Mansel, and Dominic A. Bellenger to offer a het-erogeneous picture of the post-Revolutionary exile communities, which supported the consideration of a pan-European movement and welcomed the recourse to other disciplines such as literary studies to help revisit previously accepted theories. The emigration myth survives today, conveying a nostalgic outlook on the Ancien Régime, and it has populated our imagination with romantic fig-ures, wandering aimlessly in post-Revolutionary Europe. François-René de Chateaubriand, former émigré, acclaimed writer, and salon celebrity of Restoration France, commented on the impact the emi-gration had on nineteenth-century France: "The literary shift that made the nineteenth century proud is due to emigration and exile" [Le changement de littérature dont le XIX^{ème} siècle se vante lui est arrivé de l'émigration et de l'exil].[5] In addition, the experience of exile is intrinsically tied to the duty of memory.

Aristocratic memoirs boomed in between the two revolutions of 1789 and 1848, attesting the public's fascination with tales of fallen illustrious personalities.[6] They conveyed the literary, historical, and societal changes of the time from a subjective point of view, with an increasingly autobiographical tone. For this reason, they have proven to be a useful source for historians and literary scholars alike. This chapter examines the memoirs of Boigne specifically and argues that they are a pertinent place from which to observe the shift in aristo-cratic ethics and the development of celebrity culture. Rather than focus on the penetration of modern celebrity culture in the age of the French Revolution, as other chapters in this section do, this chapter concentrates on how people creatively voiced celebrity within the tra-ditional literary boundaries of aristocratic memoirs.

Antoine Lilti's recent definition of celebrity in the context of the eighteenth century is both meticulous and nuanced.[7] He argues that eighteenth-century celebrity overlapped with its anterior manifestations such as glory and reputation, and that there was a link between the sentimental novel and modern celebrity.[8] Glory and reputation as markers of distinction and fame belonged to the ethics of the Ancien Régime, providing a set of shared reference points, social and moral conduct codes, etiquette for social gatherings, and representation of the nobility and monarchy. By speaking of aristocratic ethics, the focus is narrowed down to the codes of conduct ruling in the spaces of noble sociability. At first sight, celebrity differs from the markers of distinction in the aristocracy because it is not manifested by symbolic representations, structured rituals, or the recognition of military valor or moral virtue. After all, talented actors and murderers can be celebrities. However, the strength of Lilti's analysis comes from stressing the overlaps between reputation, glory, and celebrity, notably in the balance between privacy and distance. The intimacy between the community and its reputed individual is mirrored but not matched by celebrity. Likewise, the universal aura conferred by modern celebrity can be confused with glory. In Boigne's memoirs, the layering of reputation, glory, and celebrity is hard to detangle, especially in the case of legendary military heroes and image-conscious leaders like Napoleon.

This chapter will give a glimpse of the personalities of the Empire and Restoration societies by reviewing the third and fourth sections of the *Récits*. I contend, like Ariane Fichtl does in her chapter in this volume, that while Lilti's definition of celebrity culture is judicious and multifaceted to fit many case studies, there is room for further expansion. Specifically, this chapter argues that Lilti's impressive study lacks examples of how contemporaries represented and manipulated the concept of celebrity in literary texts. It exposes Boigne's recourse to celebrity features, reputation, and glory to fit her political and personal agenda, and also gives prominence to how unbalanced this modern concept of celebrity was when applied to the cases of male and female literary geniuses.

Gossip and the Memoirs

"In researching the past, I have found that there were always good things to say about the worst people, and bad things about the best people. I have tried not to let my emotions affect my judgment. I admit this is quite difficult; if I have not succeeded, I promise I had the intention to do so." [En recherchant le passé, j'ai trouvé qu'il y avait toujours du bien à dire des plus mauvaises gens et du mal des meilleurs; j'ai tâché de ne pas faire la part d'après mes affectations; je conviens que cela est assez difficile; si je n'y ai pas réussi, je puis assurer en avoir eu l'intention].[9] This quote, taken from the preface to the *Récits*, crystallizes the tension in the memoirs between the desire to narrate the past and tell of its remarkable protagonists with authenticity and at the same time to escape an unavoidable subjectivity. Gossip can be defined as sharing subjective—most often negative—judgments that can appear veridical. *The Oxford Dictionary* claims that the use of the verb "to gossip" spread in the early nineteenth century.[10] There are several equivalents to "gossip" in French, such as *potin, potiner, ragôt, ragoter,* and *commérage, commérer,* that were already in use in the early nineteenth century. Just like the word gossip, they alluded to oral transmission and impartiality of judgment. It happens that Boigne compared her memoirs to storytelling in her foreword, defining them as a patchwork of "old woman's chitchat" [causerie de vieille femme] rather than a serious book.[11] This casual chitchat falls within the definition of gossip as the author of the memoirs indulges in describing anecdotical details and quietly ridiculing the behavior of the elite, with a subtle disapproving tone. It is likely that Boigne did not speak directly of *commérage* because it carries a negative meaning in French. Instead, she presented her narrative style as the familiar chitchat of a mature and wise woman. This narrative strategy has the advantage of managing the reader's expectations whilst representing her tone and style as familiar and well-meaning. Above all, fully embracing the gossip and "casual chitchat" dimension of her writings enabled Boigne to undermine her authorship and assert her modesty as a female writer, whilst promoting the validity of her informal account of people and events, through which we can see that she redefined the ethics of aristocracy in the age of celebrity.

The above analysis concurs with the autobiographical turn observed for the genre of memoirs in the long nineteenth century. There was a shift away from diplomatic and political facts, battles, and the lives of "great men" toward more personal stories.[12] Damien Zanone highlights a tension between the desire to tell personal stories and the weight of historical events. He speaks of an "intellectual dilemma" [aporie intellectuelle] to explain the decline of memoirs after the 1850s: not totally credible historically, memoirs rejected the novelistic approach and did not sufficiently engage with the consequences of autobiographical bias.[13] However, despite the decline of memoirs, they are precious documents that allow us to shed light on how aristocratic reputation was reworked in the age of celebrity. The methodology used to detangle the representations and occurrences of celebrity culture here is close textual analysis. Case studies of noble personalities and the contrasting portrayal of Napoleon in Boigne's memoirs will illustrate how entangled the concepts of aristocratic reputation, military glory, and celebrity culture are. The porous relationship between preexisting and new conceptions of renown shows that modern celebrity did not penetrate society uniformly. Boigne is likely to have been both "gossip queen" and an aristocratic memoirist eager to safeguard the past.

Aristocratic Gossip and Celebrity

The lively and colorful descriptions of some members of the nobility adapting to or resisting the successive political regimes of nineteenth-century France were the main attraction for readers and scholars of the *Récits* alike. Boigne's testimony is invaluable because it offers a parallel story to the great events unfolding in the aftermath of the Revolution by zooming in on a selection of aristocrats with whom she frequently associated. It is important to stress Boigne's personal agenda in transmitting these anecdotes. She wrote in the preface that she decided to start writing because of "the need to live in the past, when the present is joyless and the future without hope" [le besoin de vivre dans le passé, quand le présent est sans joie et l'avenir sans espérance].[14] As a survivor of the emigration, she was eager to represent herself as the last standing witness of a disappearing pre-Revolutionary set of ethics and

lifestyle. When putting pen to paper in the 1830s, her attachment to the past was highly emotional, having been conditioned by emigrating at a young age and relying on the family stories that her relatives told her. Claudine Giachetti has shown that female memoirists in the first half of the nineteenth century invested emotions and the imaginary into geographic places they recollected. She adds that writing memoirs after the Revolution was a way to resist the fatal course of time. Likewise, Henri Rossi qualifies the act of writing memoirs as "desperate attempts to survive" [des tentatives désespérées pour survivre].[15] These emotional takes on the past partly explain Boigne's critical and distant tone when describing the most famous new nobles of the Empire and Restoration: she thought of herself as distinct from them. The layering of aristocratic reputation and celebrity elements in the *Récits* had thus to do with Boigne's personal agenda and her own emotional conception of the past and present. Her memoirs are not hagiographic but at times a trivial description of the reputed aristocrats she frequently fraternized with within a chitchat and gossip-style narration. The insertion of gossip into the portraits jeopardizes the traditional depiction of aristocratic reputation and reveals the adaptation of these portrayals for the age of celebrity.

Distinguishing between references to celebrity culture and aristocratic reputation in the memoirs is challenging particularly in the case of famous European aristocrats. Noble families in Europe were connected via matrimony and political alliances, on top of which the emigration contributed to forge new affinities between French and foreign families. European aristocratic reputation, whilst being limited to a socially restricted group, had potentially no frontiers. Interestingly, Lilti has argued that transnationality was a key characteristic of modern celebrity, making it distinct from reputation.[16] In Boigne's memoirs, the foreign personalities are often celebrities; her gossip style relates their personal and extraordinary details, making their reputation close to celebrity. For example, the Princess Serge Galitzin is said to be touring the whole of Europe in search of the man figuring on a miniature portrait she found in a ruined castle. The lexical field of the wildness combined with the description of the dramatic search for this mysterious man is fit for a sentimental novel and almost out of place in the memoirs.[17]

This example tests the limits of aristocratic reputation, since the princess is known in several countries not for her prestigious rank and polite behavior but for her thrilling adventures, just like a sentimental heroine in a novel. The sentimental tropes add more color to the aristocratic portrayal, almost transforming the princess into a fictionalized and famous protagonist. Given the fact that the sentimental novel had been and remained a popular genre until the 1850s, and that Boigne wrote two fiction works during this trend, it is likely that she used novelistic stylistic elements in her memoirs. Yet, the attention to extravagant or peculiar details fit for a sentimental novel in the memoirs has to do with more than a stylistic porosity between the two genres. Through the memoirs, Boigne modernizes the traditional aristocratic portrait with exciting elements of gossip, conferring a semi-fictionalized celebrity status on the Princess Galitzin.

The example of the duc de Laval exposes the layering of old and new modes of recognition and the desire to titillate readers' curiosity with gossip-style details. Laval is described according to his noble rank first and foremost. His reputation stemmed from his military career and renowned strategic skills on the battlefield, and it was increased by the personal tragedy of losing his own son in war. However, Boigne speaks of him as a celebrity when it comes to one of his physical defect: "the duke of Laval's words gave him a sort of celebrity" [les mots du duc de Laval lui donnaient une sorte de célébrité]. His "sort of celebrity" is down to misusing common words in society and making "blunders" [balourdises] because of a poor command of the French language.[18] Laval is not a celebrity but he resembles one; this distinction is key to visualize the layers of penetration of celebrity culture. Boigne had understood the fact that celebrities were famous because of unusual and sometimes very physical characteristics, and she wittingly engages with gossip narratives to deconstruct Laval's reputation. The amusing mistakes Laval makes when talking with his peers are reported in a subjective and pejorative manner. The enunciation in the third person pronoun *on* [we] further strengthens the impression of connivance between the narrator and readers. It works as if they had direct access to the hearsay and chitchat of Boigne and her close circle.

The use of the word "celebrity" in this case stresses a type of reputation that breaks the mold of aristocratic ethics and yet does not escape a defined circle of sociability. Laval's behavior is famous because it is the antithesis of practicing the art of conversation as expected from a member of the aristocracy: he is the anti-aristocrat. Gossip narratives are thus linked to celebrity culture because they partially undermine reputation, the preexisting mode of representation. Transfiguring nobles into sentimental characters and semi-celebrities implies an awareness from Boigne of the memoirs' attractiveness to the public, helping to satisfy a desire to separate oneself from contemporary personalities and honor a certain idealized notion of pre-Revolutionary aristocracy.

Napoleon Bonaparte: Military Glory and Modern Celebrity

Boigne offers a vivid portrayal of Napoleon, from the point of view of an émigré who had returned to Paris in 1804, but is reminiscing the events some thirty years after. The emperor's representation is ambivalent in the *Récits*, an ambivalence that exhibits the author's difficult position politically at the time. Boigne particularly insists on not having affiliated with the counter-Revolutionary émigrés, nor did she associate with the supporters of Napoleon: she clearly expresses her criticism of some of the Empire political groupings. Her political stance is seemingly liberal and in support of a constitutional monarchy.[19] This position was extremely difficult to sustain at the time because Boigne could have been ostracized by refusing to participate in imperial gatherings under Napoleon. In this light, Boigne's later account of the emperor stands out in the way it contrasts his marginal position, as not belonging to her aristocratic cast or meeting traditional conceptions of renown, with attributes of celebrity culture to vouch for her irrepressible admiration for the great man's exploits.

Boigne's depiction of imperial balls reflects the memoirist's social and political standing, attesting her reluctance to be associated with the Empire and its followers and reinforcing her aristocratic identity. At the time of writing, she clearly refused to approve of Napoleon's regime and did not associate herself with the emperor's entourage. Thus, she then procures the reader with

a distant and critical picture of the Empire's social events and celebrations. She openly mocks the emperor's costume and body language, and underlines the artificiality of his heteroclite court, which was not necessarily aristocratic by birth, as under the Ancien Régime.[20] Boigne excludes Napoleon from her own community of aristocrats—he is the outsider who should not pretend to be worthy of receiving aristocratic glory. In addition, Boigne's insists on the emperor's unpleasant physical attributes: his height and weight are mentioned as unfitting for his function. She also comments on unverified rumors about his private life and irritable personality.[21] This strategy of defusing the powerful image of the emperor echoes the desacralization theories developed by scholars in the context of the fall of the monarchy. Lynn Hunt argues that print culture contributed to transforming public opinion about the royal family, dismantling the sacred and replacing it with mundane and obscene images of an impotent Louis XVI and a libertine Marie-Antoinette.[22] Boigne was aware of the impact that unpleasant body language had on aristocratic reputation, as it did with Laval. Her crude anecdotes, which are communicated via gossip-like narratives, contribute to diminishing the political power and legitimacy of the emperor.

Yet, the juxtaposition of pejorative gossip with Boigne's unstoppable admiration for Bonaparte as French glorious conqueror alludes to modern celebrity culture. The memoirist's veneration for the man's military exploits is voiced sincerely and powerfully, contrasting sharply with the ridicule she attached to his pretention of nobility and his physical body. She adheres to and shares the general feeling of pride and patriotism after Napoleon's triumphant military campaigns in Europe; she admits to having admired "the prestige of power" [le prestige de la puissance].[23] Therefore, it is difficult to detangle the imbrications of aristocratic glory and celebrity in the case of the emperor. The demeaning details about the man's appearance and private life do not cancel his national prestige. Likewise, celebrities can also combine unpleasant and pleasing features that the public is inclined to admire. By bringing competing types of recognition together without contradiction, Boigne underlines the porosity of glory and celebrity: Napoleon has and does not have aristocratic glory; he has and does not have celebrity status.

The ambivalent description of Napoleon in the *Récits* is also owed to the evolution of Boigne's national identity as an émigrée. She admits she hardly felt "French" upon her return in 1804, just like many other freshly returned émigrés.[24] After the emigration, whilst some former exiles stayed fervently anti-French and looked nostalgically upon their years abroad, others could not help but feel pride when they heard news of a French victory. Imperial propaganda appealed to a variety of political groups during and after the Empire. In the case of Boigne, the restoration of the French monarchy, which followed French imperial military defeats including the Battle of Waterloo (1815), enhanced her patriotism. She expresses her disgust at witnessing the occupation of foreign forces and the restored monarchy's weakness in defending French interests: "I had lost my anglomania" [J'avais perdu mon anglomanie]; "I had become French again" [j'étais redevenue française]; "I felt very patriotic" [j'avais éprouvé un mouvement très patriotique].[25] The idea of the *patrie* was likely to have been confused and emotionally charged when she was seeking refuge in England. Her novel *Une Passion dans le grand monde* develops at length the idea of being uprooted from one's *patrie*. The heroine has to emigrate to Brazil after an arranged marriage; Boigne substituted the Channel with the Atlantic Ocean as she creatively voiced the cruel pain of being cut off from loved ones and her home. The attachment to the *patrie* is associated with fluidity and relativity, particularly in the case of the experience of the emigration, which conditioned the heightened patriotism expressed by Boigne in her portrayal of Napoleon. This case study therefore unearths the decisive role played by the author's torn identity as ex-exile and her political agenda in the representation of modern celebrity culture.

Romantic Genius and Female Celebrity

Boigne's portrayal of the members of the nobility and the emperor combine aristocratic modes of recognition with modern celebrity features. Despite their class and political preeminence, the gossip-style narrative helped to ridicule them and integrate elements of fame within the framework of reputation and glory. This next section considers how Boigne presented contemporary literary

celebrities, the influence of Romanticism, and the gender divide between famous male and female authors.

The Literary Genius

Celebrity implies self-awareness, publicity, and a representation strategy in which affairs, immoral behavior, and bankruptcy are welcome ingredients that excite curiosity. Boigne's treatment of actor François-Joseph Talma is a perfect example of this modern conception of celebrity that is distinct from reputation.[26] She did not want to be associated with the excitement people felt when watching Talma perform. Likewise, she clearly conveys her disapproval of Chateaubriand's attempts at self-management of celebrity and desperation to be famous. He is shown relentlessly working toward this goal, in order to "to build the pedestal from which he will dominate the century" [de se faire un piédestal d'où il puisse dominer le siècle]. This obsession evokes selfishness and ruthlessness, which is recurrently criticized by the memoirist: "he is incapable of looking . . . after others; he is far too absorbed and preoccupied about himself" [il est incapable de s'occuper . . . du sort des autres; il est trop absorbé par la préoccupation de lui-même].[27] Chateaubriand fits the modern definition of celebrity particularly well because of his dissolute life and his affairs, which were widely known across borders. Those affairs, his periods of bankruptcy, and his literary bestsellers weigh equally in the celebrity balance. Readers intrigued by the writer's eventful life could hope to get to know more by reading his work.

The public's attempt at getting closer to such an unstable and selfish man is illusionary and futile as Boigne underlines with the case of Chateaubriand's *madames*. This group of respectful noblewomen jealously and relentlessly compete for the writer's attention. Boigne employs the lexical field of the theater to denounce the sheer craziness of their *idolâtrie* [idolatry]. This enhances the fact that these noblewomen's behavior is outside aristocratic ethics and expected polite behavior for women—they almost resemble actresses in their desperation to seduce Chateaubriand and secure one-on-one time with him. Thus, these women's identities are defined first and foremost by their shared frenetic admiration for their idol. Boigne speaks of "the party of the *madames*" [le corps

des *madames*], only deigning to name the most eloquent ones.[28] This group resembles the modern fan clubs of today since the fans form an indistinct mass of people who artificially create an intimate relationship with their idol.

One of the known admirers of Chateaubriand was fellow émigrée and novelist Claire de Duras. She formed an ambiguous friendship with Chateaubriand, whom she met upon her return from London in 1808. Other memoirists have commented on the non-reciprocal adoration she had for Chateaubriand.[29] She alludes to this platonic love in her posthumously published émigré novel, *Amélie et Pauline*.[30] It tells the story of an émigrée who falls in love only to be cruelly abandoned upon her return to Paris. Amélie's love interest, Henry, is already married to Pauline. Distressed from his sister's passing, he finds a consolation in Amélie. Interestingly, Chateaubriand lost his mistress, Pauline de Beaumont, shortly before losing his beloved sister Lucille. It is highly likely that Duras was inspired by her own relationship with the troubled author when she portrayed the Amélie-Pauline-Henry love triangle in her novel. The sentimental passion she unravels in her novel engenders a sharp contrast to the crude description of the *madames*' behavior given by contemporary memoirists. Real-life fan behavior and its mirroring in fiction pinpoints the role played by the sentimental trend in refining the vocabulary of celebrity culture.[31] This reading of the novelist's adoration can explain why celebrity culture took root in the sentimental trend and the growing Romantic movement.

Boigne's characterization of Chateaubriand's genius shows that the representations of celebrity and Romanticism were intertwined. The Romantic genius often painted in nineteenth-century texts combines marginality with an innate talent in a particular artistic field. In the case of Chateaubriand, Boigne claims that his achievements as a writer contrast with and complement the disgraceful aspects of his personal life. She explains this phenomenon by the fact that all geniuses suffer from solitude and boredom, making it vital for them to pursue agitation, risks, and immorality. According to Boigne, Chateaubriand wanted "to feel various sensations to fight boredom, because ultimately, here lays the greatest secret of his life" [éprouver des sensations variées pour se désennuyer, car, au bout du compte, c'est là le but et le grand secret de sa vie].[32]

This allegory of the perpetually unsatisfied man, aimlessly seeking distractions, has roots as far back as the Renaissance and Albrecht Dürer's *Melencolia* in 1514. The Romantic movement, which took France by storm in the 1800s, actualized this philosophical motif, notably in artistic representations of melancholic heroes in novels and paintings.[33] The novel of sensibility that had reigned in the previous century was reshaped with these preoccupations. For example, Stendhal and Astolphe de Custine vividly describe the idleness of youth and the difficulty of fitting within class and social expectations after the collapse of the Ancien Régime.[34]

Chateaubriand's portrait is the same as that of the Romantic hero found in contemporary novels. Consequently, his celebrity status fed into the romantic representations of the time. The narrative strategy and lexical field used in the memoirs to introduce modern celebrities give clues as to what Boigne saw in such famous characters. It is possible that representing literary personalities as romantic geniuses allowed Boigne and many observers to make sense of one particular aspect of modern celebrity culture: how merit and immorality can work together to increase value. This also confirms Lilti's argument about an "interweaving of literary and celebrity scandal" [enlacement des mécanismes littéraires et scandaleux de la célébrité].[35] Whether creatively reframed within the sentimental novel, as seen in Duras's work, or cynically portrayed in Boigne's memoirs, modern celebrity culture was conceived and represented within sentimental and romantic tropes and reference points.

The Case of Madame de Staël: The Risks of Female Celebrity

"It is surprising that the most powerful geniuses are affected by this impression . . . Madame de Staël, Lord Byron, Mr de Chateaubriand are vivid examples of this, and it is to escape monotony that they damaged their life" [Il est étonnant que les plus puissants génies sont sujets à cette impression. Madame de Staël, Lord Byron, monsieur de Chateaubriand en sont des exemples frappants, et c'est surtout pour échapper à l'ennui qu'ils ont gâté leur vie].[36] Boigne here places the prominent author and thinker Madame de Staël amongst male literary geniuses of her time. Like Chateaubriand, the female writer sought distractions to compensate for the

blandness of life. Although the memoirist presents literary genius as having no gender, she paints the social misconduct of Staël more acutely, and it has more profound consequences than in the case of Chateaubriand. Chateaubriand is fascinating to his contemporaries because of the combination of his talent and scandal. However, Staël's literary genius does not make her scandalous behavior fascinating or appealing in the same way. On the contrary, the famous woman's unruly behavior seriously undermines her merit. The fact that Boigne represents Staël justifying her own behavior because of her genius is telling of the dichotomy at play in the memoirs between representations of male and of female genius and the need for women to justify their unorthodox life choices: "She saw herself as a unique being, and that her genius excused the most unacceptable behavior for mere mortals" [Elle se regardait comme un être à part, auquel son génie permettait des écarts inexcusables aux simples mortels].[37] This section will argue that although Boigne placed Staël under the same banner as male geniuses of her time, Staël's amoral behavior was not balanced out by references to Romanticism, which in turn affected her celebrity status.

The first difference in the representation of Staël's celebrity in the *Récits* versus that of men is the insistence at length upon the marginality and instability of her position: she is a famous female author and thinker but also an exiled member of the aristocracy and, unlike Boigne, Staël was forced back into exile during the Empire. The first encounter between the two women is narrated with distance. Boigne describes two interlocking circles of celebrity, from the public to Staël and from Staël to Talma. Boigne admits being impressed by the writer's "great celebrity" [cette grande célébrité] and "singular procession" of admirers [ce singulier cortège]. Simultaneously, Staël was herself so eager to attend a performance by Talma that she had taken the risk of leaving her assigned residence in Switzerland to come to Lyon.[38] Here, Boigne superposes Staël and Talma's celebrity, a *mise en abyme* that reinforces the absurdity and triviality of celebrity culture, whilst exhibiting how restrained the famous author's aura and power is. Likewise, Staël's talent as liberal intellectual is recognized but immediately undermined by the fact that she cannot help but embarrass her interlocutors: "with no wish to embarrass

or to hurt their feelings, she would pick the topics of discussions that would most offend the people she was addressing" [sans la moindre intention d'embarrasser, encore moins de blesser, elle choisissait les sujets de conversation . . . les plus hostiles aux personnes auxquelles elle les adressait].[39] Notably, Boigne recalls when Staël upset her by talking about her unhappy marriage to the General de Boigne, and when Staël cornered another noblewoman in front of twenty guests about the impact that the lack of chastity had on motherhood. By stating that Staël was still very attached to the "most puerile ideas of the aristocracy" [les plus puériles idées aristocratiques], Boigne deconstructs Staël's liberal reputation.[40] The latter's ignorance of social etiquette yet fondness for aristocratic ideas makes this portrayal of celebrity more about the danger of a woman's risky incursions into publicity than about the attractiveness of scandalous fame.

The contrasted portrayal between Chateaubriand and Staël has to be resituated within the context of gendered behavior rules in eighteenth- and nineteenth-century France. As a literary celebrity in exile, could Staël really escape the limitations of her sex? Despite its promising ideals, the Revolution did not increase women's equality. Nonetheless, the view that the *salonnière* enjoyed more freedom before the Revolution has been nuanced. Previously, scholars had described the pre-Revolutionary salon as a space where men were "in the same relationship to power as women."[41] With the collapse of the Ancien Régime, noblewomen lost their independent platform and had to dedicate their life to motherhood and domestic duties.[42] Having argued that the *salonnières* mostly emulated the status quo of monarchic France, Jolanta Pekacz has since contested this black-and-white view and now maintains that it was safer for these women to act in this non-transgressive way, especially since they had interiorized the limitations of their sex.[43] Likewise, the recent effort by scholars to revise the theory of performative gender also reflects the difficulty of concretely mapping the evolution of women's interiorized limitations. Asserting one's authorship as a woman brought another layer of contradiction between the need to respect the noblewoman's code of conduct and the promotion of one's literary work, which is evident in most of Staël's fictional works. Being a female

author was a double-edged sword: on the one hand, writing an acclaimed sentimental novel showed mastery of the expression of sensibility, a skill highly praised and said to be innate to women; on the other hand, publishing also meant leaving a pre-approved limited sphere and becoming a public woman, just like a prostitute. It thus dragged the female author into a space of scrutiny and sexual objectification. In the case of Staël, the experience of ostracism during the Empire complicated her status further. From *salonnière* and writer, she became the female scapegoat of the Empire's totalitarian regime. Her celebrity was thus shaped by different contexts before and after the Revolution, and especially by her exile and resistance to Napoleon's attempt at muting her voice. This unstable identity as celebrity writer and woman is obvious in Boigne's memoirs. Although Boigne compares Staël to contemporary male geniuses, Staël is shown as merely testing and taunting the limits of her exile and female restrictions.

The damaging consequences of celebrity culminate with the portrayal of the writer's extramarital love affairs. This unwomanly behavior narrated at length in the memoirs lessens Staël's intellectual aura, despite her celebrity. Her major downfall is her rebellious heart, which is demonstrated with a myriad of anecdotes about her infatuation for her successive lovers. These trivial domestic considerations are made to contrast sharply with and bring into question her status as intellectual genius. Boigne, for instance, recounts Staël's domestic scenes with Benjamin Constant. The two lovers have a tumultuous and volatile relationship including horrible domestic arguments in front of guests.[44] Constant's wedding to another woman aggravates Staël's fury, and she threatens to take her own life, forcing Madame Récamier to intervene. Later on, Boigne mocks how Staël became attached to Albert de Rocca, a man without the intellectual qualities of Constant. Boigne insists upon the unnatural aspect of this relationship: Rocca is a *roturier*, a sous-lieutenant in the army, twenty years younger than Staël. He is said to feel privileged to have attracted the attention of the famous woman. This unbalanced union amounts to embarrassing situations in society, where Rocca publicly expresses his jealousy. Boigne concludes that her friend is "a spiritual woman who loves a fool" [une femme d'esprit qui aime un sot].[45] The violence of this phrase,

stylistically recalling traditional moralistic fables, considerably lowers Staël's intellectual merit. The undermining of the famous female author is therefore twofold, on the basis of her unwomanly public display of domestic fights and her affection for a mediocre man that does not match her elite status. Moreover, Boigne's readership was prepared for this vision: the dilemma of unbalanced love and status was developed abundantly in *Corinne, ou l'Italie* (1807), which Miranda Kiek discusses earlier in this volume.[46] The novel tells of the unavoidable risks attached to being a female artist, and the eponymous heroine ultimately pays a high price for being intellectually superior to her lover, who cannot reconcile his passion with her intellectual freedom. The novel engages with the problem for women authors struggling to fit within society's expectations and to promote their talent and expertise successfully despite the modesty expected of them.

As shown earlier, in Boigne's memoirs, the anecdotes that caricature and ridicule writers are superposed onto the aura of their genius; even Chateaubriand was not exempt from this biased portrayal. Yet, when describing Chateaubriand's shocking behavior with women, Boigne diverts the ridicule onto his female fans, the *madames*. In the case of Staël, the roles are reversed: Boigne's angle is fully concentrated on the devastating consequences of her unfortunate life choices. Boigne does not blame Constant for misleading his lover, nor does she attack Rocca for profiting from Staël's fortune, as he is far too naïve and insignificant to matter to the story. Instead, Staël is shown as the one both guilty of pursuing unavailable or unsuitable men and suffering from the consequences of her obsessions, just like Boigne had painted Duras as languishing after Chateaubriand. Staël's cause of death is even linked to her unnatural liaison with the mediocre Rocca. Boigne's representation of Staël's celebrity does not benefit from the same positive literary references used in the case of the male genius. Whilst talent and genius appear to be genderless, the romantic aura making up for the immoral behavior of celebrities works in favor of men only. As such, we can conclude that modern celebrity culture in the first half of the nineteenth century was still influenced by aristocratic ethics to the detriment of famous female authors. Male authors escaped many of the aristocratic

virile duties because they were seen within the frame of romantic genius, and could fully embrace and benefit from the prestigious and scandalous life of a celebrity.

The emigration crystallized a period of transition and cohabitation between aristocratic reference points and value systems and modern celebrity culture. In Boigne's *Récits d'une tante*, most of the references to celebrities of her time were heterogeneous in the way they combined traditional and new conceptions of renown. The memoirs have thus been invaluable to grasping how modern celebrity culture was conceived and creatively represented within preexisting systems of value and recognition. Study of the portraits of renowned nobles illustrates the intertwining of celebrity elements and aristocratic reputation. It also uncovers how narrative tools such as the sentimental and gossip-style anecdotes can help voice this combination. This chapter evidences that the representation of modern celebrity culture in texts has been greatly impacted by identity and political agendas. It predicates the importance that the stigmas of exile had on literature and on the collective consciousness of the French in the first half of the nineteenth century. The ambiguity of Napoleon's portrayal, balancing between glory and celebrity, brings to the fore the torn identity of Boigne as émigrée, royalist, noblewoman, and patriot enthusiast.

Finally, the comparison of Chateaubriand with Staël shows that not only did the mechanisms of celebrity for talented men and women work differently, but that also Romanticism contributed to separating male and female celebrity further. The elite genius author escaped the social expectations of his rank—his indolence and scandalous private life did not contradict his celebrity. Contrastingly, despite her equal genius, the famous female author was not exempt from having to comply with aristocratic gendered codes of conduct. The image of the Romantic hero in literature was eminently male, and thus the imbrications between the Romantic movement and celebrity culture did not translate to the famous woman.

In adopting a pragmatic approach at the crossroads between the preservation of her social standing and the desire to be part of the new united France, Boigne was eminently modern in her

representation of celebrity culture. I contend that it was her identity-building experience as an émigrée that ultimately informed this pragmatic angle and helped to reshape pre-existing aristocratic ethics for modern celebrity.

Notes

1. Éléonore-Adèle d'Osmond, comtesse de Boigne, *Une Passion dans le grand monde*, 2 vols. (Paris: Michel Lévy Frères, 1867); Boigne, *La Maréchale d'Aubemer* (Paris: Michel Lévy Frères, 1868); Boigne, *Récits d'une tante, Mémoires de la comtesse de Boigne, née d'Osmond*, 5 vols. (Paris: Emile-Paul Frères, 1921–23).

2. Françoise Wagener establishes a chronology of Boigne's life, dating the moment she actually started writing in April 1835, after her protégé Micheline Lange died accidentally at fourteen years old. Wagener, *La Comtesse de Boigne (1781–1866)* (Paris: Flammarion, 1997), 435, 440.

3. "The theme of being an outsider to the nation has had a rich posterity still prolific today: traitor and anti-patriotic, the émigré is also belligerent and a potential initiator of civil war" [Exogène à la nation, et le thème connaîtra une riche postérité sur laquelle nous vivons encore aujourd'hui, traître et anti patriote, l'émigré est aussi belliqueux, un fauteur de guerre civile en puissance], in Emmanuel de Waresquiel, "L'Emigration dans les débats politiques français au XIXe siècle, Naissance d'un mythe," *La revue administrative* 61, no. 364 (July 2008): 417. The emigration historiography of the nineteenth century remained very politically biased, and largely focused on the royal family and the court in exile. See, for instance: Henry Forneron, *Histoire générale des émigrés*, 3 vols. (Paris: Plon-Nourrit, 1884–90). Twentieth-century histories of the emigration, although not partisan anymore, failed to go beyond the anecdotal, see: Jean Vidalenc, *Les Emigrés français (1789–1825)* (Caen: Publications de la Faculté des lettres et sciences humaines de l'Université de Caen, 1963); and Ghislain de Diesbach, *Histoire de l'Emigration: 1789–1814* (Paris: Perrin, 1984).

4. Juliette Reboul and Laure Philip, eds., *French Emigration in Revolutionised Europe: Connected Histories and Memories* (Basingstoke, UK: Palgrave Macmillan, 2019).

5. François-René de Chateaubriand, *Mémoires d'Outre Tombe* (Paris: Arvensa, 2015), Partie II, Livre I, XI, Génie du Christianisme; suite—Défauts de l'ouvrage, 571.

6. Henri Rossi, *Mémoires aristocratiques féminins, 1789–1848* (Paris: Honoré Champion, 1998).

7. Antoine Lilti, *Figures publiques, l'invention de la célébrité 1750–1850* (Paris: Fayard, 2014), 12–13, 20.

8. Ibid., 11, 15.

9. Boigne, *Récits*, 1:7.

10. The *Oxford Dictionary online*, accessed February 6, 2020, https://en.oxforddictionaries.com/definition/gossip.

11. Ibid.

12. The *Confessions* of Jean Jacques Rousseau (1782) had first introduced the autobiography as worthy of publishing and reading. Antoine Lilti makes a link between Rousseau and modern celebrity culture in "The Writing of Paranoia: Jean-Jacques Rousseau and the Paradoxes of Celebrity," *Representations* (Summer 2008): 53–83.

13. Rossi, *Mémoires aristocratiques*, 10; Damien Zanone, *Ecrire son temps, les Mémoires en France de 1814 à 1848* (Lyon: Presses universitaires de Lyon, 2006), 275–86, 291.

14. Boigne, *Récits*, 1:5.

15. Claudine Giachetti, *Poétique des lieux, Enquête sur les mémoires féminins de l'aristocratie française (1789–1848)* (Paris: Champion, 2009); Rossi, *Mémoires aristocratiques*, 495–96.

16. Lilti, *Figures publiques*, 63.

17. Boigne, *Récits*, 1:205.

18. Ibid., 1:197–99.

19. Ibid., 1:301.

20. Ibid., 1:247.

21. Ibid., 1:264.

22. Lynn Hunt, *The Family Romance of the French Revolution* (Berkeley: University of California Press, 1992).

23. Boigne, *Récits*, 1:194, 213.

24. Ibid., 1:186.

25. Ibid., 1:291.

26. Antoine Lilti, *The Invention of Celebrity*, trans. Lynn Jeffress (Cambridge: Polity, 2017).

27. Boigne, *Récits*, 1:265, 274.

28. Ibid., 1:274.

29. Blanche Joséphine, duchesse de Maillé, *Souvenirs des deux Restaurations*, ed. Xavier de La Fournière (Paris: Perrin, 1984), 19, 102, 230–31, 232–33.

30. Claire de Duras, *Mémoires de Sophie, suivi de Amélie et Pauline*, ed. Marie-Bénédicte Diethelm (Paris: Edition Manucius, 2011).

31. On the sentimental novel and celebrity, Lilti wrote that the success of this genre "accompanied the nascent culture of celebrity" [accompagne la culture naissante de la célébrité], in *Figures publiques*, 19. Translation from Lilti, *The Invention of Celebrity*, 15.

32. Boigne, *Récits*, 1:268.

33. Many scholars have tried and failed to give a satisfactory definition of what Romanticism is. As Michael Ferber has pointed out, perhaps this failure is due to trying too hard to delineate this trend. The solution would be to conceptualize it as a large family with multiple facets, whose members bear resemblance to one another but not to all, yet they would stand out in a large crowd. Ferber, *A Companion to European Romanticism* (Oxford: Blackwell, 2005), 5–7.

34. Stendhal, *Armance, ou quelques scènes d'un salon de Paris* (Paris: Urbain Canel, 1827); Astolphe de Custine, *Aloys, ou le religieux du Mont Saint Bernard* (Paris: Vézard, 1829).

35. Lilti, *Figures publiques*, 299. Translation in Lilti, *The Invention*, 220.

36. Boigne, *Récits*, 1:230.

37. Ibid., 1:227.

38. Ibid., 1:222–23.

39. "[O]ne bizarre inconsistency of her otherwise very sociable mind was that it completely lacked tact" [une bizarre anomalie de cet esprit si éminemment sociable, c'est qu'il manquait complètement de tact], ibid., 1:226.

40. Ibid., 1:224, 226–27.

41. Margaret H. Darrow, "French Noblewomen and the New Domesticity, 1750–1850," *Feminist Studies* 5, no. 1 (Spring 1979): 48.

42. Ibid.

43. Jolanta K. Pekacz, *Conservative Tradition in Pre-Revolutionary France* (New York: Peter Lang, 1999), 4, 12.

44. Boigne, *Récits*, 1:225.

45. Ibid., 1:233.

46. Germaine de Staël, *Corinne ou l'Italie*, 2 vols. (Paris: H. Nicolle, 1807).

BIBLIOGRAPHY

Archives and Manuscript Sources

BRITISH MUSEUM (BM) PRINTS

A Deputation from Jonathan's and the Free-Masons, 1771 (BM 1868, 0808.4458, BM Satires 4871).

A French Capt. of Dragoons Brought to Bed of Twins, 1771 (BM 2010,7081.362).

Chevalier d'E-n (d'Eon) returnd or the Stockbrokers Outwitted, September 1, 1771 (BM 2010,7081.362).

Employment During Recess, 1786 (BM 1868,0808.5582, BM Satires 6994).

Every Man Has His Hobby-Horse, 1784 (BM 1868,0808.5284, BM Satires 6566).

Pacific-Overtures,-or-A Flight from St Cloud's-"Over the Water to Charley."A New Dramatic Peace Now Rehearsing, 1806 (BM 1868,0808.7435, BM Satires 10549).

Peachum and Lockit, 1790 (BM J,4.13 BM Satires 7627).

The Dagger Scene, or The Plot Discover'd, 1792 (BM, 1868,0808.6255, BM Satires 8147).

The Dancing Dogs, As Performed at Sadler's Wells with Universal Applause, 1784 (BM 1868,0808.5357, BM Satires 6636).

The Discovery of the Female Free-Mason, June 25, 1771 (BM 1868,0808.4456, BM Satires 4865).

The Fall of Achilles, 1785 (BM 1868,0808.5409, BM Satires 6770).

The Last Scene of the Managers Farce, 1795 (BM Y,10.164, BM Satires 8647).

The Pit Door. La Porte du Parterre, 1784 (BM 1860,0623.100, BM Satires 6769).

The Raree Show executed for the benefit of Mr Somebody at the Expence of John Bull, 1788 (BM J,4.16, BM Satires, 7273).

The Trial of M. D'Eon by a Jury of Matrons, 1771 (BM 1868,0808.9959, BM Satires 4862).

Carton de papiers intéressans à conserver pour le retour de Mlle d'Eon en la patrie, 1791–1803, MS 9362. Bibliothèque nationale de France.

Collection of Printed Paragraphs, cut out of English Newspapers, relating to the Chevalier d'Eon, 1776–1777. ADD MS 11340, British Library.

Fonds d'Eon 277AP/1. Archives Nationales, Paris.

Fonds d'Eon, "répertoire numérique détaillé", accessed February 6, 2020, https://www.siv.archives-nationales.culture.gouv.fr/siv/recherchecon-sultation/consultation/ir/pdfIR.action?irId=FRAN_IR_000716.

MS Chevalier d'Eon/40, Brotherton Collection. University of Leeds Library.

Papiers de la Chevalière d'Eon, classés par elle-même, MS 9033. Bibliothèque nationale de France.

Periodicals

Courier de l'Europe
Courier Français
Critical Review
Edinburgh Evening Courant
Edinburgh Phrenological Journal
Gazette médicale de Paris
Gazette nationale ou le Moniteur universel
Gazetteer and New Daily Advertiser
General Advertiser
General Evening Post
Journal de Paris
Journal des artistes
Journal des Sçavans
Journal Oeconomique, Année 1772
La grande colère du Père Duchesne
Le Logographe, journal national
Le Patriote français
Le Pianiste
Le Vieux Cordelier
Les Révolutions de France et de Brabant par Camille Desmoulins
Lloyd's Evening Post and British Chronicle
London Chronicle

Monthly Review
Morning Chronicle and London Advertiser
Morning Herald
Morning Post and Daily Advertiser
Phrenological Journal and Magazine of Moral Science
Revue de Paris
Revue et gazette musicale de Paris
Revue musicale
The Annual Register, or A View of the History, Politics, and Literature
 for the Year 1781
The Anti-Jacobin Review and Magazine; or Monthly Literary Censor
The Daily Universal Register
The Edinburgh Advertiser
The Edinburgh Review Or Critical Journal
The General Magazine and Impartial Review
The Lady's Monthly Museum
The Literary Chronicle and Weekly Review
The Phrenological Journal and Magazine of Moral Science
The Public Advertiser
The Star
The Westminster Magazine or the Pantheon of Taste
Theatrical Inquisitor, and Monthly Mirror
Vert-Vert: Journal politique du matin et du soir
Whitehall Evening Post

Secondary Sources

Aghion, Irène. "Collecting Antiquities in Eighteenth-Century France: Louis XV and Jean-Jacques Barthélemy." *Journal of the History of Collecting* 14, no. 2 (November 2002): 193–203.

Agoult, Marie. *Correspondance générale*: vol. 1, *1821–1836*. Edited by Charles F. Dupêchez. Paris: Honoré Champion, 2003.

Altick, Richard D. *The Shows of London*. Cambridge, MA: Belknap Press, 1978.

Anquetil-Duperron, Abraham Hyacinthe. *Zend-Avesta, ouvrage de Zoroastre, contenant les idées théologiques, physiques & morales de ce législateur, les cérémonies du culte religieux qu'il a établi, & plusieurs traits importans relatifs à l'ancienne histoire des Perses: traduit en françois sur l'original zend, avec des remarques; & accompagné de plusieurs traités propres à éclaircir les matières qui en sont l'objet*, vol. 1. Paris: Tilliard, 1771.

———. *Voyage en Inde: 1754–1762: relation de voyage en préliminaire de traduction du Zend-Avesta*. Edited by Jean Deloche, Manonmani

Filliozat, and Pierre-Sylvain Filliozat. Paris: Ecole Française d'Extrême-Orient, 1997.

App, Urs. *The Birth of Orientalism*. Philadelphia: University of Pennsylvania Press, 2010.

Archives parlementaires de 1787 à 1860. Recueil complet des débats législatifs et politiques des chambres françaises. Edited by Jérôme Mavidal and Emile Laurent, et al. 96 vols. Paris: Dupont; CNRS, 1867–1990.

Asleson, Robyn, ed. *A Passion for Performance: Sarah Siddons and Her Portraitists*. Los Angeles: J. Paul Getty Museum, 1999.

Aspinall, Arthur. *Politics and the Press, c.1750–1850*. London: Home & Van Thal, [1949].

Athanassoglou-Kallmyer, Nina. "Blemished Physiologies: Delacroix, Paganini, and the Cholera Epidemic of 1832." *The Art Bulletin* 83, no. 4 (2001): 686–710.

Auerbach, Emily. *Searching for Jane Austen*. Madison: University of Wisconsin Press, 2004.

Auerbach, Nina. "Jane Austen's Dangerous Charm: Feeling as One Ought about Fanny Price." *Persuasions* 2 (1980): 9–11.

Aulard, François-Alphonse. *L'Eloquence parlementaire pendant la Révolution française*. Vol. 2. Paris: Hachette, 1886.

———. *La Société des Jacobins: recueil des documents pour l'histoire du club des Jacobins de Paris*. 6 vols. Paris: Jouaust; Noblet; Quantin, 1889–97.

Austen, Jane. *Mansfield Park: Authoritative Text, Contexts, Criticism*. Edited by Claudia L. Johnson. New York: W.W. Norton, 1998.

Baker, Keith Michael. *Inventing the French Revolution. Essays on French Political Thought in the Eighteenth Century*. Cambridge: Cambridge University Press, 1990.

Baridon, Laurent. "Jean-Pierre Dantan, le caricaturiste de la statuomanie." Special issue, *Sculptures et caricatures: Ridiculosa* no. 13 (2006): 127–43.

Barker, Hannah. *Newspapers, Politics, and Public Opinion in Late Eighteenth-Century England*. Oxford: Clarendon Press, 1998.

Barlow, Frank. "The King's Evil." *English Historical Review* 95, no. 374 (January 1980): 3–27.

Barrel, John. *Imagining the King's Death: Figurative Treason, Fantasies of Regicide, 1793–96*. Oxford: Oxford University Press, 2000.

Barret-Kriegel, Blandine. *Les Académies de l'histoire*. Paris: Presses Universitaires de France, 1988.

Barry, Elizabeth. "From Epitaph to Obituary: Death and Celebrity in Eighteenth-Century British Culture." *International Journal of Cultural Studies* 11, no. 3 (September 2008): 259–75.

Baruth, Philip E., ed. *Introducing Charlotte Charke: Actress, Author, Enigma.* Urbana: University of Illinois Press, 1998.

Bassanville, Madame la comtesse de. *Les Salons d'autrefois: souvenirs intimes, 1e série.* Paris: J. Victorion, n.d.

Bell, David. *Lawyers and Citizens. The Making of a Political Elite in Old Regime France.* Oxford: Oxford University Press, 1994.

Bély, Lucien, ed. *Dictionnaire de l'Ancien Régime; Royaume de France XVIe–XVIIIe siècle.* Paris: Presses Universitaires de France, 1996.

Benjamin, Walter. *Illuminations.* Edited by Hannah Arendt. Translated by Harry Zorn. London: Pimlico, 1999.

Bennett, Andrew. *Romantic Poets and the Culture of Posterity.* Cambridge: Cambridge University Press, 1999.

Bercegol, Fabienne, Stéphanie Genand, and Florence Lotterie, eds. *Une "période sans nom." Les années 1780–1820 et la fabrique de l'histoire littéraire.* Paris: Classiques Garnier, 2016.

Berenson, Edward. *Heroes of Empire: Five Charismatic Men and the Conquest of Africa.* Berkeley: University of California Press, 2010.

———, and Eva Giloi, eds. *Constructing Charisma. Celebrity, Fame, and Power in Nineteenth-Century Europe.* New York: Berghahn Books, 2010.

Berlanstein, Lenard R. "Women and Power in Eighteenth-Century France: Actresses at the Comédie-Française." *Feminist Studies* 20, no. 3 (1994): 475–506.

———. *Daughters of Eve: A Cultural History of French Theater Women from the Old Regime to the Fin de Siècle.* Cambridge, MA: Harvard University Press, 2001.

———. "Historicizing and Gendering Celebrity Culture: Famous Women in Nineteenth-Century France." *Journal of Women's History* 16, no. 4 (Winter 2004): 65–91.

Besslich, Barbara. "Cato als Repräsentant stoisch formierten Republikanertums von der Antike bis zur Französischen Revolution." In *Stoizismus in der europäischen Philosophie, Literatur, Kunst und Politik. Eine Kulturgeschichte von der Antike bis zur Moderne,* edited by Barbara Neymeyr, Jochen Schmidt, and Bernhard Zimmermann, 368–69. Vol. 1. Berlin: De Gruyter, 2008.

Bindman, David. "Texts as Design in Gillray's Caricature." In *Icons, Texts, Iconotexts: Essays on Ekphrasis and Intermediality,* edited by Peter Wagner, 309–23. Berlin: De Gruyter, 1996.

Birn, Raymond. "Le *Journal des Savants* sous l'Ancien Régime." *Journal des Savants* 1, no. 1 (1965): 15–35.

Black, Jeremy. *The English Press in the Eighteenth Century.* Philadelphia: Philadelphia Press, 1987.

Blakemore, Steven, ed. *Burke and the French Revolution: Bicentennial Essays*. Athens: University of Georgia Press, 1992.

Boigne, Éléonore-Adèle d'Osmond, comtesse de. *Une Passion dans le grand monde*. 2 vols. Paris: Michel Lévy Frères, 1867.

———. *La Maréchale d'Aubemer*. Paris: Michel Lévy Frères, 1868.

———. *Récits d'une tante, Mémoires de la comtesse de Boigne, née d'Osmond*. 5 vols. Paris: Emile-Paul Frères, 1921–23.

Bonnet, Jean-Claude. *Naissance du Panthéon: Essai sur le culte des grands hommes*. Paris: Fayard, 1998.

Boortstin, Daniel J. *The Image: A Guide to Psuedo-events in America*, 50th Anniversary edition. New York: Vintage Books, 2012.

Bordoni, Sylvia. "Parodying Corinne: Foster's The Corinna of England." *Corvey CW3 Journal* 2 (Winter 2004), accessed February 6, 2020, https://www2.shu.ac.uk/corvey/CW3journal/Issue%20two/bordoni.html.

Bouchardon, Edmé. *Etudes prises dans le bas peuple, ou les cris de Paris*. Paris: Joullain Quay de la Megisserie à la Ville de Rome, 1737–46.

Braudy, Leo. *The Frenzy of Renown: Fame and its History*. Oxford: Oxford University Press, 1986.

Briggs, Peter. "Laurence Sterne and Literary Celebrity in 1760." *The Age of Johnson. A Scholarly Annual* 4 (1991): 251–80.

Brissot de Warville, Jacques Pierre. *Le Sang innocent vengé, ou discours sur les réparations dues aux Accusés innocens*. Berlin [Neufchâtel]: Defauges, 1781.

British Fiction 1800–1829: A Database of Production, Circulation and Reception, accessed February 6, 2020, http://www.british-fiction.cf.ac.uk.

Britsch, Amédée. *La Maison d'Orléans à la fin de l'Ancien Régime: la jeunesse de Philippe-Egalité (1747–1785), d'après des documents inédits*. Vannes: Imprimerie Lafolye frères et Cie, 1926.

Brock, Claire. *The Feminization of Fame, 1750–1830*. Basingstoke: Palgrave, 2006.

Brooks, Helen. *Actresses, Gender, and the Eighteenth-Century Stage: Playing Women*. Basingstoke: Palgrave Macmillan, 2015.

Broussais, Marie. "Liszt dans les collections anthropologique du Musée de l'Homme." *L'Education musicale* 309–10 (June–July 1984): 9–11, 29–31.

Brown, Mark. "Portrait Mistaken for 18th-Century Lady is Early Painting of Transvestite." *Guardian* (London), June 6, 2012, February 6, 2020, https://www.theguardian.com/artanddesign/2012/jun/06/portrait-18th-century-early-transvestite.

Burdett, Sarah. "Martial Women in the British Theatre: 1789–1804." PhD diss., University of York, 2016.

Burke, Edmund. *The Correspondence of Edmund Burke*. Edited by T. W Copeland et al. 10 vols. Cambridge and Chicago, IL: Cambridge University Press and University of Chicago Press, 1958–78.

———. *Epistolary Correspondence of Burke and Dr. French Laurence*. London: Printed for C. and J. Rivington, n.d.

Burney, Frances. *The Court Journals and Letters of Frances Burney*. Oxford: Oxford University Press, 2014.

Burrows, Simon. *A King's Ransom: The Life of Charles Théveneau de Morande, Blackmailer, Scandalmonger, and Master Spy*. London: Continuum, 2010.

———. "A Literary Low-Life Reassessed: Charles Théveneau de Morande in London, 1769–1791." *Eighteenth-Century Life* 22, no. 1 (February 1998): 76–94.

———, Jonathan Colin, Russel Goulbourne and Valerie Mainz, eds. *The Chevalier d'Eon and his Worlds. Gender, Espionage and Politics in the Eighteenth Century*. London: Continuum, 2010.

Byrne, Paula. *Jane Austen and the Theatre*. London: Hambledon and London, 2002.

Carlson, Marvin. *Shattering Hamlet's Mirror: Theatre and Reality*. Ann Arbor: University of Michigan Press, 2016.

———. *The Haunted Stage: The Theatre as Memory Machine*. Ann Arbor: University of Michigan Press, 2001.

Castle, Arthur Michael. *Etude phrénologique sur le caractère originel et actuel de M. François Liszt*. Milan: n.p., 1847.

Caylus, Anne Claude de. *Recueil d'antiquités égyptiennes, étrusques, grecque, romaines et gauloises*. Vol. 4. Paris: Tilliard, 1761.

Chappey, Frédéric, ed. *Les Trésors des princes de Bourbon Conti*. Paris: Somogy, 2000.

Charke, Charlotte. *A Narrative of the Life of Mrs Charlotte Charke*. London: Printed for W. Reeve, A. Dodd and E. Cook, 1755.

Charton, Fabrice. "Censure(s) à l'Académie Royale des Inscriptions et Belles-lettres de la seconde moitié du XVIIe au milieu du XVIIIe siècle." *Papers on French Seventeenth-Century Literature* 36, no. 71 (2009): 377–94.

Chateaubriand, François-René de. *Mémoires d'Outre Tombe*. Paris: Arvensa, 2015.

Cheek, Pamela. "Prostitutes of 'Political Institution.'" *Eighteenth-Century Studies* 28, no.2 (Winter 1994): 193–219.

Chesney, Duncan McColl. "The History of the History of the Salon." *Nineteenth-Century French Studies* 36, no. 1/2 (Fall 2007–Winter 2008): 94–108.

Chronicon Viennense oder neueröffneter Österreichischer Bildersal vom Jahre 1790. Vienna: Alberti, 1791.

Cibber, Theophilus. *Romeo and Juliet, A Tragedy, Revis'd and Alter'd from Shakespear.* London: Printed for C. Corbett and G. Woodfall, [1748].

Cicero, *De Legibus.*

———. *De Officiis.* Translated by Walter Miller. Cambridge, MA: Harvard University Press, 1913.

———. *The Orations of Marcus Tullius Cicero.* Translated by C. D. Yonge. London: George Bell & Sons, 1903. Available online, accessed February 6, 2020, https://www.perseus.tufts.edu/hopper/text?doc=Perseus:abo:phi,0474,002:56.

———. *Pro Sextio Roscio Amerino*

———. *Second Philippic.*

Clairon, Hyppolite. *Mémoires d'Hyppolite Clairon, et réflexions sur l'art dramatique; publiés par elle-même.* Paris: F. Buisson, 1798.

———and François-Charles Huerne de la Mothe. *Libertés de La France, contre le pouvoir arbitraire de l'excommunication.* Amsterdam: n.p., 1761.

Clark, Anna. "The Chevalier d'Eon and Wilkes: Masculinity and Politics in the Eighteenth Century." *Eighteenth-Century Studies* 32, no. 1 (Fall 1998): 19–48.

Clarke, Robert, ed. *Celebrity Colonialism: Fame, Power, and Representation in Colonial and Postcolonial Cultures.* Newcastle upon Tyne: Cambridge Scholars Publishing, 2009.

———, ed. "Travel and Celebrity Culture." Special issue, *Postcolonial Studies* 12, no. 2 (May 2009): 153–72.

Cody, Lisa Forman. "Sex, Civility, and the Self: Du Courdray, d'Eon, and Eighteenth-Century Conceptions of Gendered, National, and Psychological Identity." *French Historical Studies* 24, no. 3 (Summer 2001): 397–407.

Collection complète des œuvres de l'abbé de Mably. 15 vols. Paris: C. Desbrière, 1794.

Combe, George. *A System of Phrenology.* Vol. 2. Edinburgh: Maclachlan and Stewart, 1836.

Conlin, Jonathan. "Vauxhall on the Boulevard: Pleasure Gardens in London and Paris, 1764–1784." *Urban History* 35, no. 1 (May 2008): 24–47.

Correspondance littéraire, philosophique, et critique de Grimm et de Diderot. Vol. 3. Paris: Furne, 1829.

Coulombeau, Sophie. "'Men whose glory it is to be known': Godwin, Bentham, and the London Corresponding Society." *Nineteenth-Century Prose* 41, no. 2 (Spring–Fall 2014): 277–312.

Cowan, Brian William. *The Social Life of Coffee: The Emergence of the British Coffeehouse.* New Haven, CT: Yale University Press, 2005.

————. "News, Biography, and Eighteenth-Century Celebrity." In *Oxford Handbooks Online*. Oxford University Press, 2016, accessed February 13, 2020, 10.1093/oxfordhb/9780199935338.013.132

————. "Histories of Celebrity in Post-Revolutionary England." *Historical Social Research* 32 (2019): 83–98.

Craft-Fairchild, Catherine. "Sexual and Textual Indeterminacy: Eighteenth-Century English Representations of Sapphism." *Journal of the History of Sexuality* 15, no. 3 (September 2006): 408–31.

Crimmins, James E. *Bentham's Auto-Icon and Related Writings*. Bristol: Thoemmes Press, 2002.

Croÿ-Solre, Emmanuel de. *Journal inédit du duc de Croÿ publié, d'après le ms. autographe conservé à la Bibliothèque de l'Institut*. 4 vols. Paris: E. Flammarion, 1906.

Custine, Astolphe de. *Aloys, ou le religieux du Mont Saint Bernard*. Paris: Vézard, 1829.

Darnton, Robert. *The Literary Underground of the Old Regime*. Cambridge, MA: Harvard University Press, 1982.

————. "The True History of Fake News." *The New York Review*, February 13, 2017.

Darrow, Margaret H. "French Noblewomen and the New Domesticity, 1750–1850." *Feminist Studies* 5, no. 1 (Spring, 1979): 41–65.

Davidoff, Leonore, and Catherine Hall. *Family Fortunes*. London: Hutchinson, 1987.

Davies, James Q. *Romantic Anatomies*. Berkeley: University of California Press, 2014.

Davison, Alan. "High-Art Music and Low-Brow Types: Physiognomy and Nineteenth-Century Music Iconography." *Context* 17 (Winter 1999): 5–19.

————. "Studies in the Iconography of Franz Liszt." PhD diss., University of Melbourne, 2001.

————. "The Musician in Iconography from the 1830s and 1840s." *Music in Art* 28, no. 1/2 (Spring–Fall 2003): 147–62.

————. "Liszt and the Physiognomic Ideal in the Nineteenth Century." *Music in Art* 30, no. 1/2 (Spring–Fall 2005): 133–44.

de Caso, Jacques. *David d'Angers: Sculptural Communication in the Age of Romanticism*. Translated by Dorothy Johnson. Princeton, NJ: Princeton University Press, 1992.

de Courcy, G.I.C. *Paganini, The Genoese*. Vol. 2. Norman: University of Oklahoma Press, 1957.

de Diesbach, Ghislain. *Histoire de l'Emigration: 1789–1814*. Paris: Perrin, 1984.

de Duras, Claire. *Mémoires de Sophie, suivi de Amélie et Pauline*. Edited by Marie-Bénédicte Diethelm. Paris: Manucius, 2011.

De La Fortelle, M. *La Vie militaire, politique, et privée de Demoiselle Charles-Geneviève-Louise-Auguste-Andrée-Timothée Éon ou d'Éon de Beaumont.* Paris: Lambert, 1779.

de Waresquiel, Emmanuel. "L'Emigration dans les débats politiques français au XIXe siècle, Naissance d'un mythe." *La revue administrative* 61, no. 364 (July 2008): 410–17.

Desmoulins, Camille. *Fragment de l'Histoire secrète de la Révolution.* Paris: Imprimerie Patriotique et Républicaine, 1793.

Dew, Nicholas. *Orientalism in Louis XIV's France.* Oxford: Oxford University Press, 2009.

Dictionnaires d'autrefois ARTFL Project, accessed February 6, 2020, https://artflsrvo3.uchicago.edu/philologic4/publicdicos/query?report=bibliography&head=celebrite&start=0&end=0.

Diderot, Denis. *Salon de 1767.* Edited by J. Seznec et J. Adhemar. Oxford: Clarendon Press, 1963.

Discours historiques et politiques sur Salluste, par M. Gordon traduits de l'anglois par Pierre Daudé. 2 vols. Amsterdam: Cramer, 1759.

Dobson, Michael. *Great Shakespeareans.* Vol. 2, *Garrick, Kemble, Siddons, Kean.* Edited by Peter Holland. London: Bloomsbury, 2014.

Donald, Diana. *The Age of Caricature: Satirical Prints in the Reign of George III.* New Haven, CT: Yale University Press, 1996.

Doniger, Wendy. *The Woman Who Pretended to Be Who She Was: Myths of Self-Imitation.* Oxford: Oxford University Press, 2005.

Donoghue, Frank. *The Fame Machine. Book Reviewing and Eighteenth-Century Literary Careers.* Stanford, CA: Stanford University Press, 1996.

d'Origny, Pierre Adam. *Chronologie des rois du grand empire des Egyptiens.* Paris: Vincent, 1765.

Duncan, Sophie. *Shakespeare's Women and the Fin De Siècle.* Oxford: Oxford University Press, 2016.

Dyer, Richard. *Stars.* London: British Film Institute, 1979.

———. *Heavenly Bodies: Film Stars and Society.* London: Routledge, 2004.

Echeverria, Durand. *The Maupeou Revolution: A Study in the History of Libertarianism in France, 1770–1774.* Baton Rouge: Louisiana State University Press, 1985.

Eger, Elizabeth, ed. *Bluestockings Displayed Portraiture, Performance, and Patronage, 1730–1830.* Cambridge: Cambridge University Press, 2013.

Eisner, Eric. *Nineteenth-Century Poetry and Literary Celebrity.* Basingstoke, UK: Palgrave Macmillan, 2009.

Ellis, Alfred. *Phrenology and Musical Talent.* Blackpool: Human Nature Office, 1896.

Encyclopédie, Dictionnaire raisonné des sciences, des arts et des métiers, par une Société de Gens de lettres. 17 vols. Paris; Neufchâtel: Briasson, David, Le Breton, Durand, Faulche, 1751–65, accessed February 6, 2020, https://artflsrv03.uchicago.edu/philologic4/encyclopedie1117/.

Engel, Laura. *Fashioning Celebrity: Eighteenth-Century British Actresses and Strategies for Image Making*. Columbus: Ohio State University Press, 2011.

———. *Fashioning Eighteenth-Century British Actresses and Strategies for Image Making*. Columbus: Ohio State University Press, 2016.

Eon de Beaumont, Charles-Geneviève-Louis-Auguste-André Timothée d'. *Das militarische, politische und Privat-Leben des Fräuleins d'Eon de Beaumont, ehemaligen Ritters von d'Eon*. Frankfurt; Leipzig: n.p., 1779.

———. *Krygs-Staatkundig en Burgerlyk Leven van Mejufvrouw C. G. L. A. A. T. D. d'Eon de Beaumont. Benevens de Geschriften en echte Brieven, raakende de Verschillen met den Heer de Beaumarchais, aangaande haare Sexe*. Amsterdam: n.p., 1779.

———. *The Maiden of Tonnerre: The Vicissitudes of the Chevalier and the Chevalière d'Eon*. Translated by and edited by Roland Champagne, Nina Ekstein, and Garry Kates. Baltimore: The Johns Hopkins University Press, 2001.

Fawcett, Julia. *Spectacular Disappearances: Celebrity and Privacy, 1696–1801*. Ann Arbor: University of Michigan Press, 2016.

Ferber, Michael. *A Companion to European Romanticism*. Oxford: Blackwell, 2005.

Figueira, Dorothy M. *Aryans, Jews, Brahmins: Theorizing Authority Through Myths of Identity*. Albany: State University of New York Press, 2002.

Filippi, Florence, Sara Harvey, and Sophie Marchand, eds. *Le Sacre de l'acteur, émergence du vedettariat théâtral de Molière à Sarah Bernhardt*. Paris: Armand Colin, 2017.

Finnerty, Páraic, and Rod Rosenquist, eds. "Transatlantic Celebrity: European Fame in Nineteenth-Century America." Special issue, *Comparative American Studies: An International Journal* 14, no. 1 (September 2016).

Flamarion, Edith. "Brutus ou l'adoption d'un mythe romain par la Révolution française." In *La Révolution Française et l'Antiquité*, edited by Raymond Chevallier, 91–112. Tours: Centre de recherches A. Paignol, 1991.

Foote, Samuel. *Wit for the Ton! The Convivial Jester; or, Sam Foote's Last Budget Opened*. London: Printed for W. Adlard, [1778].

Forneron, Henry. *Histoire générale des émigrés*. 3 vols. Paris: Plon-Nourrit, 1884–90.

Fornier, Edouard. "Le Palais Royal et ses environs." In *Paris à travers les ages*. Vol. 2, edited by Fedor Hoffbauer. Paris: Firmin-Didot, 1875.

Fossati. *Manuel pratique de phrénologie ou Physiologie du cerveau*. Paris: G. Baillière, 1845.

Francis, Catrin. "The Politics of Appropriation in French Revolutionary Theatre." PhD diss., University of Exeter, 2012.

Freeman, Lisa. "Mourning the 'Dignity of the Siddonian Form.'" *Eighteenth-Century Fiction* 27, no. 3 (Spring–Summer 2015): 597–629.

Friedland, Paul. *Political Actors, Representative Bodies and Theatricality in the Age of the French Revolution*. Ithaca, NY: Cornell University Press, 2002.

Gaehtgens, Thomas W., and Gregor Wedekind, eds. *Le Culte des grands hommes en France et en Allemagne: 1750–1850*. Paris: Maison des Sciences de l'Homme, 2010.

Gaillard, Pierre Alexandre. *Histoire de Mademoiselle Cronel, dite Frétillon, actrice de la Comédie de Roüen*. The Hague: n.p. 1739.

Gall, Franz Joseph. *Anatomie et physiologie du système nerveux en général et du cerveau en particulier, avec des observations sur la possibilité de reconnaître plusieurs dispositions intellectuelles et morales de l'homme et des animaux par la configuration de leurs têtes*. 4 vols. Paris: Librarie grecque-latine-allemande, 1810–19.

Gallet, Michel. *Les Architectes parisiens du XVIIIème siècle: dictionnaire biographique et critique*. Paris: Mengès, 1995.

Gallien, Claire. "Une querelle orientaliste: la réception controversée du 'Zend Avesta' d'Anquetil-Duperron en France et en Angleterre." *Litteratures Classiques* 81 (2013): 257–68.

Gamer, Michael. *Romanticism, Self-Canonization, and the Business of Poetry*. Cambridge: Cambridge University Press, 2017.

Gamson, Joshua. *Claims to Frame: Celebrity in Contemporary America*. Berkeley: University of California Press, 1994.

Gaonkar, Dilip Parameshwar, and Robert J. McCarthy, Jr. "Panopticism and Publicity: Bentham's Quest for Transparency." *Public Culture* 6, no. 3 (Spring 1994): 547–75.

Garrick, David. *The Letters of David Garrick*. Edited by David M. Little and George M. Kahrl. 3 vols. London: Oxford University Press, 1963.

Giachetti, Claudine. *Poétique des lieux, Enquête sur les mémoires féminins de l'aristocratie française (1789–1848)*. Paris: Champion, 2009.

Gibbs, Christopher, and Dana Gooley, eds. *Franz Liszt and His World*. Princeton, NJ: Princeton University Press, 2006.

Giles, David. *Illusions of Immortality: A Psychology of Fame and Celebrity*. Basingstoke: Macmillan, 2000.

Goldsmith, Oliver. *The Vicar of Wakefield*. London: Penguin, 1982.

Goldstein, Jan. *The Post-Revolutionary Self*. Cambridge, MA.: Harvard University Press, 2005.

Goncourt, Edmond de. *Mademoiselle Clairon d'après ses correspondances et les rapports de police du temps*. Paris: Charpentier et Cie Editeurs, 1890.

Goodman, Jessica. *Commemorating Mirabeau. "Mirabeau aux Champs-Elysées" and Other Texts*. Cambridge: Modern Humanities Research Association, 2017.

Grell, Chantal. *L'Histoire entre érudition et philosophie. Etude sur la connaissance historique à l'âge des Lumières*. Paris: Presses Universitaires de France, 1993.

————. *Le Dix-huitième Siècle et l'antiquité en France. 1680–1789*. Oxford: Voltaire Foundation, 1995.

Grenby, Matthew O. *The Anti-Jacobin Novel: British Conservatism and the French Revolution*. Cambridge: Cambridge University Press, 2001.

Grey, Charles Harold. *Theatrical Criticism in London to 1795*. New York: Columbia University Press, 1931.

Gross, Jean-Pierre. *Fair Shares for All: Jacobin Egalitarianism in Practice*. Cambridge: Cambridge University Press, 1997.

Grubert, Alain-Charles. "Les 'Vauxhalls' Parisiens au XVIIIe siècle." *Bulletin de la société de l'histoire de l'art français* (1972): 125–43.

————. *Les Grandes Fêtes et leurs décors à l'époque de Louis XVI*. Geneva: Librarie Droz, 1972.

Guermazi, Alexandre. "Les Législateurs face aux demandes de vertu des citoyens parisiens." In *Vertu et politique. Les Pratiques des législateurs (1789–2014)*, edited by Michel Biard, Philippe Bourdin, Hervé Leuwers, and Alain Tourret. Rennes: Presses universitaires de Rennes, 2015.

Habermas, Jürgen. *The Structural Transformation of the Public Sphere*. Translated by Thomas Burger. Cambridge: Polity Press, 1989.

Haffenden, Chris. *Every Man His Own Monument: Self-Monumentalizing in Romantic Britain*. Uppsala: Acta Universitatis Upsaliensis, 2018.

Hahn, Hazel. "Street Picturesque: Advertising in Paris, 1830–1914." PhD diss., University of California, Berkeley, 1997.

Hall, Edith, and Rosie Wyles. "The Censoring of Plutarch's Gracchi on the Revolutionary French, Irish, and English Stages, 1792–1823." In *The Afterlife of Plutarch*, edited by John North and Peter Mack, 141–47. London: Institute of Classical Studies, 2018.

Hammer, Dean. *Roman Political Thought From Cicero to Augustine*. Cambridge: Cambridge University Press, 2014.

Hardy, Siméon-Posper. *Mes Loisirs ou Journal d'événemens tels qu'ils parviennent à ma connoissance, 1753–1789*. Vol. 2, edited by Pascal Bastien, Simon Dagenais, and Sabine Juratic. Paris: Hermann, 2014.

Harris, Ian. "Publishing Parliamentary Oratory: The Case of Edmund Burke." *Parliamentary History* 26, no. 1 (February 2007): 122–30.

Harris, Michael. *London Newspapers in the Age of Walpole: A Study of The Origins of the Modern English Press.* London: Associated University Presses, 1987.

Harvey, Anthon, and Richard Mortimer, eds. *The Funeral Effigies of Westminster Abbey.* Woodbridge: Boydell, 1994.

Haugen, Janine Marie. "The Mimic Stage: Private Theatricals in Georgian Britain." PhD diss., University of Colorado, 2014.

Haydon, Benjamin Robert. *Life of Benjamin Robert Haydon, From his Autobiography and Journals.* Edited by Tom Taylor. 3 vols. New York: Harper & Brothers, 1853.

———. *The Diary of Benjamin Robert Haydon.* Edited by W. B. Pope. 5 vols. Cambridge, MA: Harvard University Press, 1960–63.

Hays, David. "Carmontelle's Design for the Jardin de Monceau: A Freemasonic Garden in Late-Eighteenth-Century France." *Eighteenth-Century Studies* 32, no. 4 (Summer 1999): 447–62.

Hazlitt, William. *The Collected Works of William Hazlitt.* Edited by A.R. Waller and Arnold Glover. 12 vols. London: J.M. Dent & Co., 1902–4.

———. *Lectures on the English Poets.* 2nd ed. London: Taylor and Hessey, 1819.

———. *The Spirit of the Age: or Contemporary Portraits.* London: Henry Colburn, 1825.

Hébert, Jacques René. *La Grande Colère du Père Duchesne.* Paris: n.p., 1793.

Hepburn, Allan. "Imposture in *The Great Gatsby*." In *Modernist Star Maps: Celebrity, Modernity, Culture*, edited by Aaron Jaffe, 55–70. London: Routledge, 2016.

Hermary-Vieille, Catherine. *Moi, Chevlier d'Eon, Espionne du roi.* Paris: Albin Michel, 2018.

Higgins, David. *Romantic Genius and the Literary Magazine: Biography, Celebrity, and Politics.* London: Routledge, 2005.

Hill, John. *The Actor: A Treatise on the Art of Playing.* London: Printed for R. Griffiths, 1750.

Horne, Richard H., ed. *The History of Napoleon.* London: R. Tyas, 1841.

Hunt, Lynn. *The Family Romance of the French Revolution.* Berkeley: University of California Press, 1992.

Inglis, Fred. *A Short History of Celebrity.* Princeton NJ: Princeton University Press, 2010.

Israel, Jonathan. *Democratic Enlightenment: Philosophy, Revolution, and Human Rights, 1750–1790.* New York: Oxford University Press, 2011.

Jackson, Richard A. "Peers of France and Princes of the Blood." *French Historical Studies* 7, no. 1 (Spring 1971): 27–46.

Jacobs, Andres. *Epiphanius of Cyprus: A Cultural Biography of Late Antiquity.* Oakland: University of California Press, 2016.

Jenner, Greg. *Dead Famous: An Unexpected History of Celebrity from Bronze Age to Silver Screen.* London: Weidenfeld & Nicolson, 2020.

Jenkins, Henry. *Textual Poachers: Television Fans and Participatory Culture.* New York: Routledge, 1992.

Jenson, Joli. "On Fandom, Celebrity, and Mediation." In *Afterlife as Afterimage: Understanding Posthumous Fame*, edited by Steve Jones and Joli Jensen, xv–xxiii. New York: Peter Lang, 2005.

Johnson, Claudia L. *Jane Austen: Women, Politics, and the Novel.* Chicago: University of Chicago Press, 1990.

Johnson, Samuel. *Johnson's Dictionary of the English Language.* Dublin: James Duffy, 1847.

Jones, Colin. *The Great Nation: France from Louis XV to Napoleon, 1715–1799.* New York: Columbia University Press, 2002.

———, and Dror Wahrman, eds. *The Age of Cultural Revolutions. Britain and France 1750–1850.* Berkeley: University of California Press, 2002.

Jones, Emrys D. and Victoria Joule, eds. *Intimacy and Celebrity in Eighteenth-Century Literary Culture.* Basingstoke: Palgrave Macmillan, 2018.

———. "Maternal Duties and Filial Malapropisms: Frances Sheridan and the Problems of Theatrical Inheritance." In *Stage Mothers: Women, Work, and the Theater, 1660–1830*, edited by Laura Engel and Elaine McGirr, 159–78. Lewisburg: Bucknell University Press, 2014.

Jouanna, Arlette. *Le Devoir de révolte: la noblesse française et la gestion de l'état moderne, 1559–1661.* Paris: Fayard, 1989.

Kates, Gary. "The Transgendered World of the Chevalier/Chevalière d'Eon." *The Journal of Modern History* 67, no. 3 (September 1995): 558–94.

———. *Monsieur d'Eon is a Woman. A Tale of Political Intrigue and Sexual Masquerade.* Baltimore: The Johns Hopkins University Press, 2001.

Kawabata, Mai. *Paganini: The "Demonic" Virtuoso.* Woodbridge: Boydell Press, 2013.

Kieffer, Jean-Luc. *Anquetil-Duperron: l'Inde en France au XVIIIe siècle.* Paris: Les Belles Lettres, 1983.

Kirkham, Margaret. *Jane Austen: Feminism and Fiction.* New York: Harvester Press, 1983.

Krawczyk, Scott. *Romantic Literary Families.* Basingstoke: Palgrave Macmillan, 2009.

Kushner, Nina. *Erotic Exchanges: The World of Elite Prostitution in Eighteenth-Century Paris.* Ithaca, NY: Cornell University Press, 2013.

Lander, James. "A Tale of Two Hoaxes in Britain and France in 1775." *The Historical Journal* 49, no. 4 (December 2006): 995–1024.

Larousse, Pierre. *Grand dictionnaire universel du XIXe siècle.* Paris: Administration du Grand dictionnaire universel, 1866.

Leppert, Alice. "Keeping Up with the Kardashians: Fame-Work and the Production of Entrepreneurial Sisterhood." In *Cupcakes, Pinterest, and Ladyporn: Feminized Popular Culture in the Early Twenty-First Century*, edited by Elana Levine, 215–31. Urbana: University of Illinois Press, 2015.

Lerner, Jillian Taylor. "Panoramic Literature: Marketing Illustrated Journalism in July Monarchy Paris." PhD diss., Columbia University, 2006.

*Lettre à monsieur A*** du P***: Dans laquelle est compris l'examen de sa traduction des livres attribués à Zoroastre.* London: Elmsly, 1771.

Leuwers, Hervé. "Servir le peuple avec vertu." In *Vertu et politique. Les Pratiques des législateurs (1789–2014)*, edited by Michel Biard, Philippe Bourdin, Hervé Leuwers, and Alain Tourret, 401–6. Rennes: Presses Universitaires de Rennes, 2015.

Lever, Evelyne. *Philippe Égalité.* [Paris]: le Grand livre du mois, 1996.

Levitin, Dmitri. *Ancient Wisdom in the Age of the New Science.* Oxford: Oxford University Press, 2016.

Levy, Michelle. *Family Authorship and Romantic Print Culture.* Basingstoke: Palgrave Macmillan, 2008.

Lilti, Antoine. *Figures publiques, l'invention de la célébrité 1750–1850.* Paris: Fayard, 2014.

———. *The Invention of Celebrity.* Translated by Lynn Jeffress. Cambridge: Polity, 2017.

———. *Le Monde des salons: Sociabilité et mondanité à Paris au XVIIIe siècle.* Paris: Fayard, 2005.

———. "Querelles et controverses: les formes du désaccord intellectuel à l'époque moderne." *Mil Neuf Cent. Revue d'histoire intellectuelle* 25, no.1 (2007): 13–28.

———. "The Writing of Paranoia: Jean-Jacques Rousseau and the Paradoxes of Celebrity." *Representations* (Summer 2008): 53–83.

Linton, Marisa. *Choosing Terror: Virtue, Friendship, and Authenticity in the French Revolution.* Oxford: Oxford University Press, 2013.

———. "Robespierre et l'authenticité révolutionnaire." *Annales historiques de la Révolution française* 371 (2013): 153–73.

Liszt, Franz. *Selected Letters.* Translated and edited by Adrian Williams. Oxford: Clarendon Press, 1998.

Livy. *Ab urbe condita.*

Luckhurst, Mary, and Jane Moody, eds. *Theatre and Celebrity in Britain, 1660–2000.* Basingstoke: Palgrave Macmillan, 2005.

Lojkine, Stéphane. *L'Œil révolté: les Salons de Diderot.* Paris: Editions Jacqueline Chambon, 2007.

Mackie, Erin. "The Narratives of the Life of Mrs Charlotte Charke." *ELH* 58, no. 4 (Winter 1991): 841–65.

Maillé, Blanche Joséphine, duchesse de. *Souvenirs des deux Restaurations.* Edited by Xavier de La Fournière. Paris: Perrin, 1984.

———. *Journal historique de la révolution opérée dans la constitution de la monarchie française.* 7 vols. London: n.p., 1774–76.

———, Barthélemy-François-Joseph Mouffle d'Angerville, and Louis Petit de Bachaumont. *Mémoires secrets pour servir à l'histoire de la République des lettres en France, depuis 1762 jusqu'à nos jours.* 36 vols. London: John Adamson, 1777–89.

Manning, Céline Frigau. "Phrenologizing Opera Singers: The Scientific 'Proofs of Musical Genius.'" *19th-Century Music* 39, no. 2 (Fall 2015): 125–41.

Marchand, Suzanne. "Dating Zarathustra: Oriental Texts and the Problem of Persian Prehistory, 1700–1900." *Erudition and the Republic of Letters* 1, no. 2 (March 2016): 203–45.

Marcus, Sharon. *The Drama of Celebrity.* Princeton, NJ: Princeton University Press, 2019.

Marmontel, Jean-François. *Correspondance.* Vol. 1, *1744–1780,* edited by John Renwick. Clermont-Ferrand: Presses universitaires Blaise Pascal, 1974.

Marmoy, C.F.A. "The 'Auto-Icon' of Jeremy Bentham at University College, London." *Medical History* 2, no. 2 (April 1958): 77–86.

Marshall, P. David. *Celebrity and Power: Fame in Contemporary Culture.* Minneapolis: University of Minnesota Press, 1997; 2nd edition, 2014.

———, and Sean Redmond, eds. *A Companion to Celebrity.* Chichester: Wiley Blackwell, 2016.

Martin, Paul M. "Noms 'antiques' de Communes sous la Révolution Française." In *La Révolution Française et l'Antiquité,* edited by Raymond Chevallier, 203–19. Tours: Centre de Recherches A. Piganiol, 1991.

Mason, Meagan. "Music Business and Promotion among Virtuosos in Paris, 1830–1848." PhD diss., University of Southern California, 2018.

Maugras, Gaston. *La Disgrâce du duc et de la duchesse de Choiseul.* Paris: Plon-Nourrit et Cie, 1903.

Mayer, Sandra. "The Prime Minister as Celebrity Novelist: Benjamin Disraeli's 'Double Consciousness.'" *Forum for Modern Language Studies* 54, no. 3 (July 2018): 354–68.

McGirr, Elaine. "'Inimitable Sensibility': Susannah Cibber's Performance

of Maternity." In *Stage Mothers: Women, Work, and the Theater, 1660–1830*, edited by Laura Engel and Elaine McGirr, 63–77. Lewisburg: Bucknell University Press, 2014.

———. "'What's in a Name?': 'Romeo and Juliet' and the Cibber Brand." *Shakespeare* 14, no. 4 (2018): 399–412.

McPherson, Heather. *Art and Celebrity in the Age of Reynolds and Siddons*. University Park: Pennsylvania State University Press, 2017.

———. "Painting, Politics and the Stage in the Age of Caricature." In *Notorious Muse: The Actress in British Art and Culture, 1776–1812*, edited by Robyn Asleson, 171–93. New Haven, CT: The Paul Mellon Centre for Studies in British Art and the Yale Center for British Art by Yale University Press, 2003.

———. "Sculpting Her Image: Sarah Siddons and the Art of Self-Fashioning." In *Women and Portraits in Early Modern Europe: Gender, Agency, Identity*, edited by Andrea Pearson, 183–202. Aldershot: Ashgate, 2008.

Mélanges publiés par la Société des Bibliophiles français. Paris: Firmin Didot, 1826.

Menger, Pierre-Michel, ed. *Le Talent en débat*. Paris: Presses universitaires de France, 2018.

Metzner, Paul. *Crescendo of the Virtuoso*. Berkeley: University of California Press, 1998.

Michelet, Jules. *Histoire de France au seizième siècle*. Paris: Chamerot, 1855.

Mohan, Jyoti. "La Civilization la plus antique: Voltaire's Images of India." *Journal of World History* 16, no. 2 (June 2005): 173–85.

Mole, Tom. *Byron's Romantic Celebrity: Industrial Culture and the Hermeneutic of Intimacy*. Basingstoke: Palgrave Macmillan, 2007.

———, ed. *Romanticism and Celebrity Culture, 1750–1850*. Cambridge: Cambridge University Press, 2009.

———. "Romantic Memorials in the Victorian City: The Inauguration of the 'Blue Plaque' Scheme, 1868." *BRANCH: Britain, Representation and Nineteenth-Century History* (2012), accessed February 6, 2020, http://www.branchcollective.org/?ps_articles=tom-mole-romantic-memorials-in-the-victorian-city-the-inauguration-of-the-blue-plaque-scheme-1868.

Montesquieu. *De l'Esprit des Lois*. Geneva: Barillot et fils, [1748].

Morande, Charles Théveneau de. *Le Gazetier cuirassé, ou Anecdotes scandaleuses de la cour de France*. [London]: Imprimé à cent lieues de la Bastille, à l'enseigne de la liberté, 1771.

More, Hannah. *Moral Sketches of Prevailing Opinions and Manners, Foreign, and Domestic: With Reflections on Prayer*. London: T. Cadell & W. Davies, 1819.

Morgan, Fidelis. *The Well-Known Troublemaker: A Life of Charlotte Charke*. London: Faber, 1988.

Morgan, Simon. "Celebrity: Academic 'Pseudo-Event' or a Useful Concept for Historians?" *Cultural and Social History*, 8, no. 1 (2011): 95–114.

———. "Heroes in the Age of Celebrity." *Historical Social Research* 32 (2019): 165–85.

Morris, Marilyn. *Sex, Money, and Personal Character in Eighteenth-Century British Politics*. New Haven, CT: Yale University Press, 2014.

Moureau, François. *Répertoire des nouvelles à la main: dictionnaire de la presse manuscrite clandestine XVIe–XVIIIe siècle*. Oxford: Voltaire Foundation, 1999.

Musset, Paul de, *Voyage pittoresque en Italie: Partie septentrionale*. Paris: Belin-Leprieur et Morizot, 1855.

National Portrait Gallery, "Our #portraitoftheday is of celebrated soldier, diplomat and fencer, Chevalier d'Eon," June 10, 2020, https://www.instagram.com/p/CBQyEnigaB5/.

Néel, Louis-Balthazar. *Voyage de Paris à Saint-Cloud, par mer et retour à Paris par terre*. [Paris]: Duchesne, 1748.

Nelson, Eric. *The Greek Tradition in Republican Thought*. Cambridge: Cambridge University Press, 2004.

———. "Utopia through Italian Eyes: Thomas More and the Critics of Civic Humanism." *Renaissance Quarterly* 59, no. 4 (Winter 2006): 1029–57.

Newlyn, Lucy. *Reading, Writing, and Romanticism: The Anxiety of Reception*. Oxford: Oxford University Press, 2000.

Newton, William Ritchey. *L'Espace du roi: la cour de France au château de Versailles, 1682–1789*. [Paris]: Fayard, 2000.

Nicholson, Eirwen. "Consumers and Spectators: The Public of the Political Print in Eighteenth-Century England." *History* 81 (January 1996): 5–21.

Nippel, Wilfried. "Images of Antiquity in the Age of the French Revolution." In *De Oudheid in de Achttiende Eeuw. Classical Antiquity in the Eighteenth Century*, edited by Alexander J. P. Raat, Wyger R.E. Velema, and Claudette Baar-de Weerd, 31–45. Utrecht: Werkgroep 18e Eeuw, 2012.

Nora, Pierre, ed. *Realms of Memory: Rethinking the French Past*. 3 vols. Translated by Arthur Goldhammer. New York: Columbia University Press, 1996–98.

Nussbaum, Felicity. *Rival Queens: Actresses, Performance, and the Eighteenth-Century Theater*. Philadelphia: University of Pennsylvania Press, 2010.

O'Quinn, Daniel. *Staging Governance: Theatrical Imperialism in London, 1770–1800*. Baltimore: Johns Hopkins University Press, 2005.

Oberkirch, Henriette-Louise de Waldner de Freundstein. *Mémoires de la baronne d'Oberkirch sur la cour de Louis XVI et la société française avant 1789*. Edited by Suzanne Burkard. Paris: Mercure de France, 2000.

OED Online. "Celebrity." January 2018. Oxford University Press, accessed February 6, 2020, http://www.oed.com/view/Entry/29424?r edirectedFrom=celebrity#eid.

Opie, Amelia. "On Seeing Mrs Siddons' Busts of her Brothers and Herself." *The European Magazine, and London Review* (May 1800).

Outram, Dorinda. *The Body and the French Revolution: Sex, Class, and Political Culture*. New Haven, CT: Yale University Press, 1989.

Ozouf, Mona. "The Pantheon: The École Normale of the Dead." In *Realms of Memory: Rethinking the French Past*, Vol. 3. Edited by Pierre Nora and translated by Arthur Goldhammer, 325–48. New York: Columbia University Press, 1996–98.

Paillard, Christophe. "Amis ou ennemis? Voltaire et les gens de lettres d'après quelques autographes inédits ou peu connus." *La Gazette des Délices. La Revue électronique de l'Institut et Musée Voltaire* (Summer 2010): 1–16, accessed February 6, 2020, http://docplayer. fr/76775157-La-gazette-des-delices-la-revue-electronique-de-l-institut-et-musee-voltaire-issn.html.

Pares, Richard, and A.J.P. Taylor, eds. *Essays Presented to Sir Lewis Namier*. London: Macmillan, 1956.

Parry, William. *The Last Days of Lord Byron*. London: Knight & Lacey, 1825.

Pascoe, Judith. *Romantic Theatricality: Gender, Poetry, and Spectatorship*. Ithaca, NY: Cornell University Press, 1997.

Pawl, Amy J. "Fanny Price and the Sentimental Genealogy of 'Mansfield Park.'" *Eighteenth-Century Fiction* 16, no. 2 (January 2004): 287–315.

Peel, Ellen, and Nanora Sweet. "Corinne and the Woman as Poet in England: Hemans, Jewsbury, and Barrett Browning." In *The Novel's Seductions: Staël's "Corinne" in Critical Inquiry*, edited by Karyna Szmurlo, 204–20. Lewisburg: Bucknell University Press, 1999.

Pekacz, Jolanta K. *Conservative Tradition in Pre-Revolutionary France*. New York: Peter Lang, 1999.

Perry, Gillian, Joseph Roach, and Shearer West, eds. *The First Actresses: Nell Gwyn to Sarah Siddons*. Ann Arbor: National Portrait Gallery and University of Michigan Press, 2011.

Philip, Laure, and Juliette Reboul, eds. *French Emigrants in Revolutionised Europe: Connected Histories and Memories*. Basingstoke, UK: Palgrave Macmillan, 2019.

Physiologie des physiologies. Paris: Desloges, 1841.

Pidansat de Mairobert, Mathieu François. *L'Espion anglois: ou, corre-spondance secrète entre milord All'Eye et milord All'Ear.* 10 vols. London: J. Adamson, 1784.

Pitts, Jennifer. "Empire and Legal Universalisms in the Eighteenth Century." *American Historical Review* 117, no. 1 (February 2012): 92–121.

Place, Charles. *De l'Art dramatique au point de vue de la phrénologie.* Batignolles: Hennuyer et Turpin, 1843.

———. *Essai sur la composition musicale: biographie et analyse phré-nologique de Cherubini avec notes et plan cranioscopique.* Paris: Les principaux librairies et éditeurs de musique, 1842.

Plutarch. *Demosthenes and Cicero.* Translated by Andrew Linott. Oxford: Oxford University Press, 2013.

———. *Life of Brutus.*

———. *Life of Publicola.*

———. *Life of Gaius Gracchus.*

Pocknell, Pauline, "Le Liszt des phrènologues: ou Liszt, Castle, la Comptesse et la Princesse." *Ostinato rigore: Revue internationale d'études musicales* 18 (2002): 169–83.

Pointon, Marcia. *Hanging the Head: Portraiture and Social Formation in Eighteenth-Century England.* New Haven, CT: The Paul Mellon Centre for Studies in British Art by Yale University Press, 1993.

Polwhele, Richard, and Thomas James Mathias. *The Unsex'd Females; a Poem, Addressed to the Author of The Pursuits of Literature.* New York: Re-printed by Wm. Cobbett, 1800.

Pope, Alexander. *The Dunciad, in Four Books.* London: Printed for M. Cooper, 1743.

Postle, Martin, ed. *Joshua Reynolds and the Creation of Celebrity.* London: Tate Publishing, 2005.

Poupin, Théodore. *Esquisses phrénologiques et physiognomoniques des contemporains les plus célèbres, selon les systèmes de Gall, Spurzheim, Lavater, etc.* Paris: Librairie médicale de Trinquart, 1836.

Prod'homme, Jacques-Gabriel. *Paganini.* Paris: H. Laurens, 1927.

Pulver, Jeffrey. *Paganini: The Romantic Virtuoso.* New York: Da Capo Press, 1970.

Quantin, Jean-Louis. "Histoire et érudition au siècle des Lumières: le cas du fragment Diodore VIII, 12." *Histoire, Economie, Société* 9, no. 12 (1990): 213–42.

Ravaisson, François, ed. *Archives de la Bastille. Documents inédits,* vol,. 12. Paris: A. Durand and Pedone-Lauriel, G. Pedone-Lauriel, 1881.

Ravel, Jeffrey S. "Actress to Activist: Mlle Clairon in the Public Sphere of the 1760s." *Theatre Survey* 35, no. 1 (May 1994): 73–86.

Reckwitz, Andreas. *The Invention of Creativity*. Cambridge: Polity, 2017.

Reid, Christopher. "Whose Parliament? Political Oratory and Print Culture in the Later 18th Century." *Language and Literature* 9, no. 2 (May 2000): 122–34.

Reid, Loren. *Charles James Fox: A Man for the People*. London: Longmans, 1969.

Reigny, Beffroy de. *Dictionnaire néologique*, 2 vols. Paris, 1800.

Reinis, Angers. J.G. *The Portrait Medallions of David d'Angers: An Illustrated Catalogue*. New York: Polymath Press, 1999.

Riccoboni, Marie-Jeanne. *Mme Riccoboni's Letters to David Hume, David Garrick, and Sir Robert Liston, 1764–1783*. Edited by James C. Nicholls. Oxford: The Voltaire Foundation and the Taylor Institution, 1976.

Richey, Lisa Ann. *Celebrity Humanitarianism and North-South Relations: Politics, Place, and Power*. Abingdon: Routledge, 2016.

Rivers, Christopher. *Face Value: Physiognomical Thought and the Legible Body in Marivaux, Lavater, Balzac, Gautier, and Zola*. Madison: University of Wisconsin Press, 1994.

Roach, Joseph. *Cities of the Dead: Circum-Atlantic Performance*. New York: Columbia University Press, 1996.

———. "It." *Theatre Journal* 56, no. 4 (December 2004): 555–68.

———. *It*. Ann Arbor: University of Michigan Press, 2007.

Robespierre, Maximilien. *Œuvres de Maximilien Robespierre*. 10 vols. Paris: Phénix, 2000.

Robinson, Nicholas K. *Edmund Burke: A Life in Caricature*. New Haven, CT: Yale University Press, 1996.

Rojek, Chris. *Celebrity*. London: Reaktion, 2001.

Rossi, Henri. *Mémoires aristocratiques féminins, 1789–1848*. Paris: Honoré Champion, 1998.

Roubaud, Pierre Joseph André. *Histoire générale de l'Asie, l'Afrique et l'Amérique*. Paris: de la Doué, 1771.

Russell, Gillian. *The Theatres of War: Performance, Politics, and Society, 1793–1815*. Oxford: Clarendon Press, 1995.

———. *Women, Sociability, and Theatre in Georgian London*. Cambridge: Cambridge University Press, 2007.

———, and Daniel O'Quinn, eds. "Georgian Theatre in an Information Age: Media, Performance, Sociability." Special issue, *Eighteenth-Century Fiction* 27, no. 3–4 (Spring–Summer 2015).

Sadrin, Paul. *Nicolas-Antoine Boulanger (1722–1759), ou, Avant nous le déluge*. Oxford: Voltaire Foundation at the Taylor Institution, 1986.

Salmi, Hannu. "Viral Virtuosity and the Itineraries of Celebrity Culture." In *Travelling Notions of Culture in Early Nineteenth-Century Europe*,

edited by H. Salmi, A. Nivala, and J. Sarjala, 135–53. New York: Routledge, 2016.

Sarmant, Thierry. "De l'Académie des Médailles à l'Académie des Belles-lettres: entre mémoire et histoire, 1663–1716." In *Akadamie und/oder Autonomie: akademische Diskurse vom 16. bis 18. Jahrhundert*, edited by Barbara Mark and Christoph Olivier Mayer, 281–95. Frankfurt: Peter Lang, 2009.

Sarton, George. "Anquetil-Duperron (1731–1805)." *Osiris* 3 (1937): 193–223.

Schoch, Richard. *Writing the History of the British Stage: 1660–1900*. Cambridge: Cambridge University Press, 2016.

Schoenfeld, Myron. "Nicolo Paganini: Musical Magician or Marfan Mutant?" *The Journal of the American Medical Association* 239, no. 1 (1978): 40–42

Schwab, Raymond. *Vie d'Anquetil-Duperron*. Paris: E. Leroux, 1934.

Scobie, Ruth. *Celebrity Culture and the Myth of Oceania*. Woodbridge: Boydell Press, 2019.

Semmel, Stuart. *Napoleon and the British*. New Haven, CT: Yale University Press, 2004.

Setzer, Sharon, ed. *Women's Theatrical Memoirs*. Vol. 4. London: Pickering & Chatto, 2007.

Shakespeare, William. *Macbeth*. Edited by Sandra Clark and Pamela Mason. London: Bloomsbury Arden Shakespeare, 2015.

Sheppard, Leslie and Herbert R. Axelrod. *Paganini*. Neptune City, NJ: Paganiniana Publications, [c.1979].

Sherman, Stuart. "Garrick Among Media: The 'Now Performer' Navigates the News." *PMLA* 126, no. 4 (October 2011): 966–82.

Simpré, Gauthier de. *Voyage en France de M. le comte de Falckenstein*, 2 vols. Paris: Cailleau, 1778.

Simpson, Erik. "'The Minstrels of Modern Italy': Improvisation Comes to Britain." *European Romantic Review* 14, no. 3 (September, 2003): 345–67.

Smith, Blake. "Un cosmopolitisme sans islam: Dara Shikoh, Kant, et les limites de la philosophie comparative dans *l'Oupnekhat* d'Anquetil-Duperron." In *Cosmopolitismes en Asie du Sud: sources, itinétaires, langues (XVIe-XVIIIe siècle)*, edited by Corrine Lefevre and Ines Županov, 121–40. Paris: Éditions de l'Ecole des hautes études en sciences sociales, 2015.

———. "Counter-Revolution and Cosmopolitan Spirituality: Anquetil Duperron's Translation of the Upanishads." In *Freedom and Faith: The French Revolution and Religion in Global Perspective*, edited by Bryan Banks and Erica Johnson, 25–48. Basingstoke: Palgrave Macmillan, 2017.

Smith, Sidonie. *A Poetics of Women's Autobiography: Marginality and the Fictions of Self-Representation*. Indianapolis: Indiana University Press, 1987.

Spencer, Jane. *Literary Relations: Kinship and the Literary Canon, 1660–1830*. Oxford: Oxford University Press, 2005.

Stadter, Philip A. *Plutarch and his Roman Readers*. Oxford: Oxford University Press, 2015.

Staël, Germaine de. *A Treatise on Ancient and Modern Literature Illustrated by Striking References to the Principal Events and Characters that have Distinguished the French Revolution*. London: George Cawthorn, 1803.

——. *Corinne, ou l'Italie*. 2 vols. Paris: H. Nicolle, 1807.

——. *Corinne, ou l'Italie*. 3rd ed. 2 vols. Paris: Frères Mame, 1807.

——. *Corinna, or Italy*. Translated by D. Lawler. London: Colburn, 1807.

——. *Corinna, or, Italy*. 3 vols. London: S. Tipper, 1807.

——. *Considerations on the Principal Events of the French Revolution*. London: Baldwin, Cradock, and Joy, 1818.

——. *De la littérature, considérées dans ses rapports avec les institutions sociales*. Paris: Classiques Garnier, 1998.

Staum, Martin S. *Labeling People: French Scholars on Society, Race, and Empire, 1815–1848*. Montreal: McGill-Queen's University Press, 2003.

Stausberg, Michael. *Faszination Zarathushtra: Zoroaster und die Europäische Religionsgeschichte der Frühen Neuzeit*. Berlin: De Gruyer, 1998.

Steinberg, Sylvie. *La Confusion des sexes. Le Travestissement de la Renaissance à la Révolution*. Paris: Fayard, 2001.

Stendhal. *Armance, ou quelques scènes d'un salon de Paris*. Paris: Urbain Canel, 1827.

Stephens, Frederic George, and Mary Dorothy George. *Catalogue of Political and Personal Satires Preserved in the Department of Prints and Drawings in the British Museum*. 12 vols. London: British Museum, 1870–1954.

Straub, Kristina. *Sexual Suspects: Eighteenth-Century Players and Sexual Ideology*. Princeton, NJ: Princeton University Press, 1992.

Stuurman, Siep. "Cosmpolitan Egalitarianism in the Enlightenment: Anquetil-Duperron on America and India." *Journal of the History of Ideas* 68, no. 2 (April 2007): 255–78.

Swane, Warren. "Da Costa v Jones, 1778." In *Landmark Cases in the Law of Contract*, edited by Charles Mitchell and Paul Mitchell, 119–34. Oxford: Hart Publishing, 2008.

Swann, Julian. "Disgrace Without Dishonour: The Internal Exile of

French Magistrates in the Eighteenth-Century." *Past and Present* 195, no. 1 (May 2007): 87–126.

———. *Exile, Imprisonment, or Death: The Politics of Disgrace in Bourbon France, 1610–1789*. Oxford: Oxford University Press, 2017.

———. "From Servant of The King to 'Idol of the Nation': The Breakdown of the Personal Monarchy in Louis XVI's France." In *The Crisis of the Absolute Monarchy: France from Old Regime to Revolution*, edited by Julian Swann and Joël Félix, 63–89. Oxford: Oxford University Press, 2013.

Tate, Robert Jr., and Tawfik Mekki-Berrada. "Mathieu Pidansat de Mairobert (1727–1779)." In *Edition électronique revue, corrigée et augmentée du Dictionnaire des journalistes (1600–1789)*. Edited by Anne-Marie Mercier-Faivre and Denis Reynaud, accessed February 6, 2020, http://dictionnaire-journalistes.gazettes18e.fr.

Taylor, David Francis. "Byron, Sheridan, and the Afterlife of Eloquence." *The Review of English Studies* 65, no. 270 (June 2014): 484–94.

———. *The Politics of Parody: A Literary History of Caricature, 1760–1830*. New Haven, CT: Yale University Press, 2018.

———. "The Practice of Caricature in 18th Century Britain," *Literature Compass* 14, no. 5 (May 2017), accessed February 13, 2020, DOI: 10.1111/lic3.12383.

———. *Theatres of Opposition: Empire, Revolution, and Richard Brinsley Sheridan*. Oxford: Oxford University Press, 2012.

The Corinna of England, Or a Heroine in the Shade; A Modern Romance. Edited by Sylvia Bordoni. Chawton House Library Series. New York: Routledge, 2008.

The Exhibition of the Royal Academy, MDCCXCI. The Twenty Third. London: T. Cadell, 1791.

Thiéry, Luc-Vincent. *Guide des amateurs et des étrangers voyageurs aux environs de Paris*. Paris: Hardouin et Gattey, 1788.

Tillyard, Stella. "Celebrity in Eighteenth-Century London." *History Today* 55, no. 6 (2005): 20–27.

Trilling, Lionel. *The Opposing Self: Nine Essays in Criticism*, 208–30. New York: Viking Press, 1955.

Trippett, David. "Exercising Musical Minds: Phrenology and Music Pedagogy in London circa 1830." *19th-Century Music* 39, no. 2 (Fall 2015): 99–124.

Tuite, Clara. *Lord Byron and Scandalous Celebrity*. Cambridge: Cambridge University Press, 2015.

Tumble-Down Dick: or, Phaeton in the Suds. London: Printed for J. Watts, 1736.

Turcot, Laurent. *Le Promeneur à Paris au dixhuitieme siècle*. Paris: Editions Gallimard, 2007.

Tussaud, Marie. *Biographical and Descriptive Sketches of the Whole Length Composition Figures, and Other Works of Art, Forming the Unrivalled Exhibition of Madame Tussaud.* Bristol: J. Bennett, 1823.

Tytler, Graeme. "Character Description and Physiognomy in the European Novel (1800–1860)." PhD diss., University of Illinois at Urbana-Champaign, 1970.

———. *Physiognomy in the European Novel: Faces and Fortunes.* Princeton, NJ: Princeton University Press, 1982.

Valensi, Lucette. "Eloge de l'Orient, Eloge de l'Orientalisme. Le jeu d'échecs d'Anquetil-Duperron." *Revue de l'histoire des religions* 212, no. 4 (October–December 1995): 419–52.

Van der Blom, Henriette. *Cicero's Role Models: The Political Strategy of a Newcomer.* Oxford: Oxford University Press, 2010.

Van Krieken, Robert. *Celebrity Society.* New York: Routledge, 2012.

———and Nicola Vinovrski, eds. "Celebrity's Histories: Case Studies and Critical Perspectives." Special issue, *Historical Social Research Supplement,* 32 (December 2019).

Vice, John, and Stephen Farrell. *The History of Hansard.* London: House of Lords Hansard and the House of Lords Library, 2017.

Vidalenc, Jean. *Les Emigrés français (1789–1825).* Caen: Publications de la Faculté des lettres et sciences humaines de l'Université de Caen, 1963.

Vigée Le Brun, Louise-Élisabeth. *Souvenirs 1755–1842.* Paris: Honoré Champion, 2015.

Vivian, Frances. *A Life of Frederick, Prince of Wales, 1707–1751.* Edited by Roger White. Lewiston: Edwin Mellen Press, 2006.

Voltaire. *Correspondence.* Edited by Théodore Besterman. Vol. 11. Geneva: Institut et musée Voltaire, 1970.

Výborný, Zdenek. "The Real Paganini." *Music & Letters* 42, no. 4 (October 1961): 348–63.

Wagener, Françoise. *La Comtesse de Boigne (1781–1866).* Paris: Flammarion, 1997.

Walker, Alan. *Franz Liszt: The Virtuoso Years, 1811–1847.* Ithaca, NY: Cornell University Press, 1987.

Wanko, Cheryl. *Roles of Authority: Thespian Biography and Celebrity in Eighteenth-Century Britain.* Lubbock: Texas Tech University Press, 2003.

Weber, Brenda. *Women and Literary Celebrity in the Nineteenth Century: The Transatlantic Production of Fame and Gender.* Farnham: Ashgate, 2012.

Weber, William. *Music and the Middle Class: The Social Structure of Concert Life in London, Paris and Vienna between 1830 and 1848.* Burlington: Ashgate, 2004.

Wechsler, Judith. *A Human Comedy: Physiognomy and Caricature in 19th-Century Paris.* Chicago: University of Chicago Press, 1982.

Werkmeister, Lucyle. *The London Daily Press, 1772–1792.* Lincoln: University of Nebraska Press, 1963.

West, Shearer. *The Image of the Actor: Verbal and Visual Representation in the Age of Garrick and Kemble.* New York: St. Martin's Press, 1991.

Westover, Paul. *Necromanticism: Traveling to Meet the Dead, 1750–1860.* Basingstoke: Palgrave Macmillan, 2012.

Whelan, Frederick. "Oriental Despotism: Anquetil Duperron's Response to Montesquieu." *History of Political Thought* 22, no. 4 (April 2001): 619–47.

Worrall, David. *Celebrity, Performance, Reception: British Georgian Theatre as Social Assemblage.* Cambridge: Cambridge University Press, 2013.

Wright, Angela. "Corinne in Distress: Translation as Cultural Misappropriation in the 1800s." *Corvey CW3 Journal* 2 (Winter 2004), accessed February 6, 2020, https://www2.shu.ac.uk/corvey/CW3journal/Issue%20two/bordoni.html.

Wright, Jonathan Kent. "Phocion in France: Adventures of a Neo-Classical Hero." In *Héroïsme et Lumières,* edited by Sylvain Menant and Robert Morrissey. Paris: Honoré Champion, 2010.

Wyne, John van. "The History of Phrenology on the Web." Last modified 2011, accessed February 6, 2020, http://www.historyofphrenology.org.uk/organs.html#gall.

Yoon, Monica Chiyoung. "Princess Cristina Trivulzio di Belgiojoso: Her Passion for Music and Politics." DMA diss., University of Washington, 2014.

Zanone, Damien. *Ecrire son temps, les Mémoires en France de 1814 à 1848.* Lyon: Presses universitaires de Lyon, 2006.



INDEX

Académie française, 16, 132, 249

Actors, XII, 12, 37, 84, 96, 107–8, 117, 124–28, 131–33, 138, 143, 145–46, 181, 183, 185, 187, 192, 203, 219, 227, 250, 258; actresses, XIII, 7, 12–13, 17, 93, 97, 100, 106–7, 117–23, 125–35, 138–41, 145, 147, 183–84, 186–87, 189, 192–93, 258. *See also* Cibber family; Clairon; Kemble family; Talma

Acting, 37, 75, 105, 107, 111, 117–20, 125–26, 133, 143, 147–50, 152, 195, 197; performance, vi, xiv, 7, 12, 36, 77, 84, 95–96, 101, 106–8, 111–12, 126, 141, 143, 145, 147, 149–53, 181–83, 188–90, 192, 194–95, 197, 214, 218, 261

Ancien Régime, xii, xiv, 44, 63, 129, 171, 173, 235, 249–50, 256, 260, 262

Anquetil-Dupperon, Abraham Hyacinthe, v, xi, 10–11, 44–64, 167; *Zend-Avesta* (1771), 44–47, 50, 52–54, 59–60, 62–64

Antiquity, 5, 45, 47, 49, 218, 225–28, 239

Aristides the Just, 233–34, 239, 242–43

Aristocracy, 3–4, 15, 106, 129, 172, 207–8, 217, 219–20, 249–58, 262, 265

Army, 13, 119, 157, 159, 166, 168, 170, 231, 263

Artois, comte d', 209, 220

Asia, 44–64

Audience, 11, 13, 23, 51, 60, 66, 73, 82, 94, 96, 98–101, 103, 107, 117, 145–50, 152–53, 183–84, 192, 195, 227

Austen, Jane, 13, 139, 142, 148–50, 153; *Mansfield Park* (1814), 13, 139, 142, 148–50, 165

Autobiography, 12–14, 40, 54, 118, 120, 122–23, 128, 131, 168, 174, 187, 192

Behavior, 15, 65, 76, 108, 119, 121, 123–24, 128–29, 138, 141, 144–46, 163, 204–5, 210, 251, 254–55, 258–59, 261–64

Bennati, Francesco, 78, 80–83

Bentham, Jeremy, vii, xi, 10, 22–23, 25, 27–28, 30–37, 39; Auto-Icon, vii, 10, 30, 32–37

Berlioz, Hector, 78, 83

Biography, xiv, 12–14, 29, 54, 118–123, 128, 131, 157, 161, 168, 174, 187, 192, 267

Body, xv, 11, 30, 32–33, 36, 54, 65, 78, 81, 84, 99, 106, 122, 148, 162, 165, 190, 214, 220, 256

ABOUT THE CONTRIBUTORS

Dr. Ariane Viktoria Fichtl is a historian of intellectual history of the long eighteenth century, specializing in Enlightenment studies and the reception of Classical Republicanism. She recently completed a binational PhD at the University of Lille, France, and the University of Augsburg, Germany. Ariane published her thesis, entitled *La Radicalisation de l'idéal républicain. Les Modèles antiques de la Révolution française* with Classiques Garnier (Paris) in 2020. Her new project focuses on Great Britain's blue-water foreign policy and the connections between concepts of insularity and peace in the long eighteenth century.

Dr. Chris Haffenden is an intellectual historian of nineteenth-century Britain, based at the Department of the History of Science and Ideas at Uppsala University, Sweden. His recent study, *Every Man His Own Monument: Self-Monumentalizing in Romantic Britain* (Acta Universitatis Upsaliensis, 2018), explored how a modern celebrity culture enabled distinctive new practices for making immortality in the opening half of the nineteenth century. Having been employed at the National Library of Sweden in Stockholm, he returned to Uppsala in fall 2020 to start a postdoctoral project examining the emergence of self-erasure and practices of motivated forgetting in nineteenth-century culture.

Dr. Emrys D. Jones is senior lecturer in eighteenth-century literature and culture at King's College London. Prior to joining KCL, he was lecturer and senior lecturer at the University of Greenwich, having previously studied at Oxford and Cambridge Universities. His publications, largely focused on the history of sociability and celebrity, include the monograph *Friendship and Allegiance in Eighteenth-Century Literature* (Palgrave Macmillan, 2013) and the co-edited essay collection *Intimacy and Celebrity in Eighteenth-Century Literary Culture* (Palgrave Macmillan, 2018). Emrys hosts the *Pop Enlightenments* podcast, discussing modern pop cultural representations of the eighteenth century. He is also co-editor of the journal *Literature and History,* and sits on the executive committee of the British Society for Eighteenth-Century Studies. His current projects include a monograph on eighteenth-century depictions of corrupt sociability and a co-edited collection exploring the impoliteness of periodical culture.

Dr. Miranda Kiek completed her undergraduate and master's degrees in English at Oxford University before working as a teacher and journalist for three years. Her doctoral thesis at the Department of English at King's College London focused on how the actress (real and fictional) became an important figure in the political imagination of the late Georgian era. Miranda now researches the ways in which politics, popular culture, and the arts interacted during the Romantic era. She is currently teaching at Putney High School in South-West London and is the reviewer for the "Romantic Drama" section of the *Year's Work in English Studies.*

Professor Antoine Lilti is the director of studies at the Ecole des Hautes Etudes en Sciences Sociales (EHESS) in Paris. He has published three monographs: *Le Monde des salons: Sociabilité et mondanité à Paris au XVIIIe siècle* (Fayard, 2005) (translated by Lydia G. Cochrane as *The World of the Salons: Sociability and Worldliness* [Oxford, 2015]); *Figures publiques: les origines de la célébrité (1750–1850)* (Fayard, 2014) [translated by Lynn Jeffress as *The Invention of Celebrity* [Polity, 2017]); and most recently *L'Héritage des Lumières: Ambivalences de la modernité* (Fayard, 2019).

Dr. Meagan Mason earned a PhD in historical musicology from the University of Southern California in 2018. Her dissertation, "Music Business and Image Promotion among Virtuosos in Paris, 1830–1848," describes the efforts of virtuoso conductors and instrumentalists to build their reputations through print media, salon networks, and stage presence. Meagan has a bachelor's degree from Emory University, where she was elected to Phi Beta Kappa. She lives in Paris, where she is associate editor of *Inference: International Review of Science*.

Anaïs Pédron is an independent scholar based in London. She has studied at the Universities of Angers, Poitiers, and Nantes, and at Queen Mary University of London. She is widely interested in gender, female activism, literature, and sexuality. Anaïs has published on female writers and activism in the eighteenth century in both English and French. She has recently published the article "'Nous aussi nous sommes citoyennes': Female Activism during the French Revolution" in *Women in French Studies* (Special Issue 2019), and the chapter "Olympe de Gouges, anti-esclavagiste et anticolonialiste?" in *Les Lumières, l'esclavage et l'idéologie coloniale: XVIIIe—XIXe siècle*, ed. Pascale Pellerin (Paris: Classiques Garnier, 2020).

Dr. Laure Philip is an independent scholar and literary historian of the late eighteenth and nineteenth centuries. Her thesis, completed at the University of Warwick in 2016, explored the novels of French noblewomen who were exiles in London during the 1790s. She also worked as a research associate at Western Sydney University, Australia, on a digital humanities project on the circulation of illegal French novels in the eighteenth century. With Juliette Reboul, she co-edited *French Emigrants in Revolutionised Europe: Connected Histories and Memories*, published by Palgrave Macmillan in 2019 as part of the War, Culture and Society, 1750–1850 series. The collection of essays explores the latest research and methodologies for studying the history of the French emigration and the émigrés' interaction with host populations. Laure now works in philanthropy for a research institute in Sydney, Australia.

Dr. Anna Louise Senkiw completed her DPhil at Mansfield College, University of Oxford, in 2019. Her thesis, "Made in the Media: Actresses, Celebrity and the Periodical Press in the late Eighteenth Century," examined the emergence of theatrical celebrity alongside the development of print news culture. Anna is currently working as a research assistant for the *Elizabeth Montagu Correspondence Online* project, for which she is editing Montagu's letters written to David Garrick, and as a research assistant for "Opening the Edgeworth Papers." She is currently reworking her thesis into a monograph and undertaking further research into the relationship between the royal family and the press in the eighteenth century.

Dr. Clare Siviter is a theater historian of the long French Revolutionary period and is lecturer in French Theatre at the University of Bristol. Before joining Bristol, and before taking up a postdoctoral position at the Centre d'Histoire Espaces et Cultures at the Université Clermont Auvergne, France, she completed a PhD at the University of Warwick. Clare has published on French theater and the culture of the late eighteenth and early nineteenth centuries in both English and French. Her monograph, *Tragedy and Nation in the Age of Napoleon*, appeared with Oxford University Studies in the Enlightenment in 2020. Clare was co-investigator with Dr. Annelies Andries (University of Oxford) on the project "Theatre on the Move in Times of Conflict, 1750–1850," supported by the John Fell Fund and a British Academy/Leverhulme Small Research Grant, and is a member of the editorial board for *Modern and Contemporary France*.

Dr. Blake Smith is a Harper-Schmidt Fellow at the University of Chicago, where he works on French relations with South Asia from the eighteenth century to the present. He earned his PhDs at Northwestern University and the Ecole des Hautes Etudes en Sciences Sociales, Paris (2017). He has been a fellow at the European University Institute, New Europe College, and the Arni Magnuson Institute of Icelandic Studies. In addition to his academic research, he is also the translator of Evariste Parny's poetry, K. Madavane's short story collection *Mourir à Bénarès* and Ari Gautier's novel *Le Thinnai*.

Dr. Gabriel Wick is a historian whose work focuses on gardens, public spaces, and political culture in eighteenth-century France. He is a lecturer in architectural and urban history at New York University–Paris, and in material culture at Parsons/The New School. He received his doctorate in history from Queen Mary, University of London in 2017, and holds master's degrees in landscape architecture from the University of California, Berkeley, and in historic landscape conservation from the Ecole nationale supérieure d'architecture–Versailles. He has authored and co-edited a number of books, including *Le Domaine de Méréville: Renaissance d'un jardin* (Editions des falaises, 2018) (winner of the 2018 Redouté Prize for writing on garden history), *Un Paysage des Lumières: le jardin anglais du château de La Roche-Guyon* (Artlys, 2014), and *Une Maison de plaisance au dix-huitième siècle: l'hôtel de Noailles à Saint-Germain-en-Laye* (Artlys, 2016). In 2017, he curated the exhibition *Hubert Robert et la fabrique des jardins* at the Château de La Roche-Guyon, and co-edited the catalog of the same name (RMN, 2017). He is currently advising the Fondation Chambrun on the restoration of General Lafayette's domain of La Grange-Bléneau.